Cloth and Culture

COUTURE CREATIONS OF RUTH E. FUNK

Ruth E. Funk

Cloth and Culture

Photographed by Dominic Agostini

Edited by Anita M. Kasmar

Designed by Ashley DuPree

There are many cultures in the great tapestry of life—I work to share my knowledge of world textiles and their creators.

Published by

Panache Partners, LLC

1424 Gables Court

Plano, Texas 75075

t 469.246.6060

f 469.246.6062

www.panache.com

Publishers: Brian G. Carabet and John A. Shand

Couture Creations © 2009 by Ruth E. Funk

Photographs © 2009 by Dominic Agostini

Foreword © 2009 by Jack Lenor Larsen

Preface © 2009 by James G. Shepp

Printed in China

Distributed by Independent Publishers Group

800.888.4741

PUBLISHER'S DATA

Cloth and Culture

Library of Congress Control Number: 2008943850

ISBN 13: 978-1-933415-81-9

ISBN 10: 1-933415-81-9

Right and previous pages: Cotton batik from Malaysia

For information about custom editions, special sales, premium and corporate books, please contact Panache Partners at bcarabet@panache.com

First Printing 2009

10 9 8 7 6 5 4 3 2 1

Panache Partners, LLC, is dedicated to the restoration and conservation of the environment. Our books are manufactured with strict adherence to an environmental management system in accordance with ISO 14001 standards, including the use of paper from mills certified to derive their products from environmentally managed forests. We are committed to continued investigation of alternative paper products and environmentally responsible manufacturing processes to ensure the preservation of our fragile planet.

Dedication

For my loyal friends and encouraging colleagues—

especially the many fiber artists from around the

world who have inspired my creative path—may our

lifelong love of textiles endure.

Ruth E. Funk

FOREWORD
JACK LARSEN

If the term "contemporary robes" sounds odd, like an oxymoron, that's just the point! Why does a publication on newly made dress coats come off as so unusual? There appear ever more volumes on kimonos—even on such special ones as those for Kabuki Theater. The spectacular robes of the virile Ainu and stately Mandarins are now well known. We often see luxe volumes on ancient Peruvian mantles, while the bold chapans of Central Asia take your breath away. Are we today so given over to the workaday as not to have considered contemporary raiment well outside the fashion industry?

There have been some compilations on Art-to-Wear—not many and not recently—and no monographs of a single American come to mind. Perhaps this small book will unleash the publication of talents we are but half aware. Because of artists' work frequently appearing in magazines, especially *Surface*

Design and *Selvedge*, we are now familiar with a buoyant international underground of their more-or-less wearable creations. Interestingly enough, this sudden focus on handcrafted, one-of-a-kind garments and embellished fabrics was contemporaneous.

For at least half a century (from 1920 to 1970) Modernist mores—frowning on all forms of ornament—led to a concentration on weaving, especially on the texture and broken color inherent to woven cloth. Pattern, where it was expressed at all, was either architectonic geometry or a few abstract symbols. Especially in North America, Modernism implied architecture, including interior furnishings and woven wall hangings. For the most part, the focus was austerely functional, while expressing a new freedom from old orders.

Then in 1970 at Lawrence, Kansas, two heretofore unknown women held the first Surface Design Conference. Dye chemists were invited, and as a keynote I spoke on all the resist-dyeing techniques that would soon be published as *Dyer's Art*. The organizers hoped for 200 attendees. Six hundred came: printers and dyers, those who embroidered, some who painted directly on fabric (then new), quilters, and several who combined these techniques. Oversubscribed workshops helped spread like wildfires old skills and new technology. All these craftmakers, who had long felt themselves neglected orphans, now recognized a new strength in numbers. A new movement was launched, also a new organization that has since gone from strength to strength. Their fine magazine bears the same title—*Surface Design*. If this is felt by some to be unfortunate, no alternative has appeared—although fabric entries in competitions are no longer listed as weaving, but are divided into "structural" and "embellished" approaches.

Proof of the success of this revolution came the next season, when Paul Smith's now historical Art-to-Wear exhibition at the American Craft Museum featured 25 artists, only two of them weavers—the rest working in some aspect of surface design. In the decades since, both wearable art and a growing range of embellished formats have flourished, perhaps with more exhibits and publications than market growth. Except for scarves and shawls, woven apparel has lagged because of inexpert tailoring or cloths insufficiently finished to resist sagging and slipping.

Embellishing readymade cloths has proved more sustainable, whether executed in a growing number of dye techniques—especially those pressure-resists now termed Shibori—or those worked with a needle. Both hand and sewing machine embroidery flourish, while appliqué and patchwork each year win larger fanfare with considerable crossover between traditional and modern formats. Here at last a familiar North American handcraft—rooted in recycled economy—has spilled over the globe. Current growth of remarkable patchwork quilting in Japan, India and Russia is spectacular. Enthusiasm there for the rustic dynamism of the Gee's Bend Quilts from backwater

Alabama has been phenomenal. So has the new popularity of threadbare, faded indigo boro bedcovers from northern Japan, which were repeatedly patched out of necessity. Both of these rugged and recently discovered forms are quite different from the meticulously worked American quilts first shown at the Whitney Museum. This great collection—ranging from exquisite wedding ring quilts of southern manor houses to prim Amish geometry, to flamboyant crazy quilts—was by far the most popular of the exhibitions (including the Abstract Expressionists that America sent to postwar Europe). In several capital cities I saw groups queuing up to see these quilts. The second most popular American exhibit in Europe, by the way, was of Navajo blankets first shown in the Brooklyn Museum.

In seeking to place in context Ruth's body of work, several hierarchies come to mind, such as the historic costume and haute couture. But first, for several reasons (primarily because Ruth's coats are one-of-a-kind), they relate to theatrical costume. Most cultures have created such dramatic garments to enhance characterization, giving the audience the pleasure of recognition. While we seldom see these costumes except on stage or in portraits, opera houses often showcase historic examples. At one performance, seeing a majestic gown embroidered with a thousand seed pearls, I asked, "Why such extravagance that no one in the audience can see?" The explanation was clear: "Because Spanish operatic soprano Victoria de los Ángeles could see it; she moved all the more nobly while others on stage performed accordingly." And so it is with Ruth Funk's work—often embellished with such unique nontraditional details as the disk of gleaming cowrie shells that cap her Shibori silk kimono, or the assembly of silk, metal and pearls enriching her elephant coat design.

We marvel at Ruth's breadth of expression and how—in a short timeframe—she has achieved so many very different statements. The answer of course is that the concept for each garment derives from a special fabric—not yard goods and often not apparel fabric per se—but a gleaned treasure sufficiently dramatic as to stimulate her creative juices. To assess her achievement in composing several mediums, often from different continents, we become aware of the architectural structure dominating the whole. Consider the William Morris-inspired jacket as illustrative of how this grid organizes several decorative elements into an ordered unity while, at the same time, relating the garment to the bisymmetrical frame of the wearer.

Of course, one could argue that humankind has always cherished personal adornment, such as raiments, as a symbol of status and wealth or even vanity; but only recently has it become acceptable for modern textiles to be shown as art worthy of exhibition. From the early 20th century an avant-garde focused on rather straightforwardly woven cloths for architecture. Luxury was out and so was ornament, both discarded in favor of texture and stripped-

Photograph by Roberto Dutesco © 2008, courtesy of LongHouse Reserve

On the other hand, Ruth's compositions of special cloths relate to an idiom in current focus, that of Assemblage. Think patchwork melding old and new—especially the quilts now, at least as often are seen on walls as on tester beds. But with the notable exception of Sonia Delaunay's now-priceless patchwork coats, seldom worn.

While much of the early Wearable Art was too bombastic for easy wearing or too weighty in relation to the loose fabric structure to retain their original shape, Ruth's coats are quite wearable and durable, too. Most are lined; many are reinforced with additional stitching. More than that, the Square-Cut Jacket style and classic Othello Coat silhouette accommodate a range of sizes. If lucky enough to own such a coat, one would not outgrow it. Nor would it become last season's style. Rather, it will be an heirloom and museum piece.

PREFACE

James G. Shepp

It is always a thrill when one discovers something new, especially when it is creative and exciting, and even daring. When it involves a charming, delightful and engaging individual such as Ruth Funk, it is even more exciting.

The Maitland Art Center has shown but a few exhibits completely devoted to fiber art. In 2000, Ruth Funk's exhibition was our second fiber art event. Ruth brought a dozen of her garments to the center for us to view in anticipation. They were exciting, fresh and dynamic as she revealed each one from the travel box and unfolded coat after coat. After viewing these creations, it was just a matter of finding a time-slot in the exhibition schedule to offer these works to the Central Florida gallery-visiting public.

We were delighted to present a select group of Ruth's creative wearable art garments for the visual enjoyment of not only those who work in fiber or cloth, but for all to admire the craftsmanship evident in each and every garment. It is my pleasure to support her continuing artistic journey and body of work depicted in this monograph.

I know that you will enjoy viewing, examining and marveling over the creativity that went into every one of Ruth's handmade garments. Consider the thought process and work on each item as the pieces of fabric, carpet, ribbon, buttons, shells and every other fragment were assembled together to construct these beautiful garments. There are many forms of art, and these garments are but one more to be enjoyed.

—James G. Shepp, Executive Director
The Maitland Art Center

ACKNOWLEDGEMENTS

I never thought I would write a book about my collective work. Putting a book together has been an opportunity to review all of the garments I have created since 1987. It has also been an opportunity to re-evaluate my approaches. Jack Lenor Larsen suggested I do a signature book when he saw my creations and I am deeply indebted to him for his keen professional insight and unwavering support.

Over the past 20 years I have done fashion shows and museum exhibits to raise money and awareness of textiles. I would like to thank all of the wonderful people who have supported my efforts. James G. Shepp, executive director of The Maitland Art Center, gave me my first one-woman exhibit at his museum, which was extended because of its popularity with visitors. Also, kudos to my great friends and models in the many fashion shows presented to raise money for art causes: Jane Farmer, Marissa Magill, Mary Fox, Trish Wimmer, Carol Cook, Susan Bayly and Fran Gordon.

Many thanks to my interior designer friend Denise Halkeas and her sister Martha for their gifts of beautiful fabrics, trims and encouragement. My earnest appreciation also goes to the faculty of the Florida Institute of Technology, especially Carla Funk, director of the Ruth Funk Center for Textile Arts, and the university's development department.

I would also like to acknowledge my professors at Texas Woman's University for their strong guidance at a time when women in the visual arts were just beginning to turn their dreams into career possibilities. A true thank you to abstract painter Hans Hofmann who taught me principles of art and inspired me to really see; he influenced my lifelong approach to design and ignited my creativity.

As a free-spirited artist, I have been uninhibited in my design expression and love using many embellishments and fabrics in unorthodox ways. I do not sell my garments; they are creative works meant to inspire others. I will always be grateful to my mother for teaching me to sew and to my many friends and acquaintances who applauded my artistic efforts and presentations.

Sincere thanks are also due to Dominic Agostini for photographing my garment collection and fiber art designs. Shooting hundreds of color images, he has beautifully highlighted the textiles, craftsmanship and important details. His skill and dedication to the project have brought my designs to life for viewers. One special note of thanks to my editor Anita Kasmar for her invaluable ability to translate my original design concepts, thoughts and feelings into words; I think we have both enjoyed preparing the text for readers. Finally, I would like to thank graphic designer Ashley DuPree and the publishing staff at Panache for their assistance, evaluations and encouragement during the creation of this book.

—Ruth E. Funk

"You are never too old
to set another goal or to
dream a new dream."
—C.S. Lewis

CONTENTS

INTRODUCTION
My Journey

This collection of my garments did not start out to be a book; these were pieces made by me, using high-quality craftsmanship and design in reaction to our technical society. With encouragement from many friends to present photographs of my work in book form, the publishing effort has grown. Each one-of-a-kind garment has a story: simple and focused. I get inspiration for creating a piece from the fabric, embellishments and my life experiences. What we wear is really both an expression of our culture and a reflection of our own personality. The creative result involves a mixed combination of multiple techniques, becoming a self-expression that survives on its own merits. There are no rules. The garments in this compilation are more fine art than fashion. Though my collection is quite wearable, the garments are meant to be displayed in art galleries, exhibited in museums, featured in fashion shows or at special events. Sometimes the lines get blurred between art and fashion. Many cultures equate clothes with status. My original creations pay homage to textiles as art and have been exhibited with gracious reviews in New York, Texas and Florida. My goal is to expand the legacy of textiles through future shows.

For many years museums were not interested in textiles as an "art form" for various exhibitions and displays; their delicate nature made them more costly to preserve. Fiber art is a visual language that relates to the world around us and has been part of our lives from the beginning of time. Many fabrics and patterns are global and tribal in nature, and have been developed from regional lifestyles, intended to suit the needs of people in a changing world, using materials at hand with inherited processes. For example, silk traders many years ago swapped and marketed textiles and clothes from their different cultures, sharing distinct ideas of beauty, luxury, patterns and creative processes. I have been fascinated by the cross-cultural wonder of textiles since childhood and my passion has never ceased.

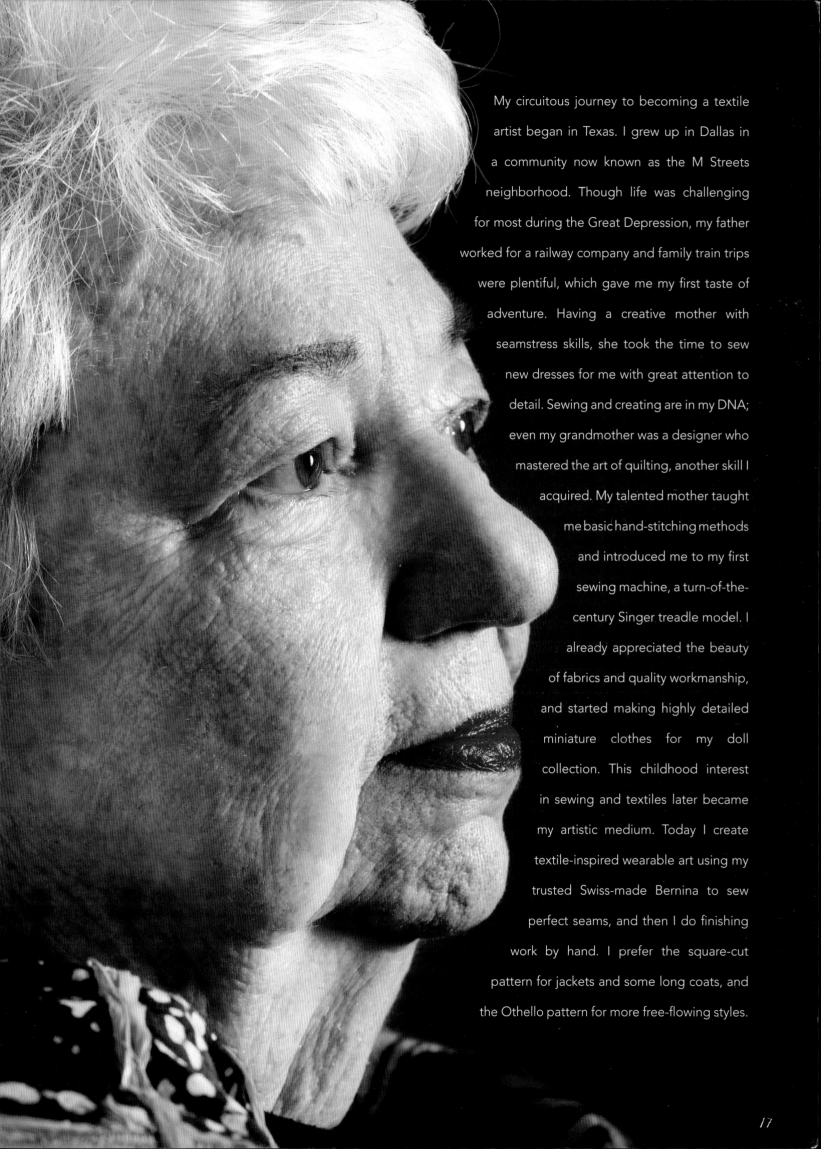

My circuitous journey to becoming a textile artist began in Texas. I grew up in Dallas in a community now known as the M Streets neighborhood. Though life was challenging for most during the Great Depression, my father worked for a railway company and family train trips were plentiful, which gave me my first taste of adventure. Having a creative mother with seamstress skills, she took the time to sew new dresses for me with great attention to detail. Sewing and creating are in my DNA; even my grandmother was a designer who mastered the art of quilting, another skill I acquired. My talented mother taught me basic hand-stitching methods and introduced me to my first sewing machine, a turn-of-the-century Singer treadle model. I already appreciated the beauty of fabrics and quality workmanship, and started making highly detailed miniature clothes for my doll collection. This childhood interest in sewing and textiles later became my artistic medium. Today I create textile-inspired wearable art using my trusted Swiss-made Bernina to sew perfect seams, and then I do finishing work by hand. I prefer the square-cut pattern for jackets and some long coats, and the Othello pattern for more free-flowing styles.

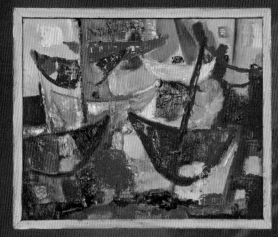

Both are ethnic patterns that have been used by many different cultures throughout the years, adapted to their specific needs and lifestyles. These basic clothing styles have often been modified due to limitations of materials, lifestyles and textile weaving methods.

An only child whose creativity was encouraged, I started piano lessons at five years old on my family's prized grand piano. Exposure to music, literature and fine arts was emphasized at home and I began painting my first colorful canvases during my teens. I attended studio art classes in public high school and naturally became the art editor of the annual yearbook. As college days were just ahead, I was faced with a difficult choice whether to major in music or focus my talents on fine art. Ready for adventure, I left home in the 1940s, decided to study art at the University of Texas at Austin and earned my bachelor's degree in interior design from Texas Woman's University—historically known as the College of Industrial Arts and Texas State College for Women—which had one of the most acclaimed fine arts and design programs in the country at that time. Academically motivated, while earning an additional year of college in occupational therapy, I was introduced to arts and crafts as a component of the therapeutic healing arts.

Further artistic training and good fortune set my course. I returned to college for my master's degree in design as applied to materials at Texas Woman's University. It was during the summer of 1956 that I received an opportunity through my professor to attend a summer oil painting workshop instructed by Hans Hofmann in Provincetown, Massachusetts. Another summer in Nantucket was an opportunity to study silk-screen printing on cotton and silk. I also spent some time in Northampton working with fabrics and indigo dye methods.

As a painter, I became a bold colorist and abstract expressionist artist; my early artwork depicts robust paintings of ships at sea (shown above). Hofmann, the renowned German-born American abstract expressionist painter, had risen to great heights in the New York School and his traditional methods and avant-garde concepts concerning the nature of painting were largely based on Cézanne, Kandinsky and Picasso's Cubism. A contemporary of artists de Kooning and Pollock, Hofmann was known for his push-pull spatial theories, his reverence for nature as a source for art and his philosophy of art; he was an important interpreter of modernism and its relevance to advanced painting. I blossomed as an artist through my workshop experience. Hofmann taught me a whole new way of seeing. Seeing is a language unto itself and one must learn how to see as an artist.

The progressive Bauhaus modernist movement also influenced me. Bauhaus was originally intended to be a combined architectural school, crafts school and academy of the arts: unifying art, crafts and technology. Post World War I, this was the age of the Bauhaus, a cultural movement that was a reaction to social change, which aspired to an aesthetic relevance. I was immersed in art studies soon after this time and credit my evolution as a designer to exploring this period. My professors were products of the Bauhaus philosophy and I benefited as a student of the Modernist school, one of the most important design movements of the 20th century.

I lived the proverbial Bohemian lifestyle in the Village for a time. As a young woman I thrived in New York City—the vibrant urban energy, its rich tapestry of people and free thinkers. Instead of moving to Paris, I continued my art studies in Manhattan. I lived there shortly after the Museum of Modern Art had opened in Midtown and soon after becoming a member, I was lucky to meet Dorothy C. Miller, scholar and champion of modern American art in MoMA's acquisition department. The city's stimulating intellectual environment inspired me, as did the wildly exciting New York '40s and '50s art scene.

While Director of Education for the Albany Institute of History and Art for three years during the late 1950s, I was also part owner of a contemporary art exhibition space called 327 Gallery. In 1983, I attended the Attingham Study Program in England sponsored by the National Historic Trust. This emphasized the English country house as an art form as well as in-depth study of all the decorative arts. My studies and travels abroad added to my knowledge and expanded my repertoire. I taught in the fine arts department for 25 years at Russell Sage College, seven years of which were devoted to teaching the history of art in association with the institute in Albany. I was appointed director of the college's first interior design department and continued to teach design until my retirement.

I reinvented my artistic self in the 1980s after my husband and I went to Florida for a more leisurely lifestyle and to escape northern winters. Our snowbird seasons expanded into year-round living in 1995. I enjoyed the Floridian way of life, but the sunny coastal climate with its high humidity had me searching for clothing in which to stay cool and fashionable. With few options available, I thought about designing my own garments. I had not sewn since I had learned to make doll clothes as a girl, but I decided to create my own hand-sewn garments to fit my figure and sense of style.

The wearable art movement became a popular phenomenon in the 1970s. High-quality handwork and craftsmanship were emphasized in reaction to an increasingly technological society. One characteristic of the wearable art

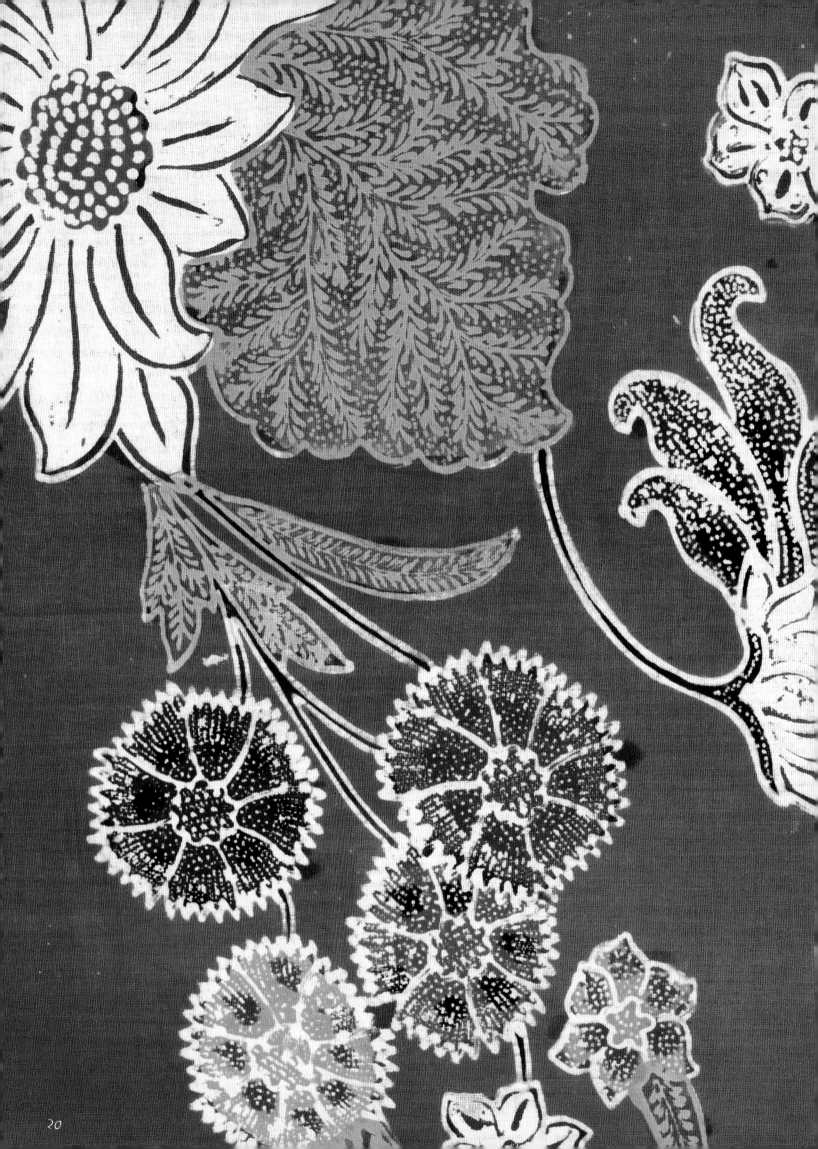

movement related to the textile arts of the Far East more than the urban culture of the West. Ancient traditions of painting, dyeing and pleating silk and cotton, techniques developed over centuries became revered. Attention to detail and meticulous craftsmanship were emphasized. But more than this, self-expression became the impetus behind creators of wearable art, and many modern artists like Picasso and Erté turned to clothing and costume to explore the aesthetics of color, design and form, as well as social commentary. To my delight, I have seen a resurgence of the Art-to-Wear movement in recent years.

Truth is, I became involved in the Art-to-Wear movement rather late in the 1980s; my creative efforts in this genre simply evolved. Florida's culture and creative activities were somewhat limited at this time and it was even hard to find good fabric stores. I started searching for fragments of interesting fabrics in antique shops, thrift stores and consignment shops. I began to recycle these materials for my own creations, using many fabrics and colors to create designs that reflect the appropriate spirit of each garment even though the pieces may not have come from the same culture. The backs of the garments became very important areas for design and unusual embellishments. Friends found my designs interesting and wanted to know where to buy them, and they enthusiastically supported the idea of exhibiting the garments. To this day, I never sew-to-sell or make a garment in multiples. I create original wearable art pieces.

Most area museums did not yet consider clothing as an art form and were not interested in an exhibit, however, with requests from our local museum, I presented several fashion shows of my garments, and in 2000 had my first, one-person exhibit at The Maitland Art Center. There were 38 pieces in the show. The art exhibit was very successful and the exhibition dates were extended by two weeks. Since then, I have had solo exhibits at several area museums including the Orlando Museum of Art, Brevard Art Museum and Vero Beach Museum of Art.

I have discovered some of the most beautiful garments in street fairs and marketplaces around the world. As I have traveled over the years, it has been surprising to see the disinterest in the heritage of textiles, costumes and culture in much of the younger generation. There seems to be a lack of desire in passing on knowledge and preserving handcrafted techniques of ethnic inheritance, especially as it applies to textiles and garments. Lots of ancestral knowledge is being lost. Many people across continents have no idea how to thread a needle or sew on a button. From East to West, most are happy to discard and trash historically rich garments for practical denim and sweatshirts. With that said, this observation helped to shape my life's passion and purpose.

It has been hard for me to watch textile and fiber arts become less valued in our contemporary society. In 2003, I started working with the Florida Institute of Technology in Melbourne, Florida, to establish an academic textile program as well as a center for education and preservation of global textiles. My entire garment collection featured in this book, as well as authentic pieces from many other cultures, now resides in the Ruth Funk Center for Textile Arts for all to appreciate.

There appears to be renewed interest in exhibitions of cloth and textiles as an art form. An increasing curiosity for cultures, designs, textiles and processes has spawned a new approach using traditional patterns, methods and materials adapted for today's lifestyles. I have also noticed a trend toward non-woven, manmade synthetic and emerging green textiles. The Costume Institute at the Met has supported exhibits of textile collections and rare combinations of clothing from well-known people and varied cultures. I hope my heartfelt art education efforts, too, will inspire others to save and respect the cloth, styles and fibers of the past, present and future.

Long live textiles!

Ruth E. Funk

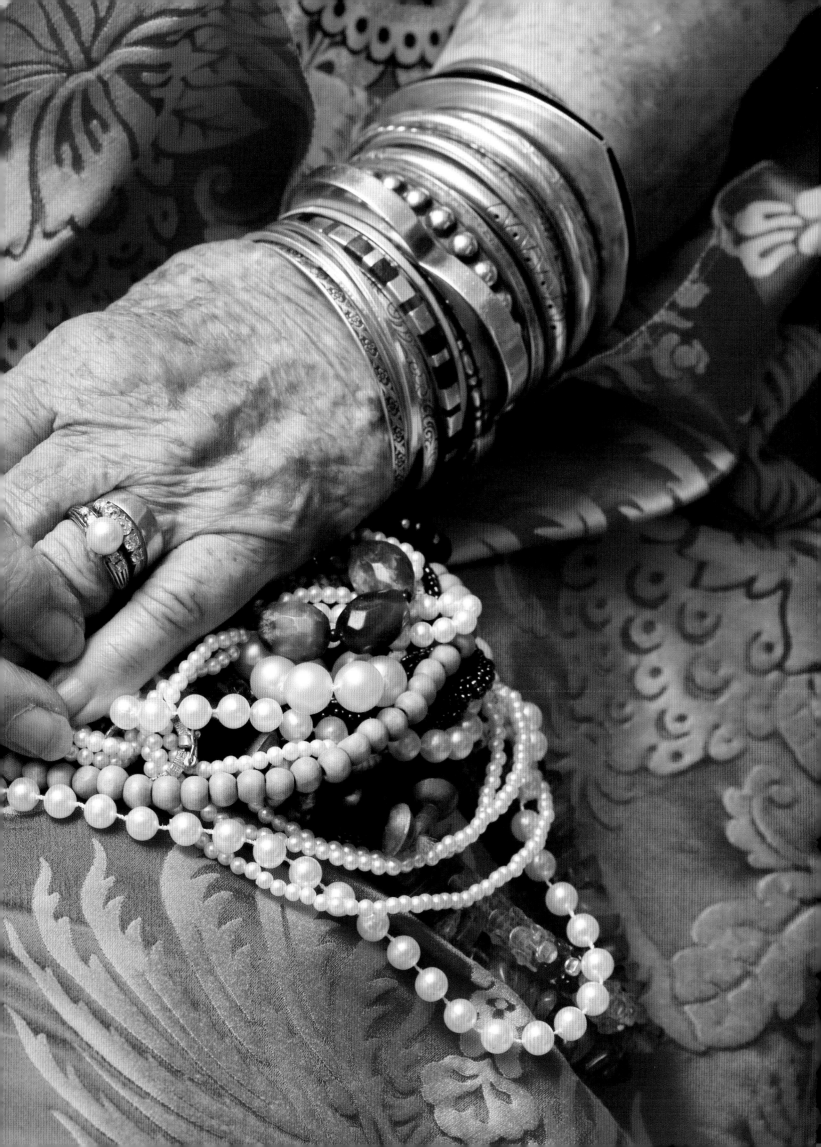

"A thing of beauty is a joy forever."
—John Keats

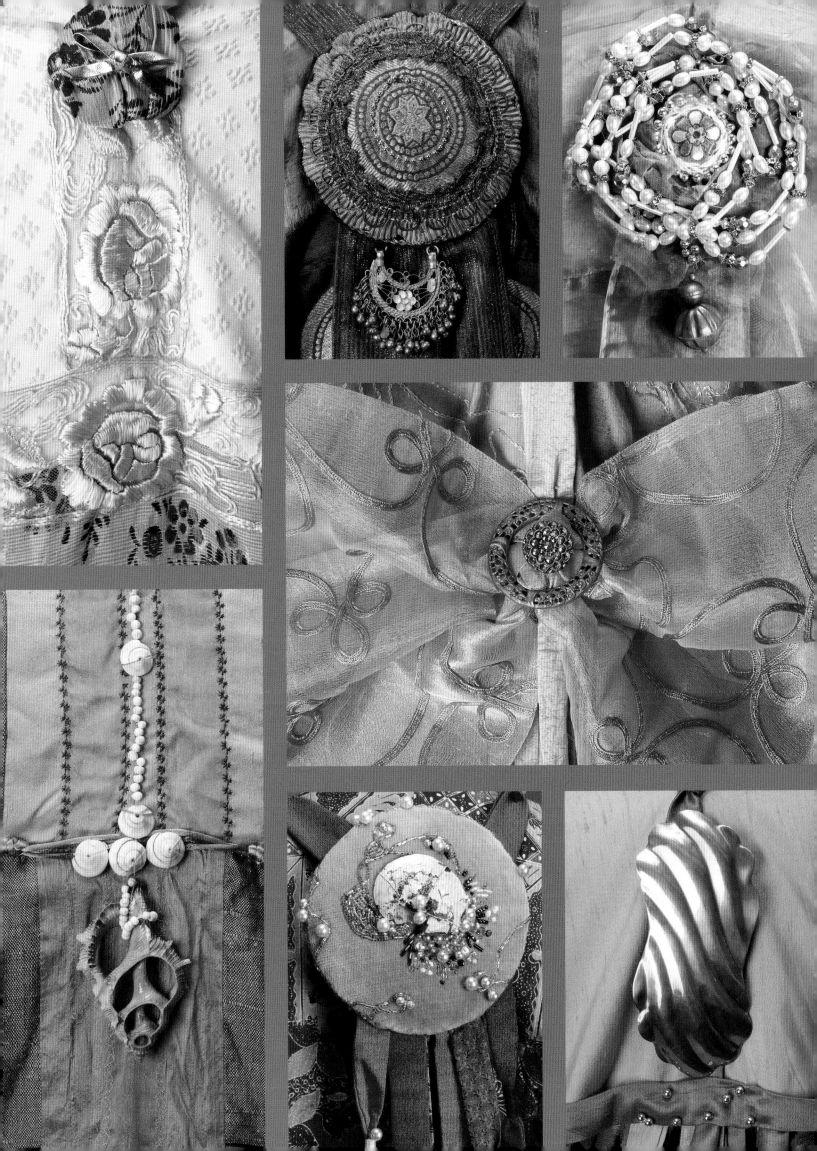

Chapter One
The Othello Coat
Timeless, elegant style meets multicultural textiles

I acquired the elegant Othello Coat pattern through friends at The Embroiderer's Guild of America more than 20 years ago. It has since become the foundation for my multicultural textile art garments. The glamorous Othello Coat pattern's true historic origin remains a bit of a mystery, but my most dramatic wearable art designs have been created following the pattern's classic lines and free-flowing style. An enigma among seamstresses, fashion designers and artists, this seemingly obscure coat pattern has become my signature style.

The popular pattern was most likely adapted for peoples' needs and lifestyles. It has evolved into its current mode, which especially pays homage to ethnic and folklore fashion, a cross between period coats and cloaks similar to the elegant cocoon silhouette reminiscent of the 1920s era. The loose-fitting garment style has hints of African origin and the tribal caftan, yet evokes the elegance of Shakespearian robes. The pattern probably changed over time because of limitations of materials, cultural lifestyles and different weaving practices.

Its regal shape requires only three yards of fabric and two simple seams; coats in my collection range in length, designed to fit my taller stature. My Bernina sewing machine is a strong part of the creative process and the Othello Coat's timeless cut only requires machine sewing of two straight seams. The gently flared sleeves are formed from deep openings that allow for maximum freedom of movement. Varying the coat length as desired, I often create my designs from handmade cloth, vintage pieces and fragile antique textile fragments, which may have imperfections that I must work around. This ideal pattern allows for creative flexibility.

My signature statement has sprung from this versatile pattern. I have worn my exquisite designs to soirées, annual galas and philanthropic events—many of these garments have even walked the runway at well-attended fashion shows benefitting my heartfelt causes.

The Great Masters used vibrant oil paints as their medium. As a textile enthusiast and wearable art designer, I use varied fabrics and colors to create designs that reflect the appropriate spirit of each garment, even though the pieces may not come from the same culture. Exquisite lightweight fabrics are best suited to the Othello Coat design. With that in mind, I carefully select my medium from interesting textiles around the world including fine Chinese silks and Indian saris, French brocades, woven damasks, hand-dyed Indonesian batik and authentic Ikat, silk, velvet, finely printed fabrics, English cottons and wool. These lighter fabrics are integral to creating the garment's fluid draping. The V-neckline and gently folded fronts fall quite gracefully as they are angled, overlapping slightly. This style of ankle-length evening coat with its turned-back lapels does not require buttons or decorative closures. My creations are fully lined with harmonious cloth to complement the overall garment design.

The backs of the garments are very important areas for design and unusual embellishments. I often feature my collected treasures from around the world, special fabric pieces and adornments. Embellishments are added gradually and evolve as the garment is made. Whether antique beads and lace, my own handmade tassels, lustrous faux pearls, vintage shoe buckles, miniature glass flowers, natural seashells or peacock feathers, final ornamental touches are sewn on by hand and my one-of-a-kind wearable art piece is complete.

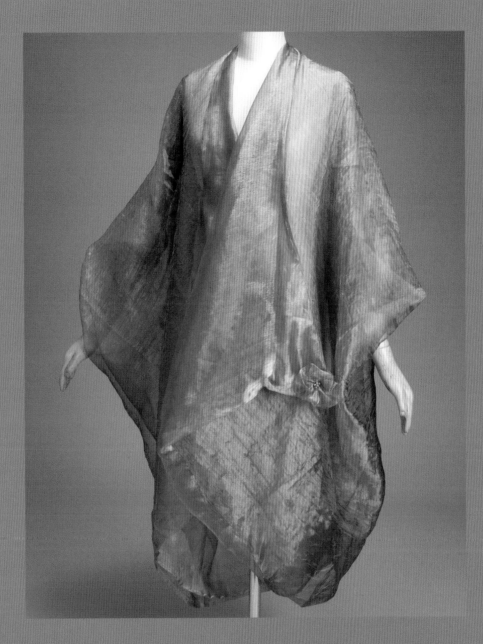

This classic pattern provides the blank canvas for my unlimited creative expression.

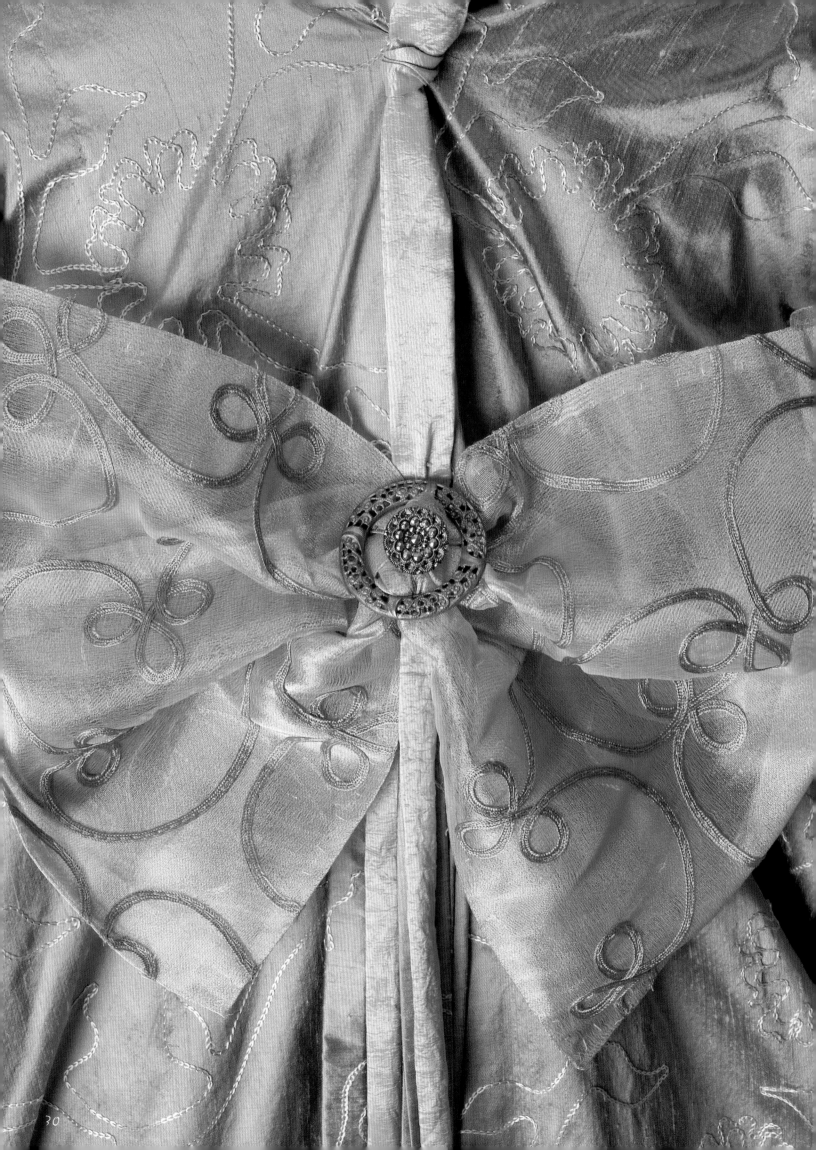

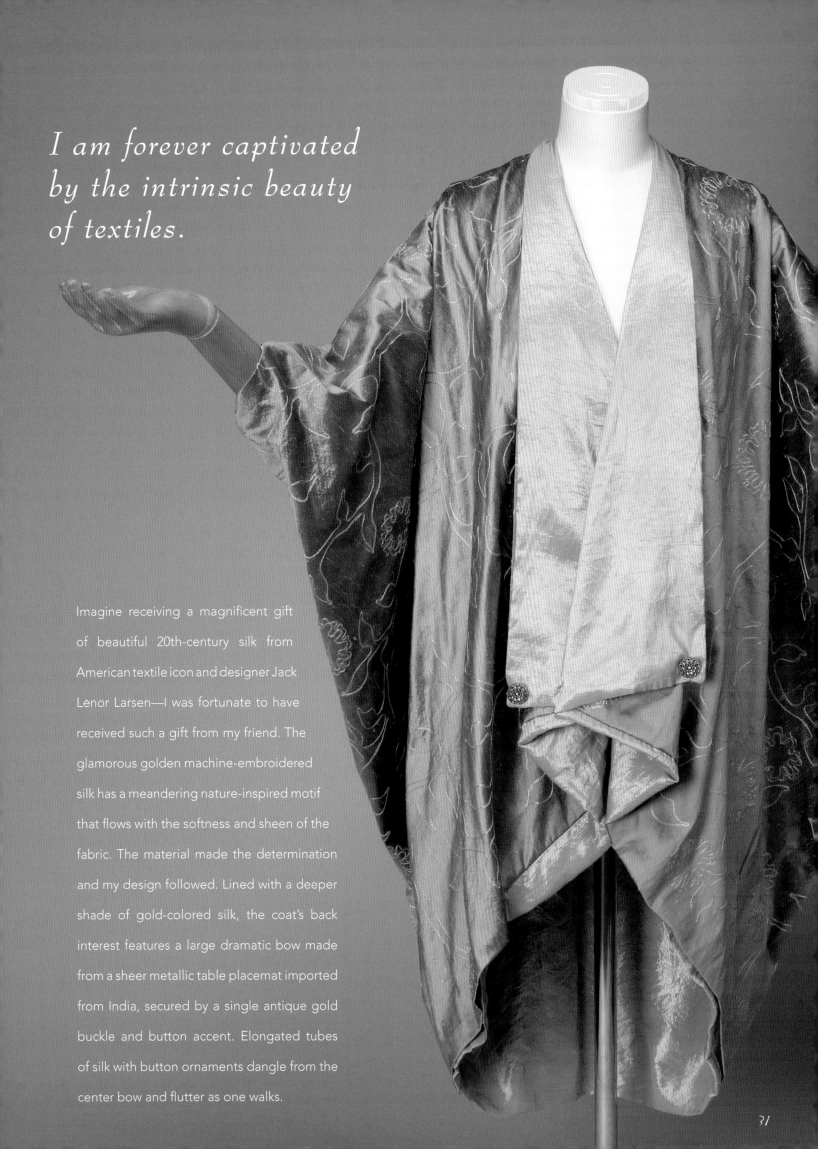

*I am forever captivated
by the intrinsic beauty
of textiles.*

Imagine receiving a magnificent gift
of beautiful 20th-century silk from
American textile icon and designer Jack
Lenor Larsen—I was fortunate to have
received such a gift from my friend. The
glamorous golden machine-embroidered
silk has a meandering nature-inspired motif
that flows with the softness and sheen of the
fabric. The material made the determination
and my design followed. Lined with a deeper
shade of gold-colored silk, the coat's back
interest features a large dramatic bow made
from a sheer metallic table placemat imported
from India, secured by a single antique gold
buckle and button accent. Elongated tubes
of silk with button ornaments dangle from the
center bow and flutter as one walks.

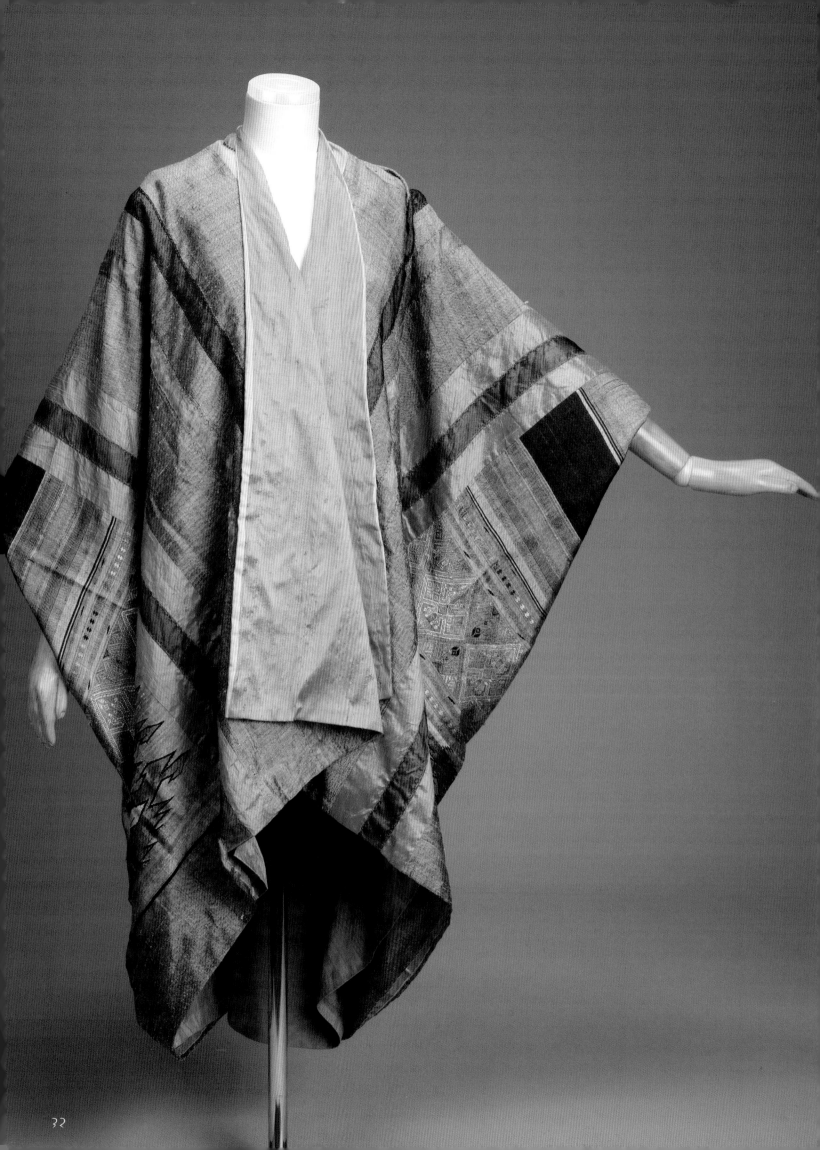

My wearable art integrates world textiles and exemplifies a new breed of cross-cultural couture dressing.

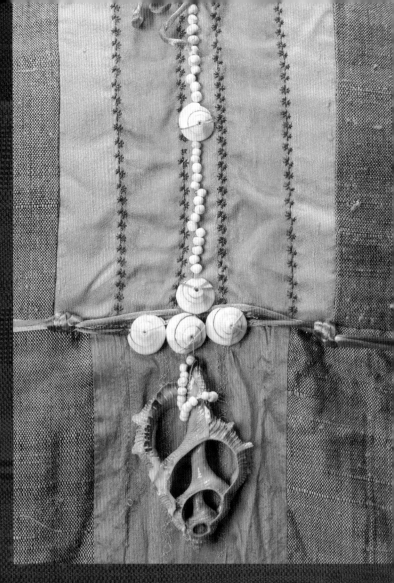

One of my friends was a school teacher in Malaysia and brought me this handwoven, silken treasure she got from local artisan weavers. This multifaceted silk fabric is a classic example of culturally traditional beauty with its soft rose tones, sage green, bands of navy blue and orange striping. Complex in its colorful design with textures and several weaving techniques combined in one piece, the intricate cloth was perfect. The broad, horizontal woven segments are fully showcased on the back of the garment. I used pure Chinese silk to form complementary sage green lapels and for the full lining. Sheer Japanese ribbons, rattail and natural sea shells trim the garment for added interest; weaving designs are international traditions. A hidden detail of handmade lace is sewn on the inside of the neck. I designed a pendant using slices of seashell, beads and silk cording to create an adornment reflecting the fabric's color scheme and its country of origin.

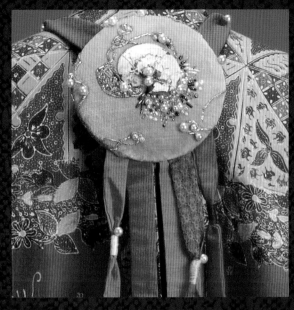

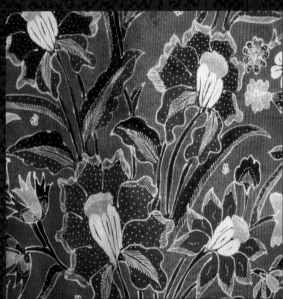

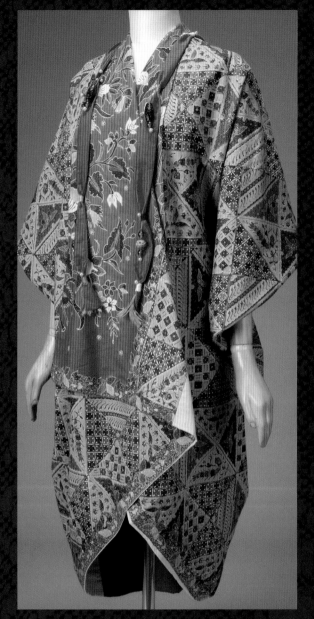

Inspired by an elaborate red floral cotton print designed by batik methods from China Seas—a designer's resource for high-quality South Seas fabrics—this interpretation takes one on an exotic journey. Juxtaposed with the batik fabric, I centered a panel of Asian hand-embroidered scarlet cotton with dramatic black orchids to compose the strikingly different garment. Simple subdued lining is made of beige cotton and remnants of the flowered batik cloth. An adornment anchors the garment back: Embracing Eastern and Western cultures, a cloth-covered disc is embellished with a prehistoric fossil from South Dakota. The garment is trimmed with narrow tubes of red cloth, feathers and old Chinese beads.

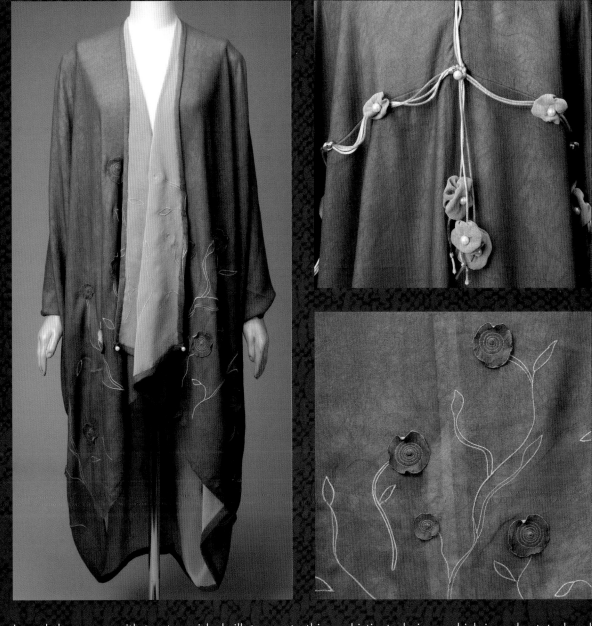

I used sheer gray with tan two-sided silk to create this sophisticated piece, which is understated and luxurious. White rattail, faux pearls and tan fabric puffs adorn the back, while machine embroidery in-line stem designs edge the hemline, hand-finished with gray silk rounds for flowers.

My work is a creative expression that pays homage to textiles and techniques.

I was enamored by six rare pieces of historic 18th-century French brocade acquired from an international textile dealer. This design was inspired from its delicately woven flower pattern and deep yellow hued background. Brocades are richly decorated, shuttle-woven fabrics, often boasting gold and silver threads added through a supplementary weft technique to give the impression that the main weave was actually embroidered upon. The heavier weight brocade, quite possibly from chair seats or cushion upholstery, was pieced together to form the full-length back and front lapels of the garment. I used contemporary Chinese silk for the coat with a quiet, miniature pattern so as not to overpower the exquisite nature of the museum-quality piece. Fine, handmade French lace found in a little California antique shop delineates the high seam across the back, punctuated by a brocade puff hand-finished with beads. A long, double strand of faux pearls with lace medallion and silken tassel defines the plunging V-shaped neckline and accentuates the brocade lapels.

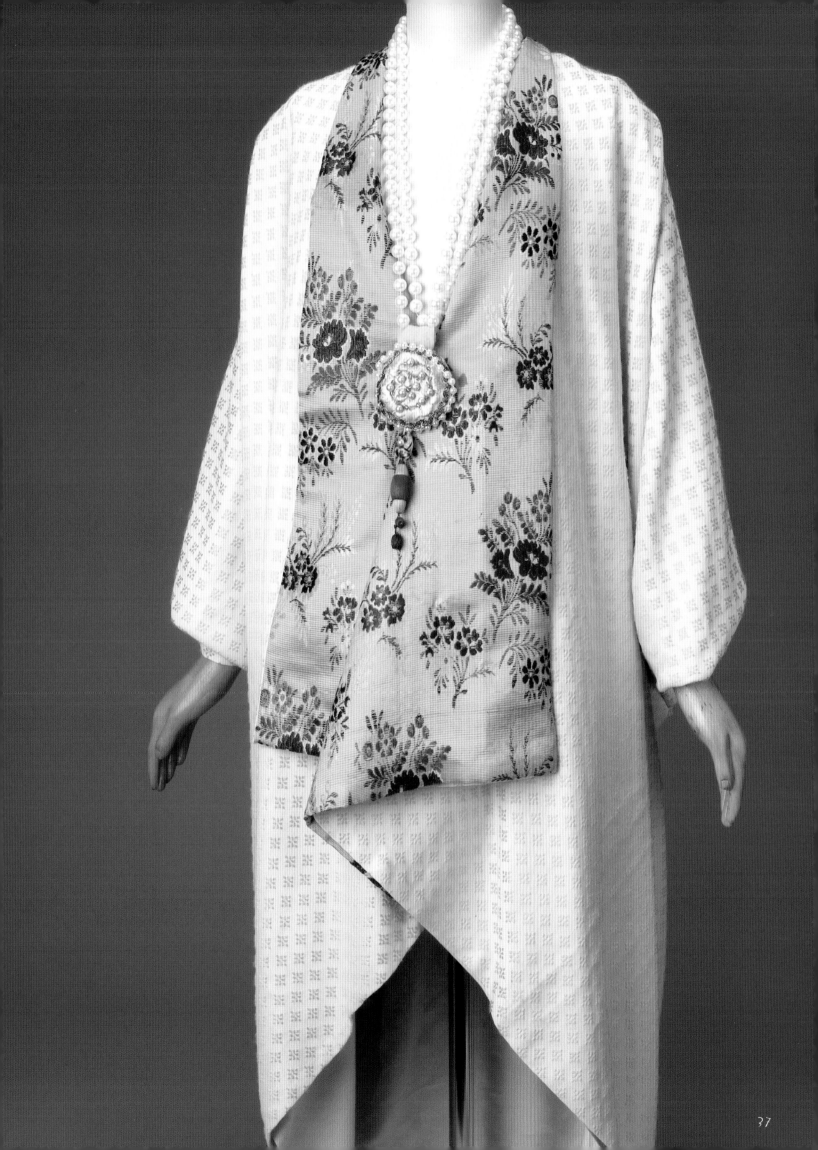

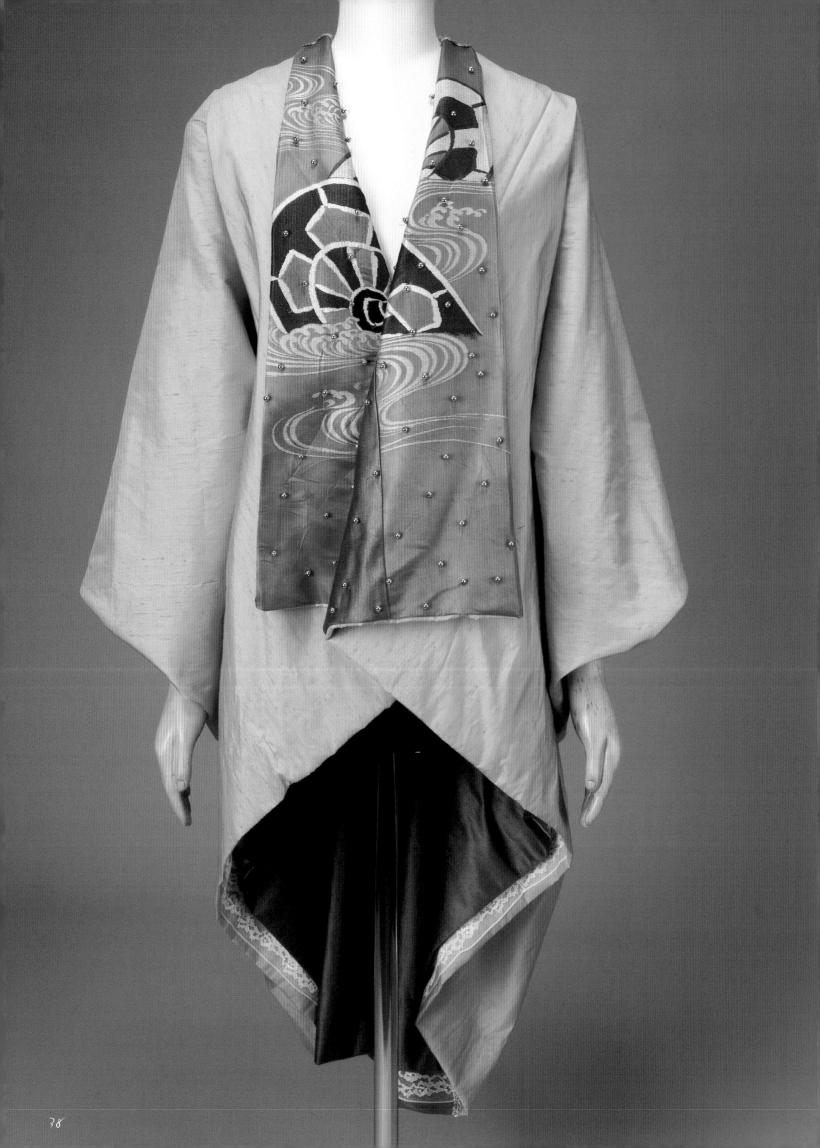

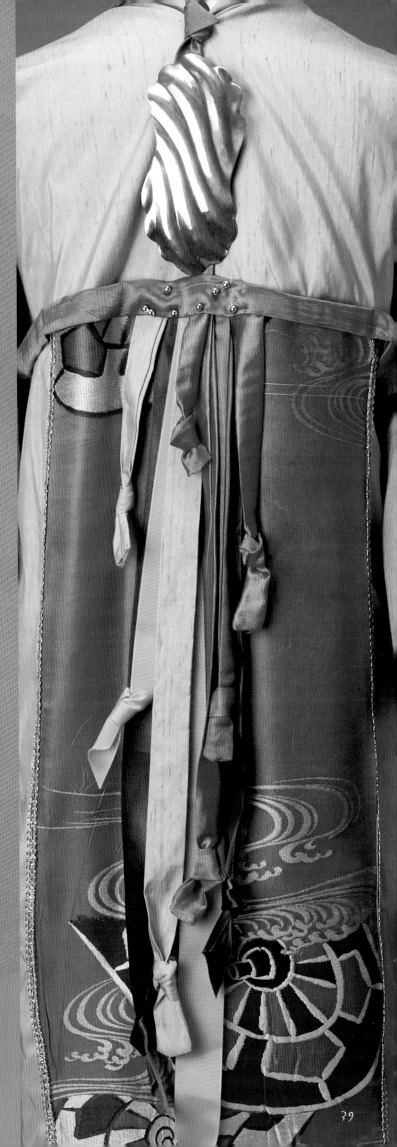

*Every garment tells
a fascinating story.*

I'm influenced by my world travels. The exploration of textiles has been an adventure. A precious antique silk Obi became my vivid inspiration for the Japonaiserie interpretation. I began by using the exquisitely hand-painted gold fabric as a full-length back panel and constructed the remaining garment from silks: luscious, solid-colored turquoise lined in midnight blue. The collar and lapels were also fabricated from the Obi remnants, creating a wonderful face-framing effect, and serve to unite the garment from front to back. This fresh artistic design reinterprets the traditional Obi sash—the belt wraps around the waist of a Japanese kimono and is tied in back—making it the focal point of the garment rather than simply an accent piece. Adorning the back are knotted silk tubes, ribbon trim and gold beads anchored by a 1930s' sculptural brass buckle.

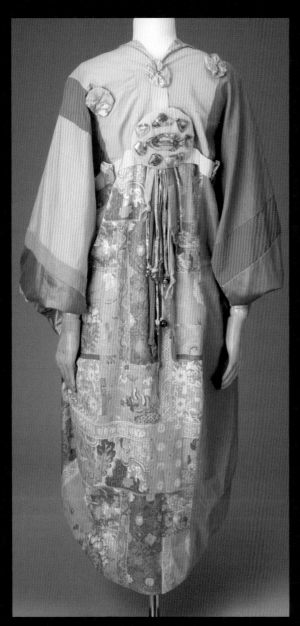
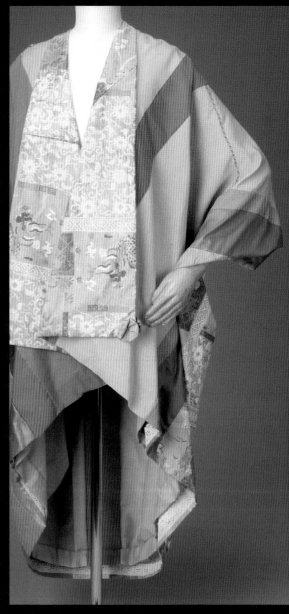

Renowned glass artist Vera Sattler is a contemporary and friend of mine. Her multicolored, fused and slumped glass sculptures are collectibles, and she gave me a handful of miniature art glass pieces that inspired my creation. I acquired an exquisitely printed English cotton upholstery remnant and the two became one. This design blends the Asian-influenced print with solid colored cotton shoulders and sleeves; a back adornment features a glass tropical fish pin created by Vera, surrounded by irregular art glass shapes attached to a fabric-covered disc. Sheer fine-gauge netting holds the glass gems in place, while colorful silk puffs, ribbons and cloth tubing with beads mimic the vibrant color scheme. The coat is lined in light green cotton.

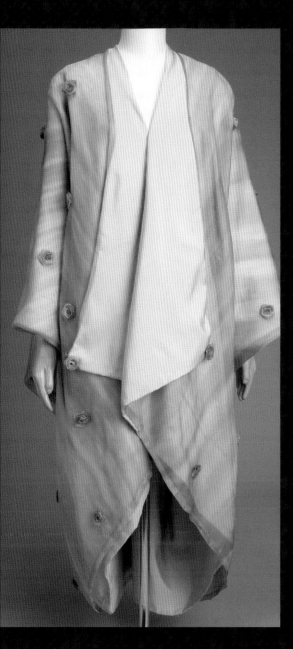
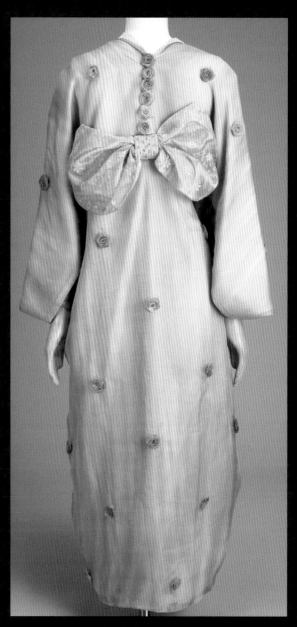

Interesting Indian silk fabric already had delicate, puff rosette trims, and its iridescent quality was perfect

for a new coat. I repurposed an imported decorative place mat with a napkin ring from India to form

a bow, so as to focus attention to the back of the garment. Pale yellow silk lines the coat and subtly

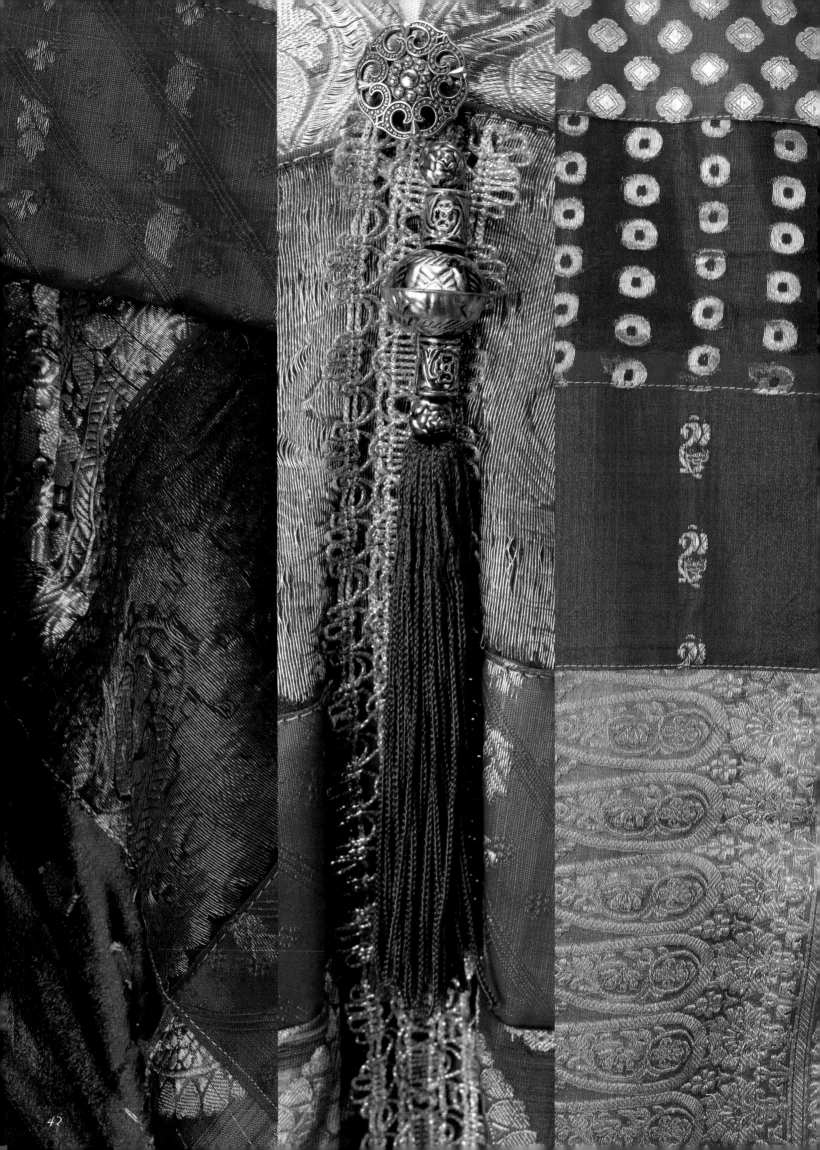

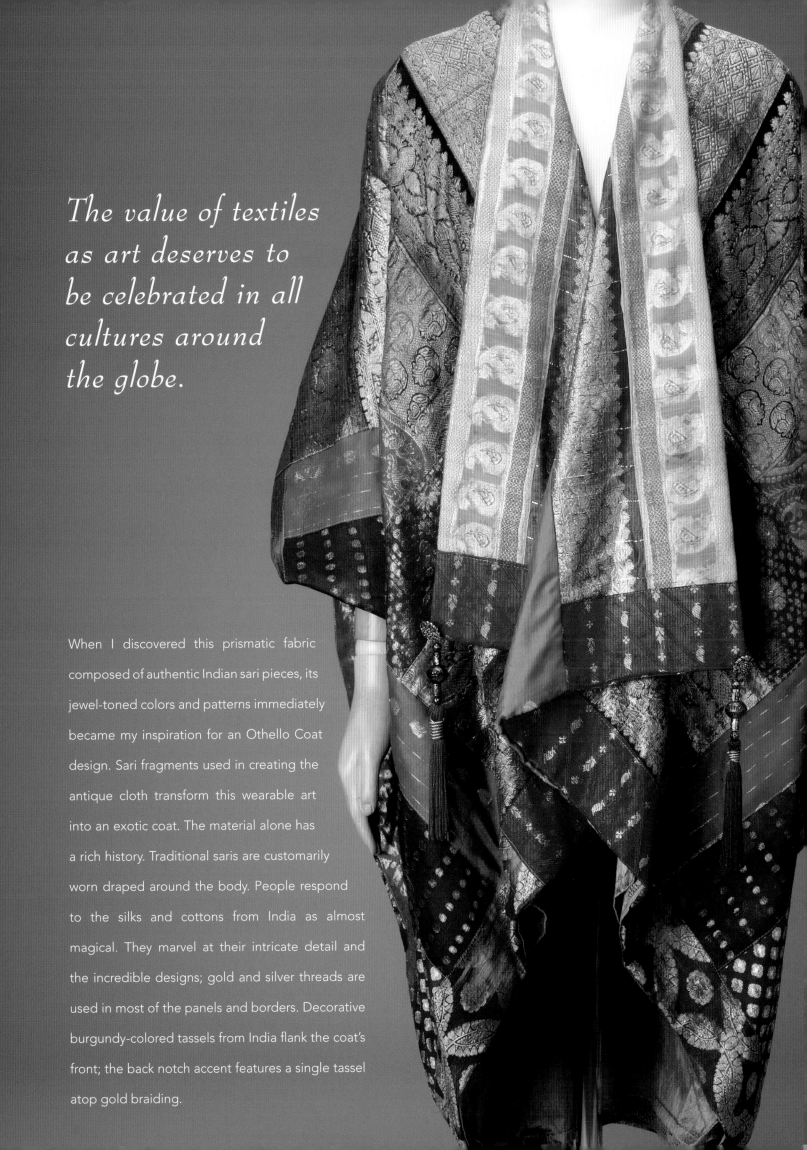

*The value of textiles
as art deserves to
be celebrated in all
cultures around
the globe.*

When I discovered this prismatic fabric composed of authentic Indian sari pieces, its jewel-toned colors and patterns immediately became my inspiration for an Othello Coat design. Sari fragments used in creating the antique cloth transform this wearable art into an exotic coat. The material alone has a rich history. Traditional saris are customarily worn draped around the body. People respond to the silks and cottons from India as almost magical. They marvel at their intricate detail and the incredible designs; gold and silver threads are used in most of the panels and borders. Decorative burgundy-colored tassels from India flank the coat's front; the back notch accent features a single tassel atop gold braiding.

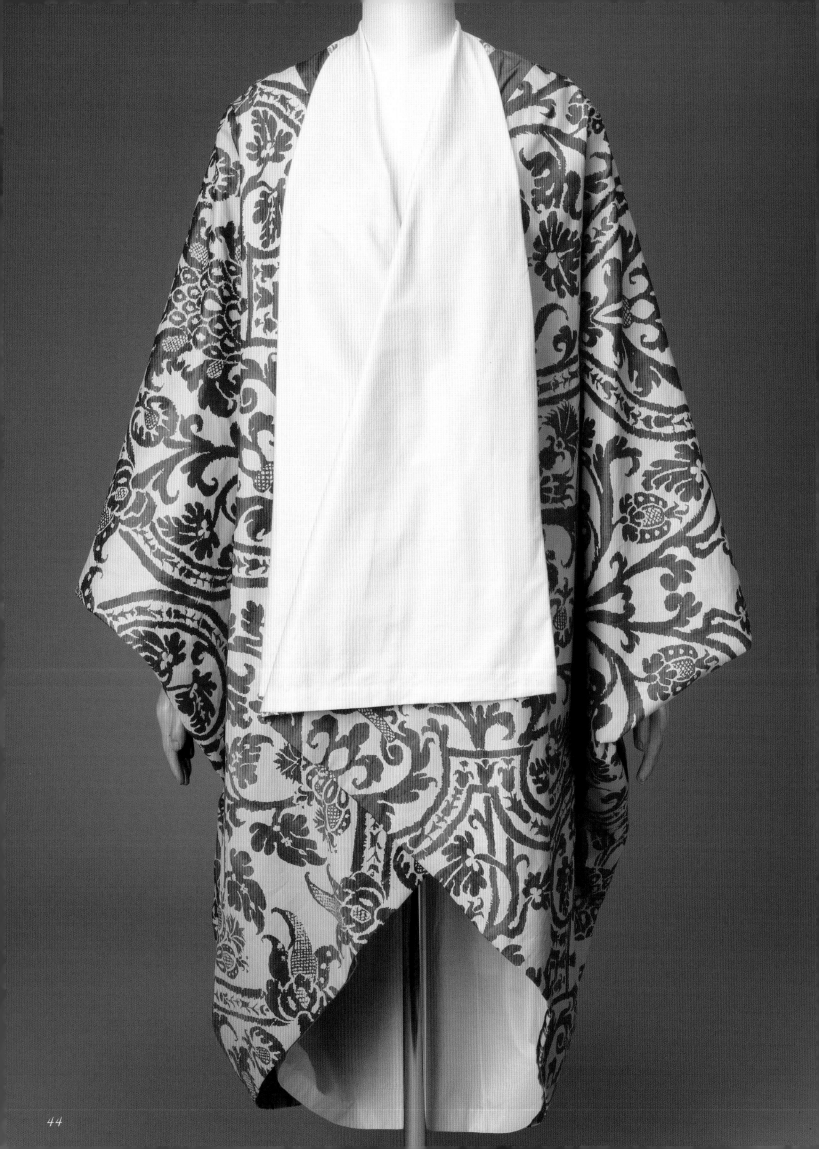

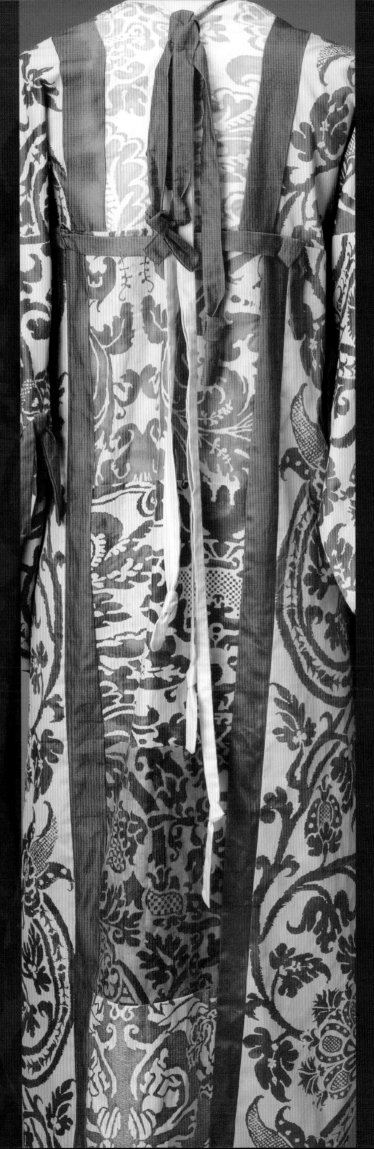

I strive to create more consciousness of textiles as an art form.

I have an affinity for Mariano Fortuny's renowned method of printing textiles; the revered, secret process was originally invented and produced in 1907 by the artist and visionary in his Venice factory-studio. Legendary Fortuny fabrics are coveted and found in the finest museums from New York to Paris, historically gracing churches, palaces and splendid homes throughout the world. When this unique piece of fabric came my way, I sewed the subtle pink on ivory printed strips down the center of the garment back. The strips were only 12-inch squares sewn together to achieve the needed length of 50 inches. The coat design was adapted based on the aesthetic of the original Fortuny print pattern; I added new, contemporary cotton fabric with a similar print and brilliant hues to complement the antique piece. Lined in cream polished cotton, the coat is further defined with solid pink banding and a trio of cloth tubes for special back interest.

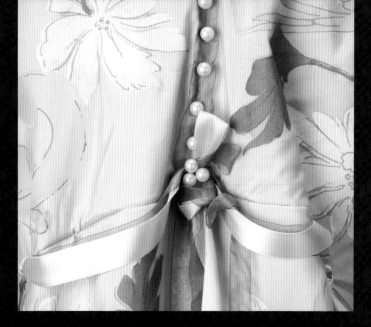

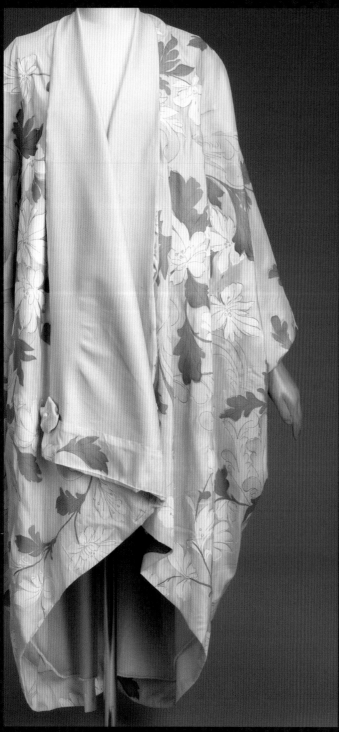

Left: A rare bolt of Chinese silk caught my attention in an American fabric shop. Its hand-painted lotus petals, scrollwork and bluebirds in delicate pastels possess a porcelain quality and refined aesthetic. For the lapels, I chose sky blue silk to mirror the watercolor-inspired palette. The garment's lining is pale blue silk and the back is dotted with decorative pearls and trimmed with blue and white ribbons. A precious lost art, dyed and hand-painted silks have been created for centuries and the finest were crafted by native artisans living in Suzhou, China. This is my reverent tribute to a treasured art that I hope will be appreciated by future generations.

Facing page: In this case, the fabric speaks for itself. Intricate China Seas soft cotton feels like pure silk. I lined the garment in simple gray-green cotton to integrate with the color scheme. Absolutely no embellishments were required to create this stunning Asian-inspired floral coat.

The character of the fabric speaks to me and it makes the determination of where the design will go.

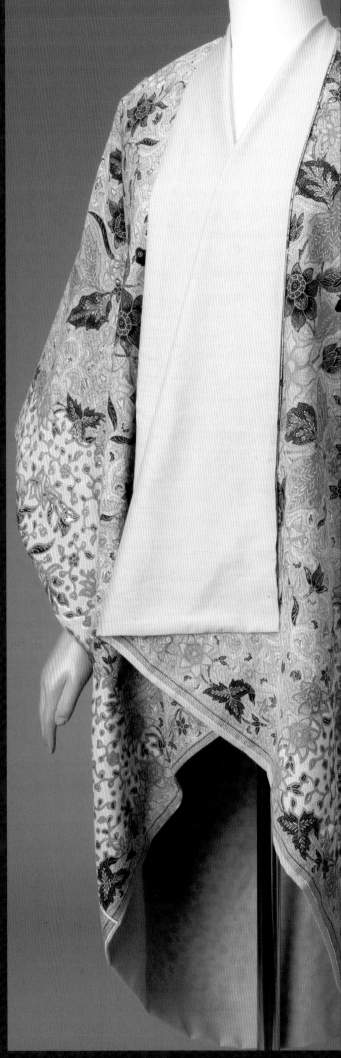

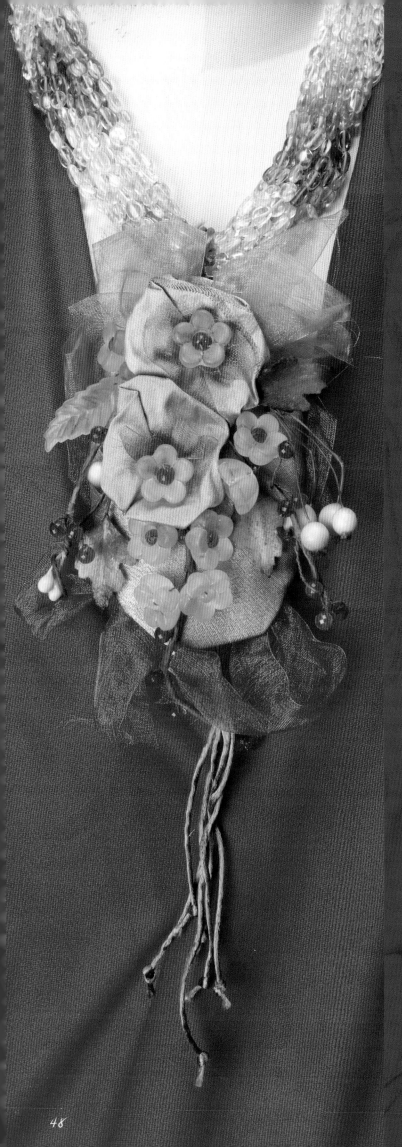

I have a reverence for folk artisans and ancestral weavers who have made lovely vintage and antique pieces. The rich heritage of textile design and techniques enthralls me.

Chinese silks are some of the most glorious fabrics known to man. I acquired celadon green, machine-embroidered Chinese silk fabric and was delighted with the blossoms of cherry red, which became the impetus behind an elegant Othello coat design. The lining made of vibrant red silk is dramatic and daring, while the tender floral embroidery gives an impression that is soft and inviting. To reiterate the embroidered flower pattern, I created a spray of handmade glass flowers and budding sprigs to adorn the back of the coat. The multi-strand necklace of transparent, green, gold and amethyst crystals with its handcrafted flower pendant mirrors the back ornamentation. Moss green-dyed ostrich feathers edge the hem of the coat, while matching satin ribbon tubes dangle from the back.

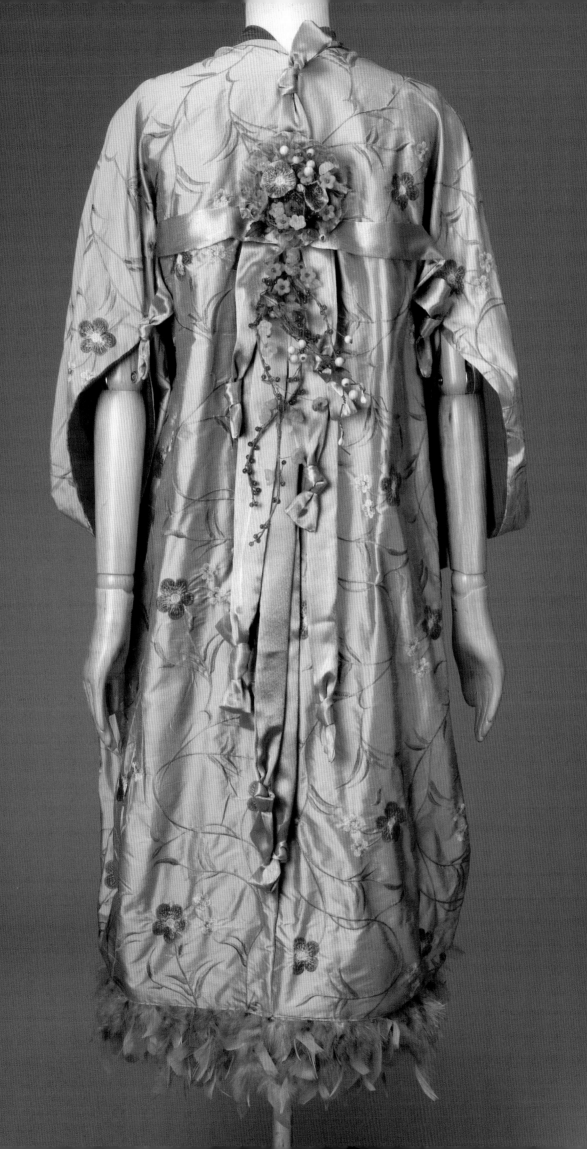

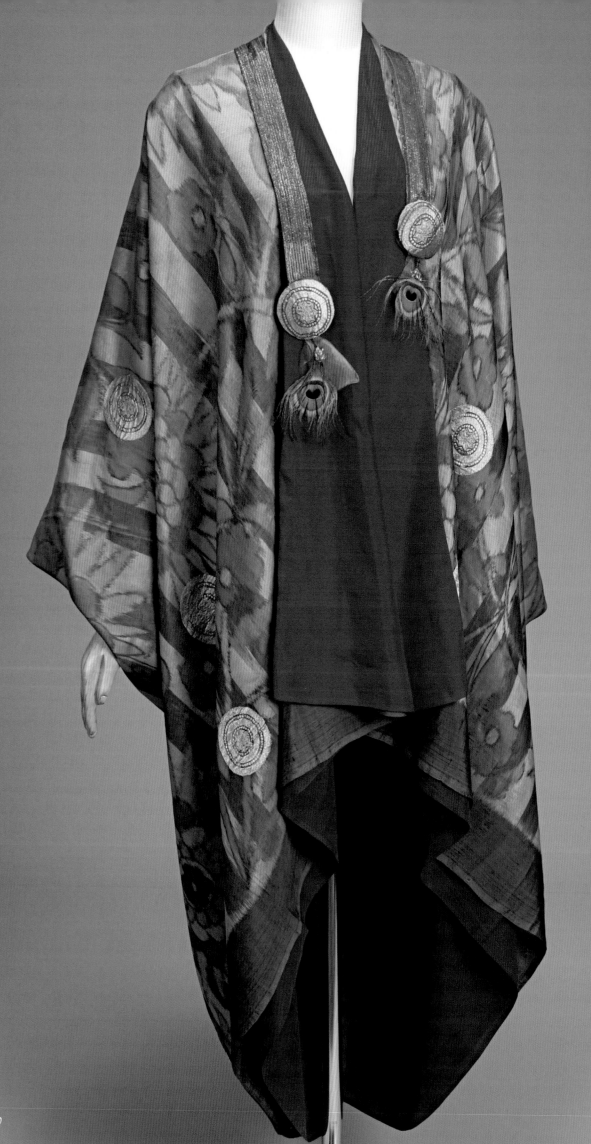

Antique beads, feathers, semiprecious stones, ribbons and shells embellish my garments with a dimensional quality.

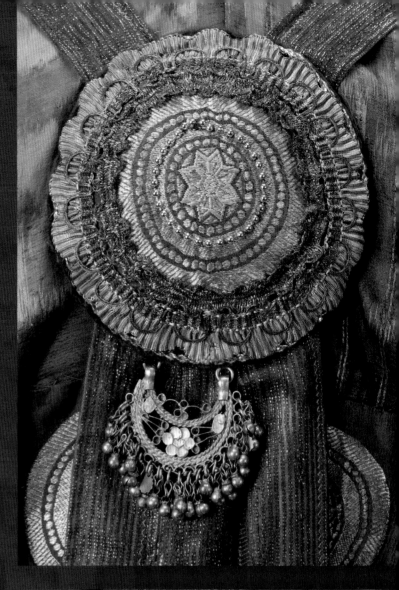

Sourcing rare textiles through my world travels is always a wonderful adventure, but I acquired this impressive 19th-century Indian silk sari from an American textile collector. The luxurious sari is reminiscent of Ikat textiles utilizing a technique of great antiquity developed in Asia, which spread to India, Malaysia, Central America and Africa. Genuine Ikat designs appear like reflections in water, with soft edges and blurred patterns. This labor-intensive process produces beautiful patterns that not only give the wearer an appreciation for handcrafted designs, but the special cloth is a work of art in and of itself. The pure silk is interwoven with 24-karat gold threads to enhance shades of deep green in contrast to the rich hues; threads are dyed before they are put on the weaving loom. Magenta silk lining and lapels contrast the dramatic emerald floral design. Adorned with a golden thread medallion, beads and an ethnic Indian earring as a memorial to my longtime friend, dangles of Japanese ribbon, beads, peacock feathers and vintage gold braiding also decorate this garment.

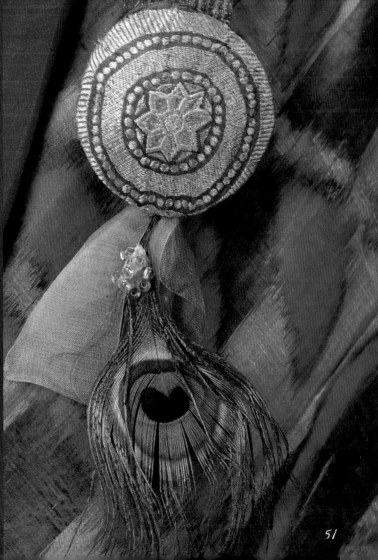

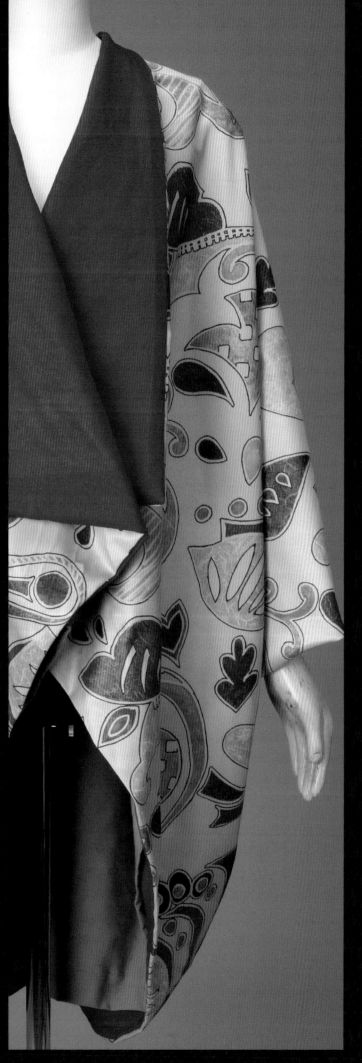

Inspiration comes from each unique textile and my imagination is free to design anew.

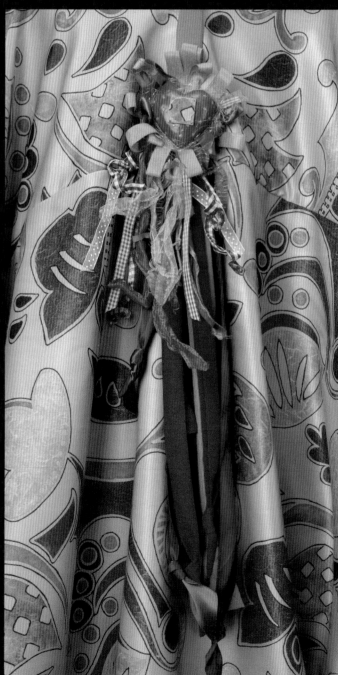

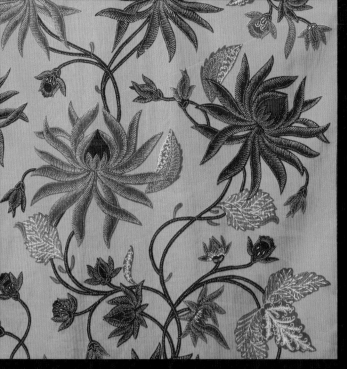

Above and right: Sourced from China Seas—one of the foremost importers of South Seas batik and superb quality fabrics—I discovered a piece of cotton batik cloth with an intense green background that features a profusion of stylized raspberry and bright blue chrysanthemums. The mid-section was designed to match and made from solid emerald green cotton. The garment's shoulders are formed from blue cotton, while wide lapels repeat the multicolored flower pattern. To accent the back panel I created an embellishment comprised of an intricately carved, milky green, faux jade roundel with graduated lengths of ribbons hanging loosely down the middle.

Facing page: I was instantly drawn to a distinctive, contemporary designer fabric of polished English cotton. Its bold and colorful printed pattern inspired my modern interpretation. A red papier-mâché heart became the back centerpiece. I simply hand-stitched the dimensional ornament onto a cloth base along with cotton tubing and various ribbon accents in bright colors, which tied the garment together for a balanced composition. The garment is lined in both green and red cotton cloth; the red fabric forms the vibrant lapels for a dramatic statement.

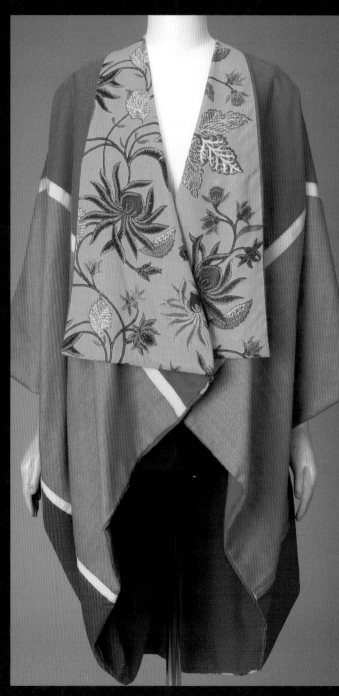

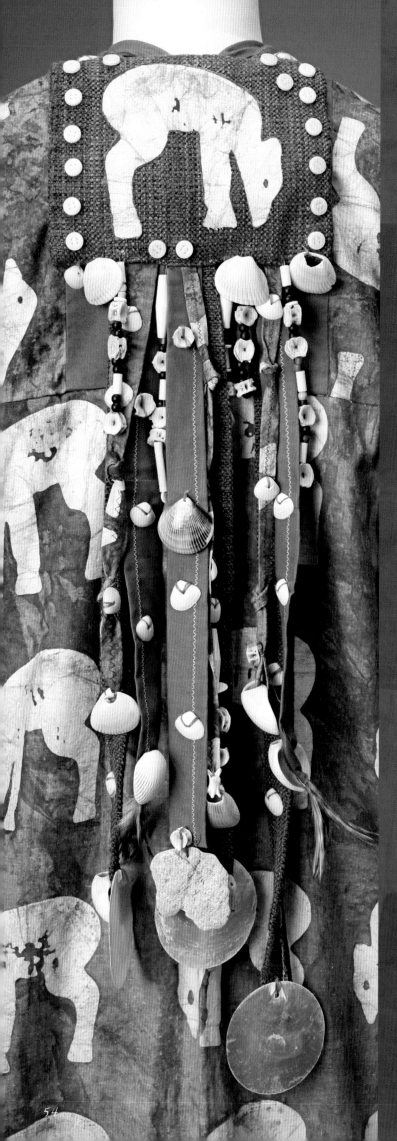

Nature inspires my designs with form, line, color and even organic embellishments. Trips to Africa have contributed to my textile adventures.

Hunting for unusual textiles has been a lifelong passion and an authentic hand-dyed batik cloth from Africa caught my eye at an art museum in Williamstown, Massachusetts. The serene fabric stimulated a new design. Batik textiles are created by a technique of drawing with melted beeswax over a lightweight cloth and subsequently dyeing it. The artful process is repeated for other colors until completed, and then wax is removed to reveal the design. This repeat pattern features a grazing animal amid a subtle, blue color palette with variegated grassland green to reflect the natural African landscape. My travels to Kenya and love for the African continent often inspire my design work. I created an unlined rectangular piece of fabric as an accessory to hang down the back and embellished it with hand-sewn tubes of fabric and recycled wind chime elements including imported capiz shells, tiny seashells, irregular beads and feathers.

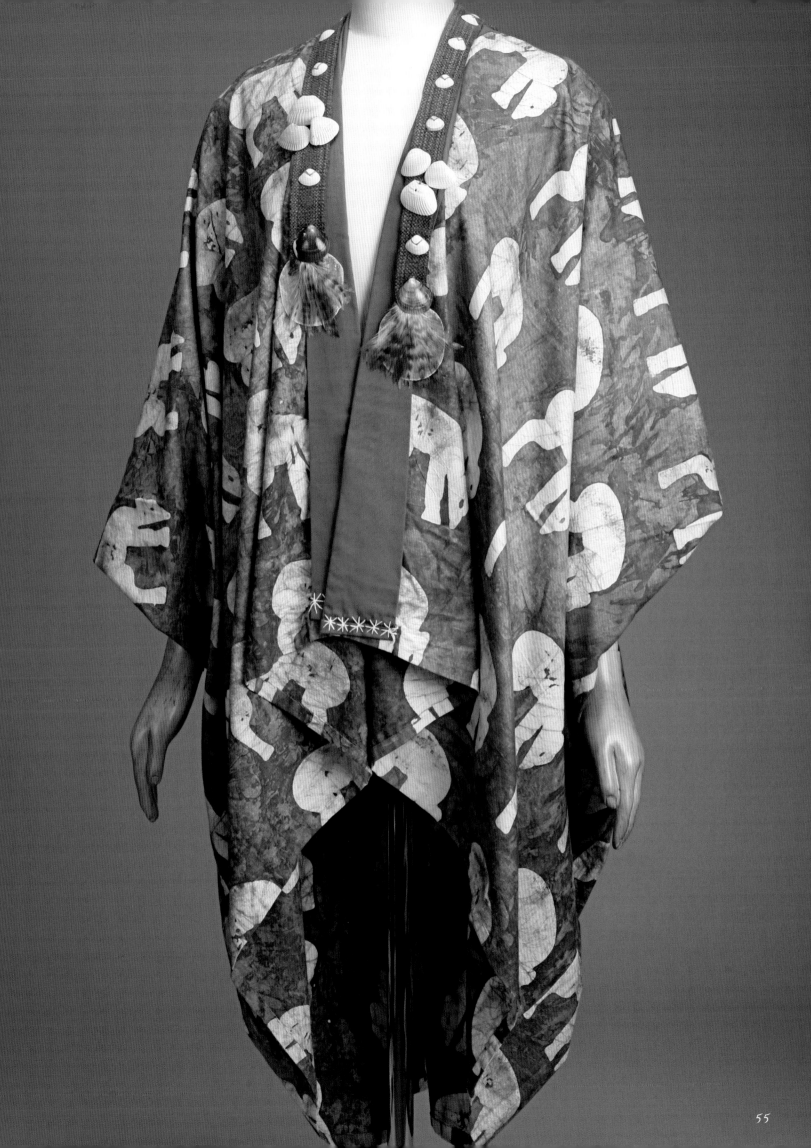

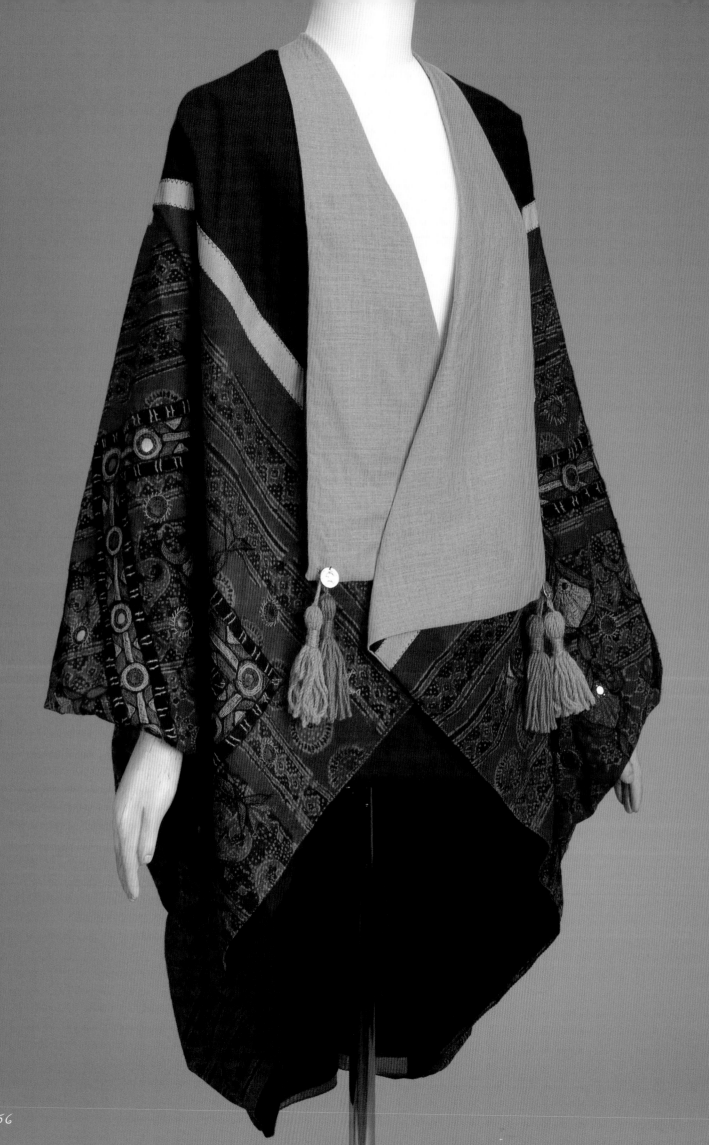

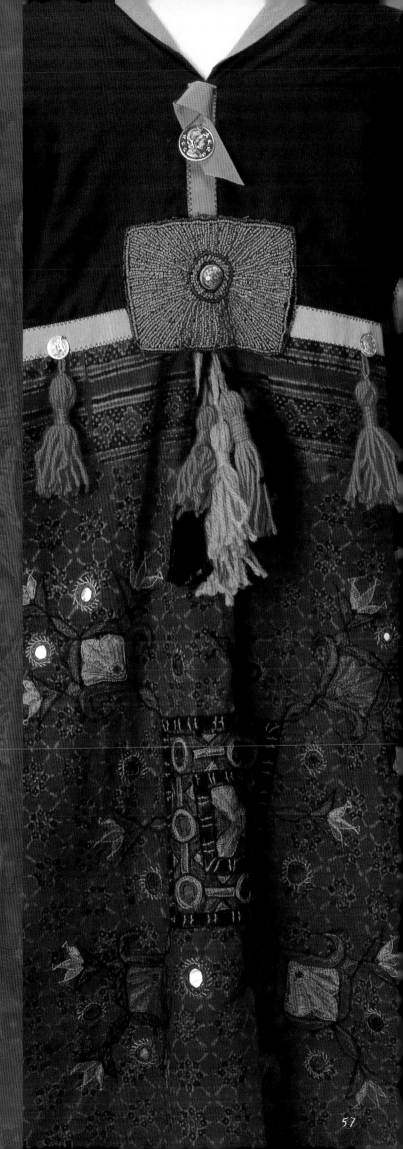

I never sketch or plan my designs. The garment evolves and embellishments are added.

An Indian tablecloth was my inspiration for the coat, which has tiny hand-cut shisha mirrors embedded in the fabric. Orange cotton creates the vivid lapels and black cotton simply lines the full-length garment. The back creatively incorporates embroidery floss, ribbon, a small beaded Indian purse adorned with tassels and ethnic coins.

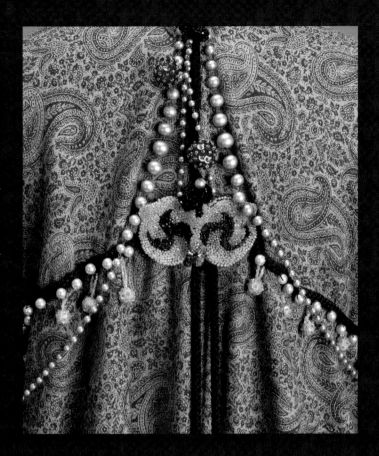

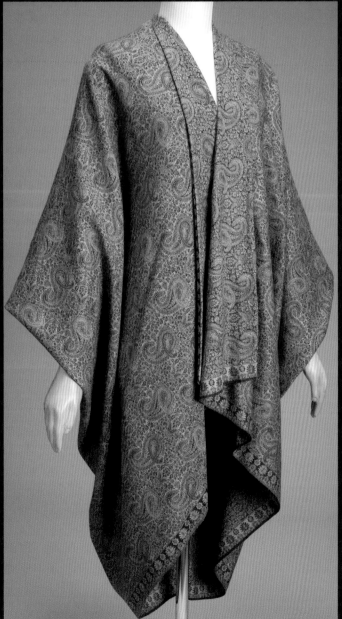

Above and left: Lightweight wool paisley from England creates a subdued reddish-brown coat with a refined and impeccably tailored presence. Embellished with pearls, sequins and antique silver-toned buttons, the coat's back dons two long rope tassels that dangle down the center of the piece.

Facing page: The colorful cloth makes the coat an engaging wearable art piece with its vertical silk strips sewn onto background with raw, frayed edges, creating textural effects. The back of the garment is embellished with a vintage ceramic pin and dangles of ribbons and fabric tubes. I lined the coat with pink silk to complement the color scheme.

Fiber art is a visual
language relating to the
world around us. It has
been a part of our lives
since the beginning of time.

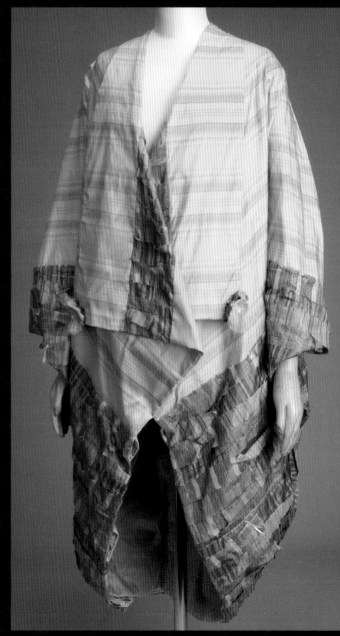

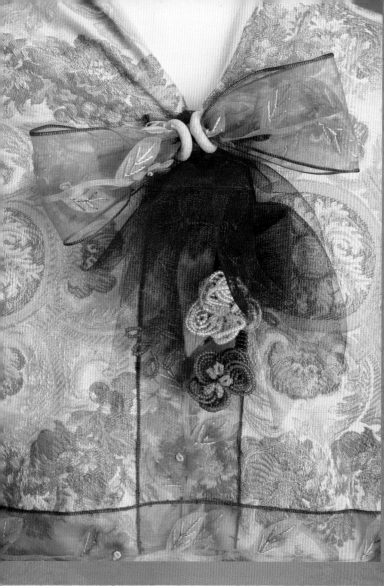

America is experiencing a renaissance of exhibitions that present textiles as an art form.

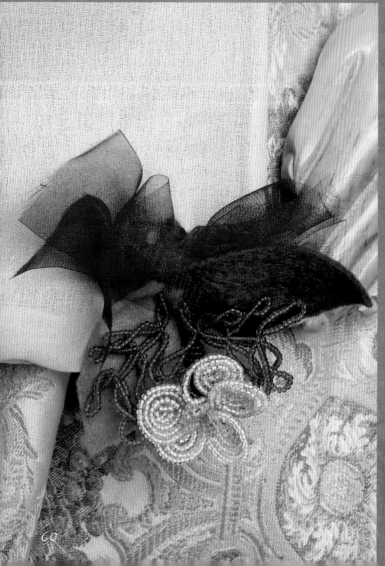

Elaborate French brocade fabric worked perfectly to create an elegant evening coat. In contrast, I lined the garment with pink silk chiffon, adding sheer ribbon from Paris with a green leaf and red rose motif. For the final touch, I hand-finished the garment with three antique French beaded flower trims that I discovered in a thrift shop.

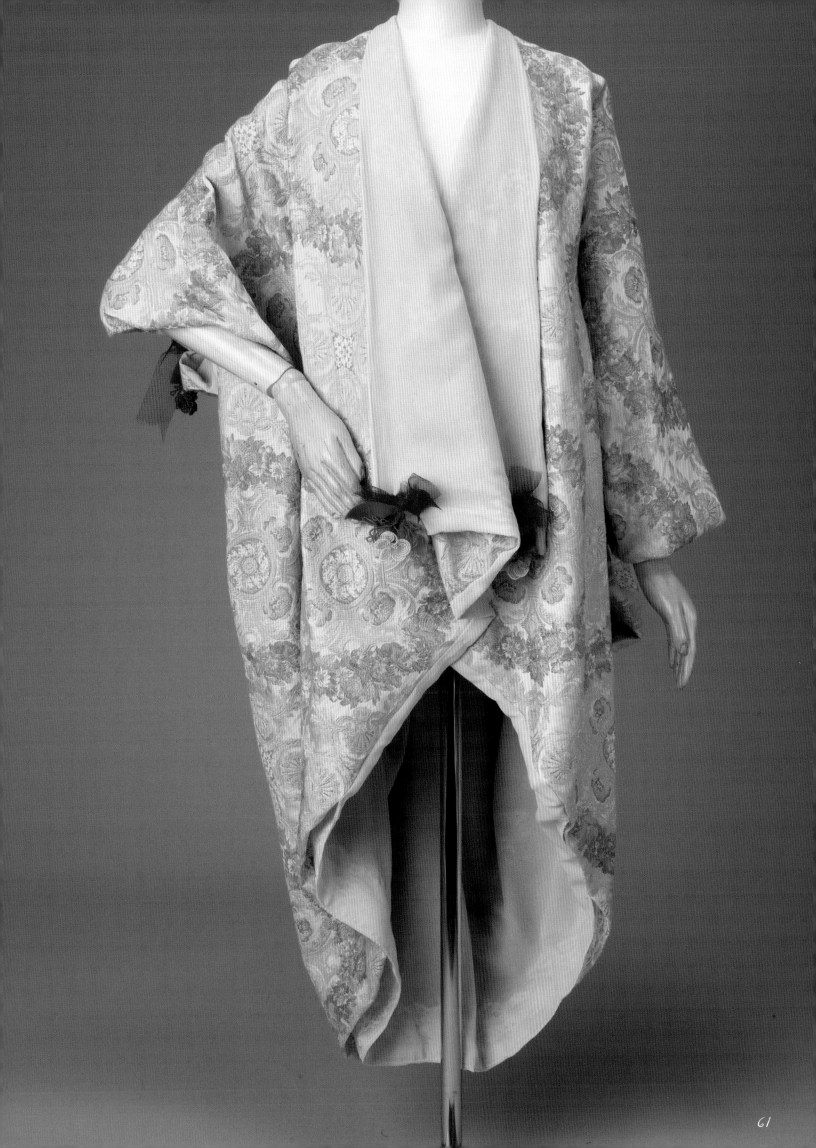

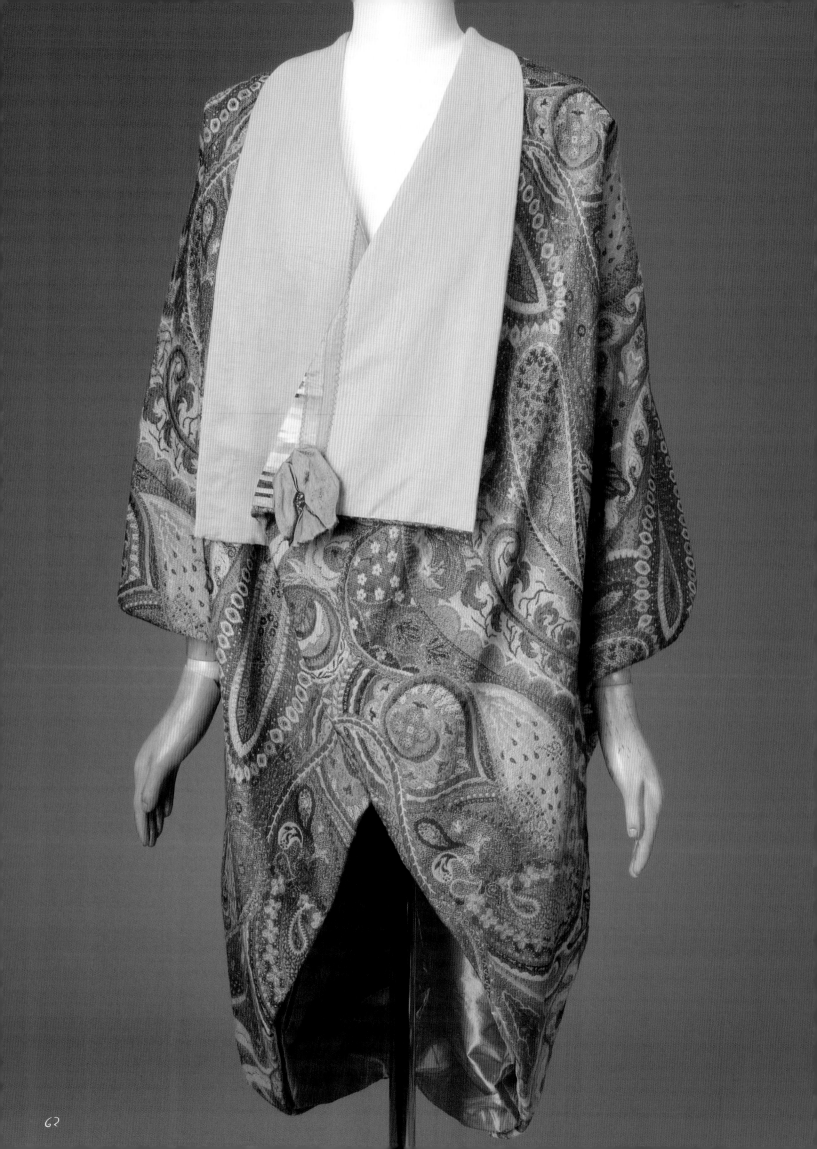

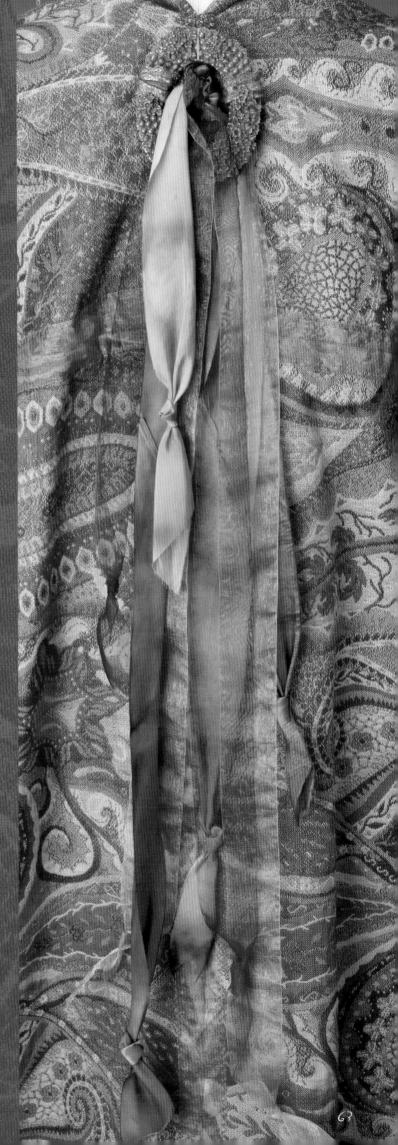

Few handmade textiles of the past will come this way again; they are lost arts that must be preserved.

Cotton damask paisley from India had such vibrant color and pattern that I chose to line the garment in soft peach-colored silk. One large antique buckle anchors the back and dangling knotted sheer ribbons create an airy effect. A silk puff adorns the front lapel for a feminine touch.

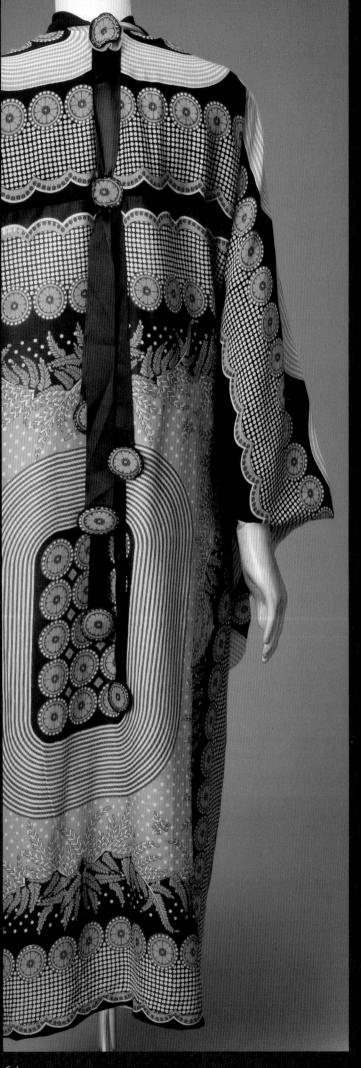

Today's resurgence of the Art-to-Wear genre honors textiles as an art form.

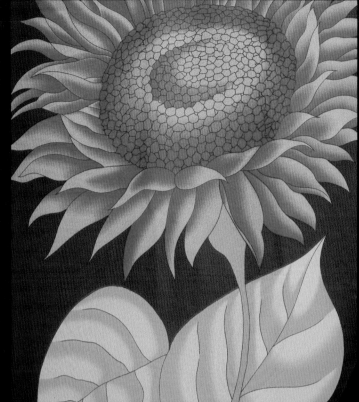

Above and right: A brilliant inspiration, this bold blue sunflower with green leaves polyester fabric printed in England determined my exciting garment design. Quite dramatic with a minimalist button and ribbon embellishment on the back, the modern botanical print is lined in bright green and yellow crêpe.

Facing page: The joy of vintage textiles is personified in a sophisticated garment made from 1920s' era voile. Its period Art Deco character was easily transformed into a grand design. Flaming orange color dominates. Pinwheel shapes, concentric striping, fern leaf motifs and a jazz-age black and white pattern work in concert. The scalloped hemline, which adds a feminine touch, was already printed on the fabric. I cut circular shapes from the fabric and used them to punctuate the black grosgrain ribbons down the back. Lined in black muslin, it is quite possible that the vintage voile may be from France, although I purchased the unique yardage in Rhinebeck, New York.

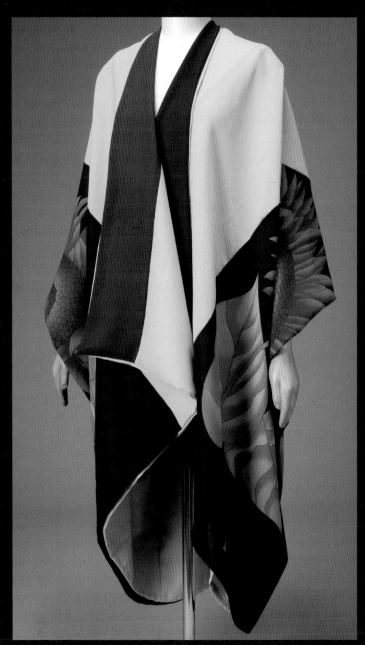

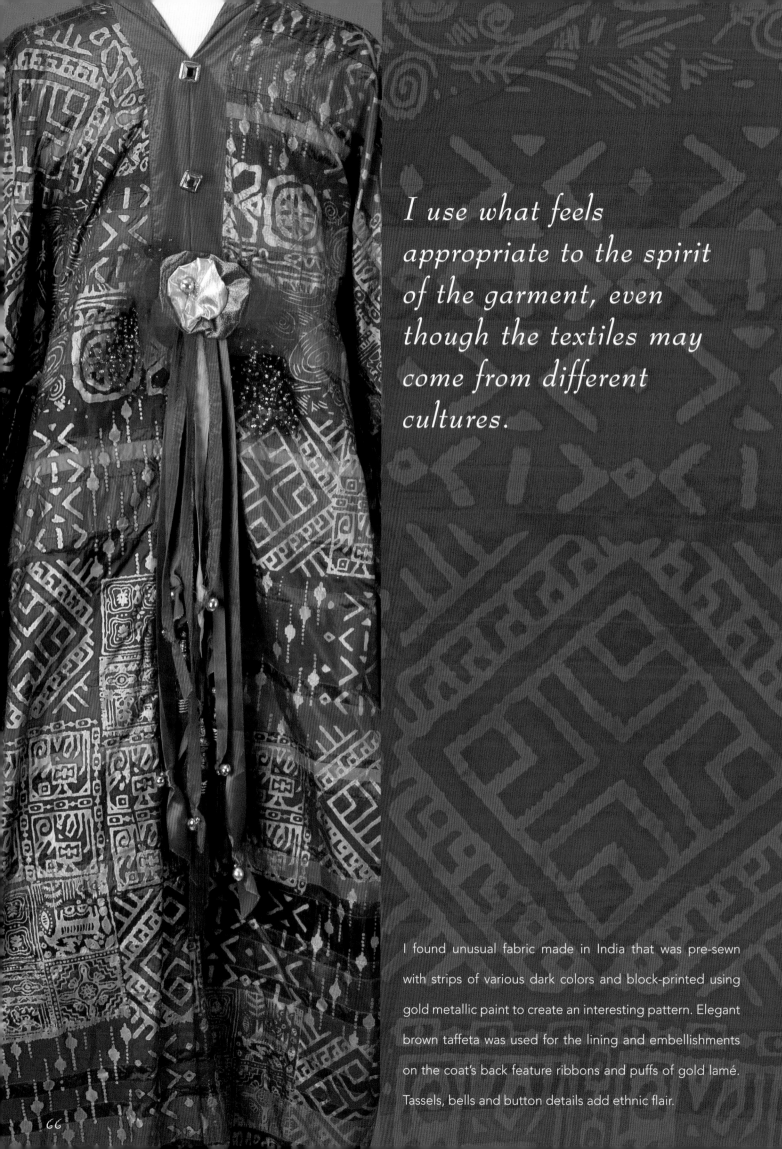

I use what feels appropriate to the spirit of the garment, even though the textiles may come from different cultures.

I found unusual fabric made in India that was pre-sewn with strips of various dark colors and block-printed using gold metallic paint to create an interesting pattern. Elegant brown taffeta was used for the lining and embellishments on the coat's back feature ribbons and puffs of gold lamé. Tassels, bells and button details add ethnic flair.

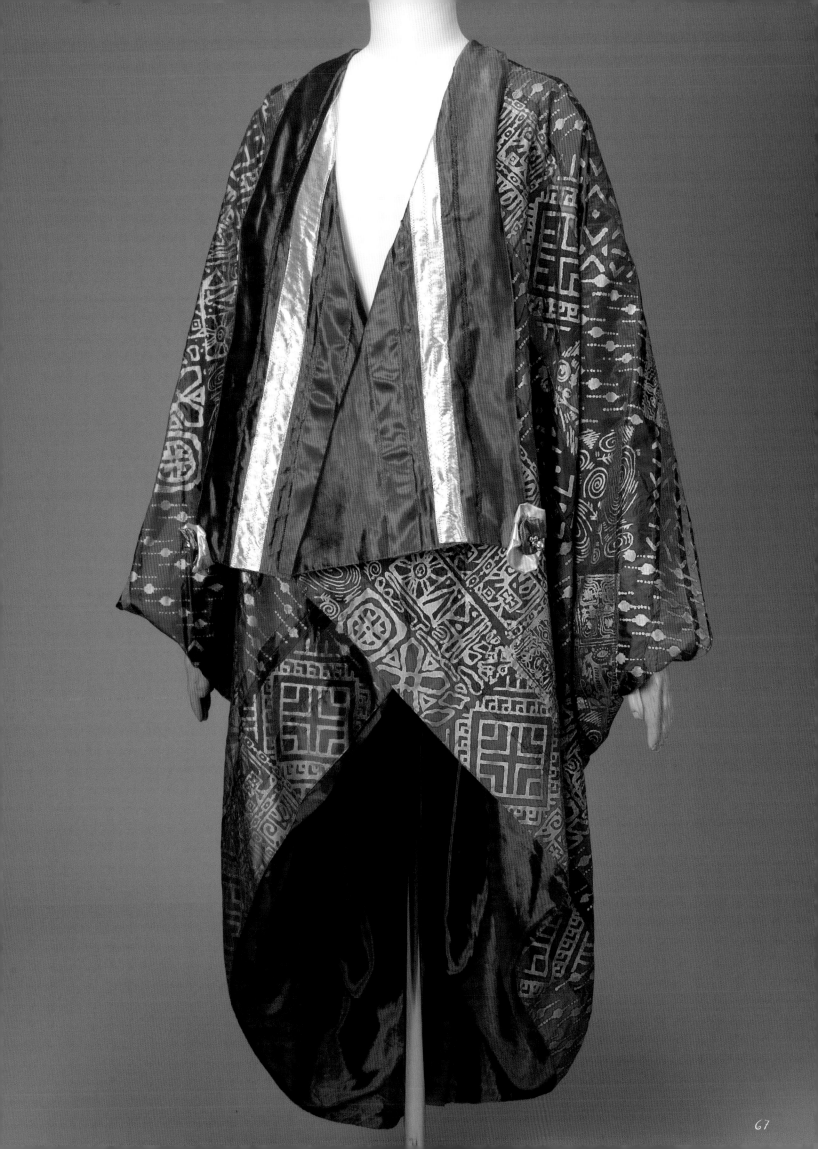

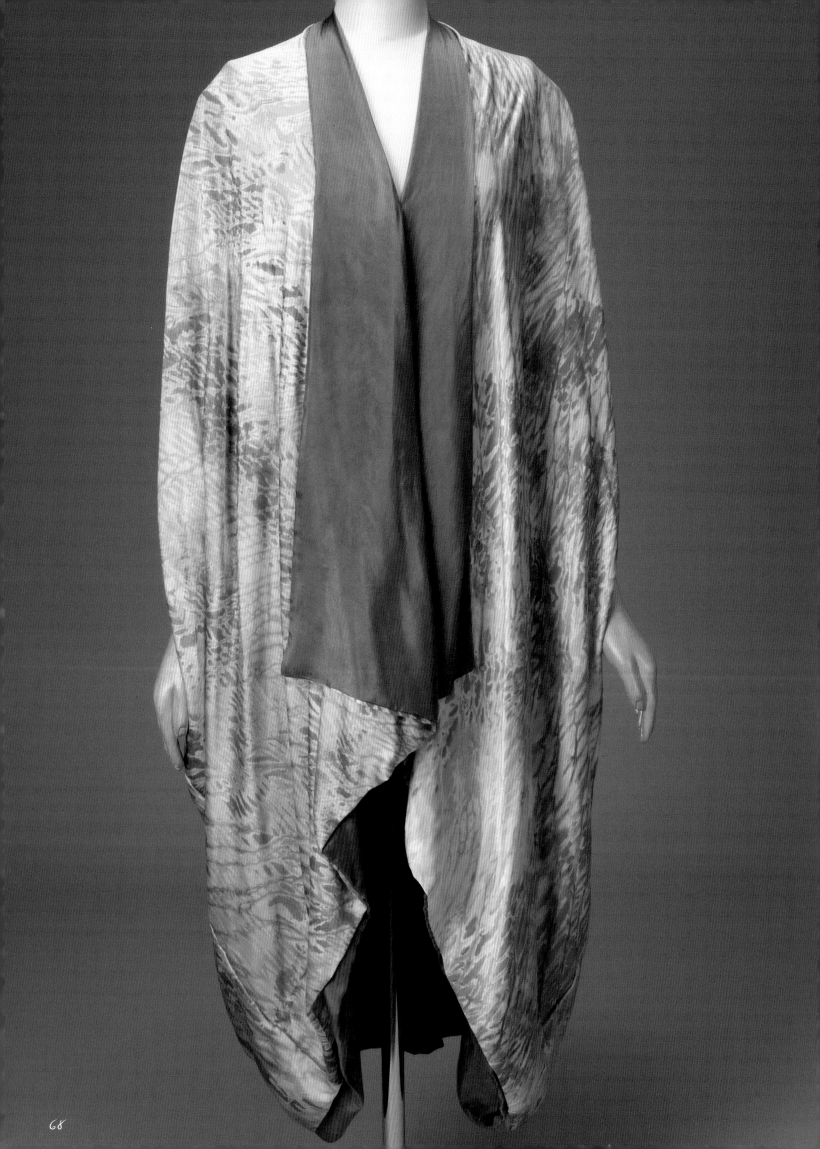

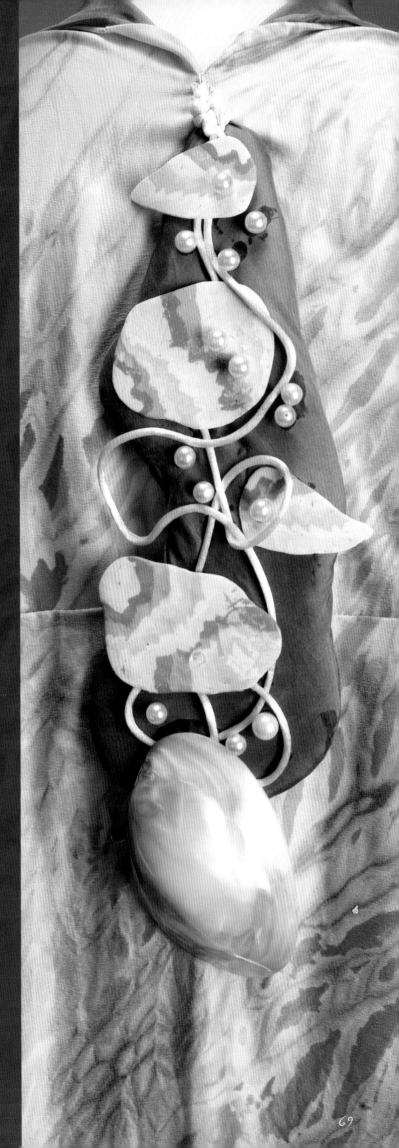

My mantra is to save our historic and rare textiles for future generations.

I gave white silk to an artist well-versed in Shibori silk dyeing process, a technique where the cloth is dipped repeatedly in different colors, the fabric wrapped around tubes with cords to create random resist-dye effects. Natural seashells, faux pearls, white rattail, ceramic earrings and pieces made by my potter friend Norma Newman adorn the back of the garment. The textile art piece is lined with slate blue silk.

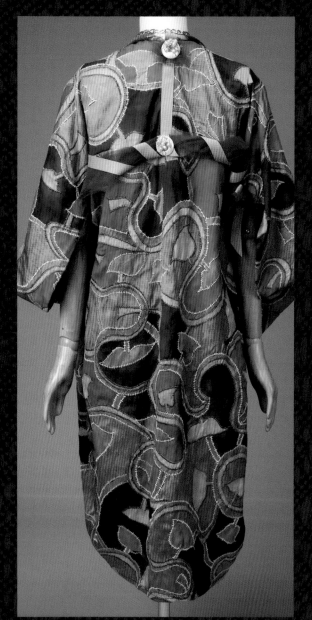

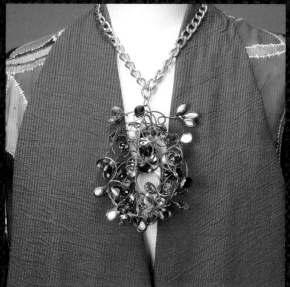

A symphony of color and an uninhibited '80s spirit is derived from an unusual piece of Indian embroidered silk with white-pointed stitch detailing and sensitive hand-painted touches. When I discovered this handmade fabric, I instantly knew it was destined to become one of my new designs. Raspberry crêpe-textured, crinkled silk lines the garment and forms the dramatic lapels. Trimmed in coordinating pink ribbons, green netting, and hand-sewn pearls on the back, the neckline features an ornamental bejeweled pendant that reflects the rainbow of purple, teal, green and gold. The dazzling necklace accent was ingeniously made by flattening a holiday bauble.

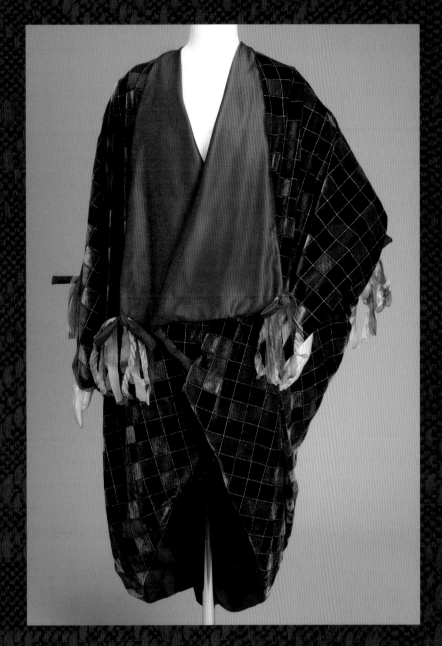

Loom-woven silk velvet from India has a festive look and irresistible tufted feeling, finely highlighted with silver threads woven throughout the deep green, red and purple geometric grid pattern. I created a decorative tassel from yarns and silk threads for a back adornment, commingled with assorted dangling fabric tubes to repeat the garment's three main colors. Lined in glossy royal purple satin, which is made using the traditional warp-dominated weaving technique, achieves a high luster and exhibits opulence.

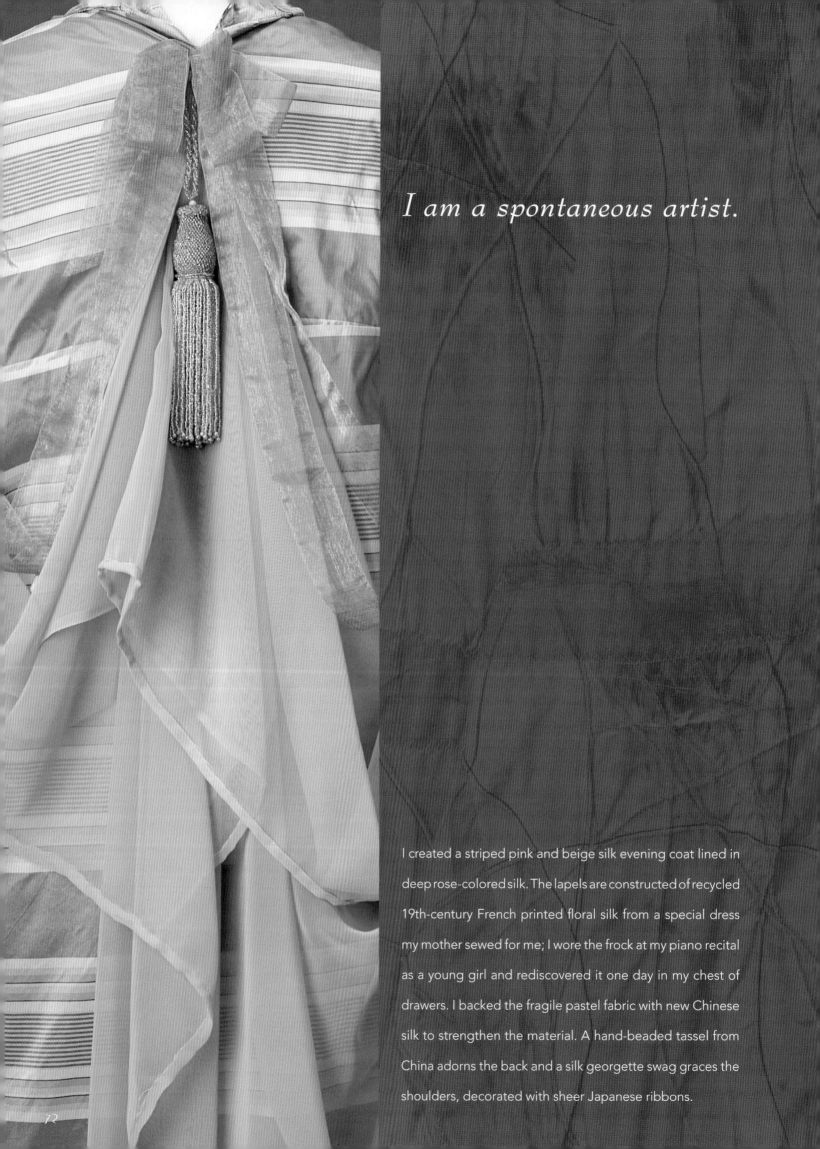

I am a spontaneous artist.

I created a striped pink and beige silk evening coat lined in deep rose-colored silk. The lapels are constructed of recycled 19th-century French printed floral silk from a special dress my mother sewed for me; I wore the frock at my piano recital as a young girl and rediscovered it one day in my chest of drawers. I backed the fragile pastel fabric with new Chinese silk to strengthen the material. A hand-beaded tassel from China adorns the back and a silk georgette swag graces the shoulders, decorated with sheer Japanese ribbons.

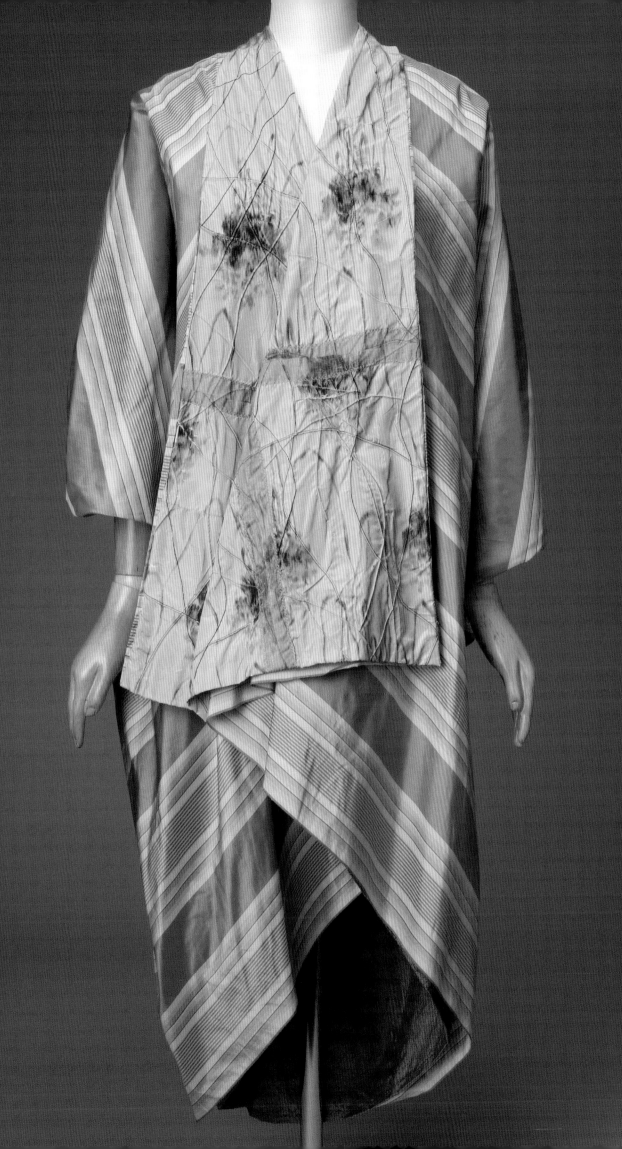

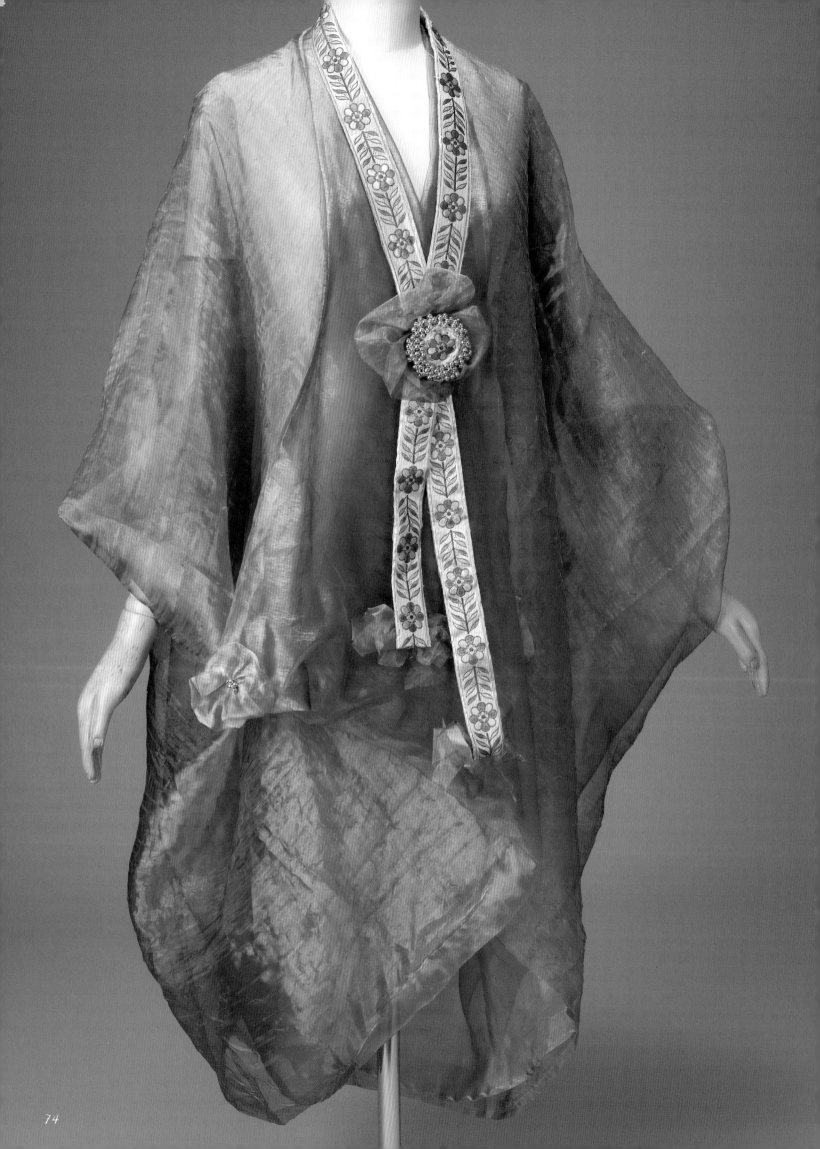

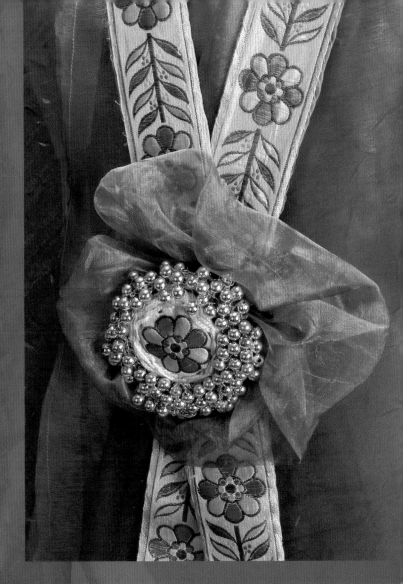

Throughout history, beautiful adornment has been a part of every culture.

Like the diaphanous wings of a delicate dragonfly the style and structure of the garment is transformed to become a spectacular coat through an iridescent green synthetic fabric with gold highlights and blue undertones. Lightweight, organza-inspired cloth reinterprets the garment in such a way as to express an elegant and airy feeling, even with its manmade fabric lining. My favorite vintage 1960s embossed leather belt with its stylized flower and leaf pattern was repurposed to become a glamorous neck piece with fabric puff and pendant clasp. I also embellished the back with an original jeweled creation: a single hand-tooled leather flower encircled with hand strung pearls and gold-tone beads. The dramatic adornment adds visual weight to the ultra sheer fabric; varying lengths of dangling ribbons float in the air with the slightest movement.

My candle burns at both ends;
It will not last the night;
But ah, my foes, and oh, my friends—
It gives a lovely light!
 —Edna St. Vincent Millay

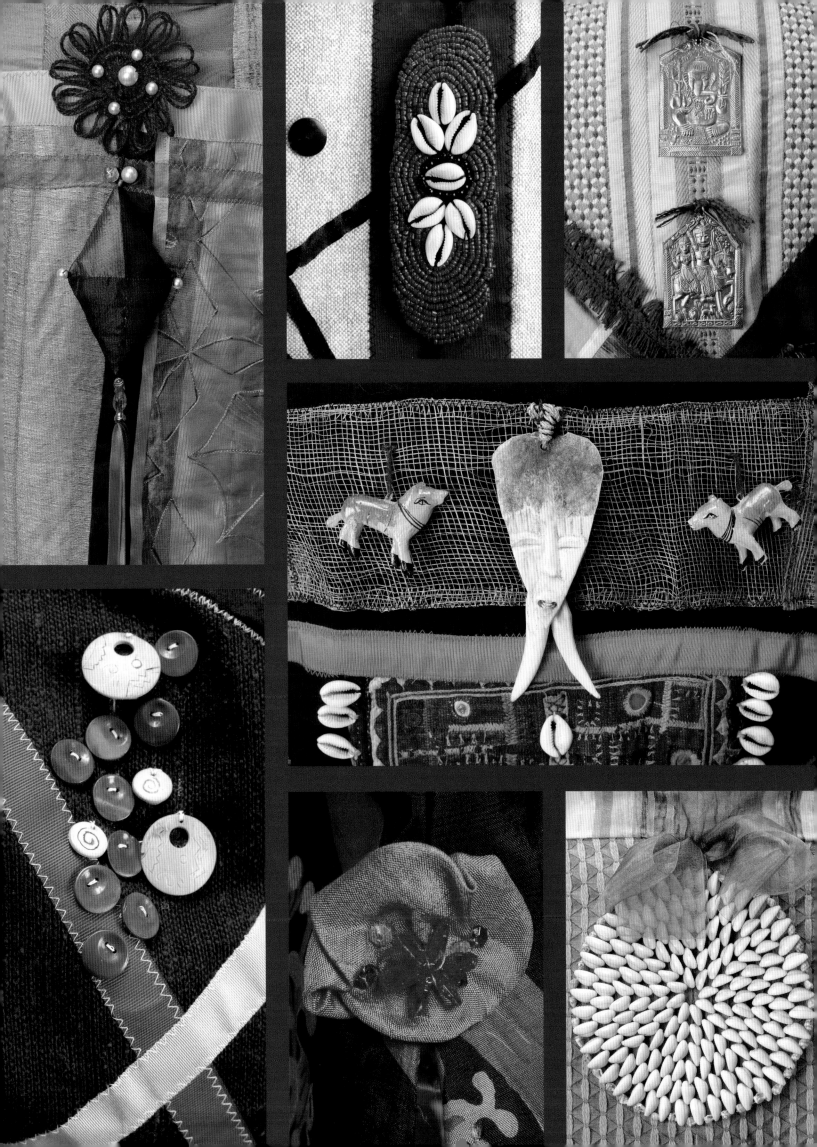

Chapter Two
The Square-Cut Jacket
Classic style transforms into avant-garde wearable art

My celebrated textile art pieces are imaginative variations on a classic clothing shape. I create new interpretations of the timeless Square-Cut Jacket garment pattern that are deeply rooted in different world cultures. Steeped in tradition, my creations pay homage to the authentic kimono, mandarin-style and historic straight-line fashion of Japan, India, China, Africa and Turkey; the simple T-shaped, square-cut garment structure possesses an ethnic feeling with folk wear flair and a slightly Bohemian attitude. My travels to Hong Kong and other exciting global destinations have certainly influenced my use of this versatile garment pattern appreciated and worn by so many men and women.

The virtually seamless, simple architectural panels of the Square-Cut Jacket pattern have provided me with ample opportunity for artistic expression. This classic shape has offered a blank canvas for me to design and sew stunning textile compositions, enhanced with my collected embellishments; the back of each jacket is an especially important area for my adornments. The pattern's simple, geometric form gives me free rein to express my passion for designing unique textile assemblages made from acquired pieces of multicultural contemporary and antique cloth. It also allows me to display my technical skills

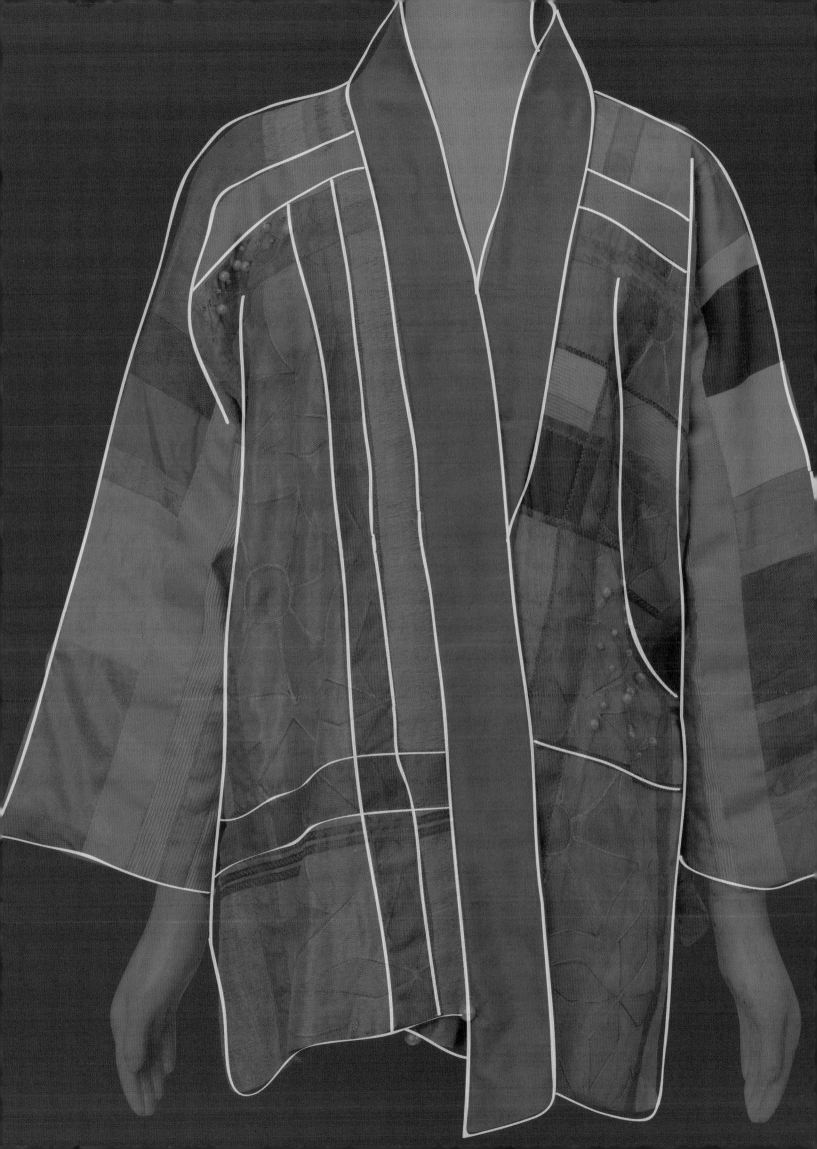

from fine embroidery stitches to appliqué work as well as essential machine stitching using my Bernina. This universal straight-line pattern truly allows for unlimited artistic adaptation, abstract ideas and experimentation.

I love wearing and exhibiting my original garments. The comfortable Square-Cut Jacket style has a democratic fit while making a dramatic fashion statement where East definitely meets West. My extensive collection includes kimono-inspired garments without the characteristic long hanging sleeves, but instead have straight and tapered sleeves, V-necklines and contrasting borders; in traditional ceremonial dress the garment has an Obi sash at the waist. The Chinese-style jacket features a small stand-up mandarin collar, frog closures and tailored long sleeves. My subtle modifications include cropped sleeves, cord neck ties and button-with-loop closures, fringed edges, pointed hems with tassel trims and original touches of colorful ribbon, shells, hand embroidery and found object embellishments.

Most seamstress-designers use a typical paper or muslin square-cut garment pattern. I cut out fabric pieces without following an actual pattern, but rather draw a diagram based on precise body measurements, which makes this jacket and coat style easy to create out of most any cloth. Medium-weight and soft fibers work best from pure cotton weaves, crisp linen and exquisite hand-woven silks to lightweight wool; the textile possibilities are endless. The Square-Cut Jacket is so versatile that it can be hip-length, mid-thigh or to the knee, and the longer version becomes a full-length coat appropriate for day or evening wear. Only three yards of fabric and two straight seams are required. I choose complementary lining to accent each garment.

Designing wearable art is my creative expression. Each uniquely designed garment unfolds intuitively as a work in progress; many times the cloth leads the way. Inspired by a textile's unique print, dye process, cultural heritage, tactile quality, age-old technique or forgotten handmade beauty, I follow my instincts and design eye, uniting different fabric colors, fibers, shapes and woven textures in a balanced composition guided by proven design principles of balance, scale and proportion. The simple, Square-Cut Jacket is just one of the secrets behind my handmade wearable art collection.

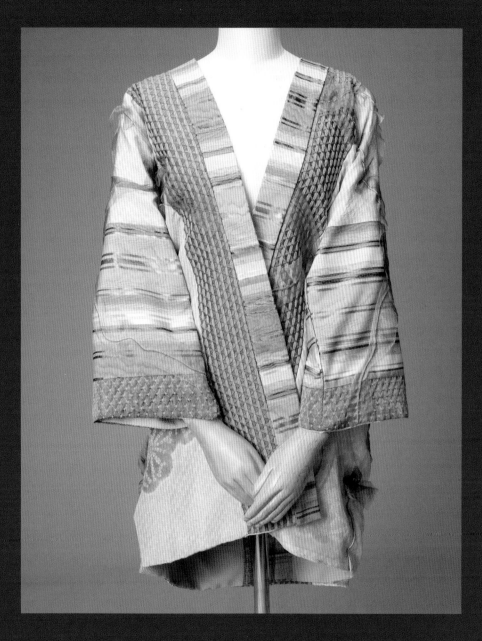

The uncomplicated square-cut
style is the perfect shape for
creating wearable art.

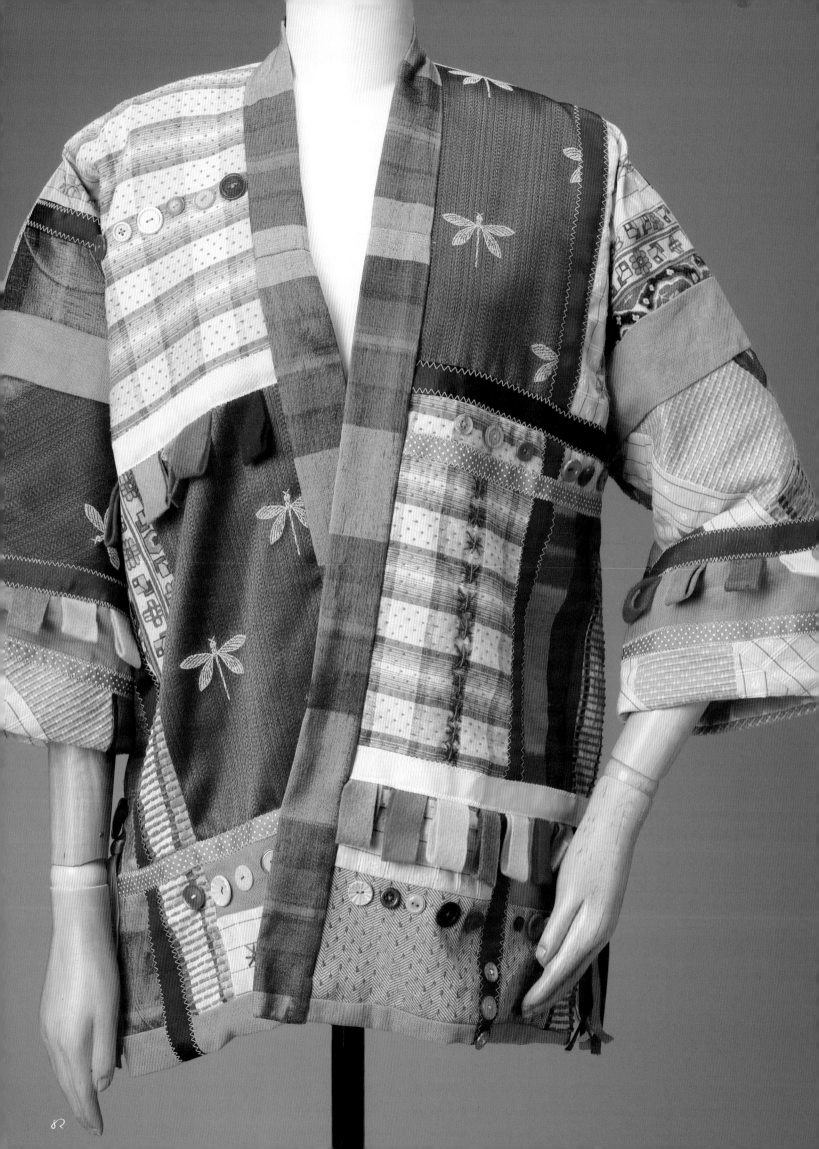

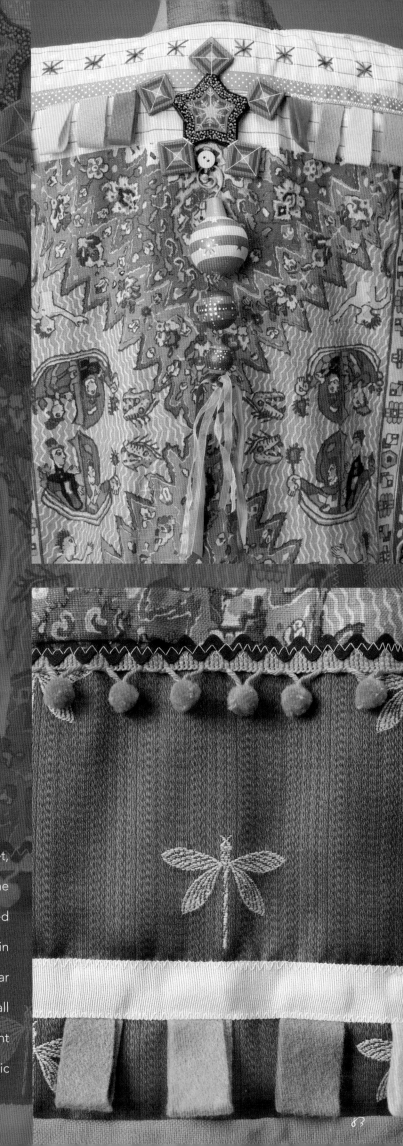

I creatively combine eclectic pieces of cloth and sew them into a new whole.

I refer to this kimono-style creation as my carnival jacket, with its colorful pieces of cotton, silk and mixed fibers. The lively mix of English and French printed cotton is enhanced by my embroidery work. Embellishments include grosgrain ribbon, buttons and folded felt strips; a handcrafted star and papier-mâché ornament dangles on the back while ball fringe and rickrack add whimsy. The lining is a screen-print leaf pattern with an inside back collage using bits of fabric and ribbon.

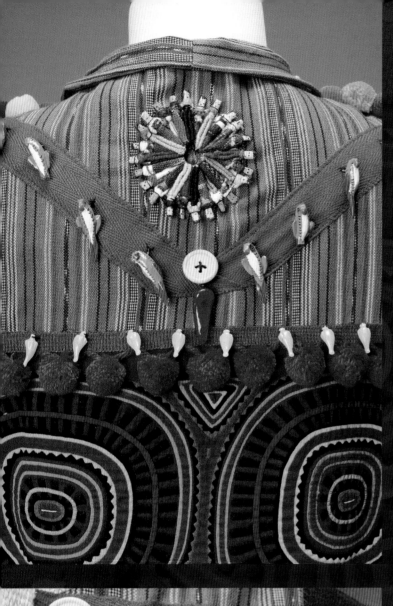

Textiles from around the world provide a kaleidoscope of color and character.

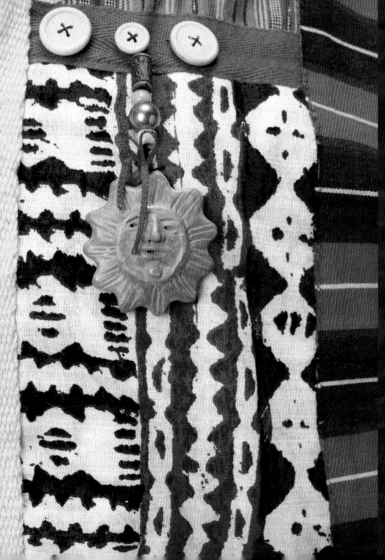

I bought a colorful antique mola that was handmade by skillful Kuna Indians from San Blas Islands in Panama. Kuna women create mola art often imitating their ancient culture's body paint designs using a reverse appliqué stitching technique; this handmade geometric piece became the back feature of my handwoven Guatemalan cotton and Indian denim ethnic-inspired jacket. Mexican terracotta sun and moon ornaments adorn the front, while belt pieces, strips of burlap, rickrack, ball fringe, wooden buttons and tassels add south-of-the-border flavor.

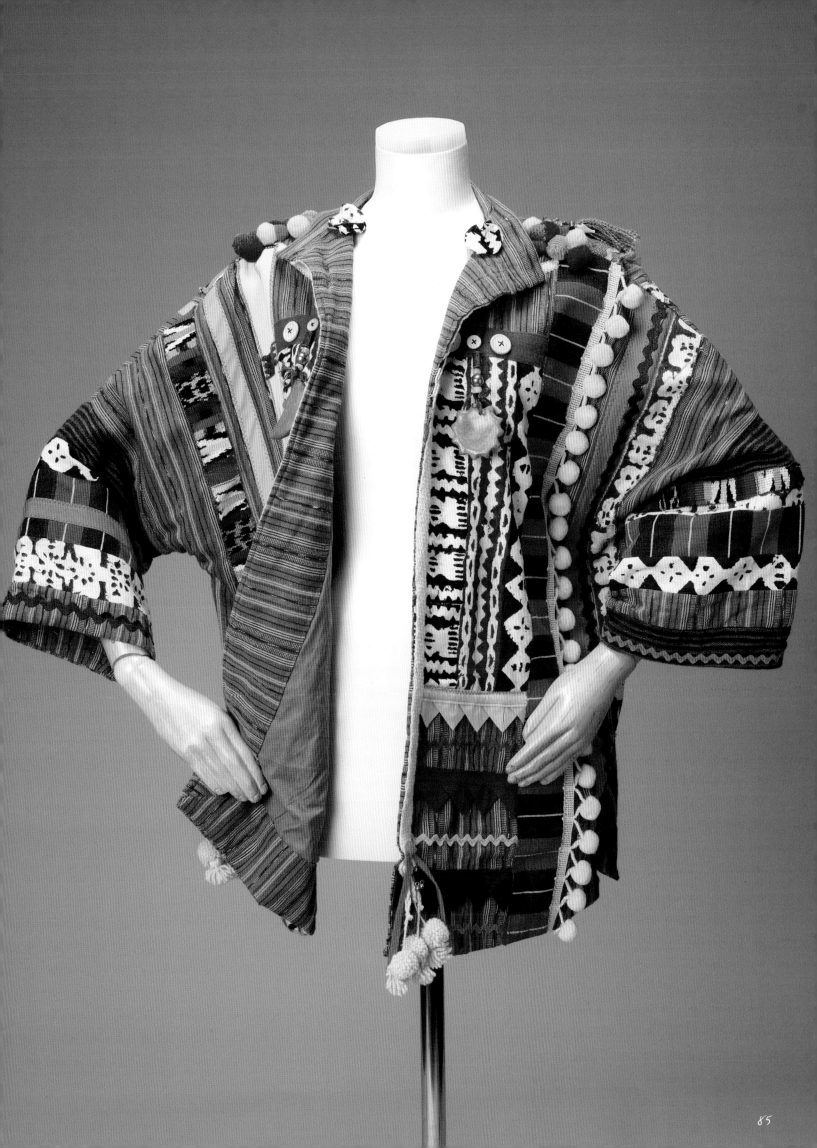

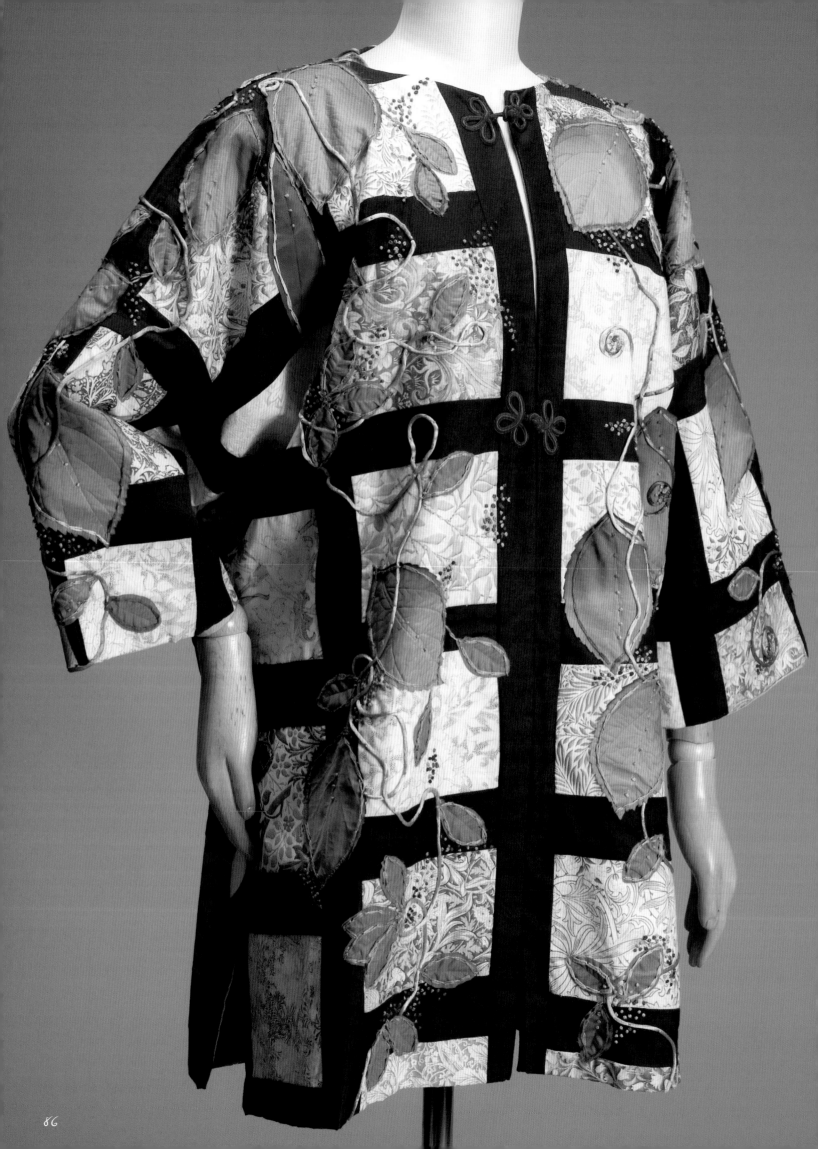

Ideas that arise along the creative process often become my inspiration for the final design.

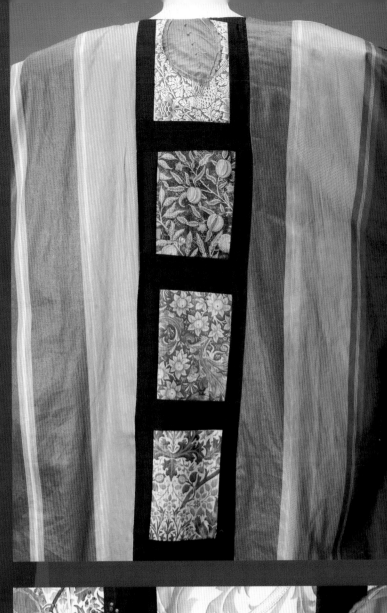

As an homage to William Morris, the 19th-century English textile designer, I preserved my treasured postcards from the Victoria and Albert Museum in London by transferring the images onto cotton cloth using a chemical process. First I applied quilt-like methods with navy blue cotton strips to construct the jacket, then appliquéd silk leaves and rattail to hold the design together. I embroidered hundreds of red French knots to the vines and accented the side slits with carved bone leaves. The garment's multicolored cotton lining features a vertical collage of postcard transfers—I often sew surprise design elements on the inside back of my unique jackets.

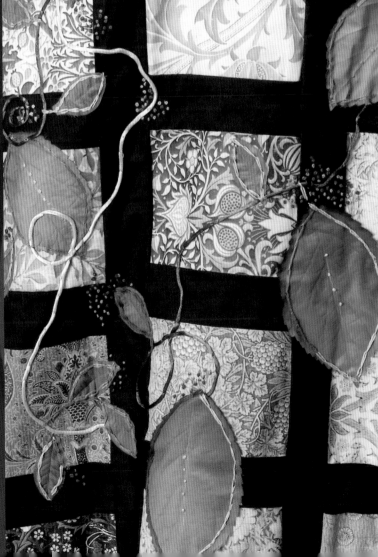

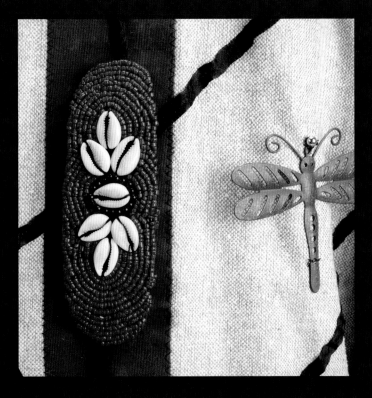

Left: The principal batik technique cotton fabric is from South America. I constructed the remaining garment using beige cotton and edged sleeves and bindings with woven braid. It is embellished with ribbons, buttons and whimsical stamped metal dragonflies, turtles, bees and bugs. I added three-dimensional zebrawood buttons to accent the jacket front, and an oval back piece is hand-beaded with shell accents—I brought these back from my visit to Kenya in the 1970s. The lining is imported African black and white cotton.

Facing page: One of the first jackets I ever made was based on a classic Vogue pattern with inset sleeves. I constructed the garment from ribbed silk with natural linen trim. Exquisite old lace and crochet pieces were placed and sewn in the center of the back. I used soft Ultrasuede binding to edge the collar and jacket front. Shell slices, beads, tassels, shisha mirrors and hand embroidery on lace add back interest and sleeve details. The garment is lined in polyester fabric and also has lace pieces inside.

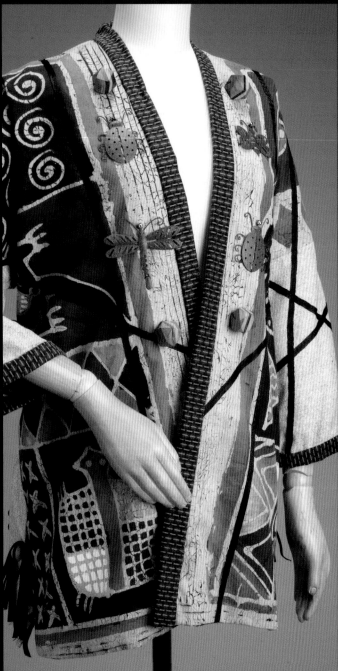

Traditional woven treasures, batik prints, fine silks, natural linen and threadwork define the piece as a composition of layers, textures and shapes.

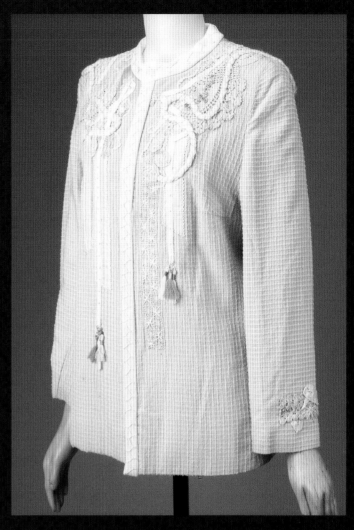

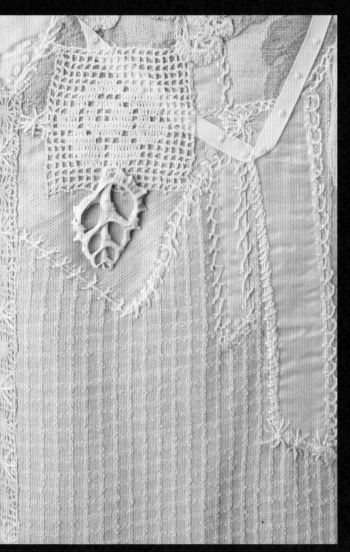

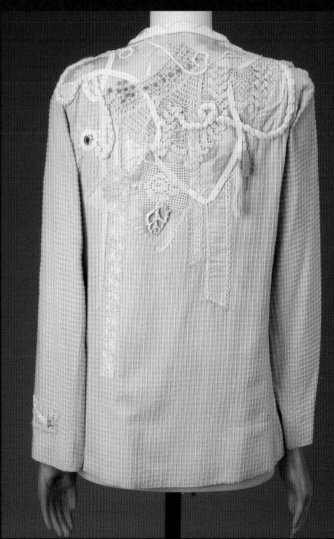

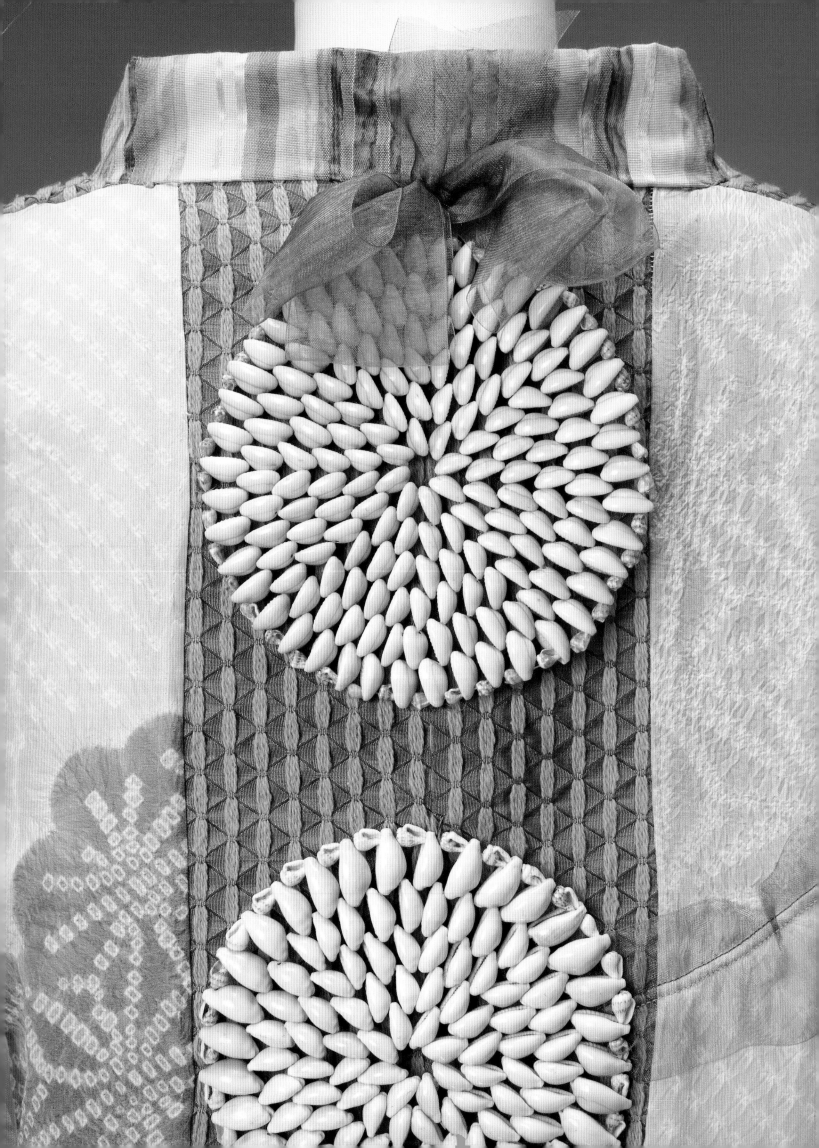

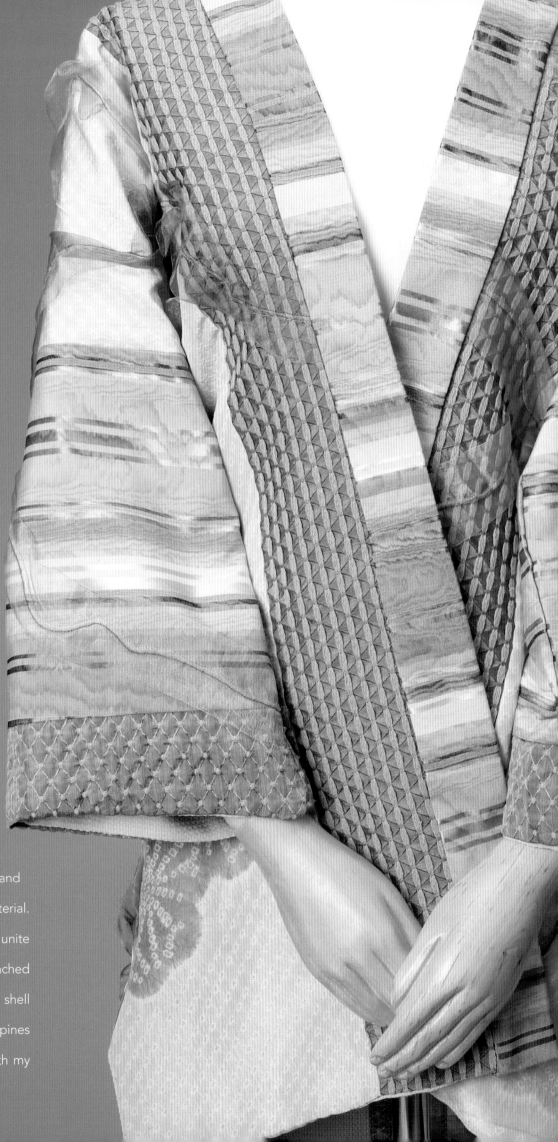

*I hand-finish
each of my
garments
with needle
and thread
techniques.*

I bought this pastel, postwar Japanese Obi, a perfect example of antique Shibori silk resist-dye technique, and turned it into a modern kimono-style jacket. The center back is a different fabric, and part of the front and sleeves are polyester striped material. I sewed sheer ribbons to unite the garment design and attached handmade 1940s' cowrie shell kitchen trivets from the Philippines for back drama, in keeping with my South Pacific theme.

My travels to Europe, Africa, Asia and Russia have strongly influenced my art form.

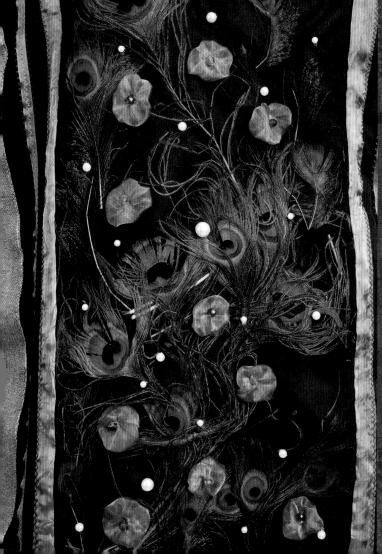

A friend gave me an antique Japanese Obi and I designed the kimono-style jacket around its fine peacock embroidery, adding solid pieces of fabric as needed. I created a composition of genuine peacock feathers and fabric flower puffs on the front and back, held in place with fine-gauge netting and edged with gold braid and ribbons. Sheer polyester fabric forms the elegant bindings and the garment is lined in black and raspberry-colored cotton. Small iridescent puffs accent the side slits.

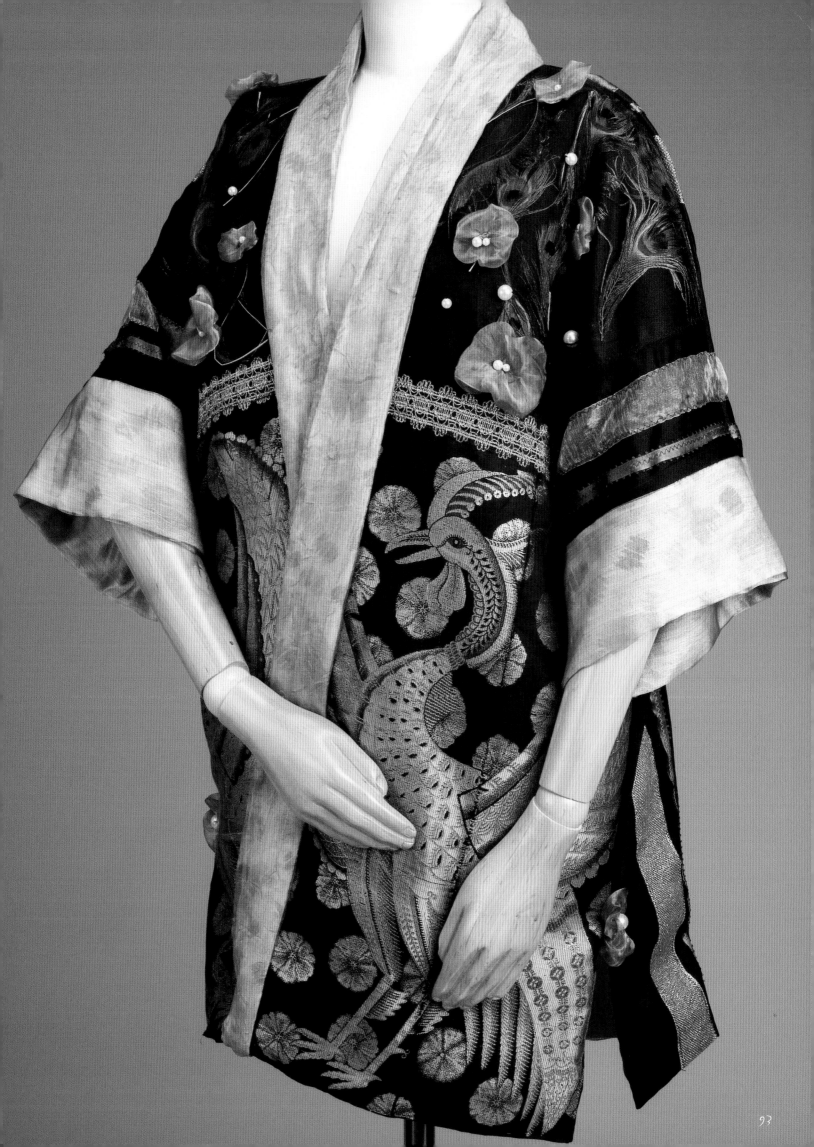

Left and above: I acquired a lovely reproduction 19th-century Spanish wool fringed shawl from the museum store at The Met in New York City and turned the yardage into a stunning kimono-style jacket. Trimmed with raspberry-colored silk, ribbons, gold braid and buttons, the beauty of the damask weave technique is wonderfully showcased. I lined the garment with orange taffeta.

Facing page: Inspired by sari fabric—worn by Indian aristocracy for hundreds of years with intricate gold- or silver-threaded metallic weaves, I trimmed the Square-Cut Jacket with gold lamé banding in keeping with the ethnic spirit of the fabric. I embellished the garment's back neckline with fabric tube streamers of the same Indian cloth trimmed with gold beads and two lamé puffs. Lined in black silk, the garment has an unexpected sari design sewn down the center of the back lining.

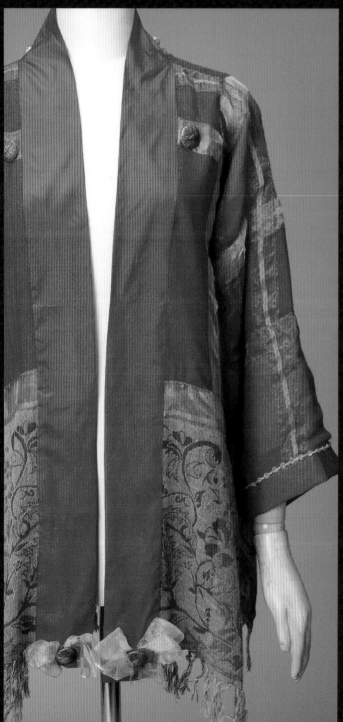

I hope each of my handmade garments exhibited in galleries and museums makes a lasting impression.

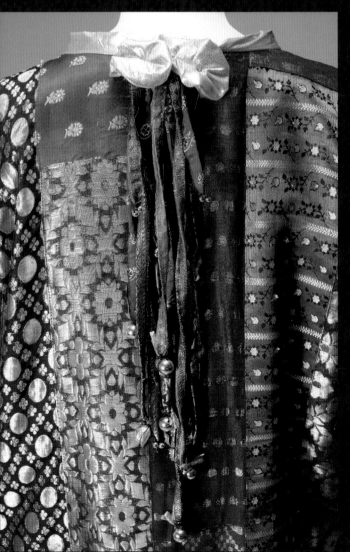

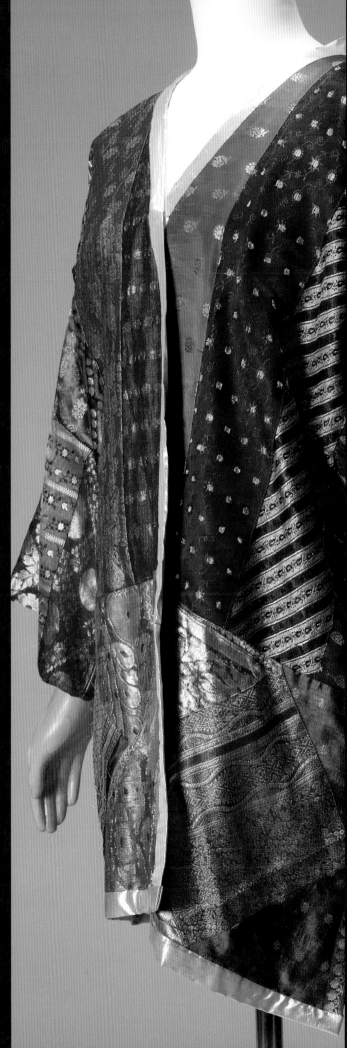

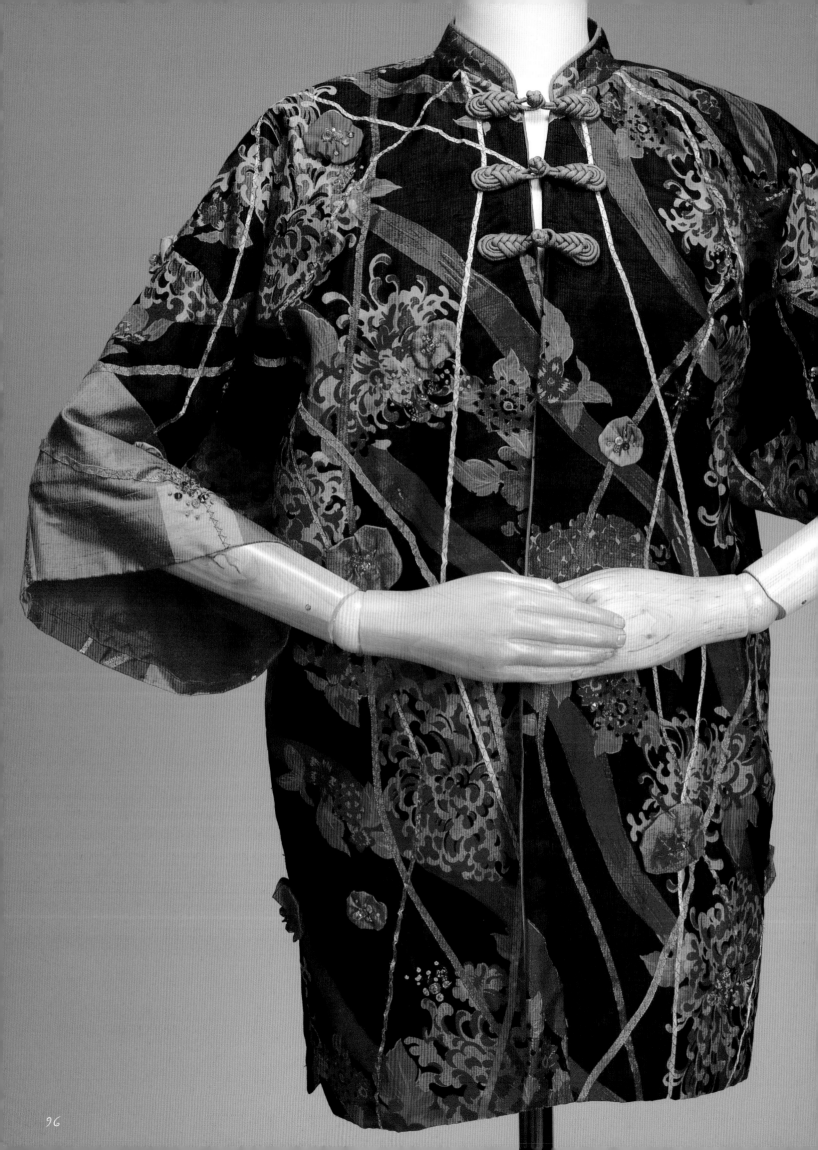

Mid-century, screen-printed silk from Thailand influenced this exotic jacket design. I disassembled my classic Jackie O-style vintage dress from a local thrift shop to make the body of the garment. Shocking pink and brilliant fuchsia tones are repeated in the Jim Thompson silk used for bindings imported from his legendary artisan silk-making shop in Bangkok. Embellishments include ribbon and fabric puffs with bead trims. The dress' original mandarin collar and frog closures were also integrated in the retro design.

As an artist and bold colorist, I love bright oranges and deep reds for their warmth.

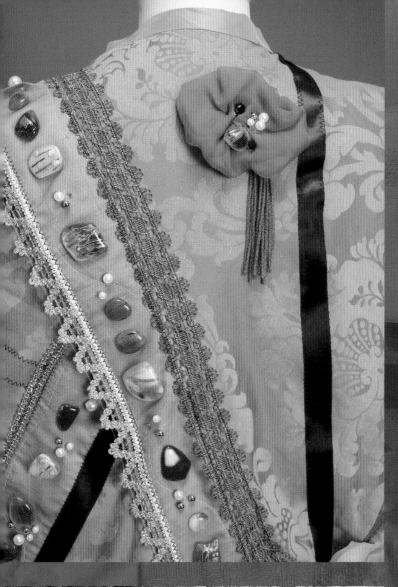

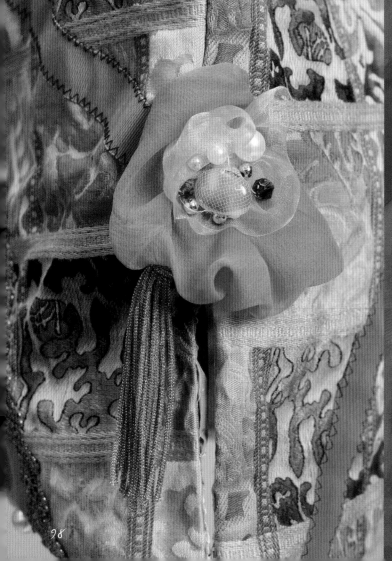

Interesting remnants, handwoven fibers, embroidery pieces, bits of cloth and found objects —they all become my artistic medium.

Contemporary, peach-colored silk damask from Milan inspired this impressive creation. I adorned the garment with a ribbons, beads, gold braid, tassels and georgette puffs in varying shades of the same hue. Vera Sattler, a glass artisan and friend, gave me myriad pieces of her colorful art glass. Using special wax I attached rows of glass gems, sewed on faux pearls and beads, then used fine-gauge netting to hold them in place. The jacket is lined in peach silk taffeta and French cotton lace; garment bindings are also silk taffeta.

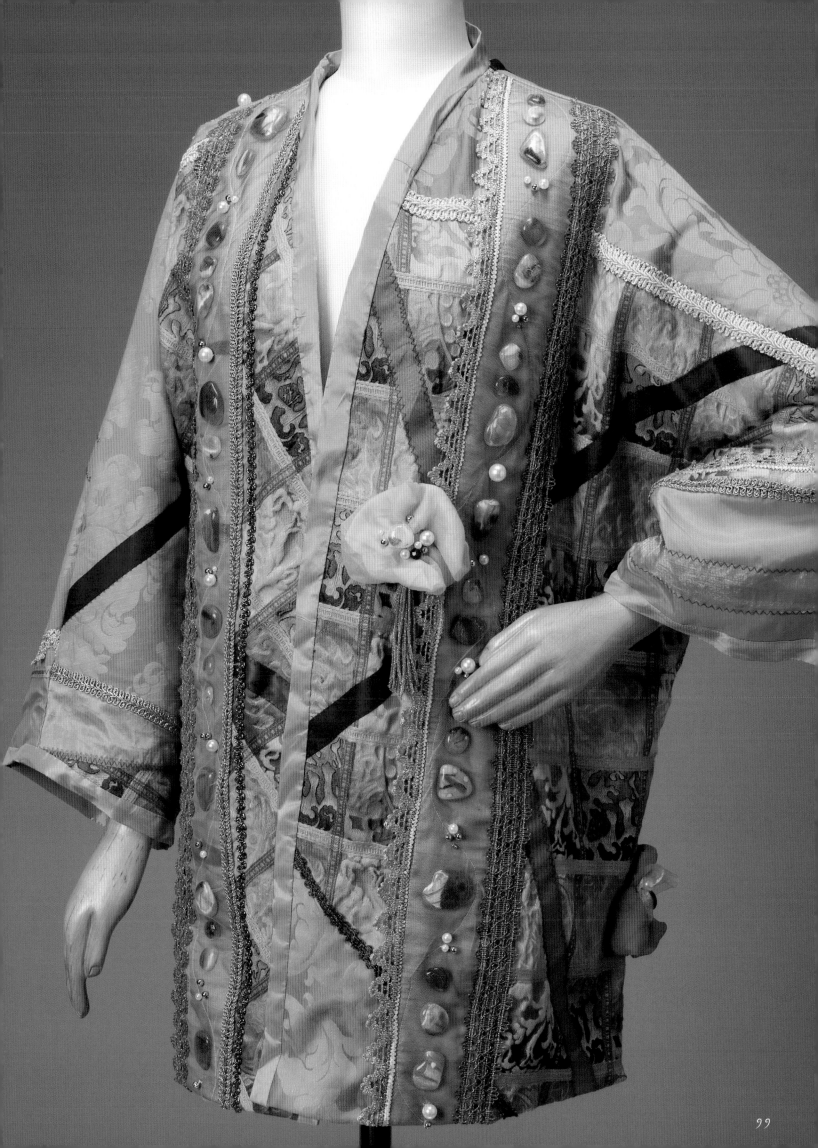

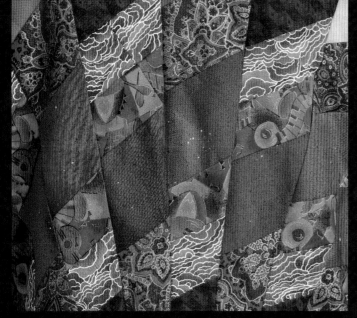

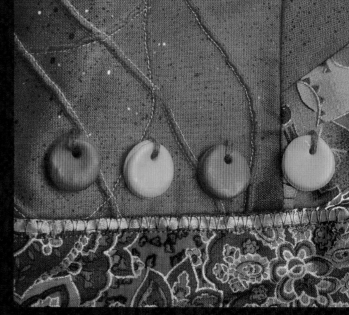

Left and above: This jazzy Square-Cut Jacket is constructed of bright red and blue printed cotton, cut and sewn into a design using traditional quilting techniques but with tucks and double-needle stitching on the front. I cut fabric pieces on an angle using a drafting tool for the back insets to create a starburst effect. Red and orange round buttons that I made from Fimo polymer modeling clay are used as decorations. The garment's lining is in various shades of peach-colored cotton.

Facing page: A German ski jacket design from a winter catalog was the inspiration for this lightweight cotton Chinese-style creation with its mandarin collar and frog closure. To accent the peach fabric, I sewed hand-crocheted wool braid, ball fringe and silk flowers with bindings of pink velveteen. The printed bouquets on the back, sleeves and front are covered with three-dimensional silk flowers under fine-gauge netting. An artful cotton lining reflects the floral theme and color scheme with its large printed flowers.

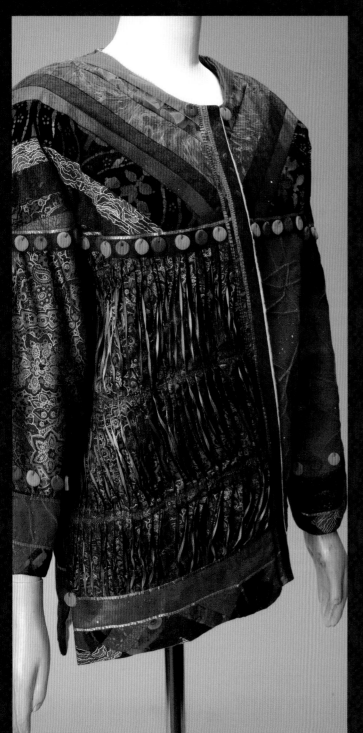

Every project is an opportunity to hone my seamstress skills, which I learned from my mother and grandmother.

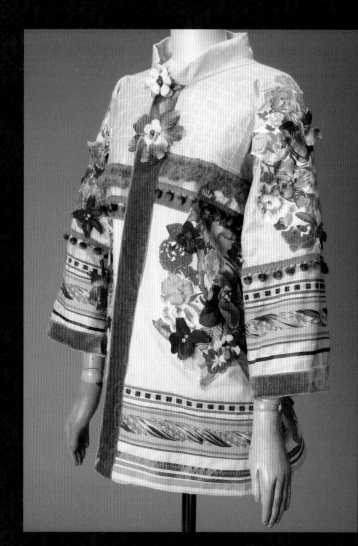

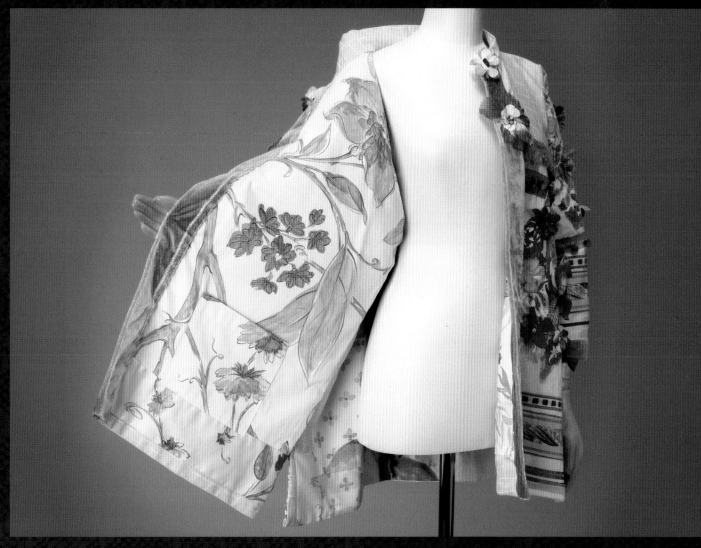

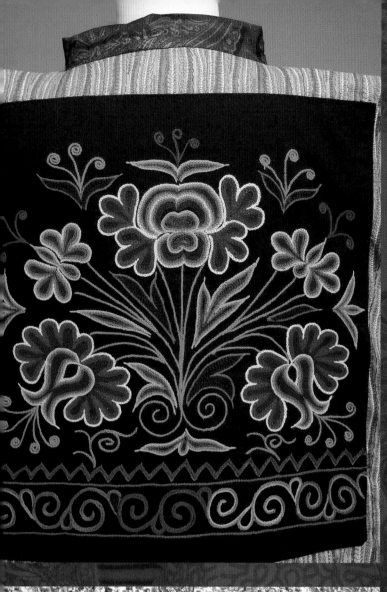

Piece by piece, I work on each garment as long as it takes to achieve the right aesthetic.

Afghanistani embroidery became the main back and front side panels, but part of the garment is soft wool challis from my 1960s dress. I recycled paisley cotton men's ties front and center, added polished cotton pieces, braid, rickrack and bells from India. Crocheted roses with dangling buttons from Yugoslavia dot the jacket and pumpkin seeds trim the back. The jacket lining is striped cotton with a Chinese embroidery square on the inside back; I bought this rare Afghan embroidery from historic textile curator Mary Hunt Kahlenberg at her renowned Santa Fe gallery. Two frog closures finish the mandarin-style jacket.

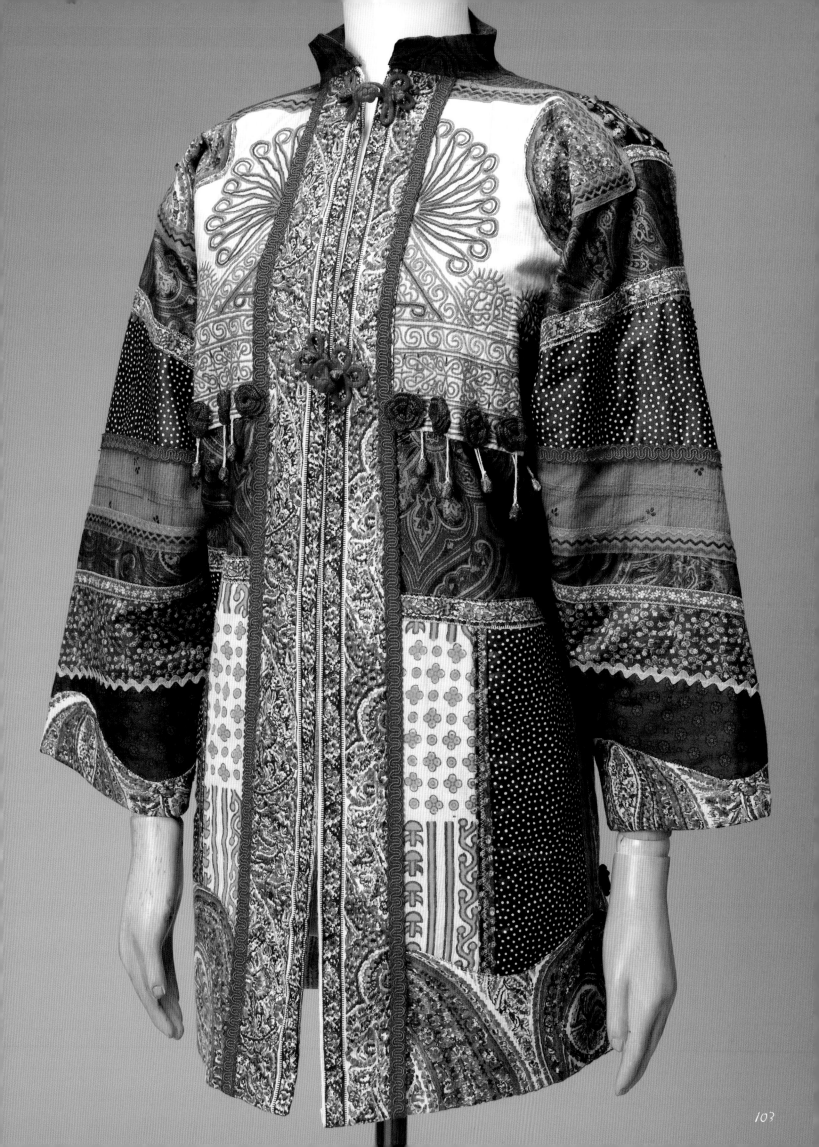

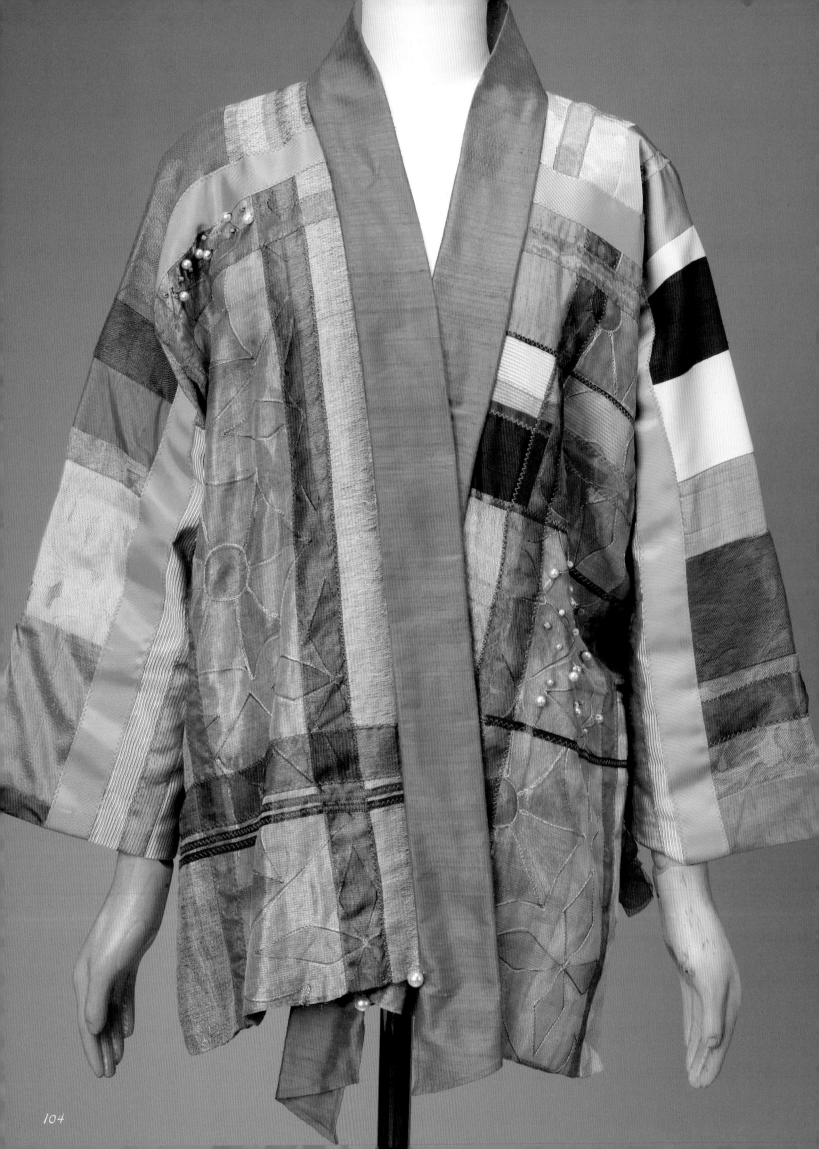

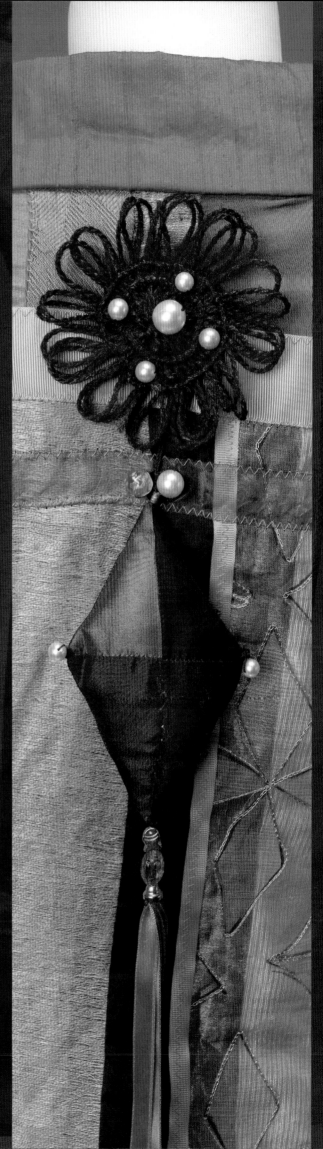

One small piece of unusual fabric can get me excited and that part inspires the whole design.

My unique kimono-style jacket features Italian silk with overlays of organza-like polyester fabric, one piece over the other, to create interesting texture and color. There is a crocheted flower sewn on the garment back with a kite-shaped dangle from India and ribbon streamers. The binding of the jacket was originally a silk scarf imported from legendary American entrepreneur Jim Thompson's studio in Bangkok. Thai Silk Company is now owned by textile expert Jack Lenor Larsen. I lined this garment in lavender-colored silk with a collage of fabric in the center back the same as the outer garment. Small puffs and faux pearl accents adorn the jacket and its side slits.

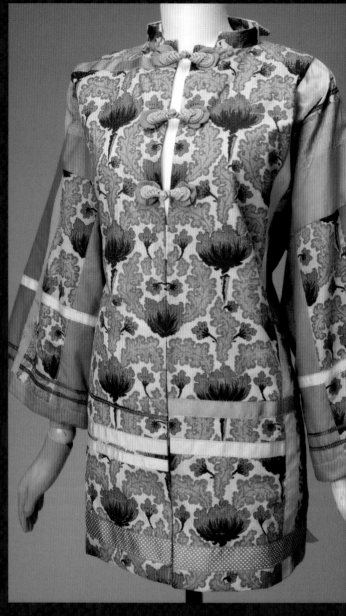

When I was in Salzburg, Austria, I fell in love with this dramatic purple thistle and leaf pattern on polished cotton. The purple and turquoise color scheme is emphasized with matching solid-colored segments and bands of cotton fabric. Grosgrain ribbons accent the piece and three frog closures secure the classic mandarin-style jacket. Its lining consists of various lavender-colored cotton fabrics to echo the shades of the exterior cloth.

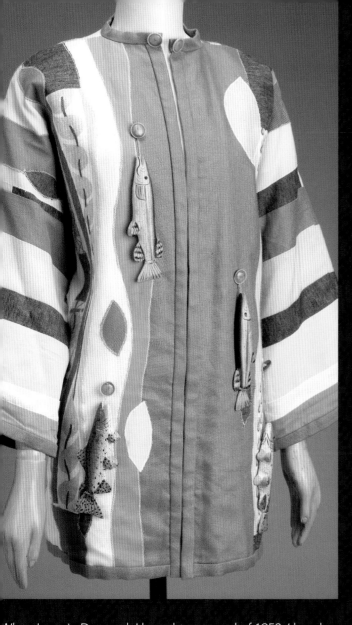
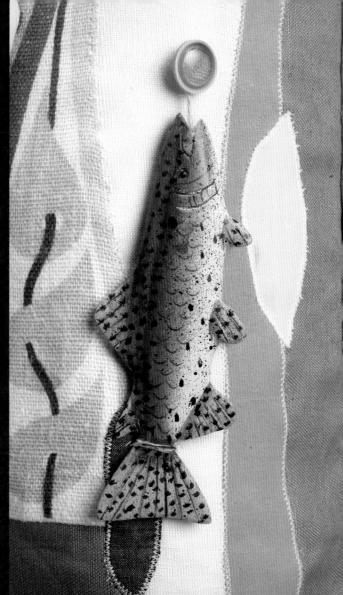

When I was in Denmark I bought one yard of 1950s' hand-screened linen with a unique, stylized fish design. I cut out patterr shapes and strips, pieced them together, and reassembled the jacket adding solid brown, yellow and neutral-colorec cotton segments for sleeves and front panels with coordinating ribbons. Hand-painted wooden fish made in Japan dangle on cotton embroidery thread attached to buttons. I lined this unusual jacket in beige and white printed cotton; bindings

My sewing machine is a strong part of the creative process.

I adapted the square-cut pattern to create wider, oversized sleeves for my floral print jacket, which was inspired by an English polished cotton fabric. Ribbons, bows, silk flowers and leaves are secured under fine-gauge netting. The jacket is lined with peach hemstitched cotton, with buttons and rickrack braid for embellishments. I used a double-needle machine-stitching technique on the front panels to add interesting texture and a single royal blue frog closes the jacket.

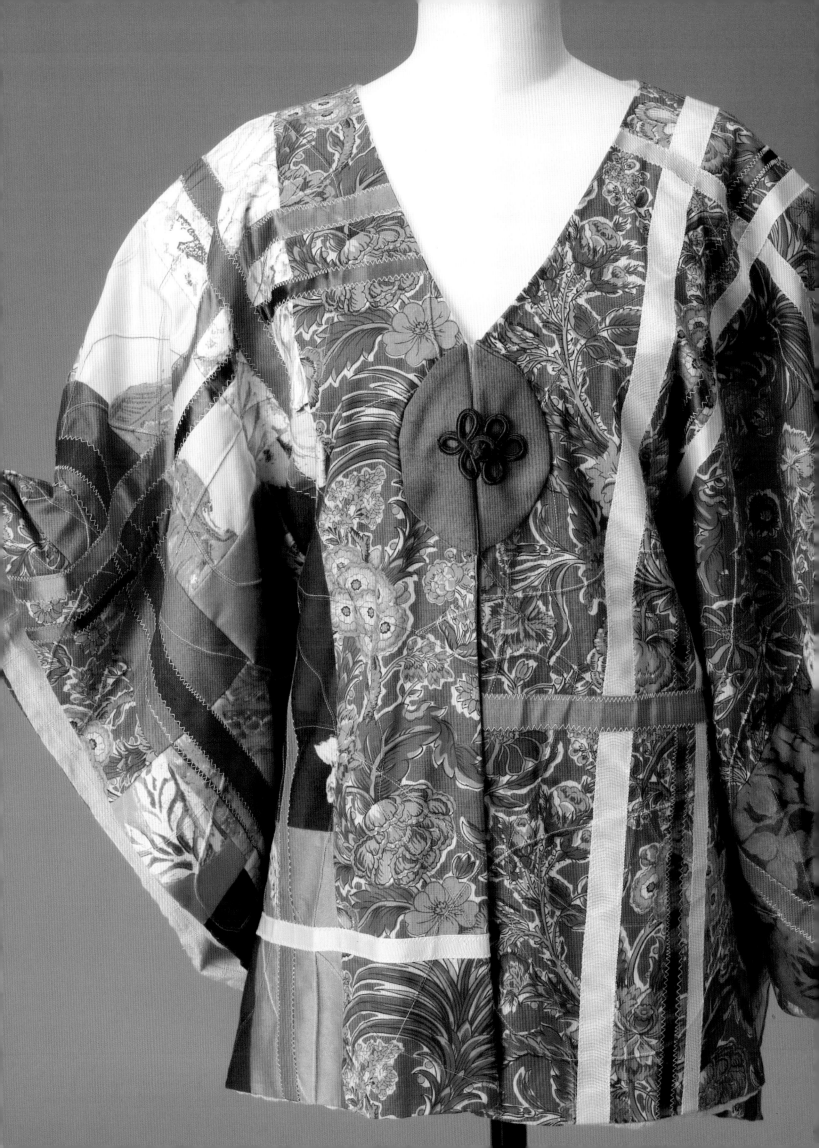

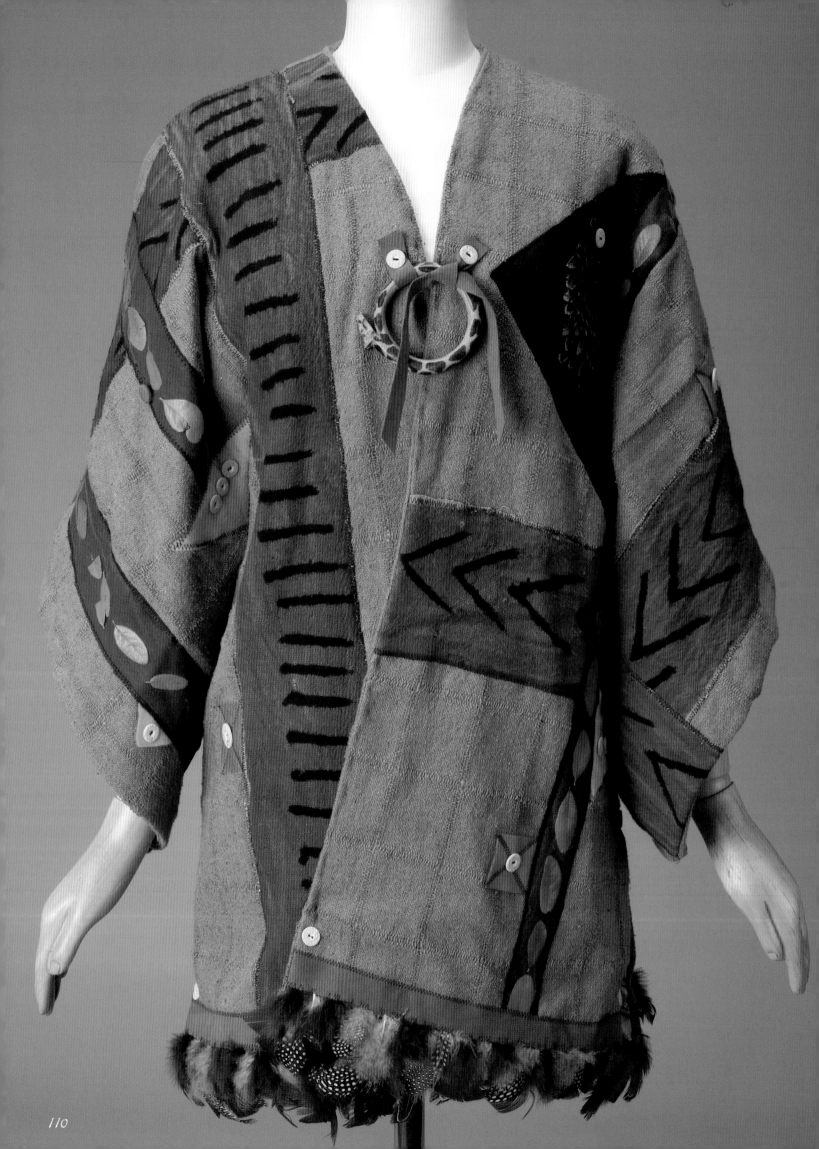

I would never mix primitive with sophisticated. The spirit of the piece must be unified.

This garment exhibits a strong African influence. I chose handwoven cotton, trims of authentic handwoven and dyed mud cloth, Ultrasuede, felt and buttons; strips of dried leaves from the trees in my yard are held in place with netting. A genuine Kuba cloth velvet piece in the center of the back creates depth to the garment with its characteristic geometric shapes. Kuba cloth is made from loomwoven raffia fibers grown in central Africa. I found a wooden giraffe bracelet to create a single closure, added natural bone buttons and edged the jacket with naturally spotted guinea fowl feathers for a tribal expression.

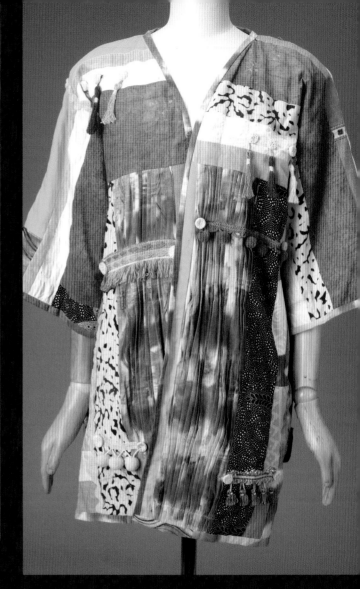

When I took a course in batik resist-dye technique I designed a piece of cotton cloth with a primitive mask design, so

constructed the jacket using it as the back panel. Various segments of cotton fabric were also incorporated; I hand-pleated

the color-washed front panels for a textural effect. Braid and ball fringe, many tassels, Fimo clay buttons and cording dyed

ndigo blue embellish the garment. This jacket is lined in multicolored tie-dyed cotton and bindings are of the same cloth

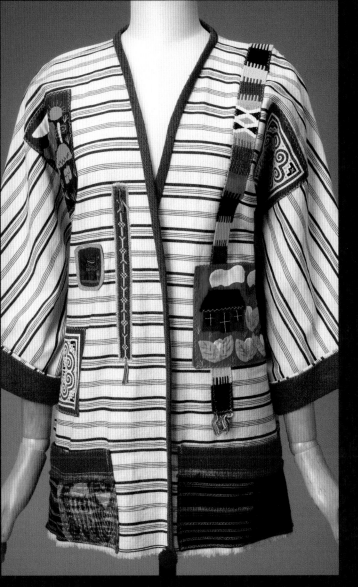
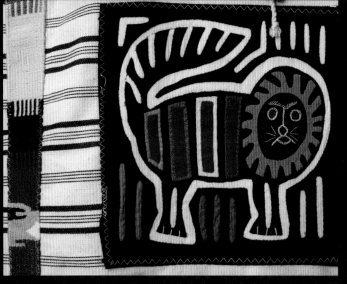
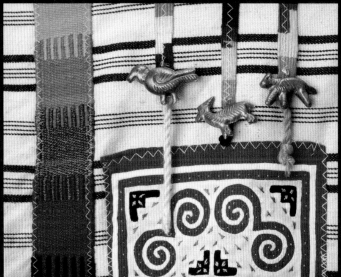

Blue and white striped denim creates the basis for this design featuring an interesting collage of handwoven belts from Mexico, a Chinese red and white embroidered medallion and folkloric reverse appliqué work from the San Blas Indians of Panama. Tiny animal charms—symbolic prayer offerings called Milagros—hang from narrow woven belt pieces to adorn the garment back. Surprise strips of small molas run down the center of the back on the inside of the unlined garment. The jacket is bound in red cotton. Front pockets are from German skirt fabric.

I have more than an appreciation for different cultures and cloth, I have passion.

This is perhaps the most multicultural creation. I used cotton from Thailand, wool yarn tassels, bone buttons and created shoulder accents by cutting the orange leather fingers from my favorite Parisian gloves. The sleeves are hand-woven fabric from a German-made skirt. I sewed cloth fragments from India on the back with buttons and shells. Embellishments include papier-mâché animals from India and my carved bone mask pendant souvenir from Kenya, attached to fiber cloth from the Philippines. The piece is lined in printed paisley cotton.

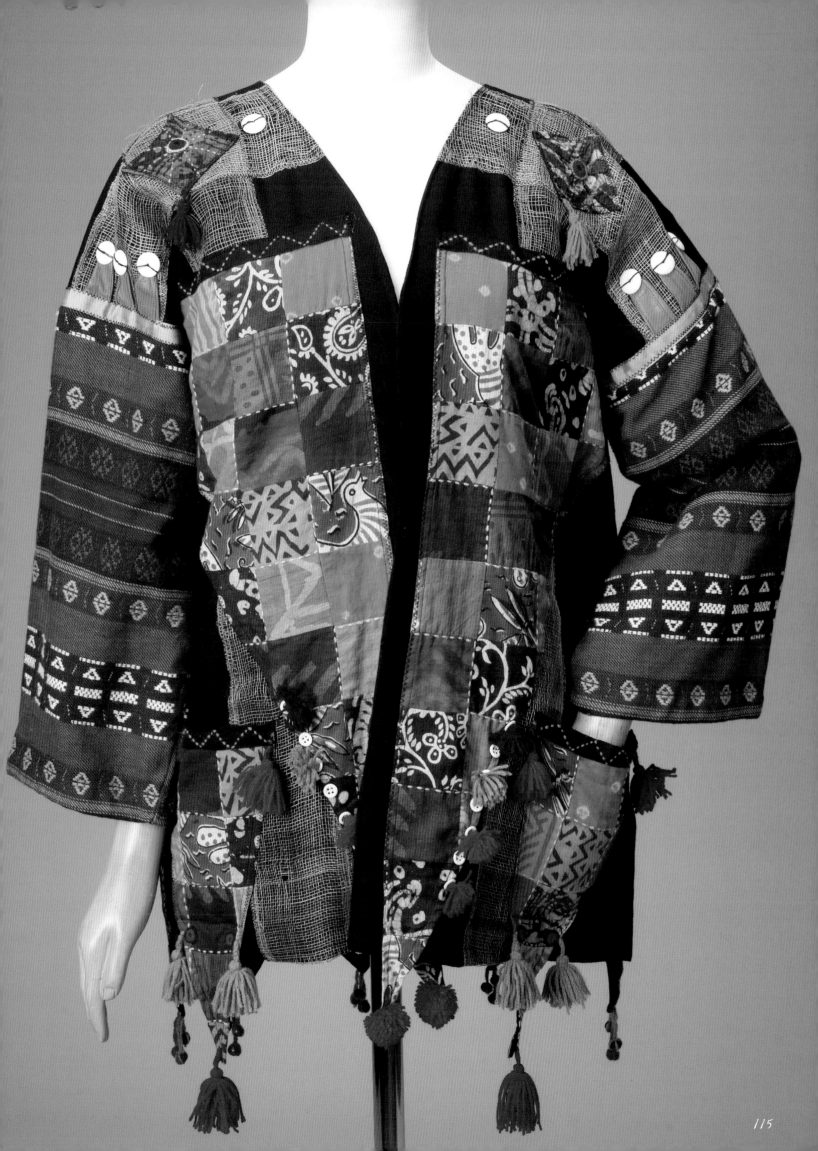

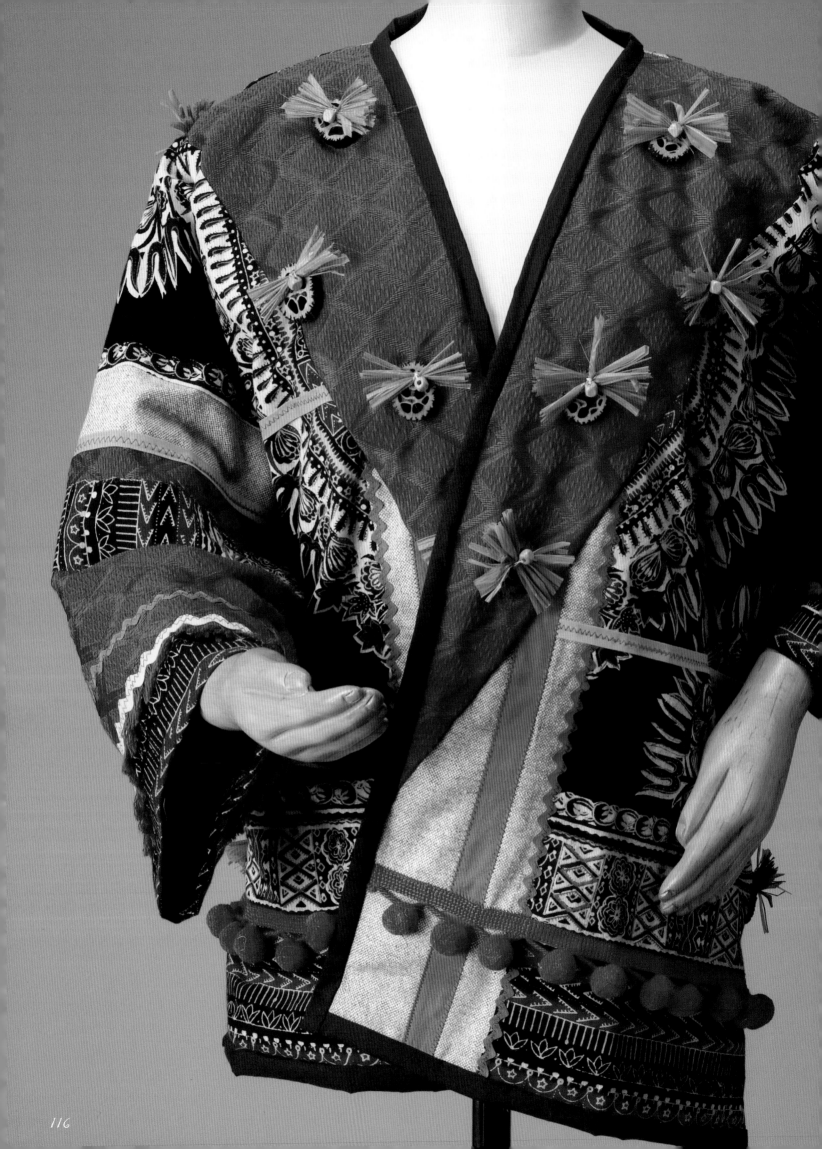

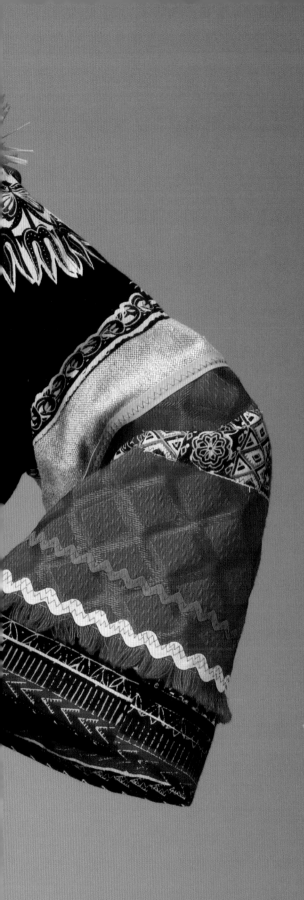

I seek to strengthen the relationship between art and textiles.

Starting with fabulous printed cotton from Indochina, I centered a unique buffalo skin circle design from India on the jacket back as a compelling focal point. Rickrack, ball fringe, ribbon, sliced walnut shells, bells with raffia fringe and beads embellish the garment. I fully lined and bound the jacket with navy blue cotton. Fabric tubes dangle from the hemline and raffia fringe adds an ethnic touch.

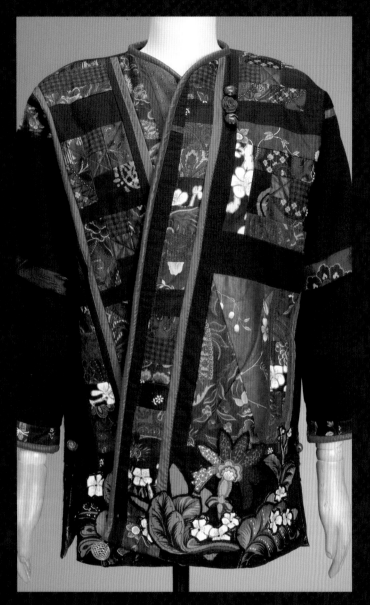

While living in upstate New York I made this heavy-weight, hand-quilted jacket to wear in the chilly climate. The main garment was created by applying traditional quilting techniques on patterned Waverly polished cotton fabric; the binding across the bottom is hand appliquéd in wool yarns. Antique red porcelain beads at the neck and side slits of the garment complement the dark blue denim segments with vibrant red cotton trim.

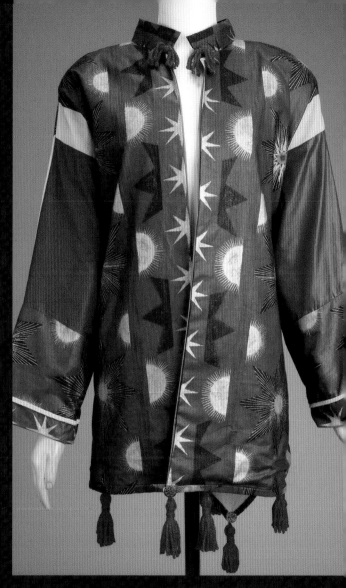

The sun-and-stars motif makes a bold statement in this Chinese-style jacket adaptation constructed from printed English cotton. I created an extra-full and somewhat irregular, V-point bottom of the garment in front and back. Wool fiber cluster ies and burgundy-colored tassels with metal buttons adorn the piece at the nape of the neck and along the hemline. The

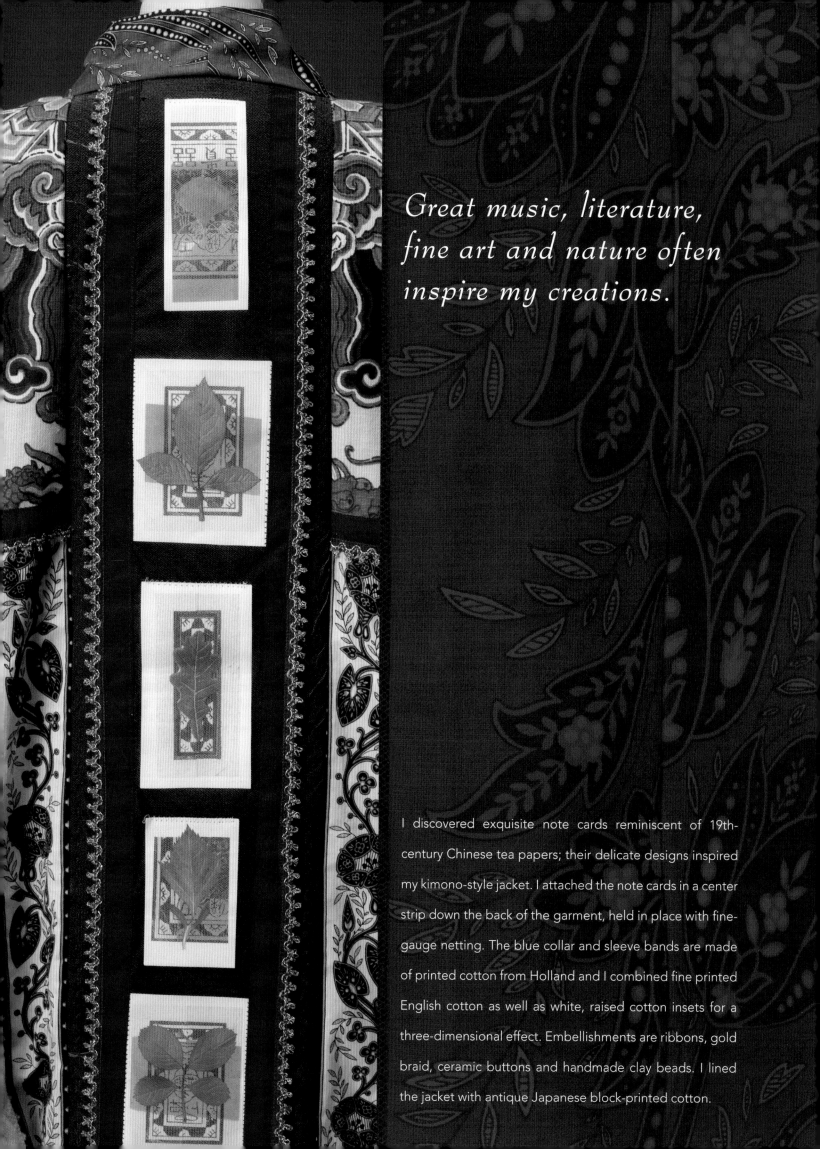

Great music, literature, fine art and nature often inspire my creations.

I discovered exquisite note cards reminiscent of 19th-century Chinese tea papers; their delicate designs inspired my kimono-style jacket. I attached the note cards in a center strip down the back of the garment, held in place with fine-gauge netting. The blue collar and sleeve bands are made of printed cotton from Holland and I combined fine printed English cotton as well as white, raised cotton insets for a three-dimensional effect. Embellishments are ribbons, gold braid, ceramic buttons and handmade clay beads. I lined the jacket with antique Japanese block-printed cotton.

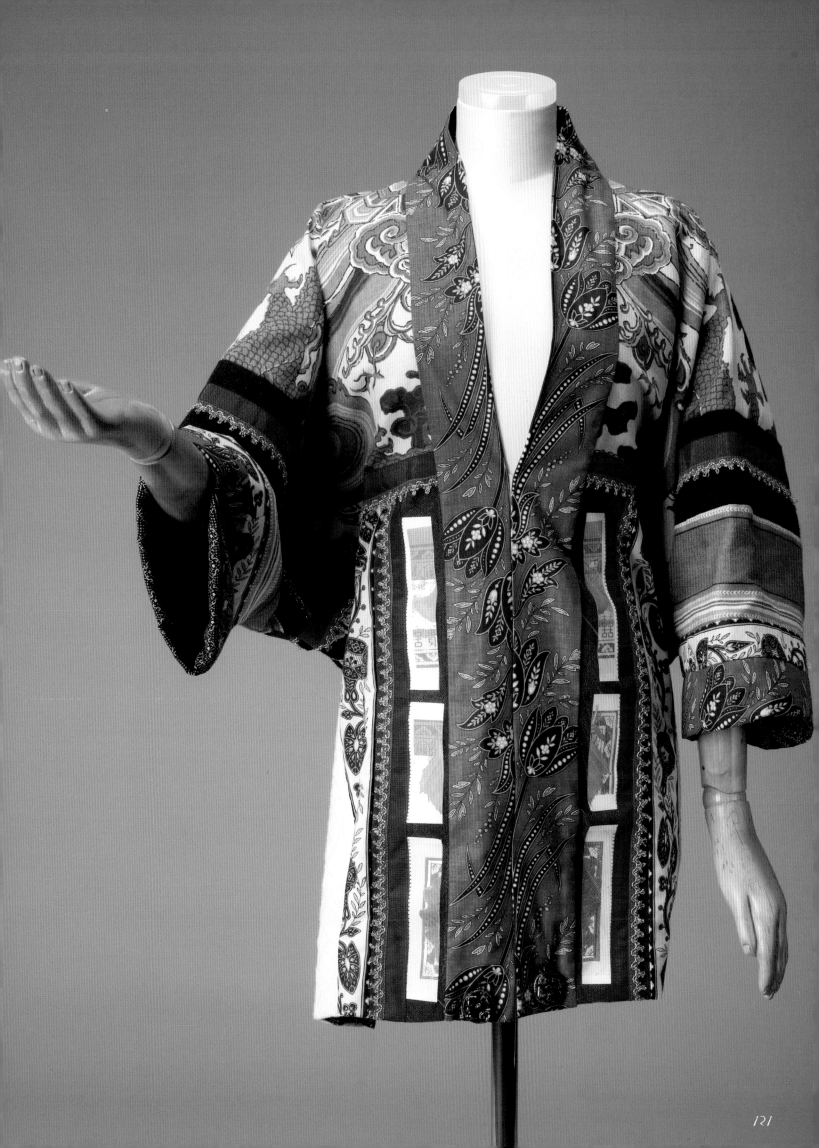

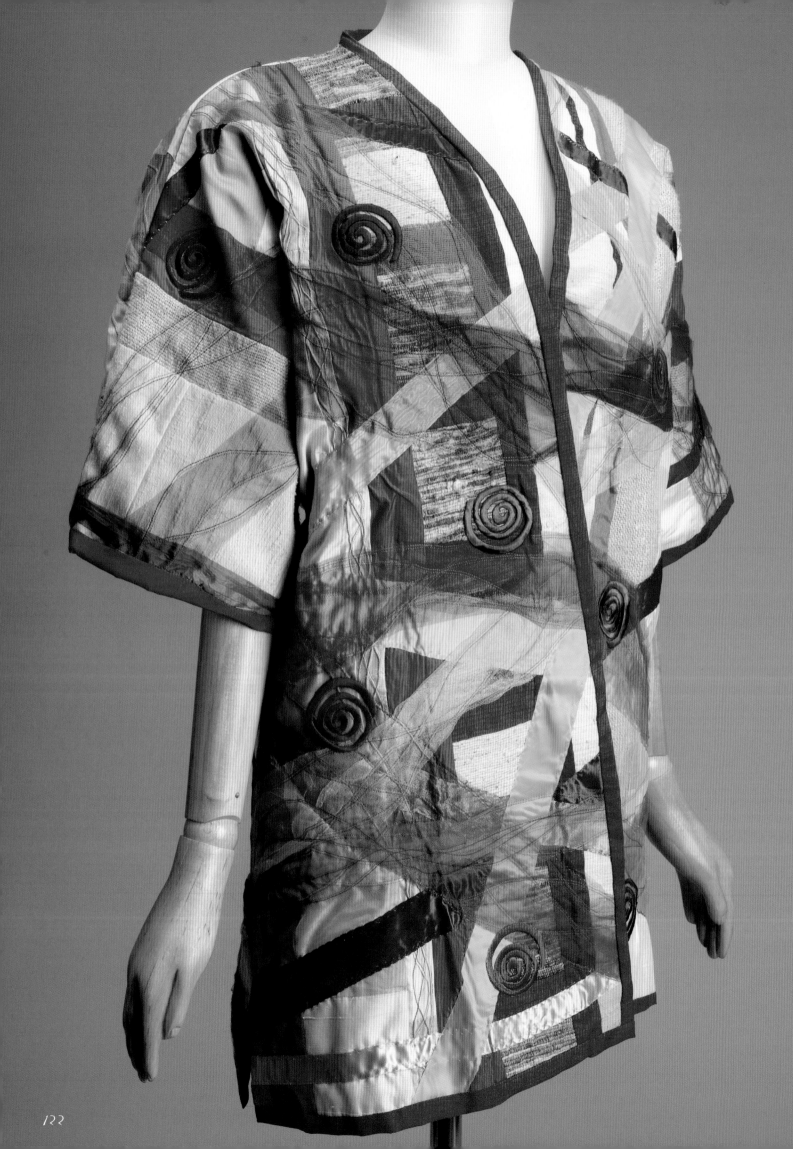

Passion is the secret behind every artist's creative power. We must believe in what we do.

One of the earliest jackets I created in the late '80s was assembled using many sample squares of silk and linen to create a refined patchwork effect. Random machine-embroidered whirligigs become colorful accents, while a rainbow of ribbons and long strips of scrunched, small-gauge netting intertwine across the body of the garment and run down the cropped sleeves. Colorful flowered georgette lining mimics the uplifting spirit of the piece.

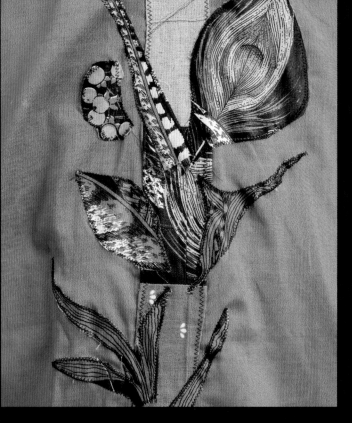

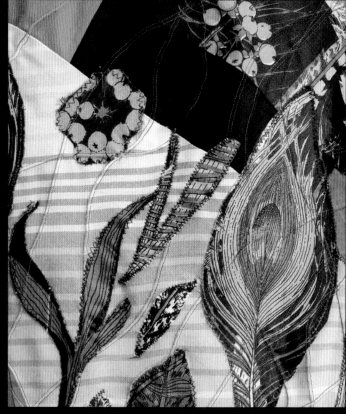

Left and above: Inspiration for this unusual kimono-style jacket came from the artistic peacock-patterned polished cotton. I cut out parts of the pattern and hand appliquéd these pieces onto various colored cotton backgrounds. The machine double-needle stitching technique was used to integrate texture on the front; one felt dangle and handmade Fimo clay beads are sewn at the top of each side slit. My jacket is lined in several pieces of cotton, and I appliquéd print fabric to the inside center of the jacket as a surprise design element.

Facing page: The black kimono-style jacket is made entirely of pure silk with three-dimensional puffs for flower sprays and silk leaves. I added ropes intended for fly-fishing that I purchased from a quaint village shop in Manchester, Vermont, and then embellished them with my colorful hand embroidery stitches. The binding trim is created of shocking pink, lavender and orange wide-striped silk imported from the acclaimed Jim Thompson Thai Silk Company in Bangkok; I lined the garment in raspberry-hued silk.

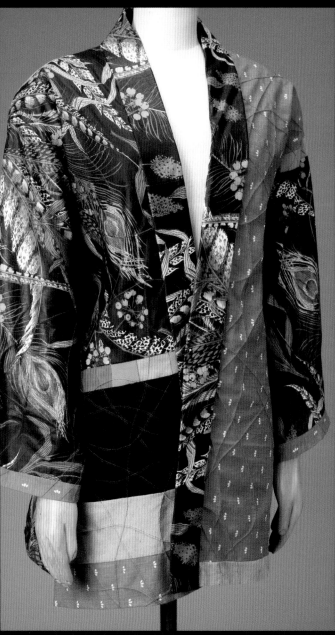

We do not pay
enough reverence to
our inheritance of
textiles. They should
be preserved and
recognized, repurposed
and reapplied.

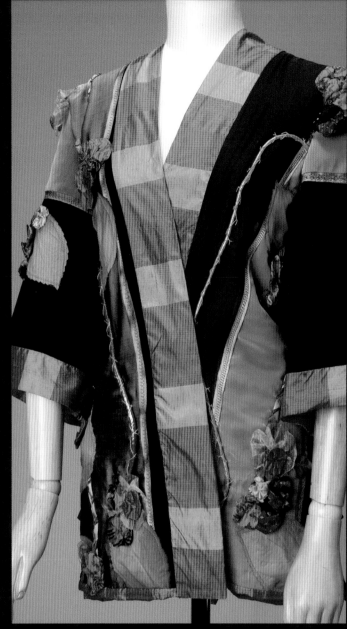

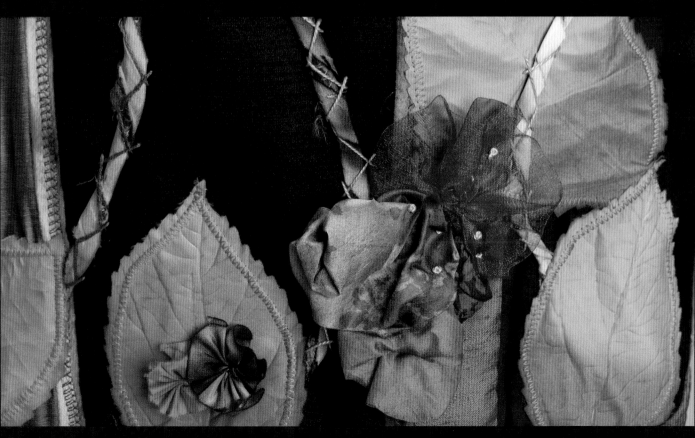

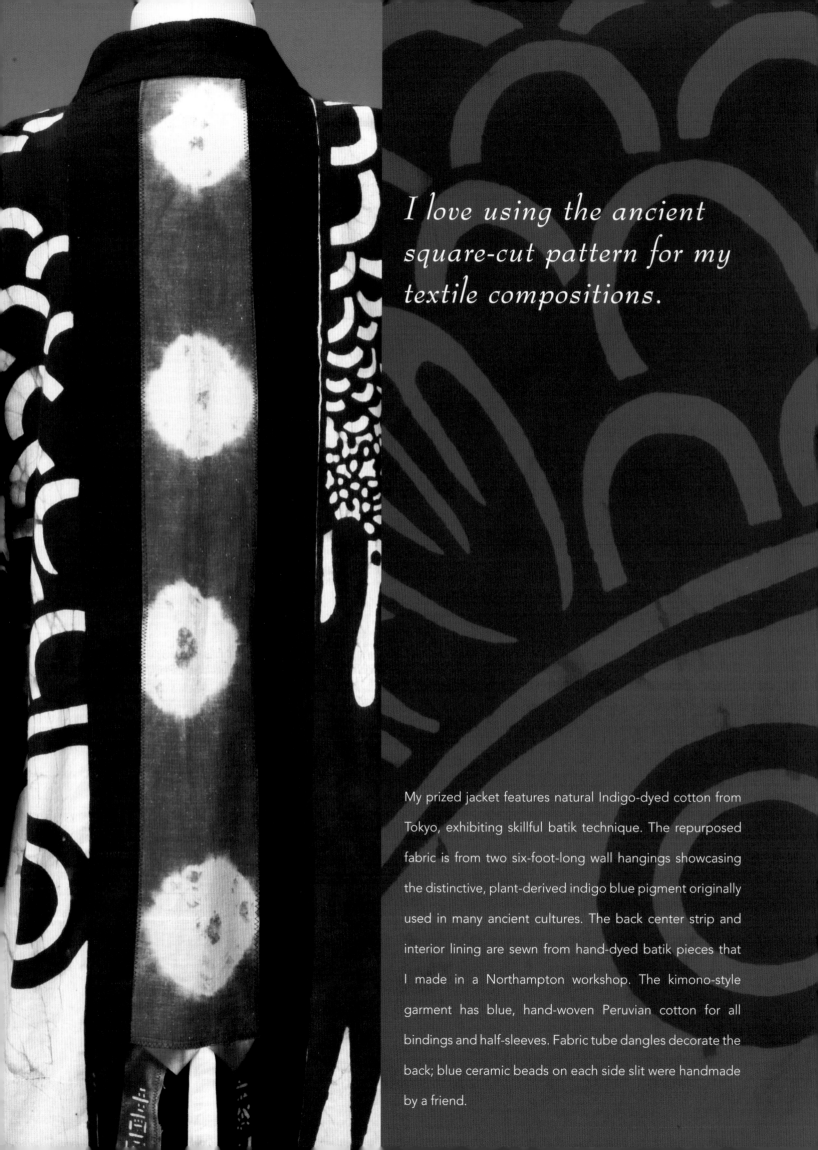

I love using the ancient square-cut pattern for my textile compositions.

My prized jacket features natural Indigo-dyed cotton from Tokyo, exhibiting skillful batik technique. The repurposed fabric is from two six-foot-long wall hangings showcasing the distinctive, plant-derived indigo blue pigment originally used in many ancient cultures. The back center strip and interior lining are sewn from hand-dyed batik pieces that I made in a Northampton workshop. The kimono-style garment has blue, hand-woven Peruvian cotton for all bindings and half-sleeves. Fabric tube dangles decorate the back; blue ceramic beads on each side slit were handmade by a friend.

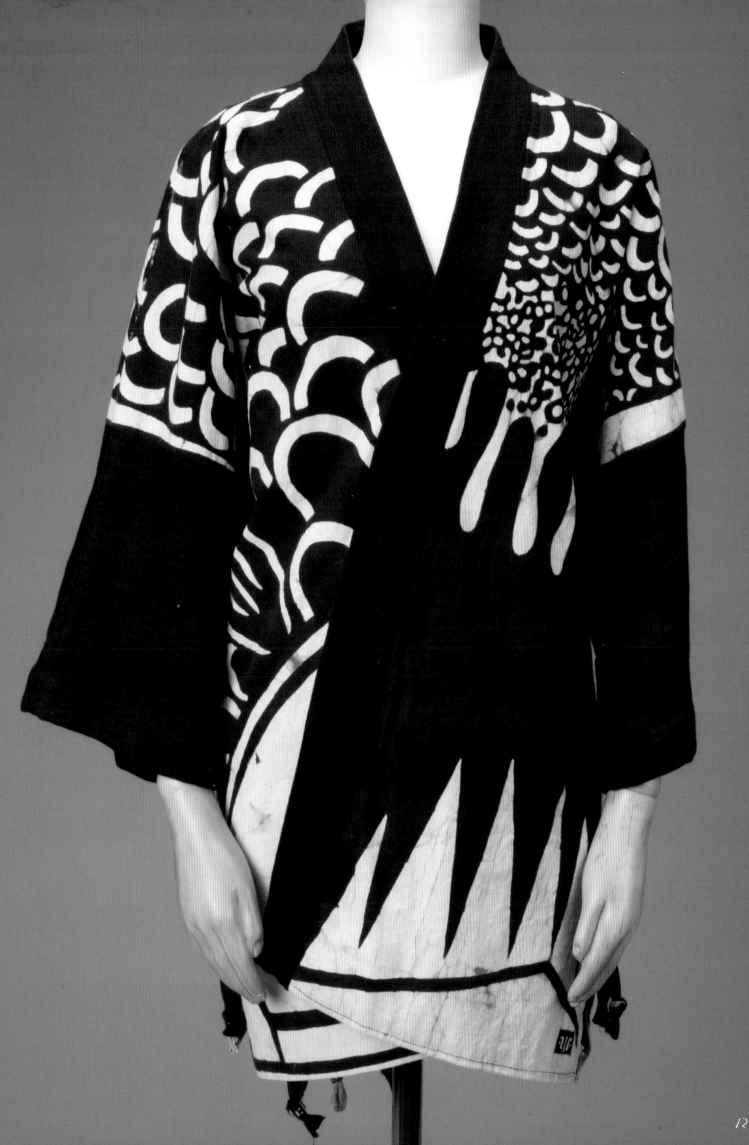

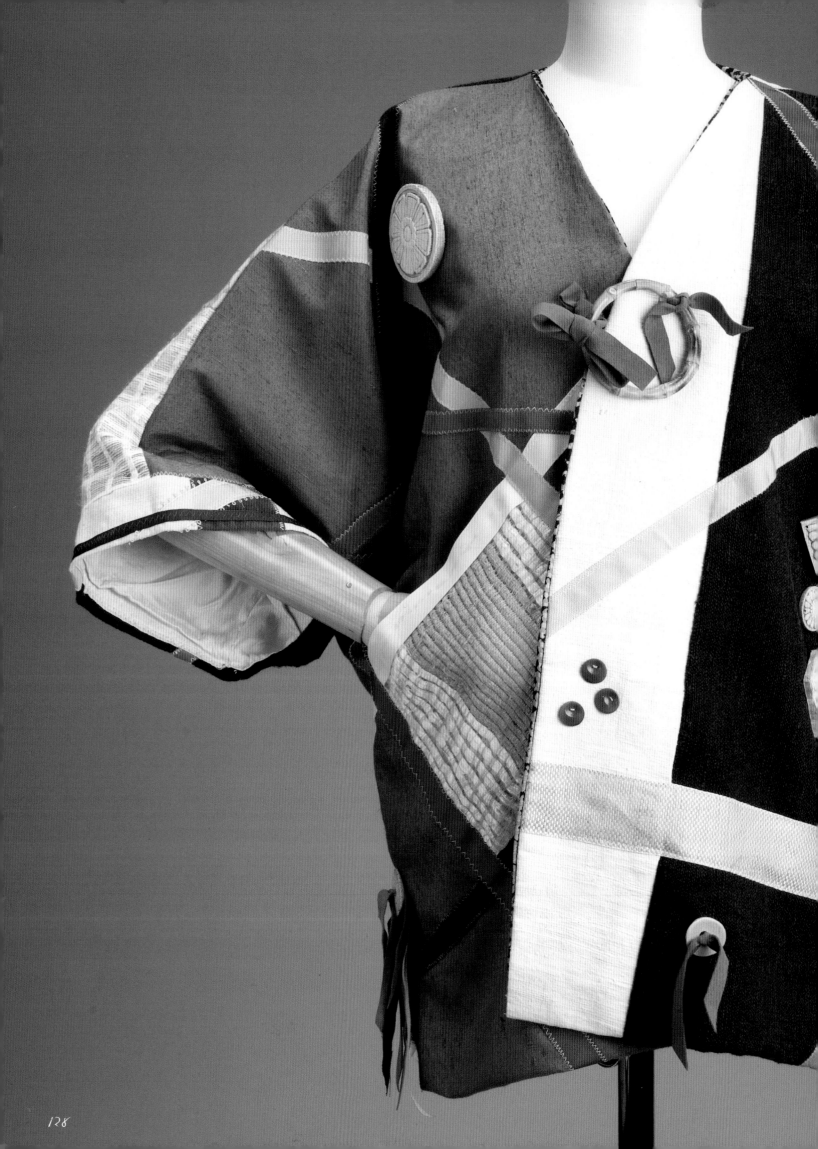

As an educator and designer, I hope students everywhere will learn from my original expressions of wearable art.

I call this my Jack Lenor Larsen jacket because it incorporates several fine samples from his designer collection of silks and cotton, assembled with various segments of cream-colored and navy blue cotton fabrics. I added wooden buttons and carved, wooden bas-relief pieces, then machine zigzag stitched ribbons and sewed clay buttons at the side slits. A natural bamboo bracelet with Ultrasuede strips creates the creative closure. The jacket lining is printed polyester.

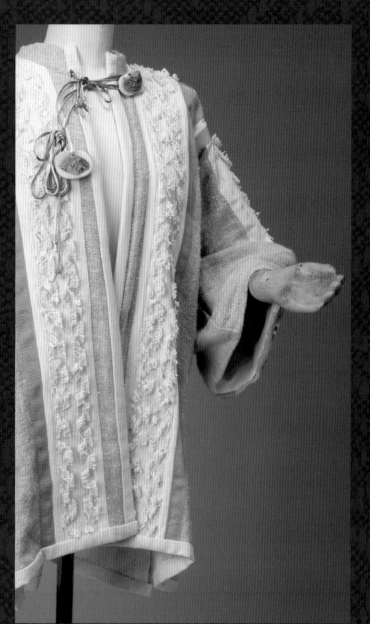

Organic material or museum-quality art objects make interesting embellishments.

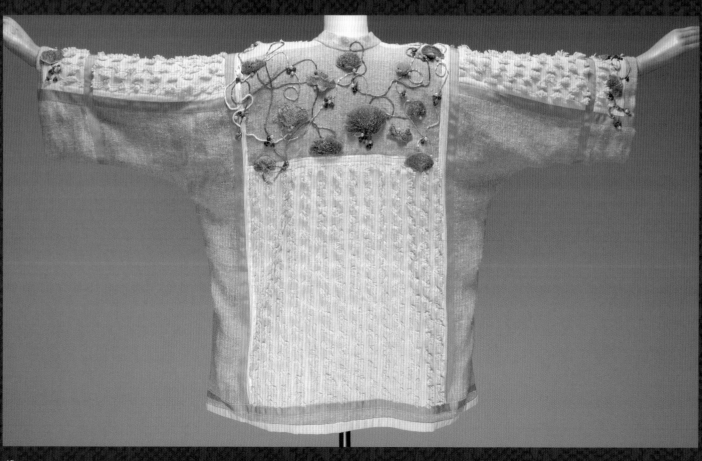

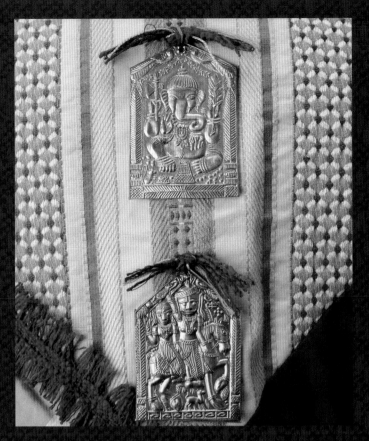

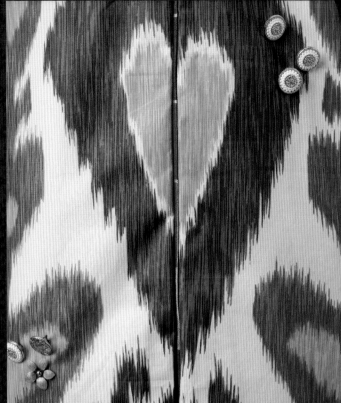

Above and right: Faux Ikat polished cotton printed in England forms the tailored jacket combined with other colorful cotton segments. I sewed fringed linen strips on the diagonal to add texture. To adorn the back, I attached detailed, pressed-brass plaques from India depicting cultural images that I bought at the Cooper-Hewitt National Design Museum in New York City. I lined the interesting collarless jacket with polished cotton plaid and used two frog closures.

Facing page: Handwoven linen trimmed in nonwoven Ultrasuede combine with cream-colored tufted cotton from India to create this unusual Chinese-style jacket with an organic feel and look. I complemented the subdued earth colors with embellishments of professionally dried shiitake mushrooms, wooden beads and rattail cord. The decorative closures were formed using Fimo polymer modeling clay. I lined the garment with American cotton fabric and handmade lace trim from Belgium. The jacket bindings and traditional mandarin collar are formed of Ultrasuede material.

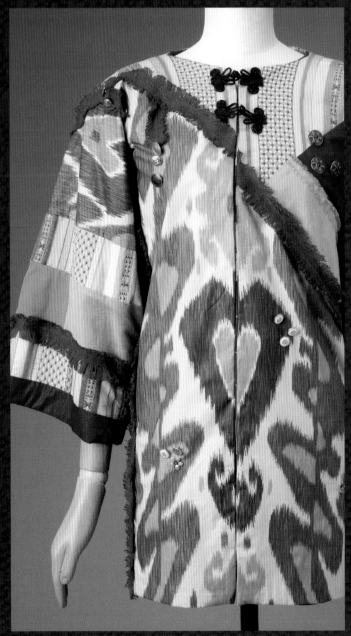

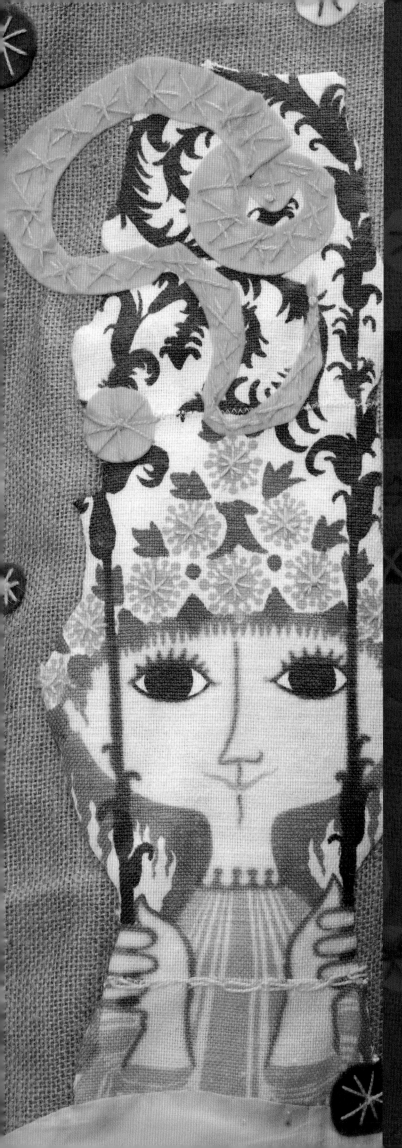

As a young student of expressionist painter Hans Hofmann, I was inspired to see in a new way. Seeing is a language, one you have to learn.

Scandinavian artist Bjørn Wiinblad's work is known the world over and I discovered the designer's screen-printed fabric of joyful figures during my trip to Denmark in the 1950s. I made the principal part of the jacket in yellow cotton burlap with assorted cotton pieces of blue, yellow and green; then I appliquéd the fabric using trapunto technique and embroidered the hand-blocked prints. Embellishments include felt circles with star-stitch embroidery and fringed burlap to edge the cotton bindings. The garment is lined in simple yellow cotton.

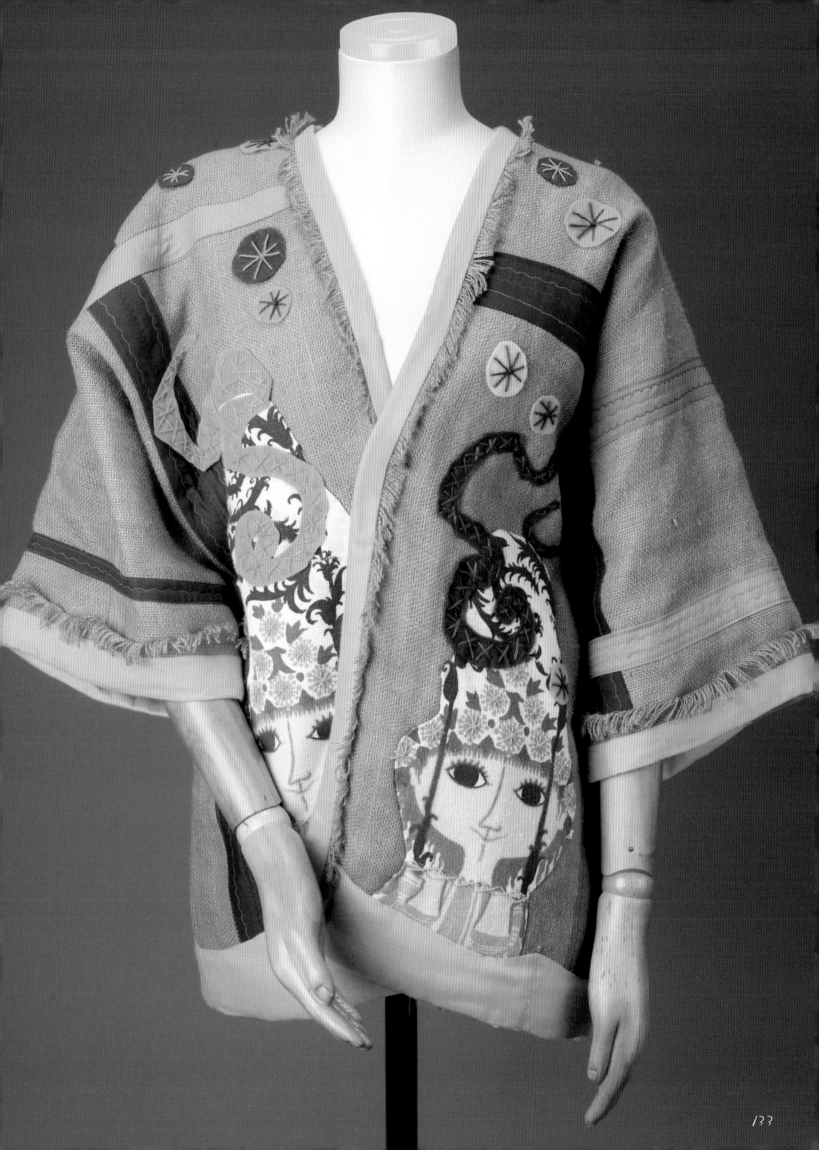

133

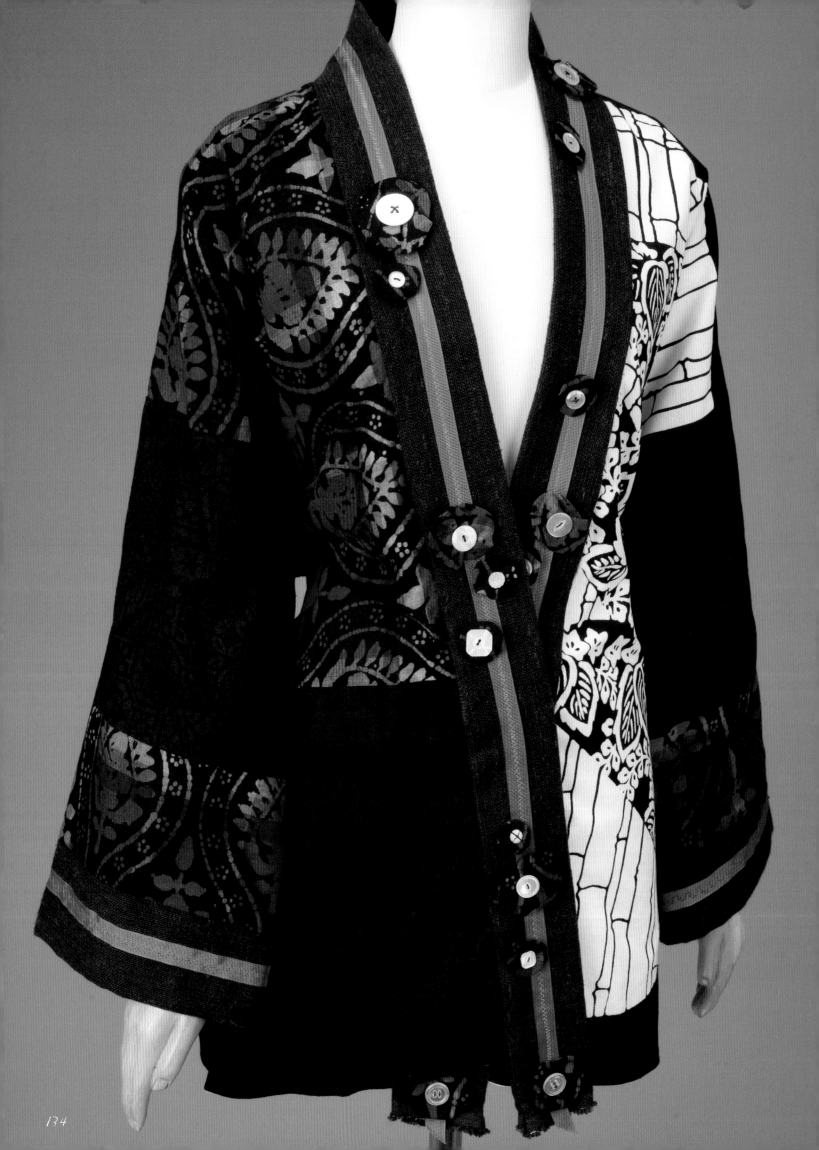

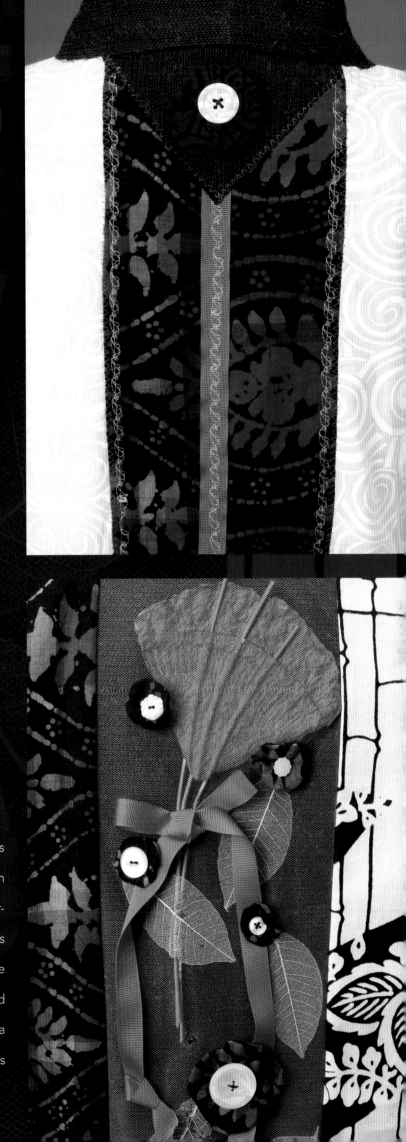

I maintain the feeling of the cloth throughout so that the assemblage becomes one seamless expression.

I used faux batik and varied American polished cotton pieces for this garment; the white and dark blue patterned cloth is part of a Japanese screen. I integrated my vast mother-of-pearl button collection into the jacket. Embellishments include ribbons, buttons, white silk leaves and one Japanese paper fan held in place by a fine-gauge netting overlay. I lined the jacket with white-on-white printed cotton and created a fabric collage strip down the inside center of the back. This jacket is trimmed in hand-woven Peruvian cotton.

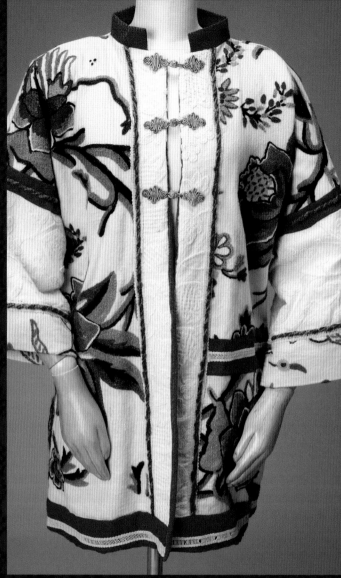

The 1,000-year-old art of exquisite crewel technique embroidery comes to life on this Chinese-style jacket with mandarin collar and frog closures. I found fragments of decorative crewelwork made of fine wool threads on linen, derived from original English designs. I combined white-on-white crewel pieces, raspberry-colored wool bands, polyester yarns, natural cotton braiding and added a yarn tassel at the top of each slit. I simply lined the piece with raspberry-colored cotton.

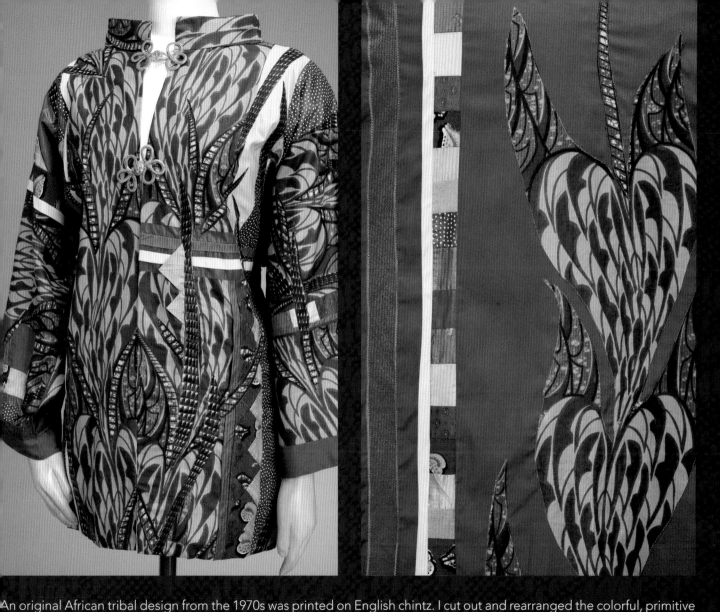

An original African tribal design from the 1970s was printed on English chintz. I cut out and rearranged the colorful, primitive patterns and strips to create this Chinese-style jacket with two frog closures. Solid green and raspberry pink polished cotton pieces are combined to create the overall effect; the lining is matching pink cotton with a collage of patterns from the same outer African fabric sewn in the center of the back. A red wooden leaf adorns the top of each side slit.

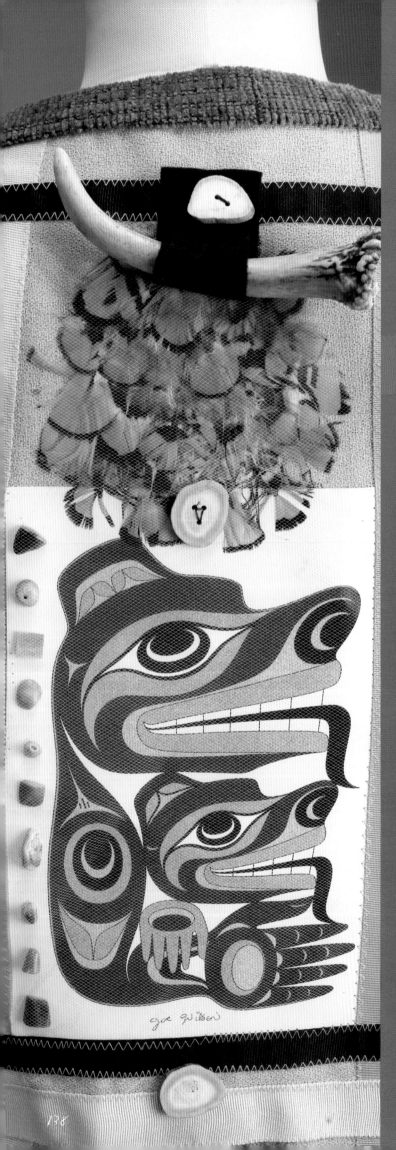

While visiting Alaska I collected small pieces of deer horn, buttons and local artifacts. I made a coat inspired by this unforgettable and introspective trip.

After my Alaskan cruise, I felt the urge to create this jacket, which incorporates a deer antler and sliced horn pieces, feather strips, beads, ribbons and ringed cowrie shells. I sewed a Joe Wilson print on paper held with fine-gauge netting to the back of the textured polyester garment, creating golden feather collages above and below. The jacket is trimmed with no-wale corduroy bindings; I added triangles and strips of brown felt details. Dangles of beads, feathers and shells are attached above side slits and the front hem.

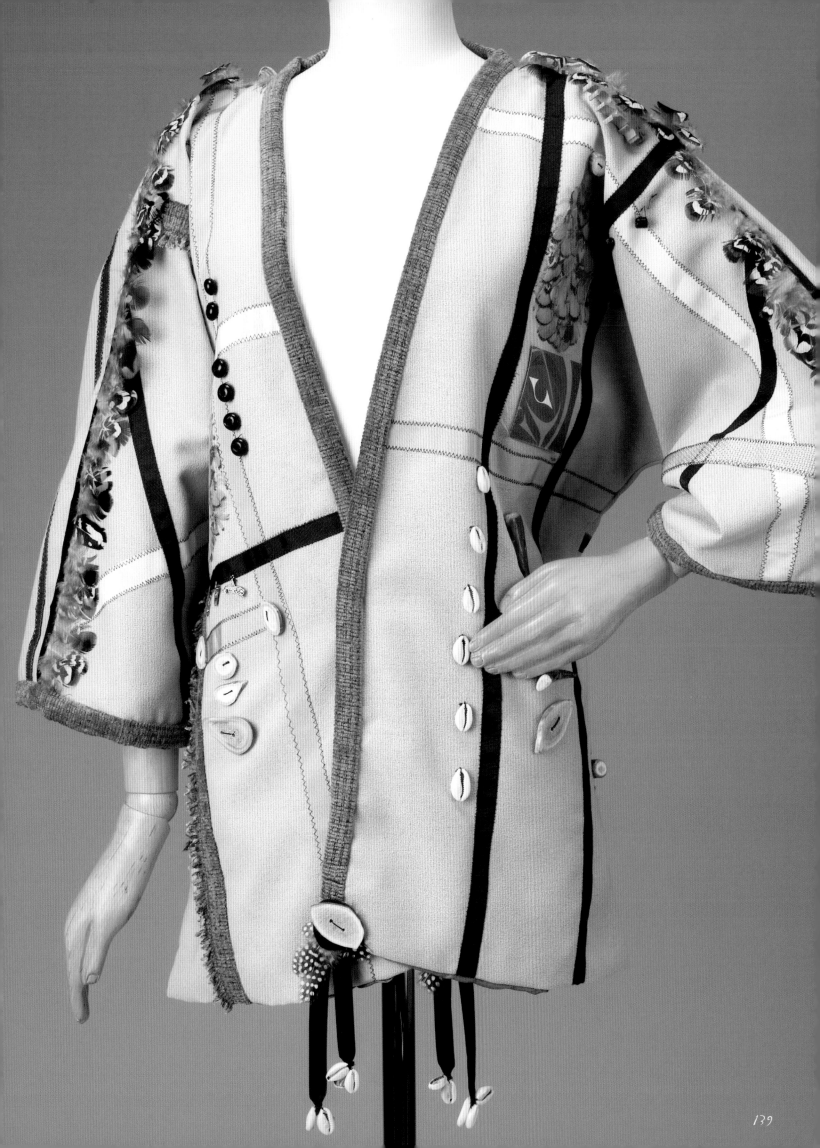

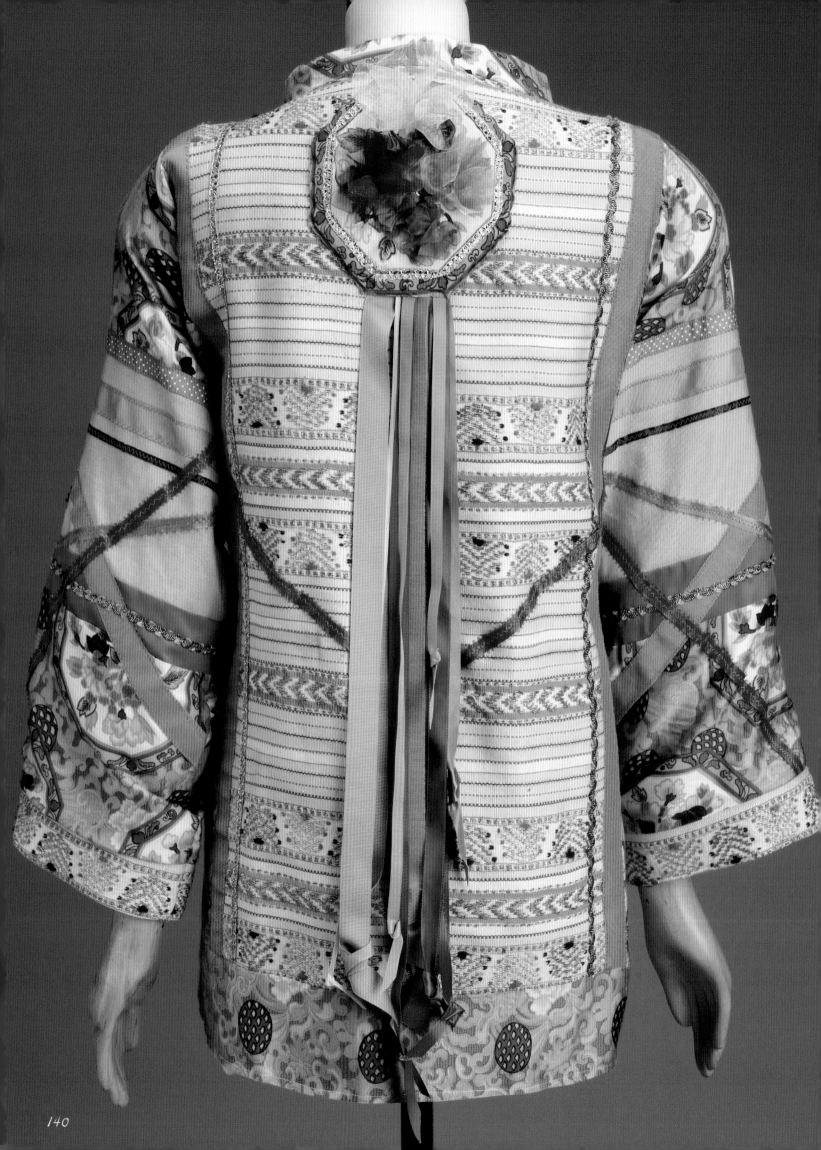

I visited a Yugoslavian marketplace where young people were selling folk embroidery pieces with little awareness of their value. Ever since, I have made a point to incorporate handmade textiles in my wearable art.

My festive Chinese-style jacket with mandarin collar features yellow and hot pink handwoven cotton pieces that I purchased in Yugoslavia. Printed silk from my thrift shop dress goes perfectly with the color scheme to form sleeves and hem banding. The back of the jacket has a centerpiece bouquet of cut and gathered fabric flowers and thin, knotted ribbons as streamers. I lined the piece with lemon yellow vintage linen tablecloth fabric, then added an interior fabric collage and puff decorations.

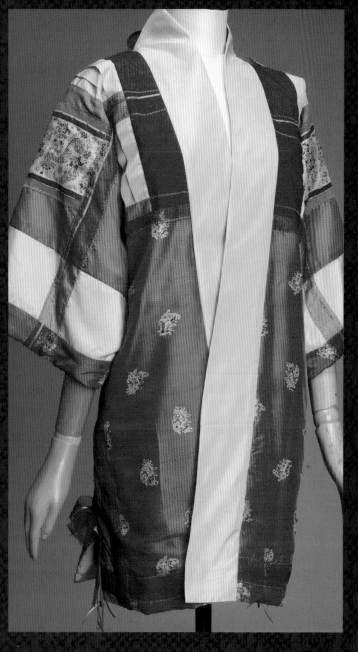

My attention to detail is a discipline. My artistic expression is intuitive.

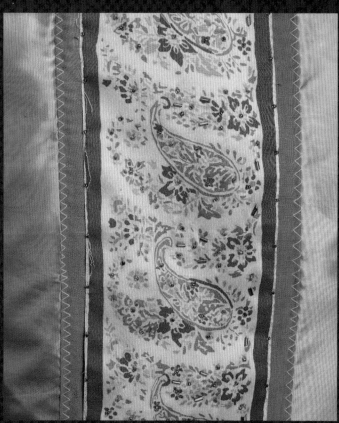

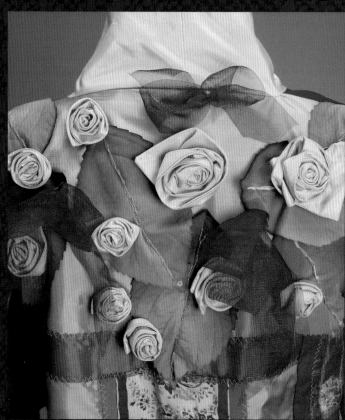

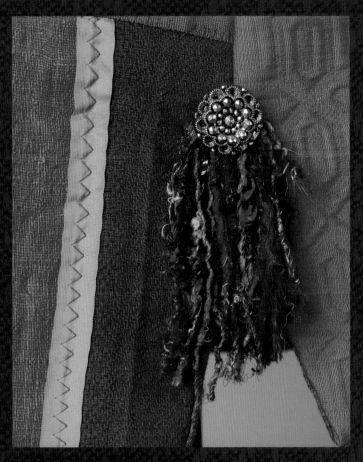

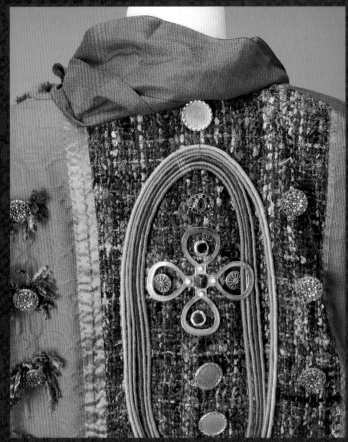

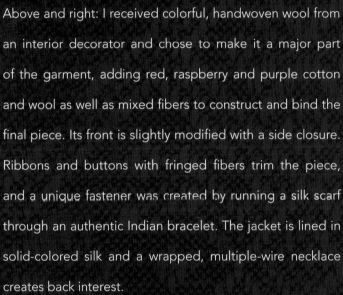

Above and right: I received colorful, handwoven wool from an interior decorator and chose to make it a major part of the garment, adding red, raspberry and purple cotton and wool as well as mixed fibers to construct and bind the final piece. Its front is slightly modified with a side closure. Ribbons and buttons with fringed fibers trim the piece, and a unique fastener was created by running a silk scarf through an authentic Indian bracelet. The jacket is lined in solid-colored silk and a wrapped, multiple-wire necklace creates back interest.

Facing page: A vintage dress from the 1960s became my inspiration for a new garment construction. Various shades of pink and moss green silk with a rich sheen and fine, floral paisley embroidered segments are integrated into this feminine composition. I adorned the piece with color-coordinating beads, sheer ribbons, pink silk roses and large silk leaves on the back. This kimono-style jacket is lined in green silk and each side slit is decorated with a single silk rose and satin ribbons.

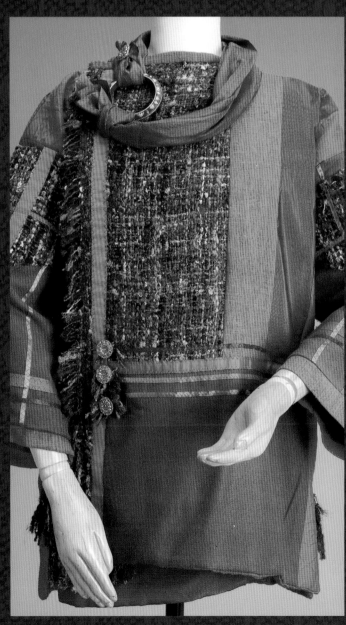

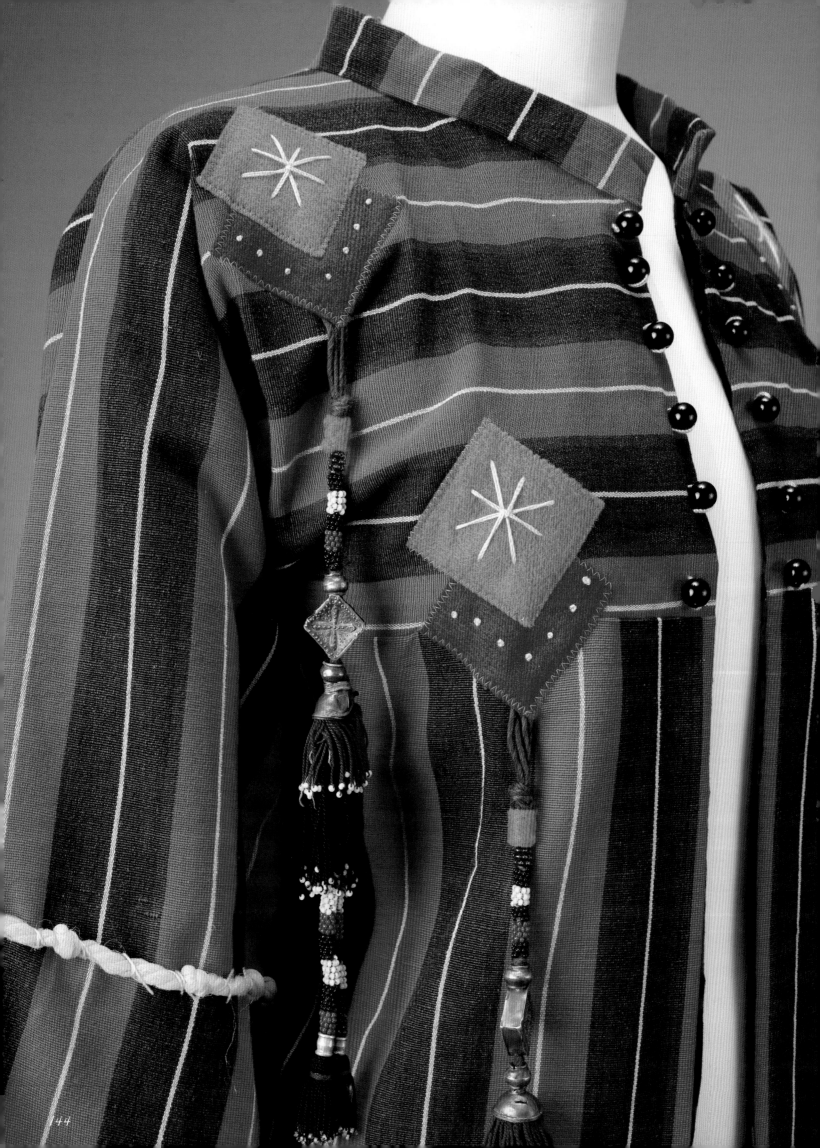

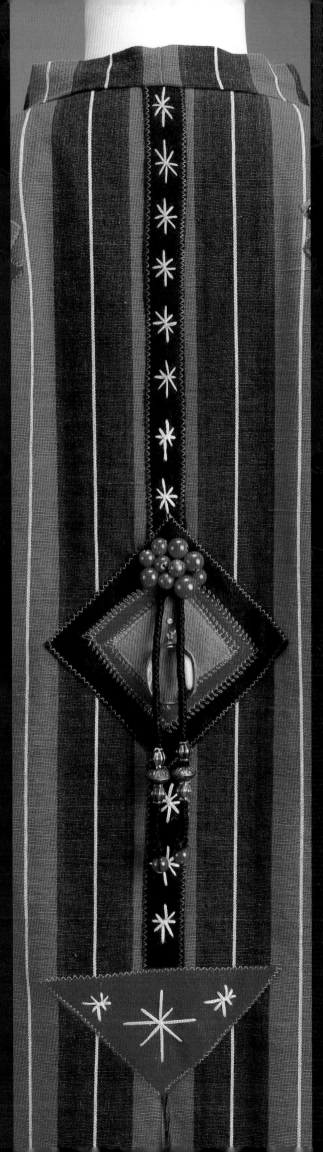

Hand-sewn touches unite multicultural textiles and embellishments.

This creation features striped cotton denim from India. I embellished the garment with buttons, wooden beads, felt diamond and triangle shapes with a center strip down the back trimmed with my cotton floss, hand-embroidered star stitches. The embellished garment design showcases several silk-and-beadwork, 19th-century Turkoman camel tassels made by Afghan tribesmen. I modified this Square-Cut Jacket to have slightly shorter sleeves and a V-pointed bottom hem accented with my own handmade tassels. The jacket is lined in faux cotton batik fabric.

Everything you experience becomes you. That is what makes us individuals.

My Panamanian friend gave me a large antique mola with an intricate, reverse appliqué bird-in-flight design that inspired this piece. Small butterfly and bird molas are attached to the front of the blue denim construction, framed with strips of colored cotton in green, yellow, purple and blue. Bright yarn tassels enhance the jacket and reflect the color scheme, while shoulders display my star-stitch hand embroidery. A friend gave me a small pewter figure from Mexico that accents the back of the neck. The lining is dyed multicolored cotton in keeping with the Latin American cultural influence.

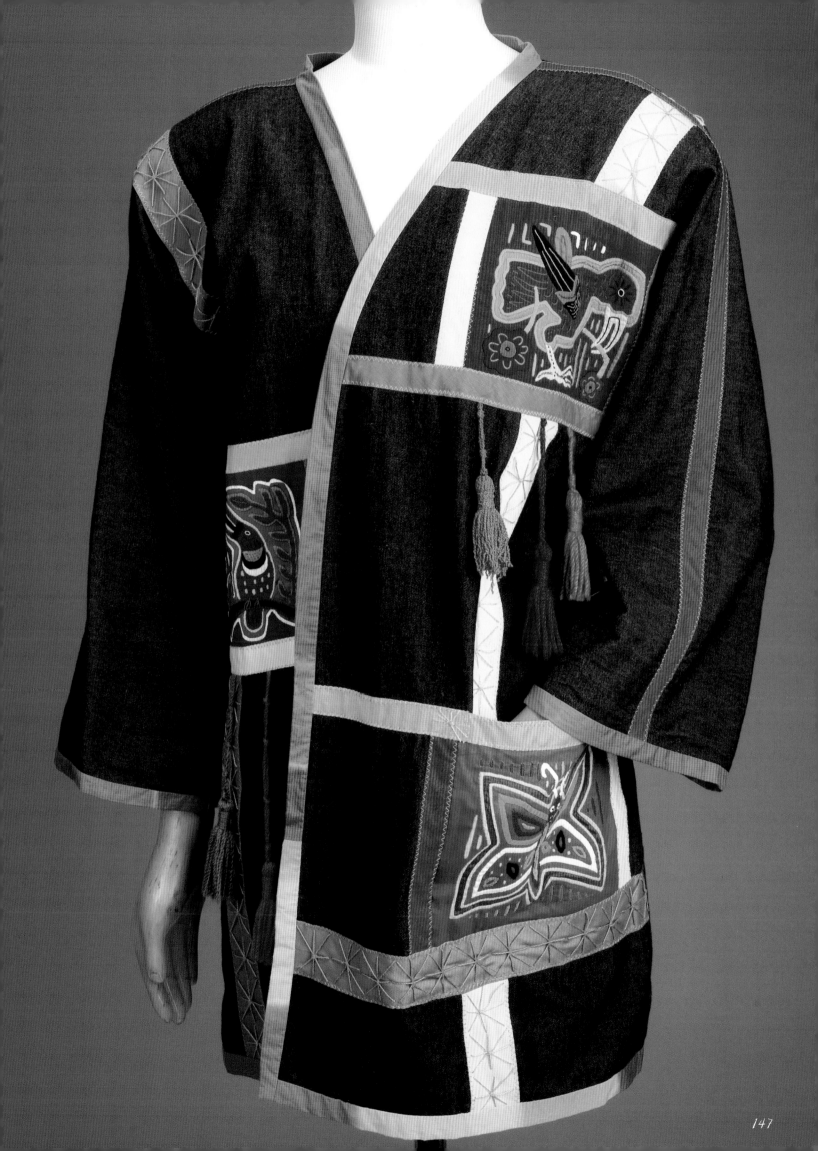

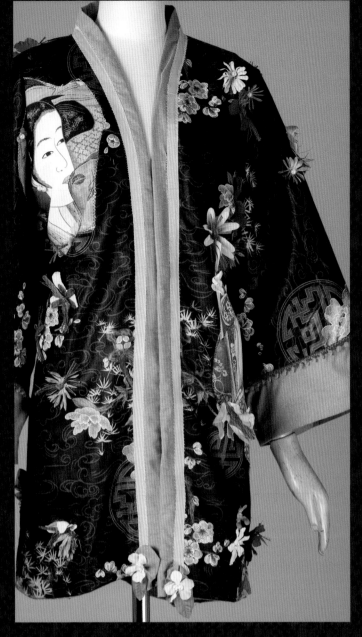

Textile construction and decoration techniques have geographical and cultural roots.

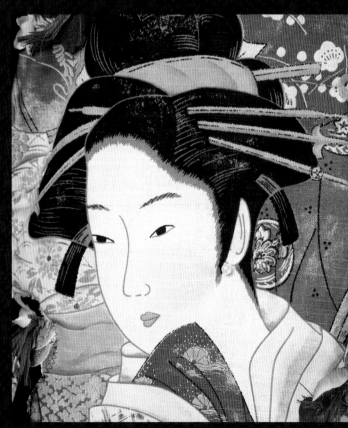

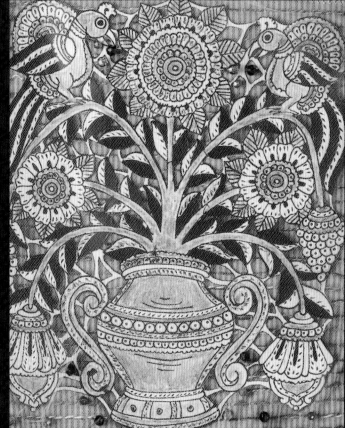

Above and right: Harmonious salmon hues of printed cotton from England combine to form a sophisticated kimono jacket. I often use the fabric's "wrong side" to create a textural effect and show off the handwoven threads of the reverse. My peachy rose-toned jacket back features one buffalo skin piece from Thailand under netting embellished with beads. I hand-colored the black outlined flower basket design with crayons to unify the color scheme. Bindings are printed peach cotton. The back and side slits are accented with braiding, fabric puffs and my handmade tassels.

Facing page: I appliquéd Japanese Geisha faces cut from a small piece of printed cotton onto a larger Oriental print fabric to lend an air of mystery. Geisha are professional female entertainers who perform traditional Japanese arts. My kimono-style jacket has banding of pink and blue cotton with tiny ball fringe trim at the sleeves. The garment is lined in blue cotton, and the center back strip is designed from small fragments of the original printed piece. Silk flowers, beads and red raffia ties randomly adorn the jacket.

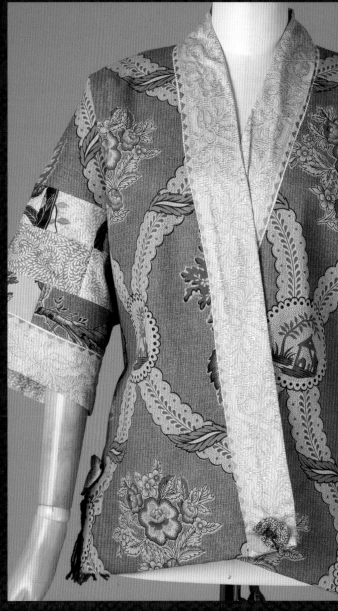

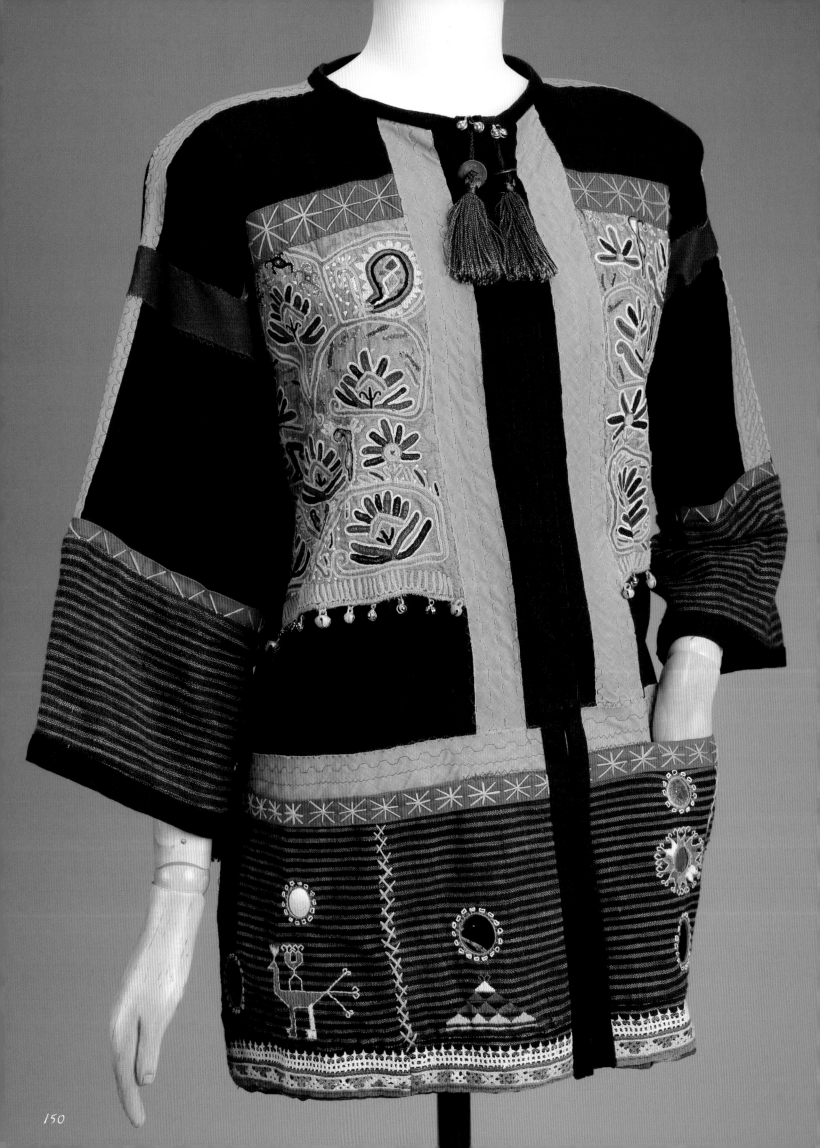

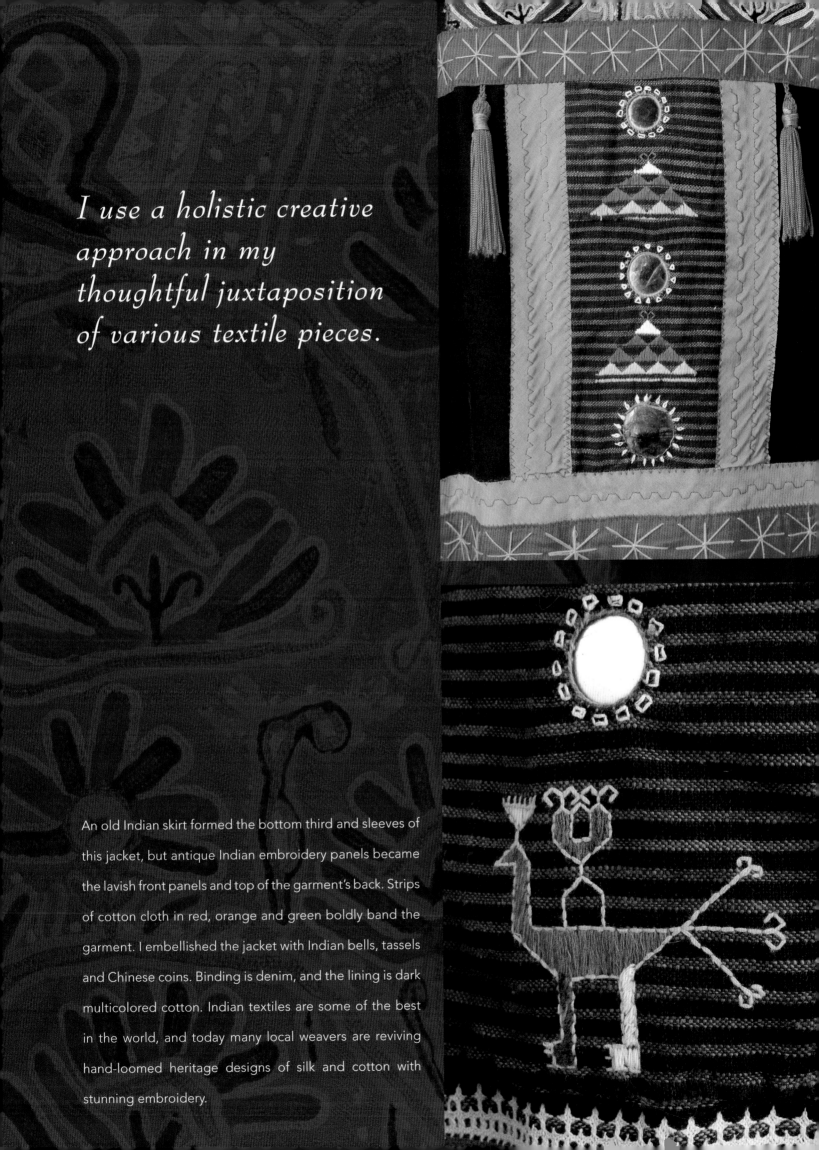

I use a holistic creative approach in my thoughtful juxtaposition of various textile pieces.

An old Indian skirt formed the bottom third and sleeves of this jacket, but antique Indian embroidery panels became the lavish front panels and top of the garment's back. Strips of cotton cloth in red, orange and green boldly band the garment. I embellished the jacket with Indian bells, tassels and Chinese coins. Binding is denim, and the lining is dark multicolored cotton. Indian textiles are some of the best in the world, and today many local weavers are reviving hand-loomed heritage designs of silk and cotton with stunning embroidery.

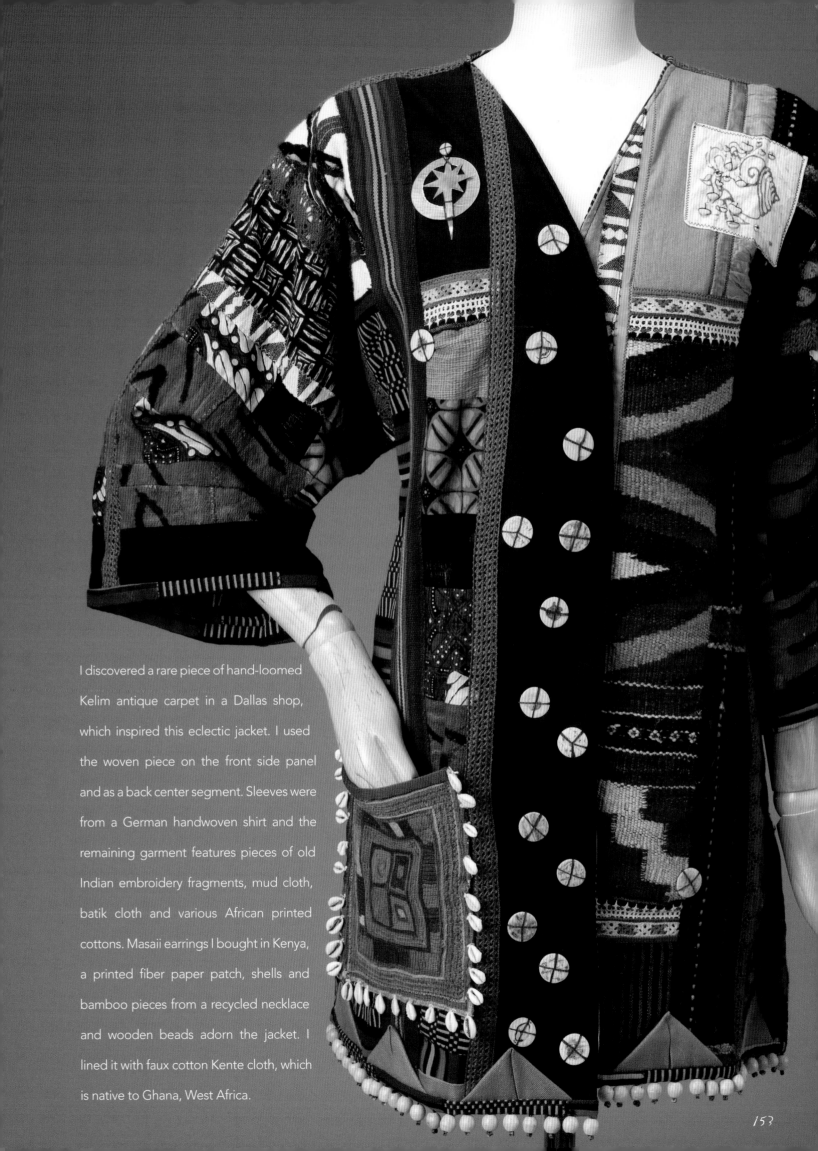

I discovered a rare piece of hand-loomed Kelim antique carpet in a Dallas shop, which inspired this eclectic jacket. I used the woven piece on the front side panel and as a back center segment. Sleeves were from a German handwoven shirt and the remaining garment features pieces of old Indian embroidery fragments, mud cloth, batik cloth and various African printed cottons. Masaii earrings I bought in Kenya, a printed fiber paper patch, shells and bamboo pieces from a recycled necklace and wooden beads adorn the jacket. I lined it with faux cotton Kente cloth, which is native to Ghana, West Africa.

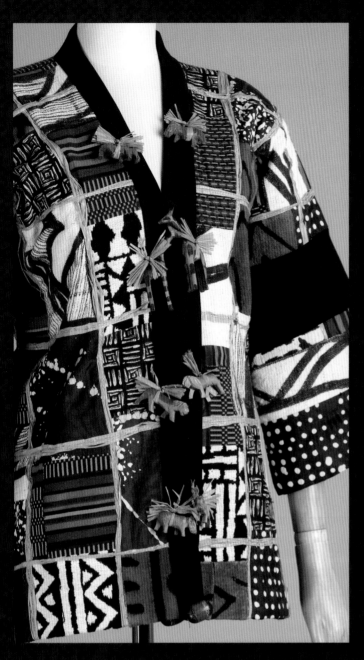

Left and below: A blend of African cloth creates a primitive expression. My trips to Kenya have always inspired me. The back of the Square-Cut Jacket features a genuine Senufo Tribe handwoven, hand-painted cotton piece with dramatic stylized gazelles. African mud cloth segments outlined with raffia trim form the jacket front and sleeves. I embellished the garment front with small carved wooden safari animals and a large wooden neck bead at the back of the neck. Each slit is adorned with a carved zebra-striped bracelet tied on with raffia. Imitation woven Kente cloth lining completes the jacket; Kente comes from the word kenten, which means basket.

Facing page: Black nonwoven felt is the main fabric used to create my shorter Square-Cut Jacket construction. The center back of the garment showcases an exquisite Indian pillow cover with beads, sequins and braided ball fringe. Shisha mirrors and a decorative medallion are sewn on for accents. Brass buttons with loop closures hold colorfully painted papier-mâché bracelets in two rows down the front red felt banding. Gold braid delineates the sleeve, neck and hem bindings with a dash of elegance.

When you touch an
ancient cloth, you can feel
the pulse of the people
who made it.

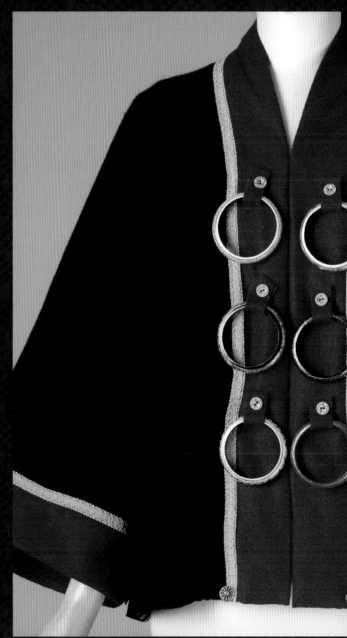

"There are two ways of spreading light; to be the candle or the mirror that reflects it."

—Edith Wharton

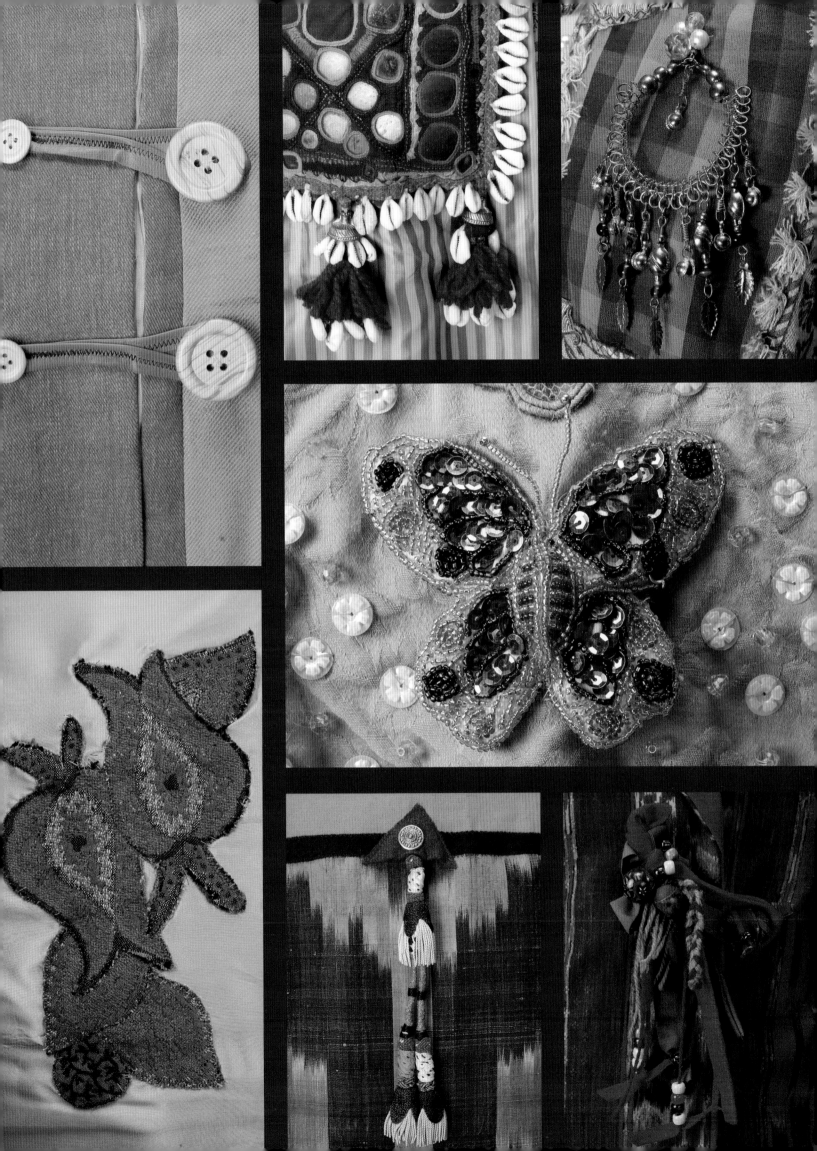

Chapter Three
The Long Coat
Textiles take form on a universal pattern

The earliest coats ever created were seamed, fitted and made in Persia. But the English began to make tunic-like coats out of metal rings for men during the Middle Ages. By the 18th century overcoats had begun to outnumber capes and cloaks as outerwear, and by the mid-20th century the terms jacket and coat became one-in-the-same for modern styles. Historically, the first coats were designed for men; but it was not until the late 1800s that coats became an acceptable part of a woman's wardrobe in many cultures.

My long coats are derived from the universal Square-Cut Jacket pattern, with a few designed using an authentic Turkish Coat pattern from a well-known folklore costume company. Many ethnic coats were designed to be cut and pieced together out of necessity, as handwoven textiles were often only 14 inches wide. For example, construction of the traditional Japanese kimono was a collage of smaller silk segments. Artisan looms were not built to create wide pieces of fabric as modern looms are today.

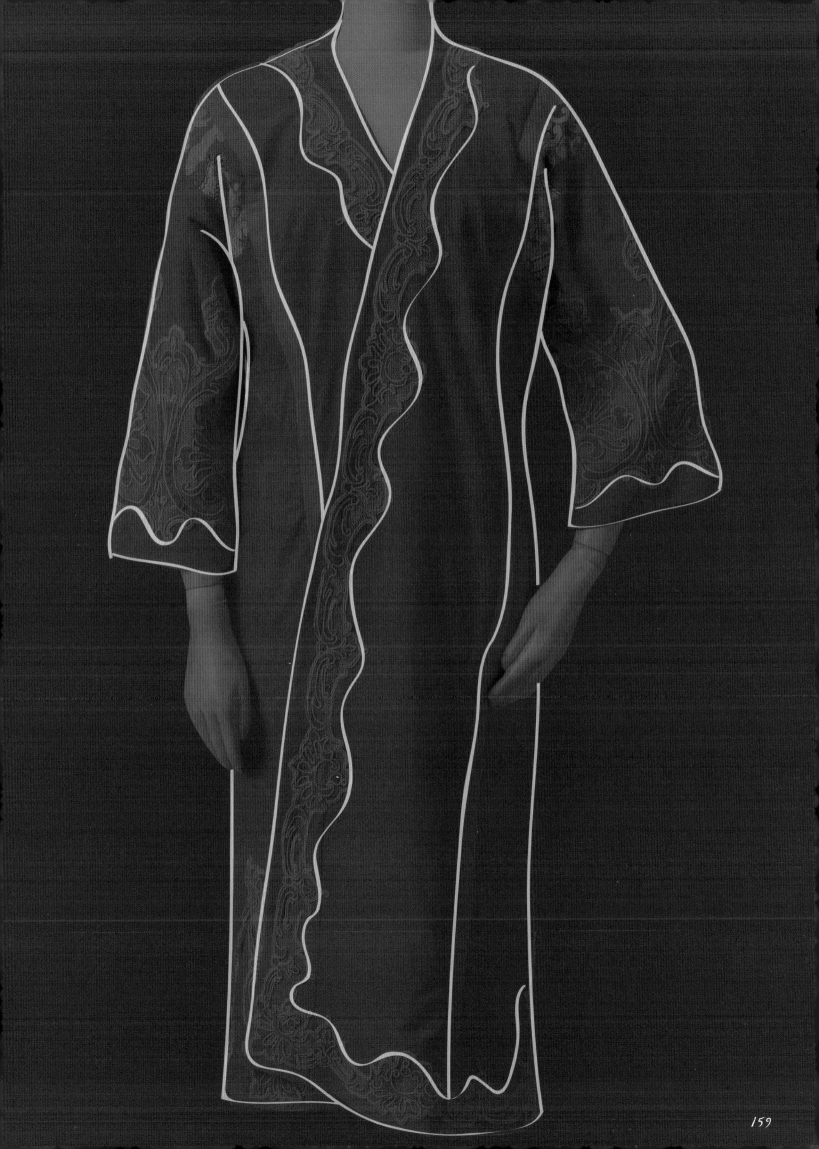

Sewing coats into wearable art is an artistic challenge, like putting pieces of a puzzle together. The cloth leads the way to an original design. Each of my long coat creations uses approximately five yards of fabric and easy straight machine seams. I choose silk, cotton, wool and linen to make full-length garments that hang softly and really showcase the fabric. I always embellish the back of each Straight-Line Long Coat to reflect the spirit of the piece, just like I do on my Othello Coats and Square-Cut Jackets.

This coat style is a modified, longer version of my jackets, measuring up to 57 inches from shoulder to hem with long sleeves, and meant to wear over coordinating pant outfits. I have exhibited a selection of my more dramatic pieces in galleries and worn them on formal occasions or for warmth during cooler months. My African- and Turkish-inspired coat designs are often collarless without closures, very similar to opera coats, impressive by their extra length alone. A few coats have stand-up and rounded collars or simply colorful bindings. Buttons, frogs, hook-and-loop fasteners and toggles were customarily used on coats in the past, but some of my designs are free to hang straight or overlap slightly like a wrapped stole.

A favorite of quilters and clothing artists, the Straight-Line Long Coat pattern has allowed me to showcase many unique, larger textile pieces that I have collected through world travels or were given to me by designer friends. Short jacket or long coat, creating wearable art is a joy.

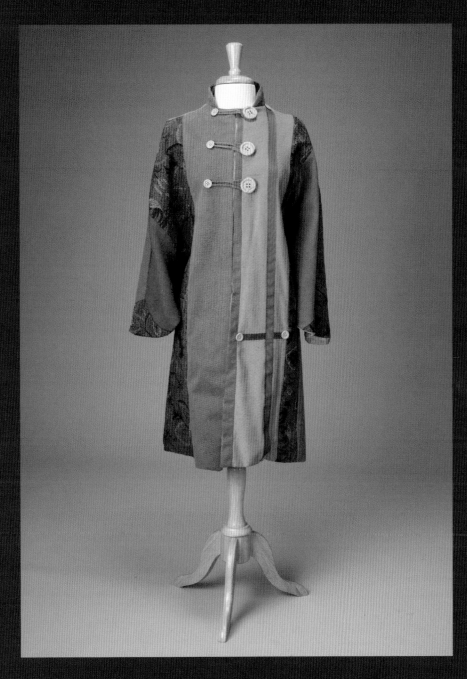

The straight lines of the long coat allow for optimal creativity.

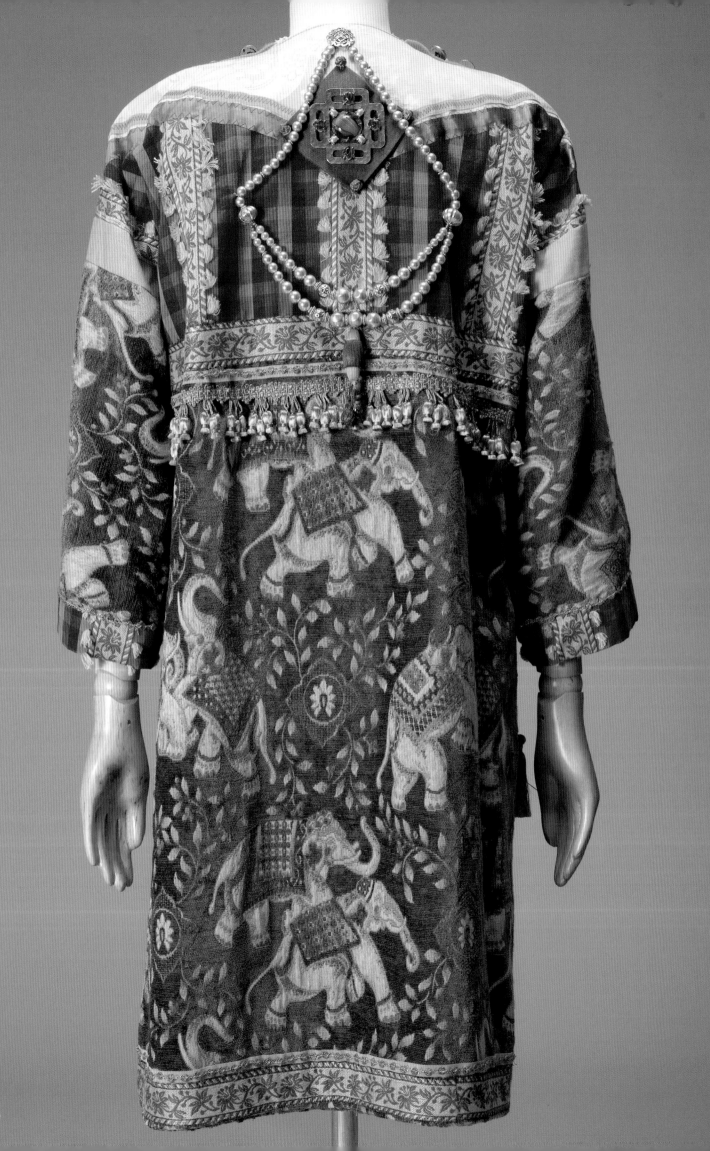

My wearable art combines cloth from varied ethnic roots, which speaks to our diversity and unity.

I named this square-cut, straight-line garment my elephant coat. The main part of the coat is made of plush emerald green and gold cloth from England, which I think gives it a regal Indian feeling. I acquired the cloth from an interior designer friend. The subtle red plaid top section is French cotton and the coat's lining is apricot-colored silk and lace. To embellish the front, I attached dangling earrings from India. The coat back features 1930s costume jewelry, embroidered braid, beads and tasseled upholstery fringe. For closures, I used two golden Chinese frog fasteners that I bought in Shanghai.

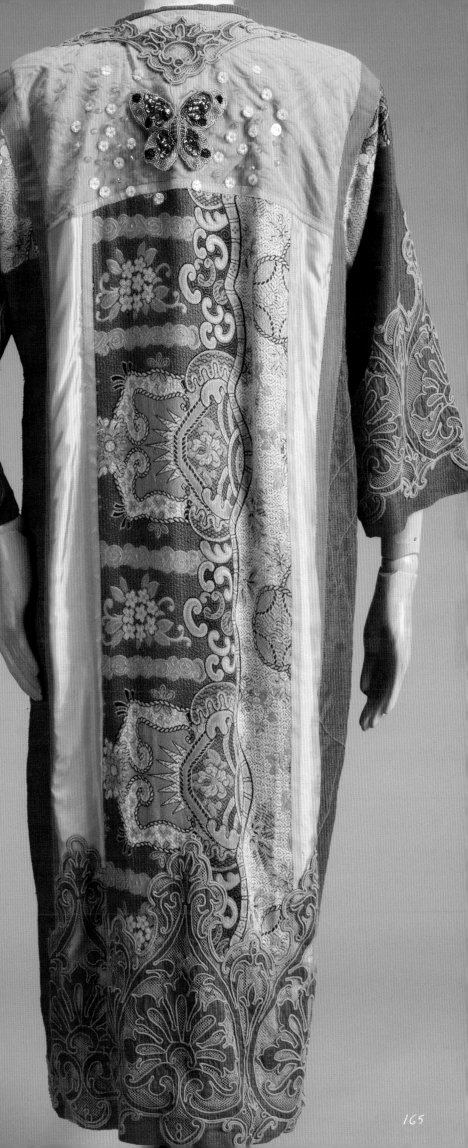

I've had a true love affair with textiles from all over the world.

The Turkish coat pattern was perfect for creating this heavy-weight red silk garment; I used the double-needle technique for added texture. Its stunning back centerpiece is archival quality, antique 19th-century Franco Scalamandré silk. The handmade braid on netting is from a house in France—part of café curtains made of pongee silk that deteriorated long ago. I repurposed it as decorative trim. The art of lace-making hearkens to the 15th and 16th centuries; the meticulous needlework is formed by intricate openwork patterns of thread. I hand-stitched the recycled lacework to trim the front, neck, sleeves and hem. My mother's beaded butterfly adorns the back with ribbon, sequins and fine-gauge netting holding it in place.

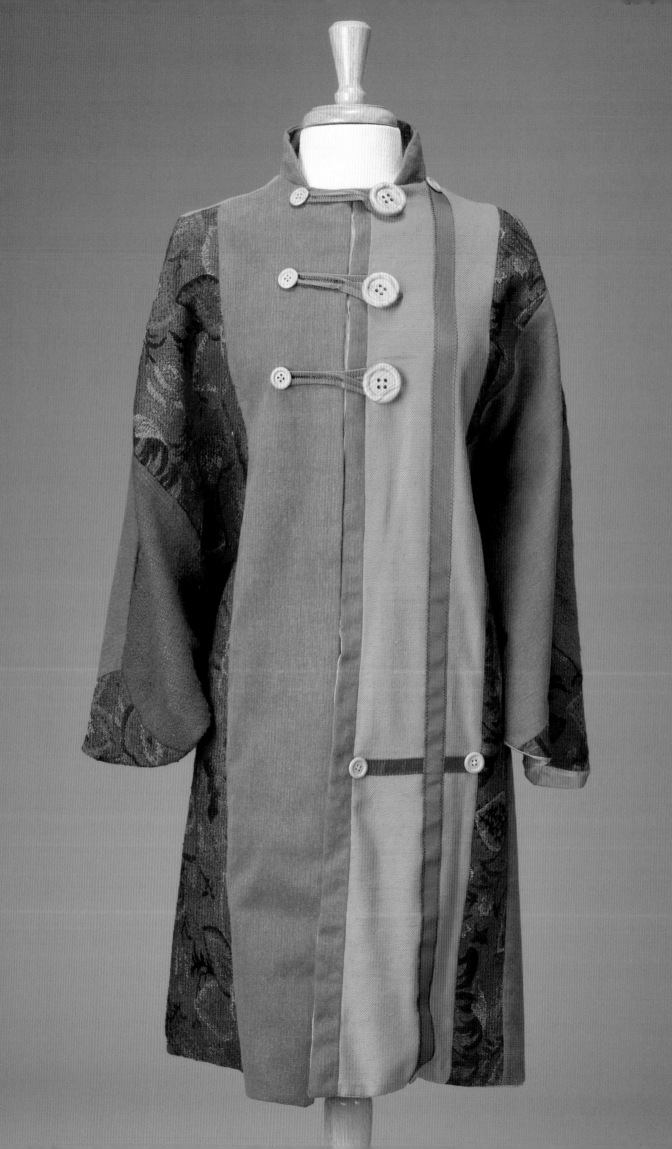

My unique art of garment-making reflects the fabric of our lives, past and present.

Inspired by an authentic Native American cape that I discovered in New Mexico, I cut the garment apart and adapted it to create my coat design with a stand-up collar. Vertical segments of handwoven linen, solid orange twill, red printed woven wool, and gray-green dyed, coarsely woven Osnaburg cotton are juxtaposed. A dash of royal blue grosgrain ribbon and bright blue handwoven nubby linen from Austria unify the piece. Wooden buttons keep the cape-like sides closed, while orange leather loops and natural wooden buttons became the coat's front fasteners. Appliquéd orange taffeta lining completes the garment.

167

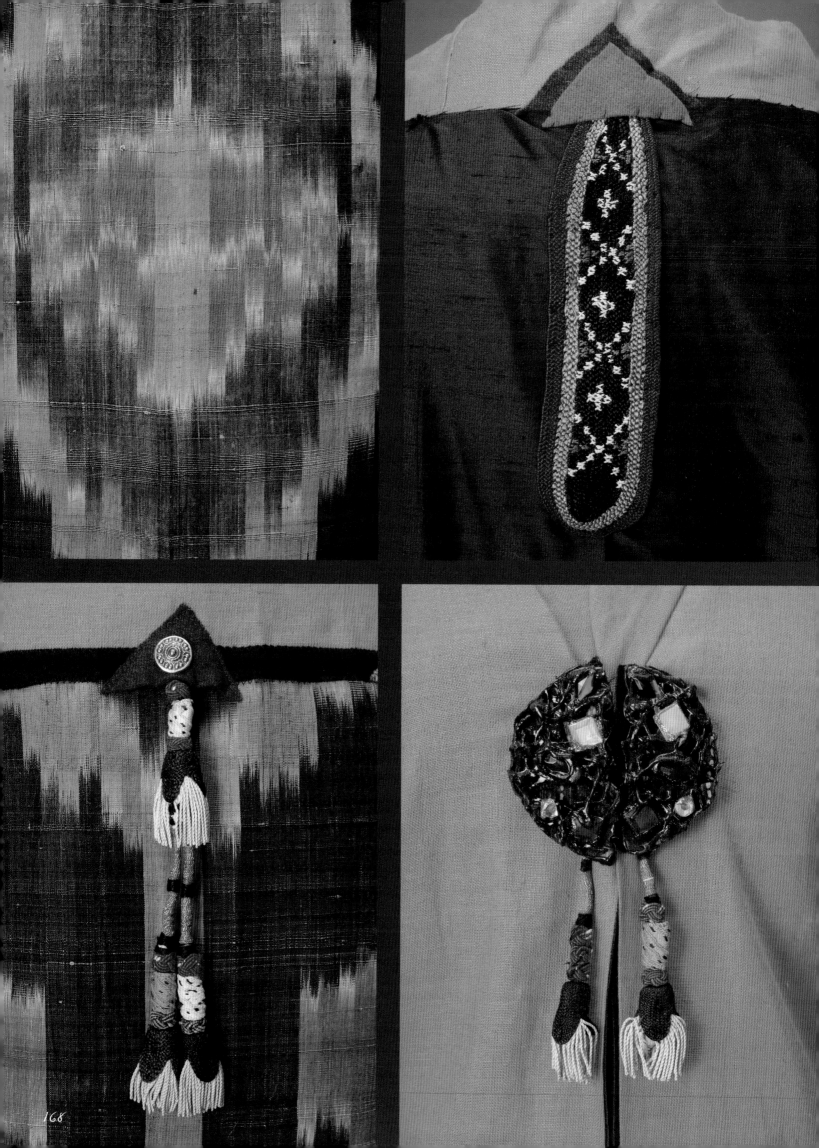

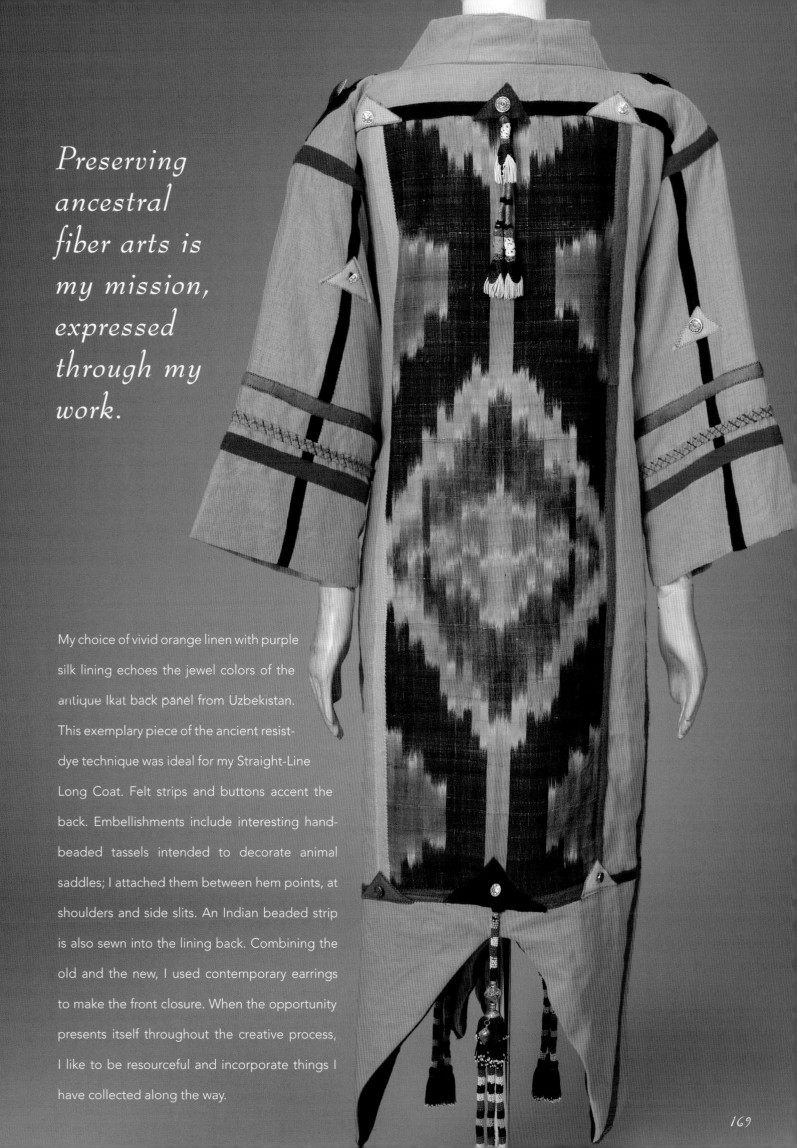

Preserving ancestral fiber arts is my mission, expressed through my work.

My choice of vivid orange linen with purple silk lining echoes the jewel colors of the antique Ikat back panel from Uzbekistan. This exemplary piece of the ancient resist-dye technique was ideal for my Straight-Line Long Coat. Felt strips and buttons accent the back. Embellishments include interesting hand-beaded tassels intended to decorate animal saddles; I attached them between hem points, at shoulders and side slits. An Indian beaded strip is also sewn into the lining back. Combining the old and the new, I used contemporary earrings to make the front closure. When the opportunity presents itself throughout the creative process, I like to be resourceful and incorporate things I have collected along the way.

169

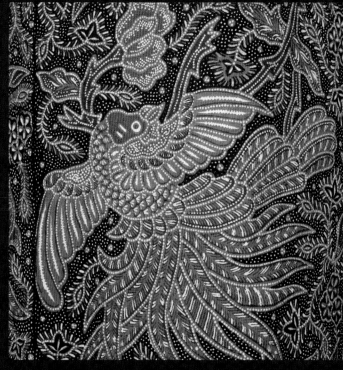

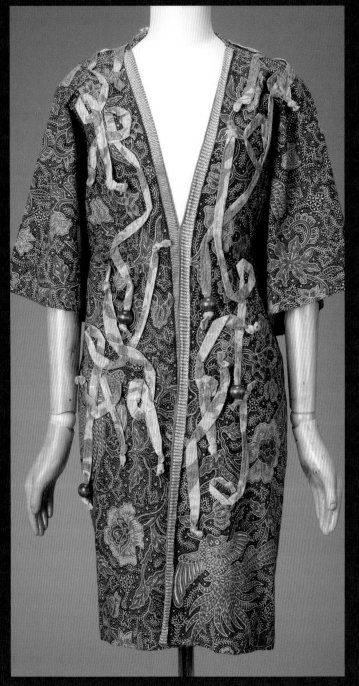

Left and above: I found this wonderful batik cotton piece from Malaysia in a Florida art museum and it became the basis for a long coat design. The floral, leaf and bird fabric pattern is so detailed that it required little embellishment. As an eye-catching accent, I chose yellow and orange Pierre Frey cotton fabric from Paris to form long fabric tubes with big wooden beads at the ends and sewed them to the front and back of the garment in ribbon-like forms. Pierre Frey was founded in 1935 as a French maison de luxe—a luxury fabric and furnishing design house. I have worn this striking straight-line coat over one of my matching pant outfits to fundraising events and received many compliments.

Facing page: Genuine cotton batik from Malaysia with its intricate repeat diamond and floral pattern and rich color scheme was natural for me to envision as a straight-cut coat construction. I trimmed the piece with dozens of slim satin ribbons tied with round wooden beads for colorful texture and interest. Shorter, elbow-length sleeves are modified for hotter weather. The garment has no closures; its bindings are simply outlined with a trio of ribbons in blues, purple and red. The coat is shown wrap-style in front, but it was designed to hang straight, free from the body.

*With gratitude I make
each garment, thinking of
those who have spun and
woven, drawn and dyed,
designed and printed to
create such glorious cloth.*

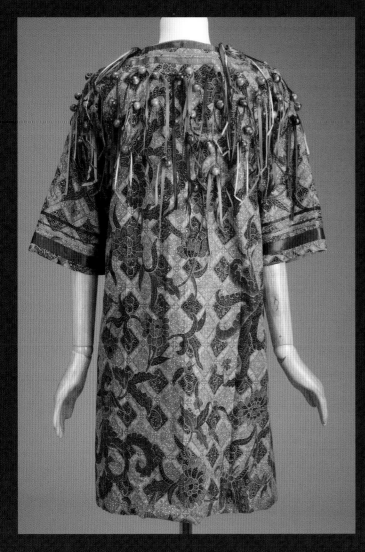

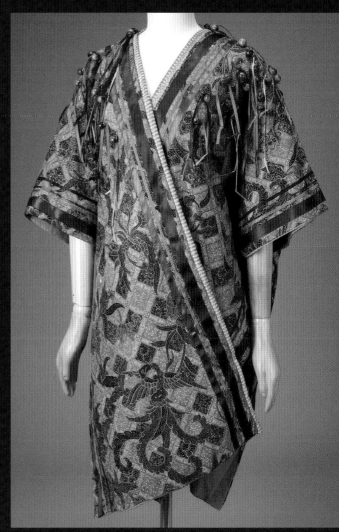

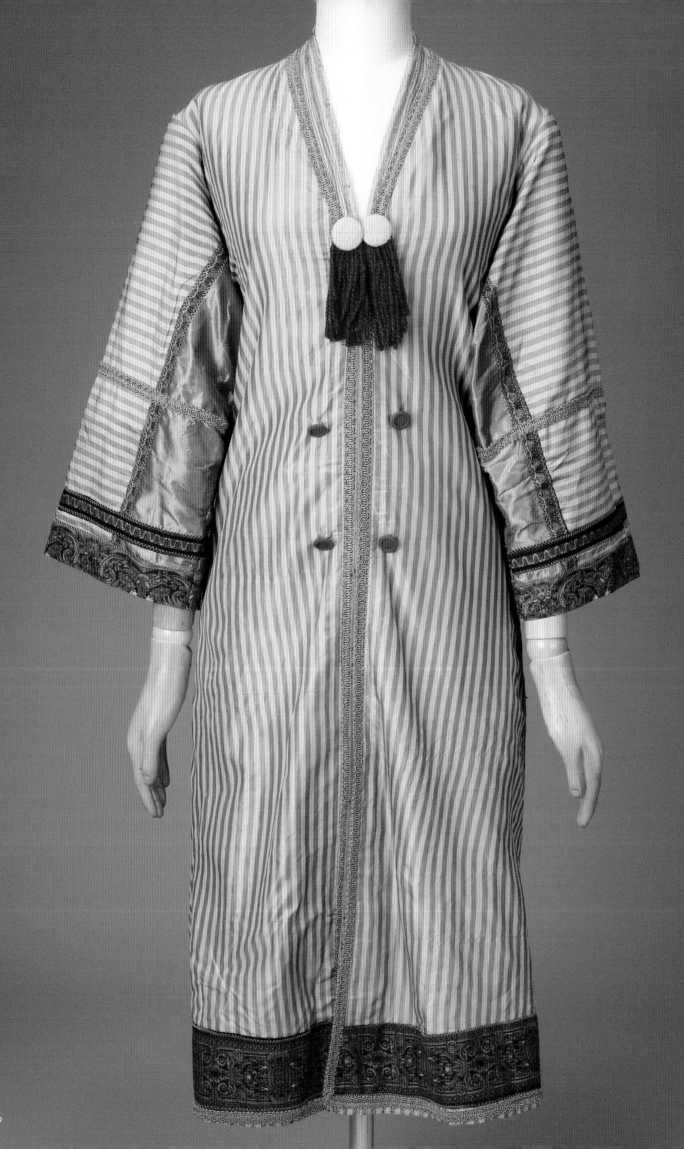

My life's work pays homage to textiles from humble woven cotton to the most resplendent silks.

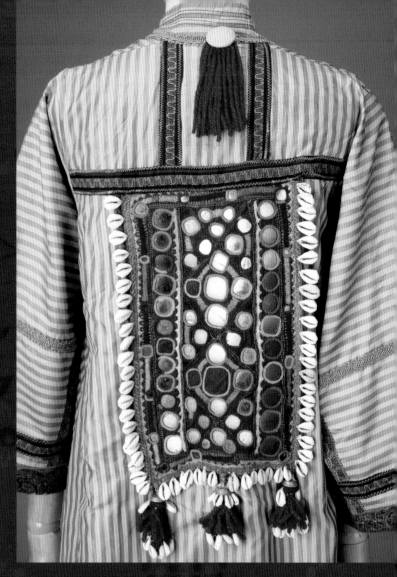

I adapted a fascinating Middle Eastern 19th-century silk ankle-length coat from Afghanistan, most likely from the Pashtun tribe. Their garb speaks to heritage, rather than religion or ceremony. The colors and patterns reflect specific tribes, much as Scottish tartans speak of distinct clans. First, I widened the narrow sleeves with rust-colored silk inserts. A bottom border of contemporary cotton contrasts the traditional yellow and green lustrous striped silk. I lined the coat with Russian cotton paisley. Ribbons, beaded tassels and felt buttons trim the garment. On the back, a fragment of genuine Indian embroidery with numerous shisha mirrors is framed with hand-sewn cowrie shells. I feel grateful to have rescued this rare ethnic garment.

The interplay of light, color and texture comes to life on my long coats.

Using my authentic Turkish coat pattern, I turned yards of faux indigo Ikat-inspired cotton fabric into an exotic ethnic coat. The red embroidered square panel with its stylized repeat cross pattern is centered on the back; it was intended to be a decorative pillow cover. I connected the entire design with German braiding on shoulders and back, adding polyester fabric puffs trimmed with buttons. The garment is lined in a small paisley cotton print. This long coat style is bound with bright red printed polyester fabric to delineate its shape.

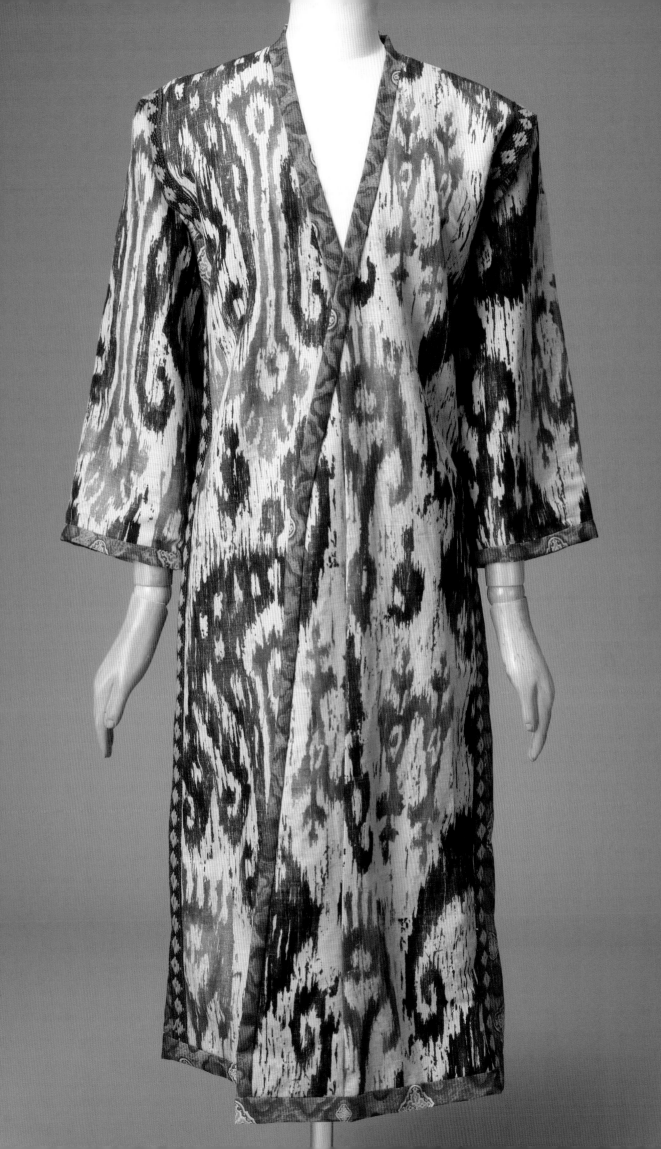

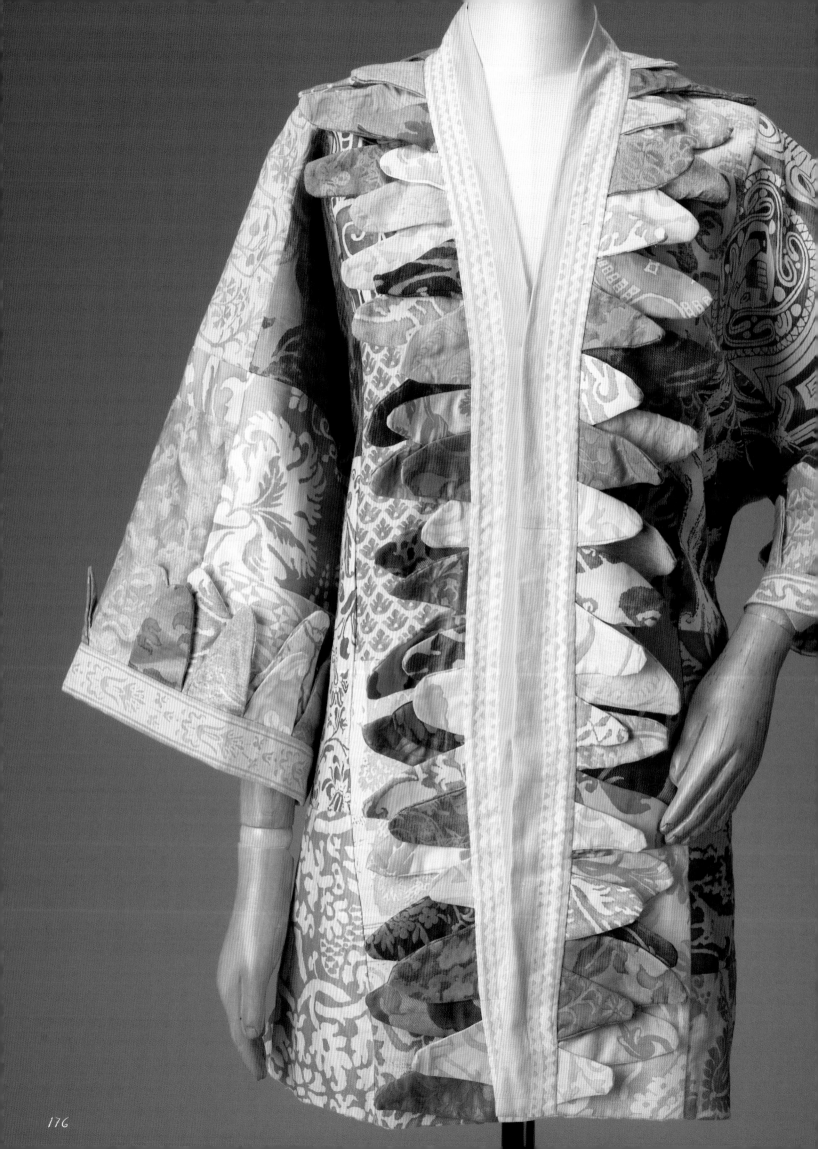

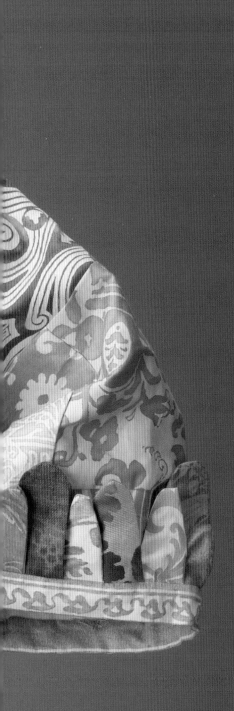

When I was teaching interior design in Albany, New York, during the 1970s, I would take my students to shop on Madison Avenue—Manhattan's premier shopping street where top interior decorators purchased the best fabrics from respected dealers. An interior designer friend of mine gave me a collection of Fortuny printed cotton square samples. I designed my favorite couture patchwork coat combining these elegant textiles into a wearable art composition. Fortuny fabric is the garment's story and I sewed and layered cloth petal shapes to edge the front bindings and sleeves for three-dimensional interest. The coat lining is unexpectedly solid-colored yellow and maroon cotton.

Couture is art. It's all about fine materials and sewing by hand.

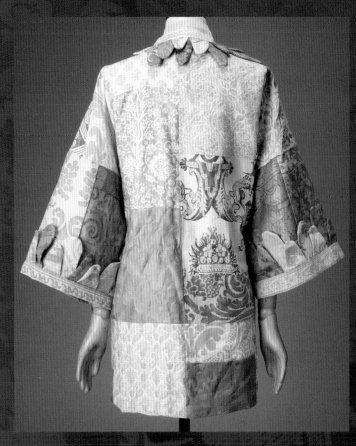

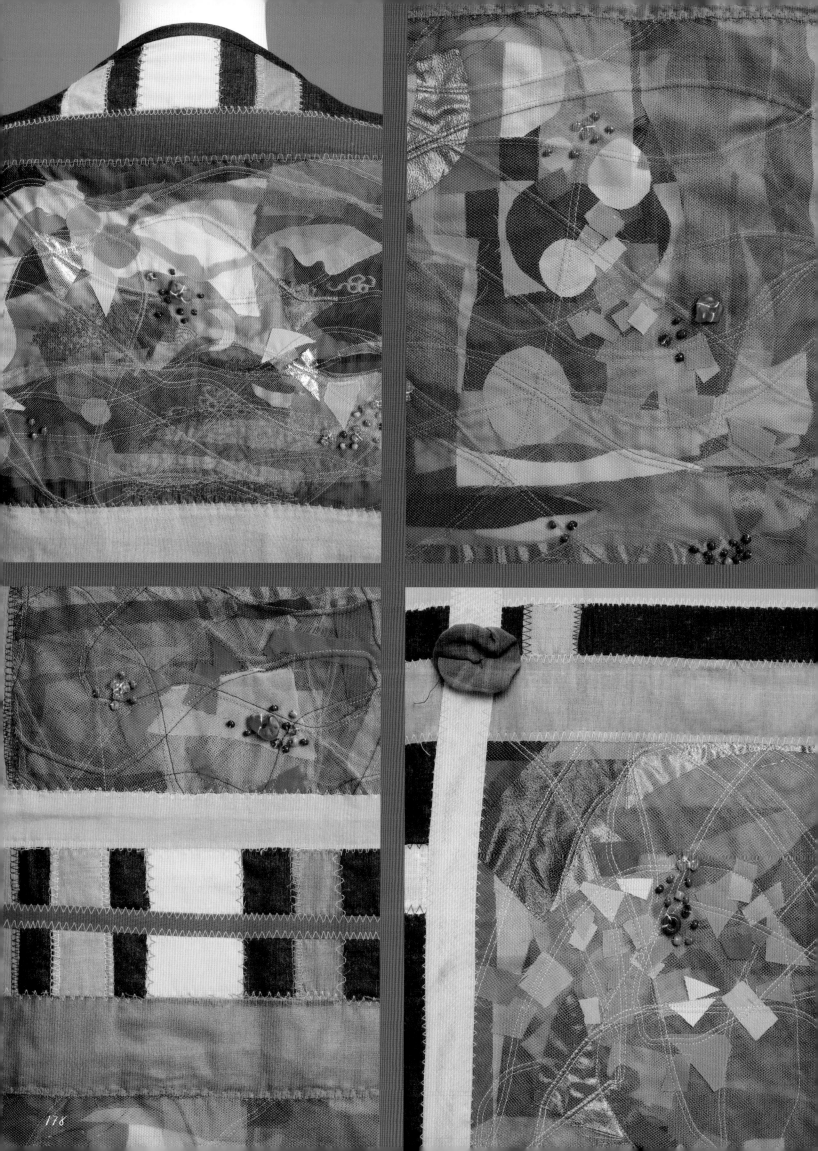

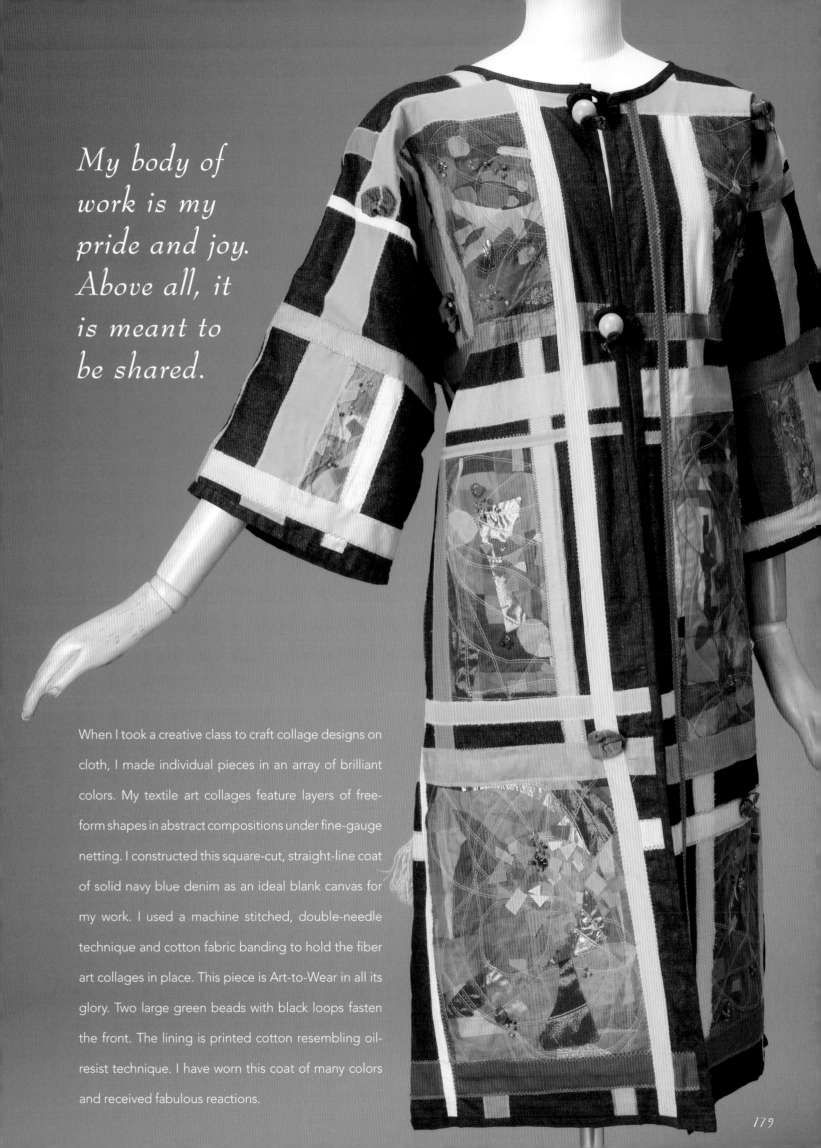

*My body of
work is my
pride and joy.
Above all, it
is meant to
be shared.*

When I took a creative class to craft collage designs on cloth, I made individual pieces in an array of brilliant colors. My textile art collages feature layers of free-form shapes in abstract compositions under fine-gauge netting. I constructed this square-cut, straight-line coat of solid navy blue denim as an ideal blank canvas for my work. I used a machine stitched, double-needle technique and cotton fabric banding to hold the fiber art collages in place. This piece is Art-to-Wear in all its glory. Two large green beads with black loops fasten the front. The lining is printed cotton resembling oil-resist technique. I have worn this coat of many colors and received fabulous reactions.

Left and above: Red-hued cotton pieces and cotton velour unite to form my full-length Turkish coat. I applied machine stitched, double-needle technique for curvilinear texture to the main body of the garment. Striped silk bindings outline the garment shape and a handmade tassel adds a distinctive touch. My embroidery floss star stitches hold miniature shisha mirrors; beads and ribbons further define the piece. Indian shisha mirrors come from the Hindi word for "little glass." The embroidery technique is called mirror-work or abla embroidery and today sequin pailettes or coins are also used. I lined the coat with cotton paisley to mirror the outer fabric.

Facing page: Embroidered and handwoven Guatemalan cotton became my inspiration for this piece with rustic, ethnic flair. The principal back interest is made of a heavy-weight, antique handwoven textile—with symbolic animals and patterns—that was once perhaps a mat or small rug. I used handwoven natural linen for the main coat construction and trimmed the front and back with ribbon, braids and buttons. Fringed burlap, rickrack, yarn tassels and handwoven belts from Mexico continue the folklore theme. The coat lining and bindings are red striped cotton. I attached a charming yarn doll from Mexico to become a whimsical element on the back.

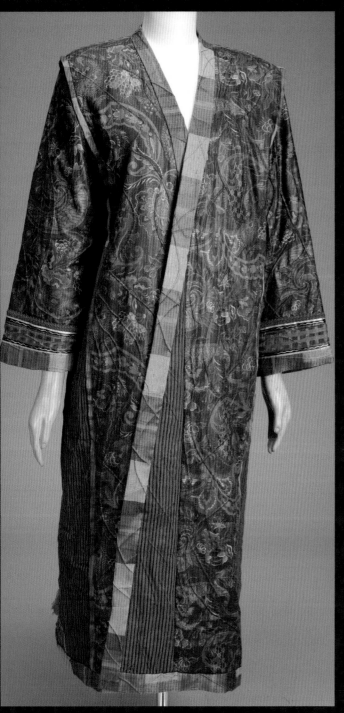

My garments are not mere clothing pieces— they are to be admired and studied for their display of textile artistry.

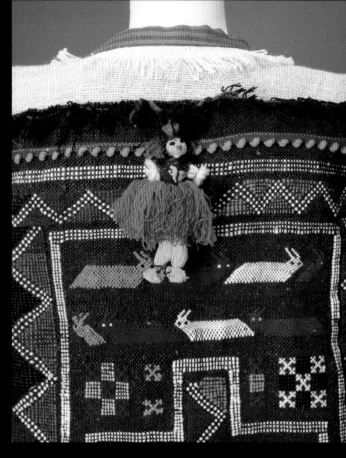

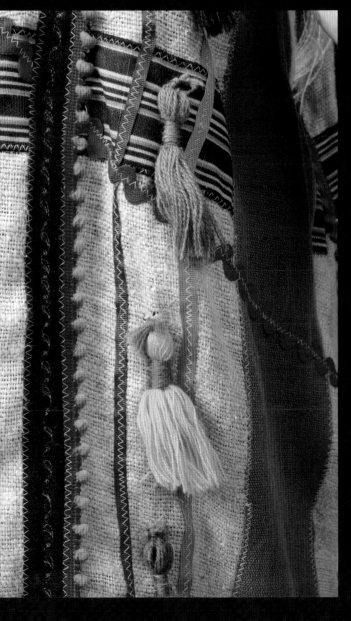

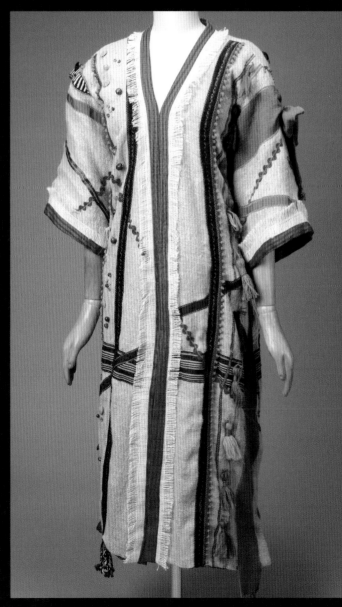

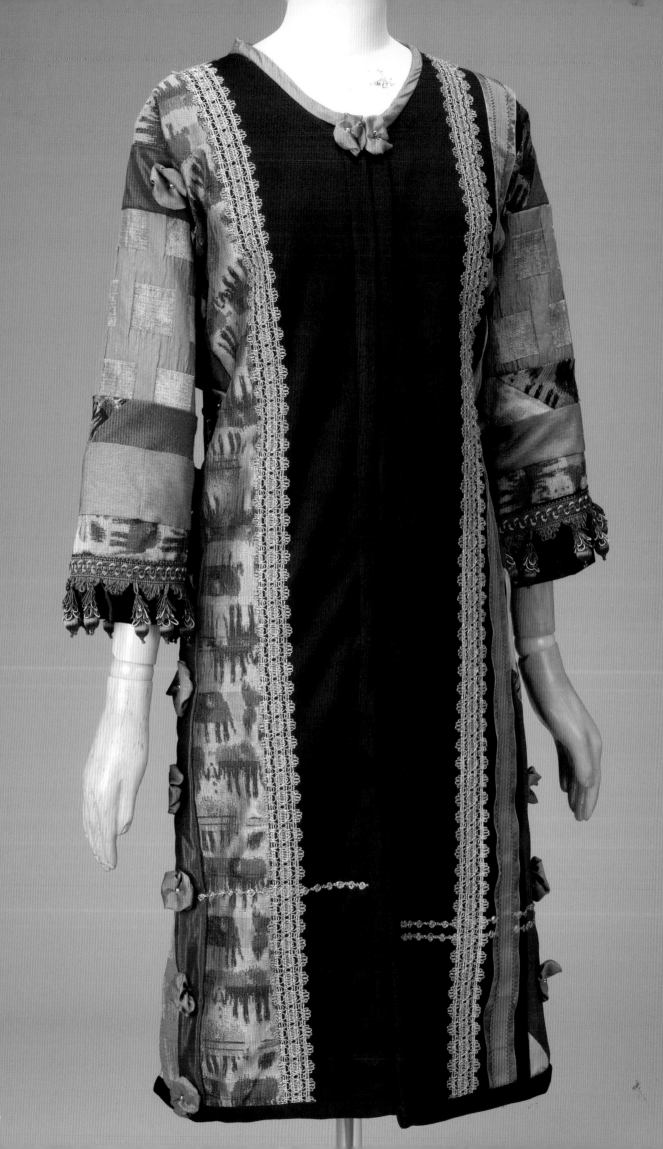

The art of textile-making and its processes must be taught to our youth, so the legacy of cloth and culture lives on.

A unique combination of textiles helped to create a beautiful, heavy-weight long coat. I chose classic black crêpe panels combined with furniture upholstery fabric for its rich, tapestry-like look and feel. A lavishly embroidered and beaded inset piece down the back's center is from India. Glittering rows of Indian shisha mirror-work accent the highly detailed interlocking circles with flower designs. Wide gold braid, fabric puffs with pearls and green beads embellish the elegant garment. Upholstery ball fringe trims the sleeves and along the hemline. Orange taffeta lining is my colorful surprise element.

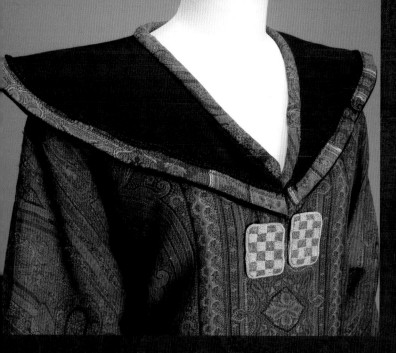

One may call it finery, raiment or theatrical costume. My garments simply express my passion for cloth, culture and craftsmanship.

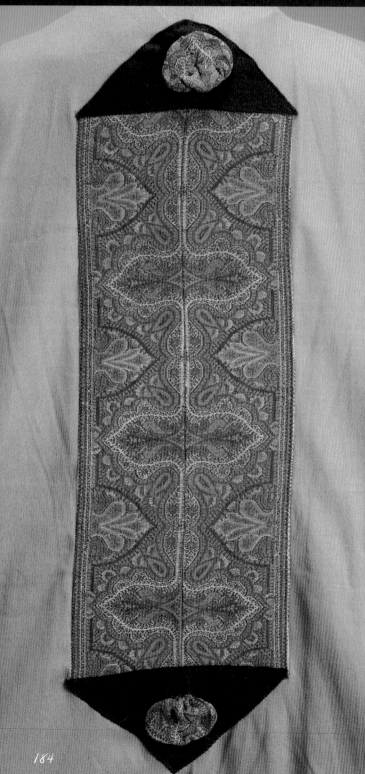

I envisioned an opera coat using this museum-quality, antique 19th-century wool paisley piece from England. Imperfections required that I cut up the handwoven fabric to construct the full-length coat, but I was able to save the hand-finished edge as the bottom hem. I added a stiff black felt collar to create a face-framing element. Over 100 years ago, large squares of exquisite silks and lightweight wools were made into "piano shawls," worn as wraps or draped on the top surface of a grand piano. Trimmed with black rope, black crêpe and cut-steel shoe buckles from the 19th century, the coat has a quiet British elegance. I lined it in pink cotton with a small piece of the same exterior fabric.

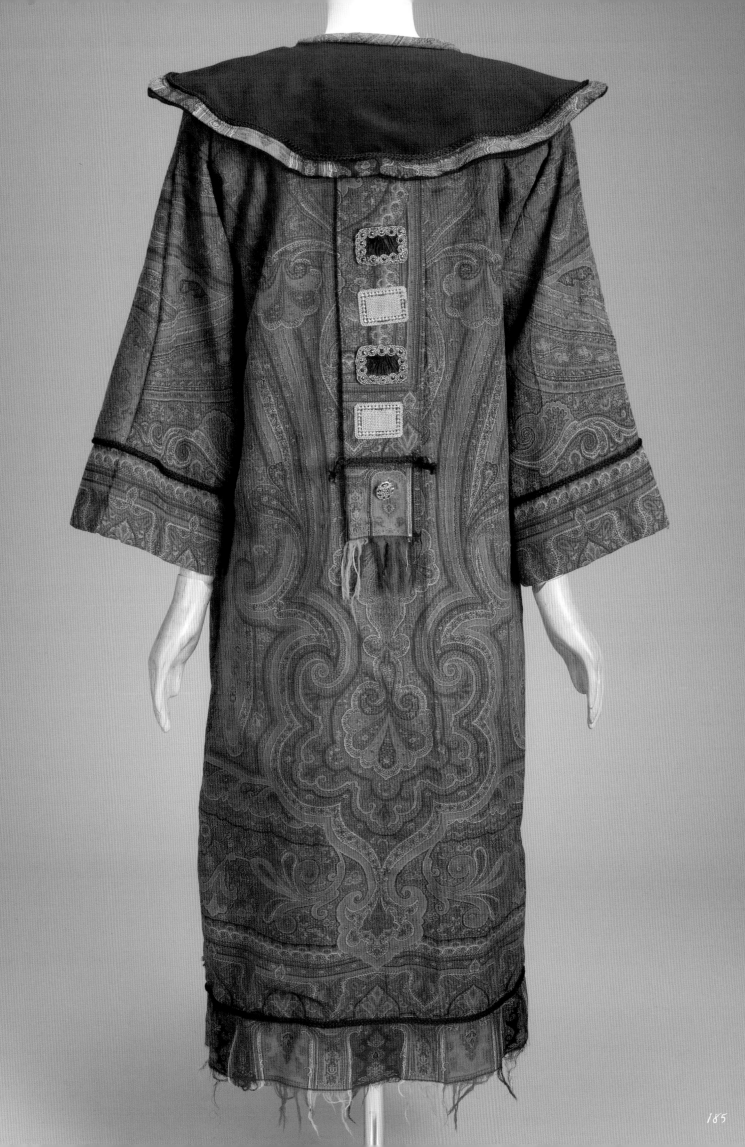

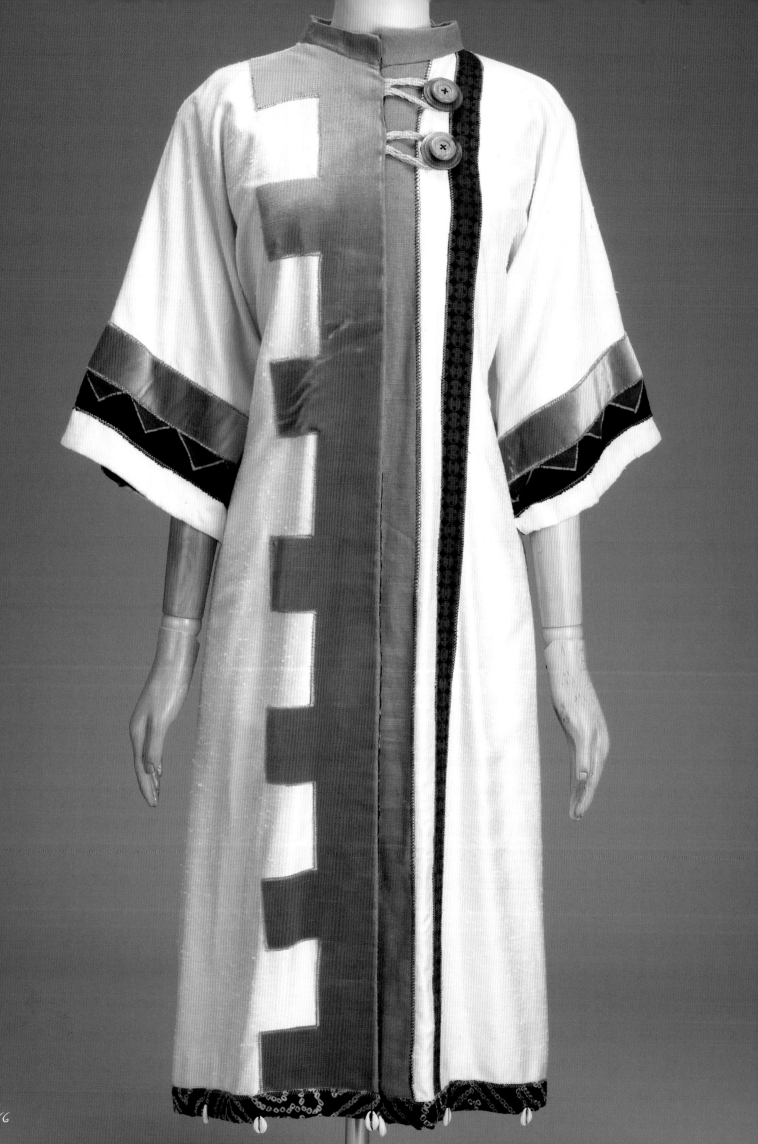

186

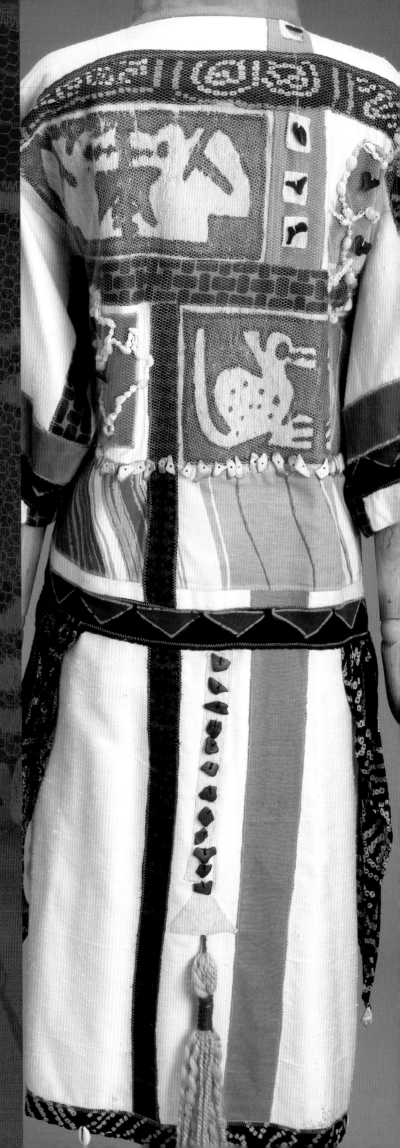

Materials vary from tough to delicate, plant-derived to synthetic, loom-woven to nonwoven. The variety of textiles and techniques is endless.

Featured in *Fiberarts* magazine, my white, textured Etruscan cotton cloth coat is trimmed with contrasting gold velveteen geometric strips and a handwoven cotton stand-up collar. Shoulder details, decorative triangle pieces and the hem of the garment are all made of Shibori silk dyed fabric. I integrated two back panels of primitive animal imagery on course, textural fibrous fabric held in place under fine-gauge netting. I recycled the material from a Samoan tote bag. Embellishments include handmade yarn tassels, small seashells, bamboo pieces and striped cotton print swatches held under fine-gauge netting. The coat is lined with American-made batik cotton in a flower-and-leaf pattern. Wooden buttons with loops fasten the coat.

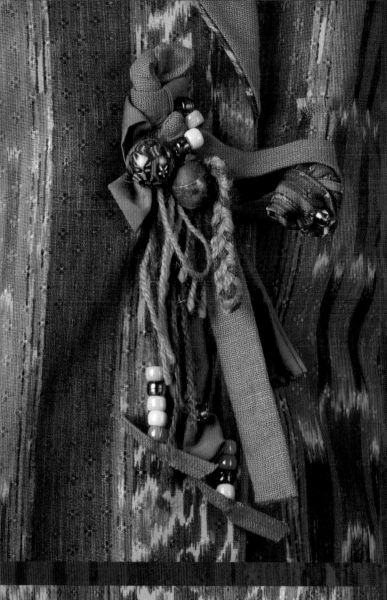

My needle has traveled across many continents through each textile it has touched.

My royal red straight-line, square-cut design with notched lapels is adapted into an opulent opera-style coat for evening wear, as it is reminiscent of a fitted cloak with a more dramatic collar and long sleeves. The fabric is faux Ikat, made of manmade fibers and printed in England. Lined and trimmed with red linen, the piece has fabric puffs at the top of each side slit and added coordinating fabric tubes with beads to flutter down the back. The front of the ankle-length garment features fasteners made of assorted cords and beads that reflect the red and teal color scheme of the body of the garment.

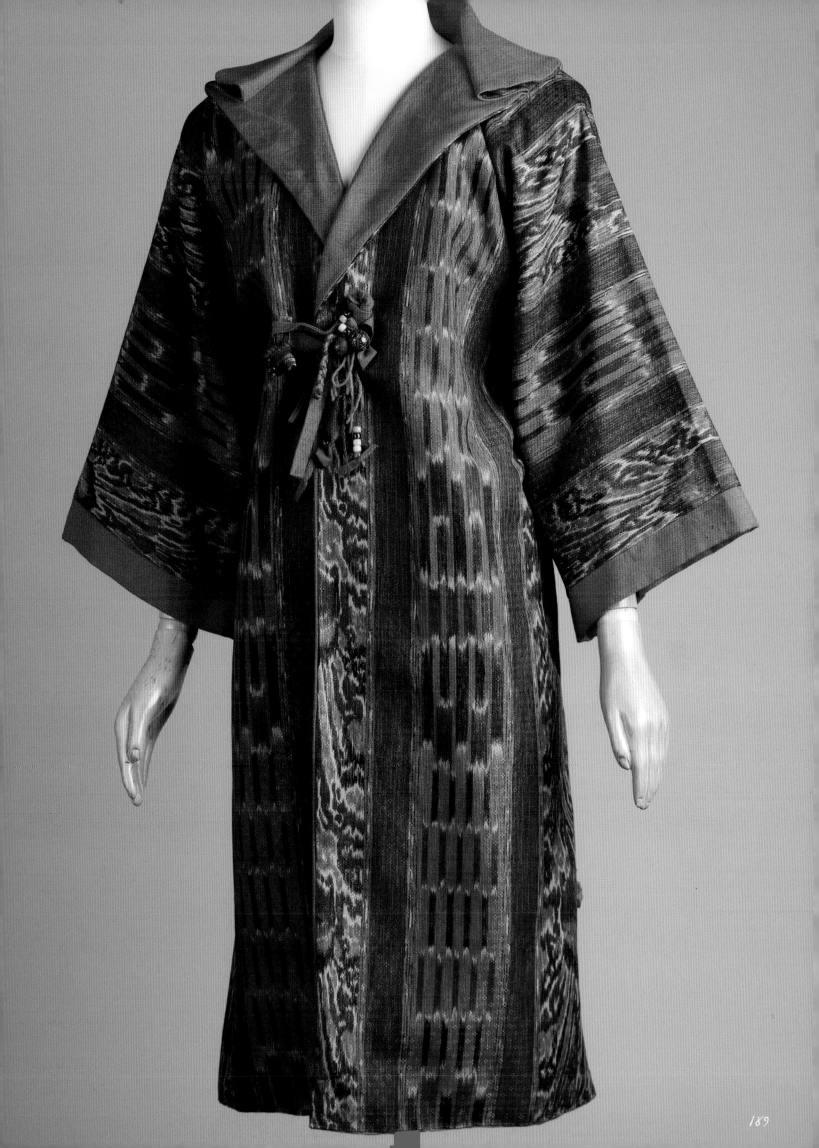

"If of thy mortal goods, thou art bereft,
And of thy meager store
Two loaves alone to thee are left,
Sell one, and with the dole,
Buy hyacinths to feed the soul."
—Sheikh Muslih

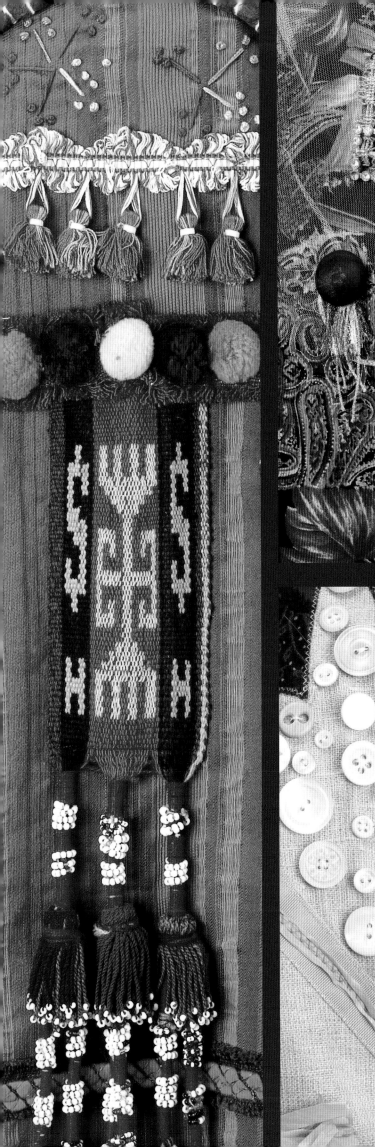
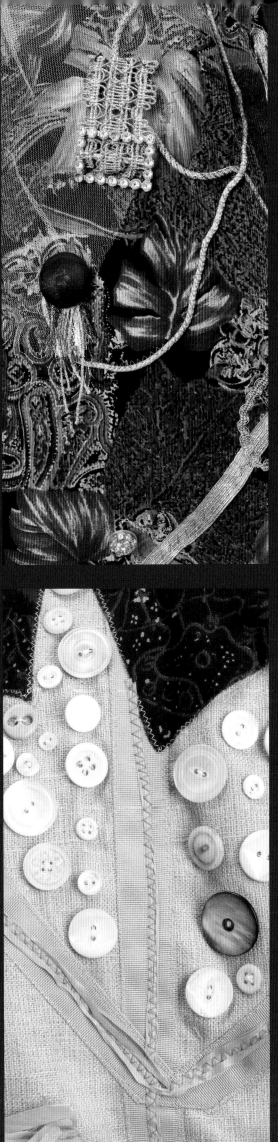

Chapter Four
The Vest

Ethnic textiles as applied to essential style

An important part of fashion in many countries around the world for centuries, the vest garment can signify a tribe, a position or a culture. In many ethnic groups vests are an essential element of folk costumes worn by men, women and children. My wearable art vests reflect a range of ethnic textiles and embellishments from Eastern Europe to Southeast Asia. Fine hand-sewing skills, weaving methods and design principles as applied to materials come to life on each simple vest.

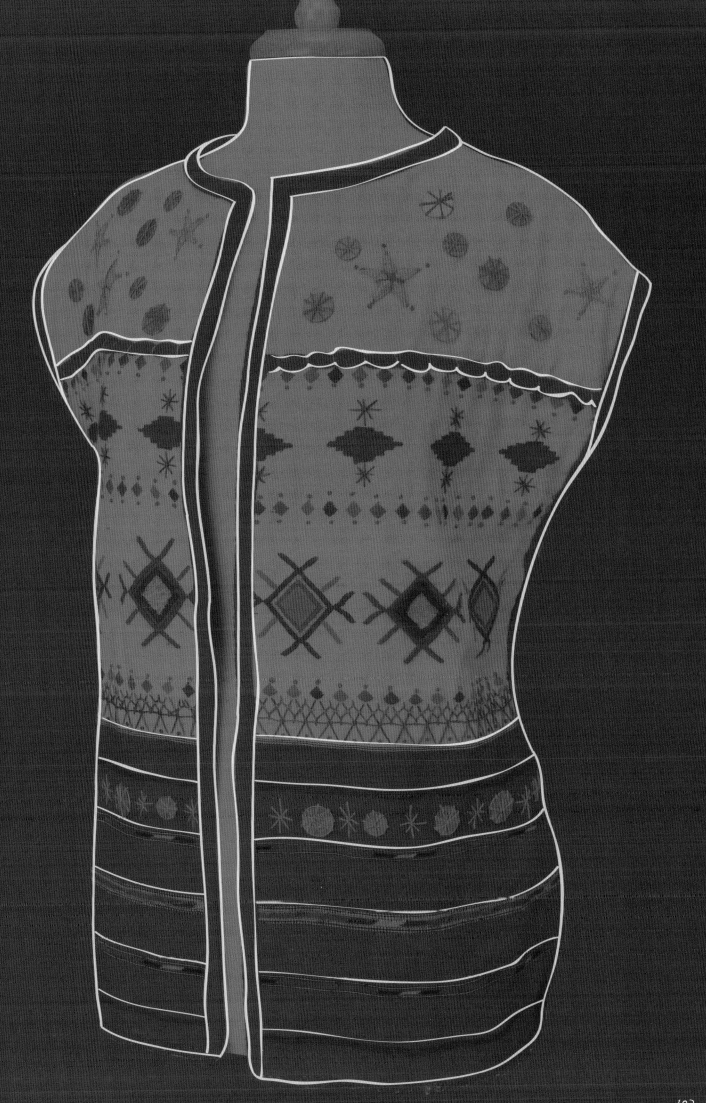

193

The word "vest" is derived from the French language, meaning a robe or gown, and Latin *vestis* from *vestire*, meaning to clothe. The origin of the vest garment is based on a style brought back to England by visitors to the Persian court of Shah Abbas. That model had sleeves and was longer than the coat worn over it. The vest evolved shorter to above the knee, then to mid-thigh, to hip-length and finally, by 1790, up to the waistline. It had became sleeveless around the 1750s.

My unique vest designs are simply sleeveless adaptations of the straight-line, Square-Cut Jacket pattern or, in some instances, a side-panel pattern. The basic cut is reminiscent of the first unisex tunic, which was worn belted in ancient Greece and Rome. I allow my vests to hang freely and comfortably; they are not fitted to the body, although some you will see have been pinned at the waist on their display mannequins to appear that way. My vests use no more than one and a half yards of fabric and require two machine-stitched seams or side insets.

I construct custom vest creations using an array of multicultural textiles. Some of my vests have been worn as original wearable art showpieces at social events, exhibited in galleries and others have been modeled in my wearable art fashion shows. They have provided a simple way to express my passion for world textiles, as well as incorporate fine hand-finishing techniques and the art of embellishment, all of which I have grown to love and appreciate.

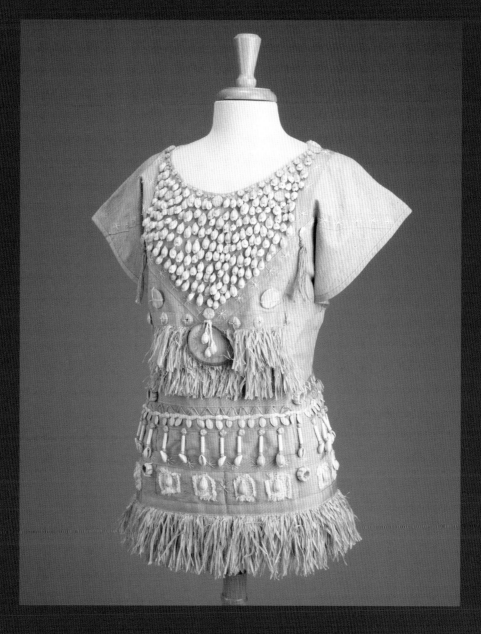

Vests provide a simple way to
express my passion for textiles.

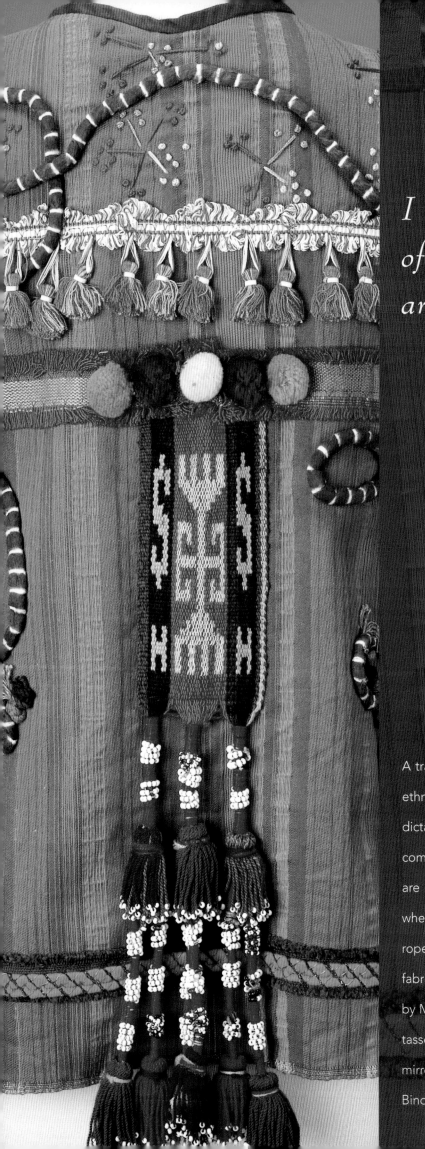

I unify the front and back of each vest to create artistic balance.

A traditional waist-length back and longer front make this ethnic side panel pattern a unique design. Imported textiles dictated this design. Heavy woven tapestry-like cotton composes the main garment. Snake rope pieces from India are actually lengths of cotton fabric twisted tightly, and when unraveled create scarves, but I chose to use them in rope form. The back handwoven centerpiece is on striped fabric accented with exotic beaded animal tassels made by Middle Eastern tribesmen. Embellished with ball fringe, tassel fringe and braid, embroidered rings hold shisha mirrors, and French knots and star stitches finish the vest. Bindings are maroon-colored cotton.

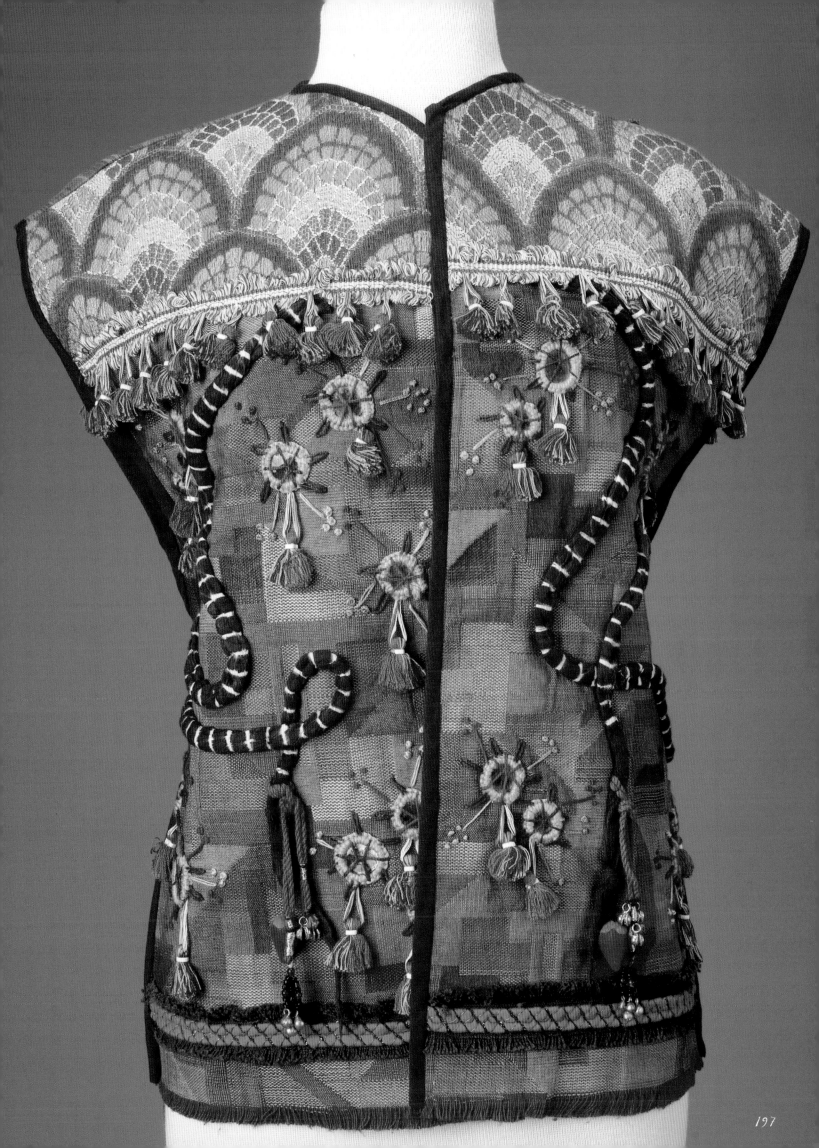

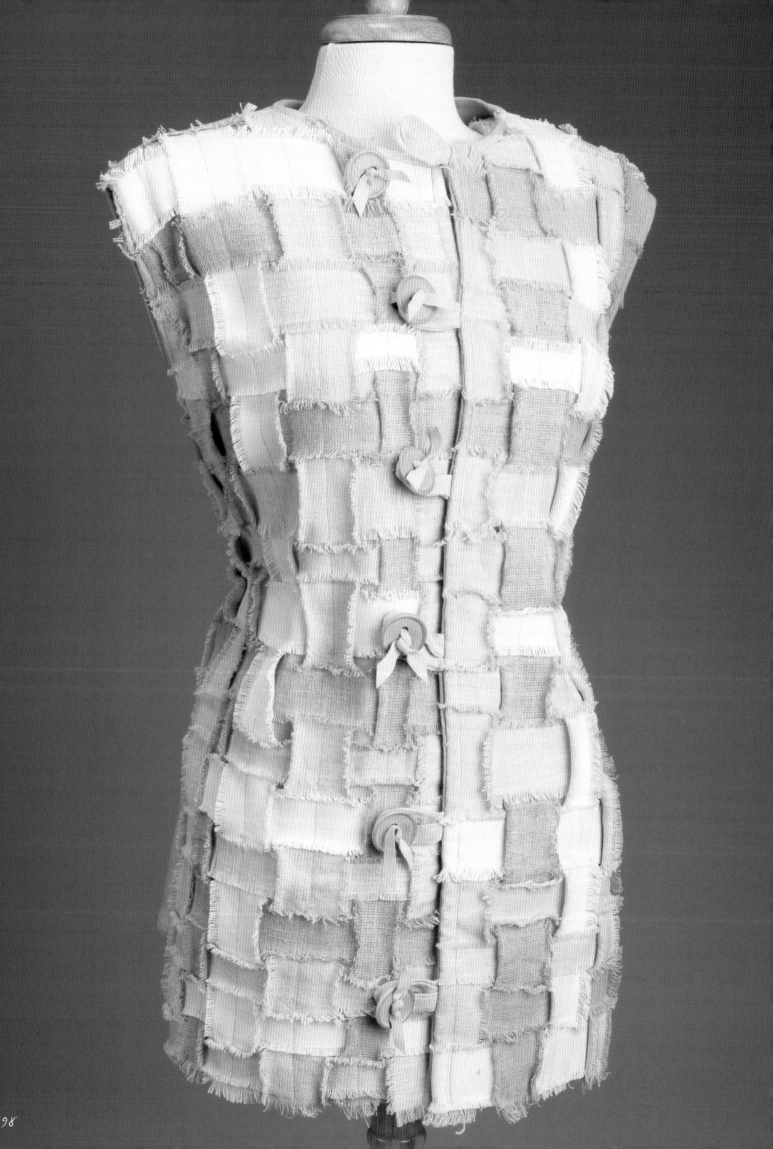

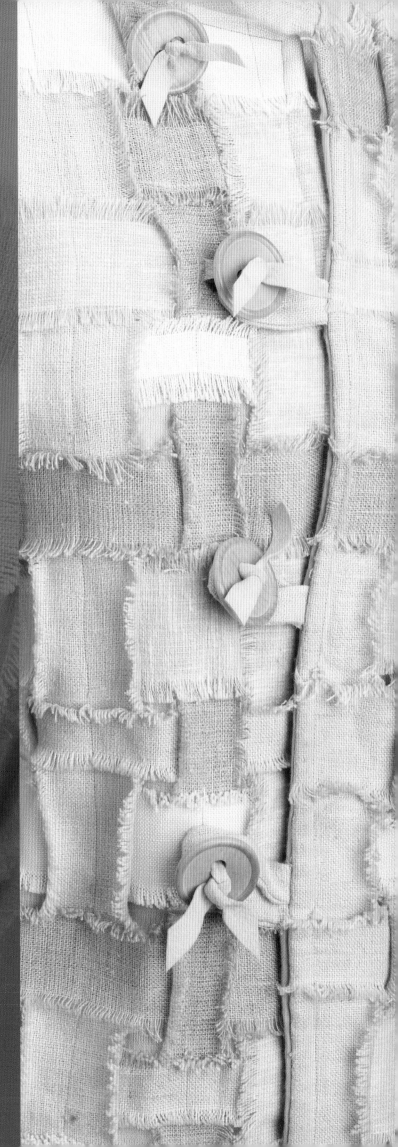

Hand-weaving techniques inspire me; I am dedicated to my craft down to every last detail.

Although this sleeveless vest garment appears to be fitted, it is straight-line and hangs freely; we pinned it on the form. I cut handwoven linen strips of light tea-colored shades to create an interesting over-and-under basket weave design using a basic interlace technique of horizontal weft and vertical warp pieces. I frayed the linen strips first to create fringed texture. The back of this vest is solid Ultrasuede and I used the same nonwoven synthetic material to make loops and ties for the front's large wooden button closures; lap closures are on the sides. The vest is lined with neutral polyester fabric.

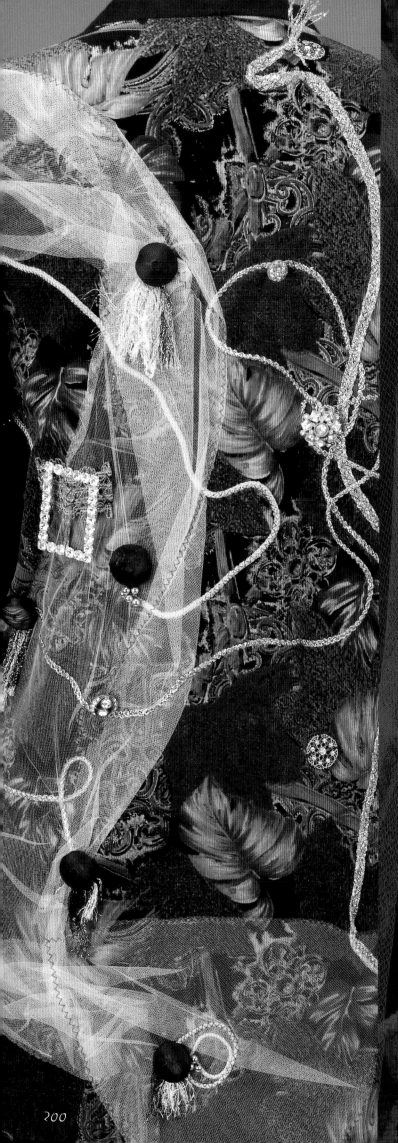

*My vests are collages
of recycled textiles
and trinkets. I am a
preservationist.*

I discovered unusual printed corduroy from Germany with a
very interesting leafy pattern in rust and brown autumn hues.
Using tacking techniques, I attached pieces of recycled
vintage rhinestone costume jewelry, antique shoe buckles
and sparkling buttons commingled with gold threads,
holiday braiding and twisted fine-gauge netting to give a
flow of unity to the front and back of the vest. The straight-
line garment is loose-fitting and has cropped sleeves; the
vest requires no closures and bindings are made of black
cotton fabric.

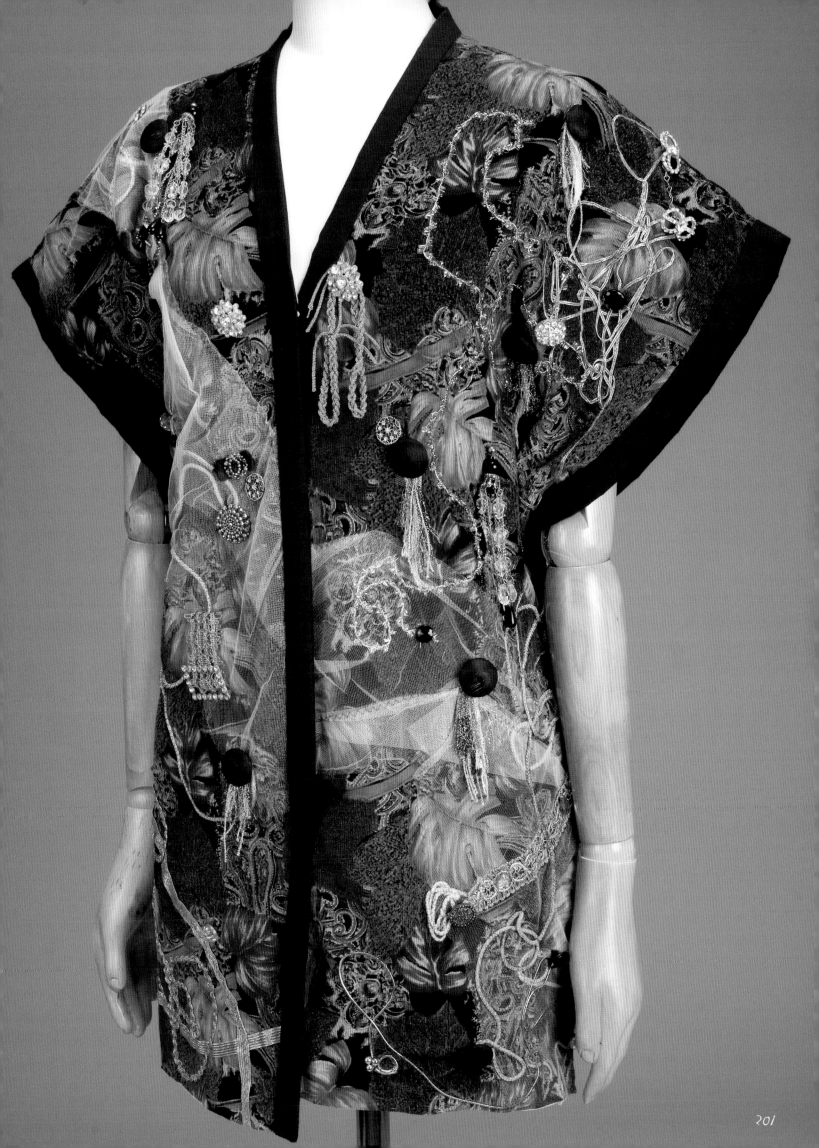

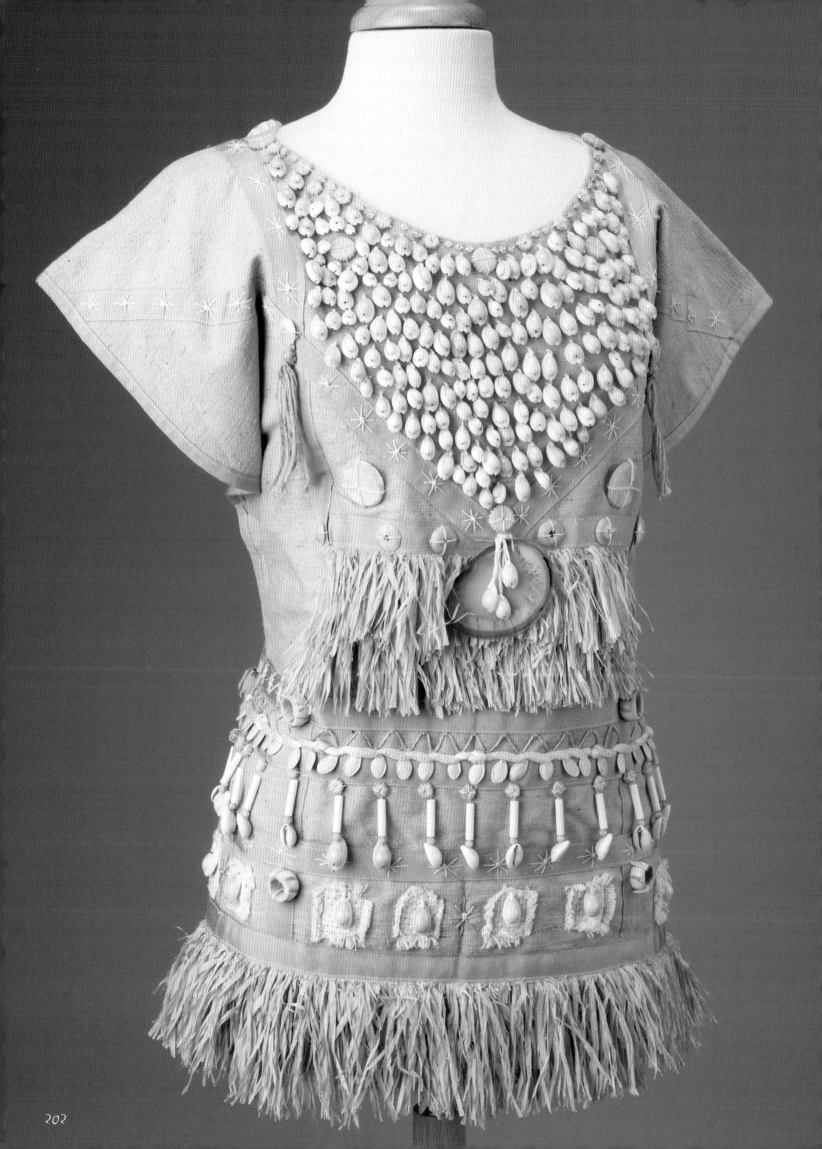

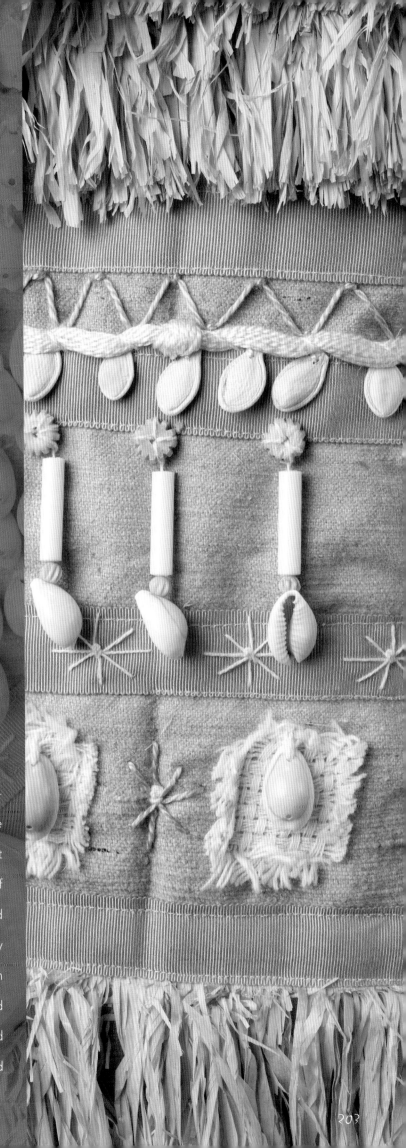

Fiber art accents range from star-stitch embroidery to finishing touches of raffia palm.

Inspired by Native American tribal dress, I created a hip-length vest of natural handwoven linen by modifying the Square Cut Jacket pattern with cropped sleeves. Front embellishments make this vest an outstanding example of the art of adornment. I recycled wind chimes and attached rows of cowrie shells. Small cowrie shells were formerly used as money in parts of Africa, South Asia and the South Pacific. Grosgrain ribbon, star stitch embroidery, sliced geodes, bone pieces, tassels and dried pumpkin seeds add interest, while raffia palm fringe strips edge the waist and hemline. The garment is lined in white polyester fabric.

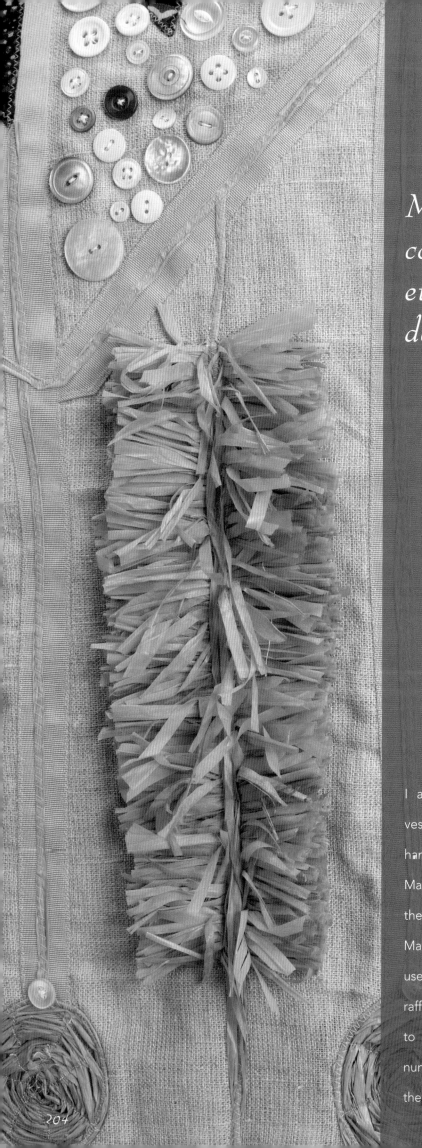

My antique button collection combines with ethnic trims to further define the vest shape.

I am proud of this piece made following an ethnic vest pattern with under-the-arm insets. Natural-colored handwoven linen became the vest construction. I added Malaysian batik cotton triangles and shapes to delineate the shoulders and bottom hem. Native to Africa and Madagascar, dried raffia palm leaves and fibers are often used for decorative purposes on tribal clothing. I integrated raffia fringe strips, concentric circles and straight lines to adorn both front and back. The vest is finished with numerous pearlized buttons from my vast collection. I lined the vest with an ethnic patterned cotton fabric.

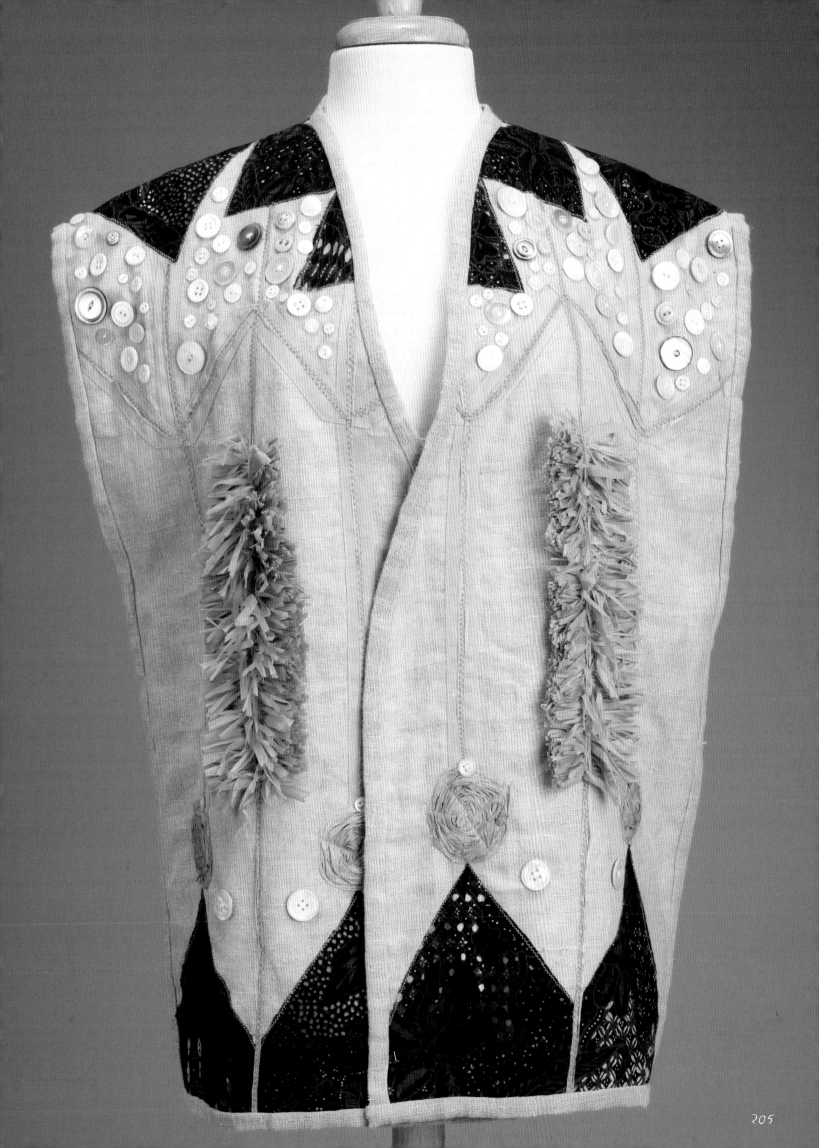

205

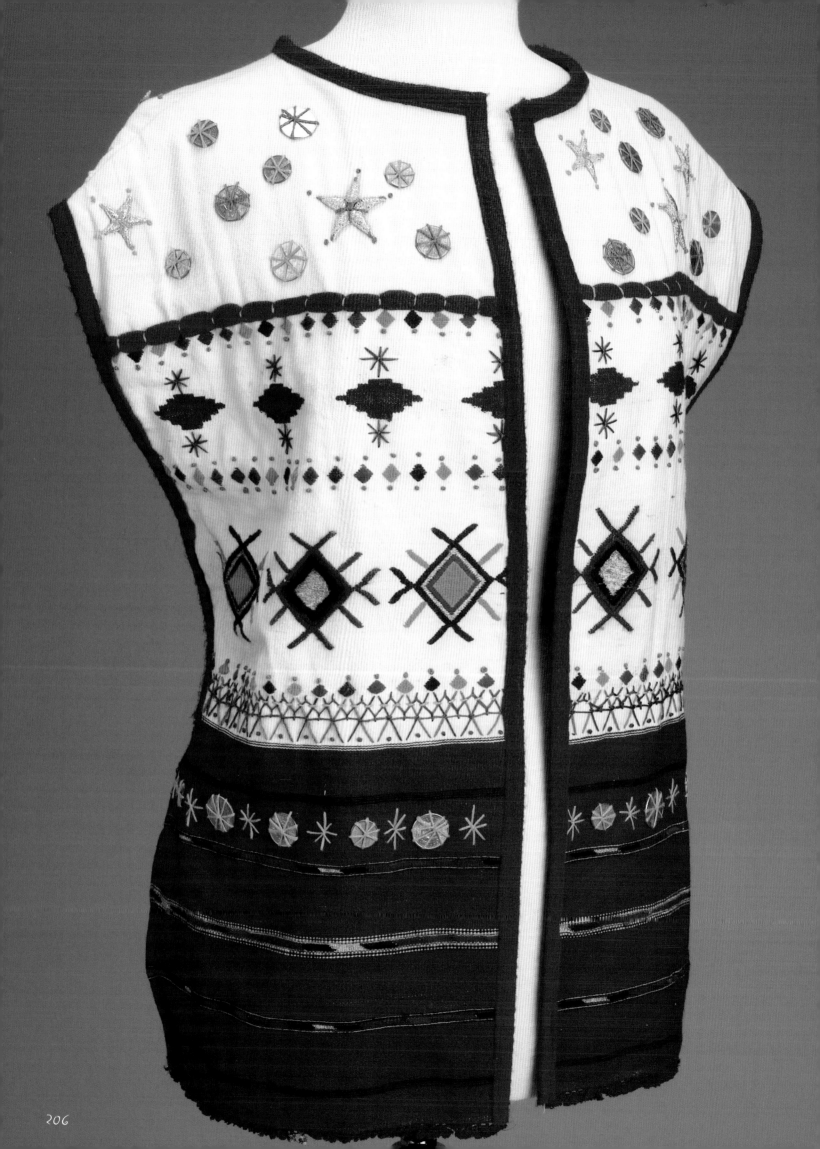

Segments of cloth and coins from world cultures, when combined, tell an interesting story.

Hand-weaving and embroidery work are lost arts that are under appreciated in many countries. I discovered these lovely red and white folk art textiles and was delighted to save them from their fate. I bought the handwoven cotton and embroidery pieces at a Yugoslavian marketplace during my visit in 1991. The sleeveless vest was created with red woven fabric for the lower third of the garment, white embroidered segment for the upper bodice. The bindings and diamond back trim are cut of nonwoven felt. I added gold crosses and stars from a local sewing craft shop and attached Yugoslavian coins with embroidery floss star stitches.

"Whatever is not eternal is
eternally out of date."
—C. S. Lewis

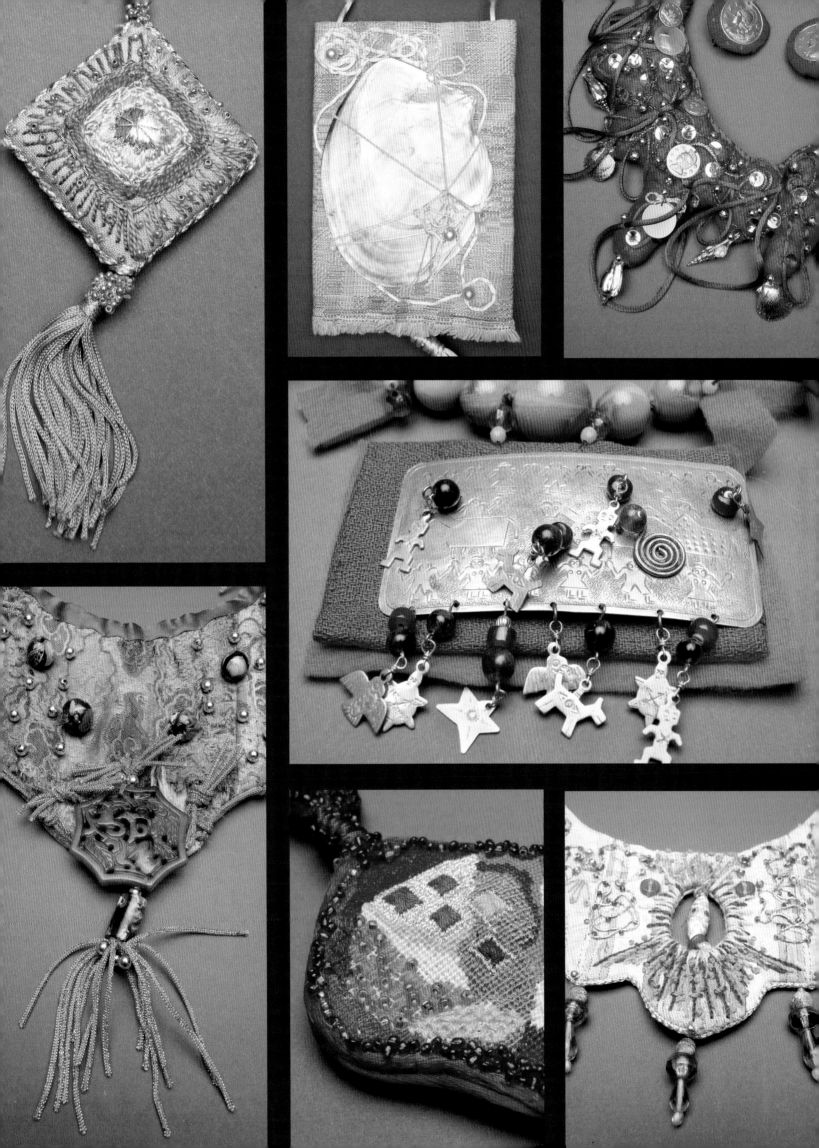

Chapter Five
Fiber Art Designs

Original creations from textiles, threads and trims

I have always had an affinity for adornment. Throughout the ages in many cultures—from the ancient Egyptians' golden broad collars to tribal African Maasai leather and beadwork, from India's precious ruby and emerald jewels to the glittering crowns of European royalty—women and men have been fond of adornment, which often identified social class. I appreciate the beauty of hand-fabricated global jewelry; every day I wear an armful of sterling silver bangles collected from India and various world cultures. My favorite 1960s vintage cluster ring with a deep blue oval sapphire encircled by diamonds is in a classic platinum ballerina setting. This antique ring style was inspired by the look of a ballerina's tutu and proves that anything can become jewelry inspiration.

In college I wrote my master's thesis on contemporary jewelry design, which brought to light many innovative jewelry artists of the 1950s. During my teaching years while living in upstate New York, I began working as a jewelry artisan using sterling silver and decorative enamel to create stylized pins and pendants, and some silver necklaces and bracelets. This postwar genre of jewelry was quite popular and fun to make.

My private studio in my 200-year-old Georgian home was equipped with a good firing kiln. I had all of the silversmith tools of the trade including an antique blacksmith anvil and forging hammers, which I used to form metal pieces. Brilliant colors inspire me, thus my attraction to the art of enamelwork. Enamel is a vitreous glaze that is intensely heated and fused to metals like copper or silver. Although there are many specific techniques that may be used in enameling, irregular patterns and decorative effects highlight my jewelry designs. I sprinkled grains of pigment on pure silver and fired each piece to form hard, glossy geometric shapes and lines of bright color as abstract expressions. A few of my original silver pieces were exhibited and sold in New York art galleries and boutiques in Albany and Manhattan.

Just before moving to Florida in the 1980s, I packed up my enamellist workshop and passed it on to a budding jewelry designer and Skidmore graduate. It was hard to say good-bye to my full studio, but I was on my way to a new creative adventure in a smaller home work space. My love for the design aspects of jewelry-making reignited my background in fine art as applied to materials, expressed in every handcrafted fiber art design that was about to emerge.

Over the next 25 years, I designed freeform, sculptural jewelry designs out of colorful, lightweight fabric—sewn and stuffed with ultra-soft cotton-polyester fiberfill following my own original neckpiece pattern. I also created several beaded necklaces and pendants featuring traditional threadwork techniques, some with semiprecious stone accents. My colorful fiber art designs often feature hand-stitched embroidery, beads and embellishments, pin-loom threadwork, needlework and fine hand-crocheting techniques alone or in combination. I learned over-and-under floss weaving technique from my friends at The Embroiderer's Guild of America; the basic pin loom is made from a simple foam base with straight pins. I constructed most of my unique neckpieces to accent jacket and coat ensembles. Handmade loop-and-bead closures or brass hook-and-ring wire clasps secure my virtually weightless neckpieces and pendants.

Some of my handcrafted pieces are showcased on an antique muslin-covered mannequin from late 19th century Paris. Each creation was photographed to focus on the special details and weaving intricacies. Beyond one-of-a-kind necklaces, I also designed a few decorative back pieces, a handmade clutch evening bag and highly embellished, Asian-inspired pocket purses to expand my collection. I made these luxurious textile purses to coordinate with my wearable art jackets and coats. Similar to my garment collection, the signature handmade jewelry pieces and accessory constructions reflect many different types of woven cloth, sewing techniques and fibers, as well as natural polished stones, seashells and traditional embellishments from interesting cultures, both old and modern.

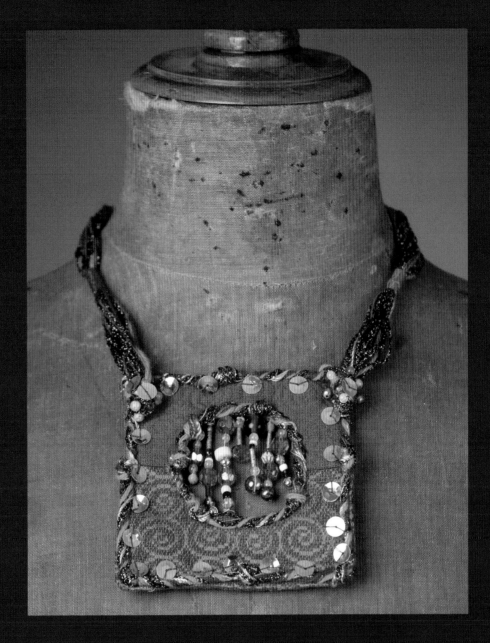

Throughout history, the art of
adornment has taken many forms.
Fiber art design is one expression.

For each handmade necklace, ideas are usually based on the materials and the design intuitively evolves. I used a remnant of blue, tan and cream cotton batik from Thailand to form the stuffed freeform neckpiece. Natural hemp cording, irregularly shaped bamboo beads, antique coins, golden bells from India and a dash of bright blue beading with yarn accent the collar-style creation. The fastener is a loop of thread over a bead. Matching fabric button earrings have gold bead and yarn details.

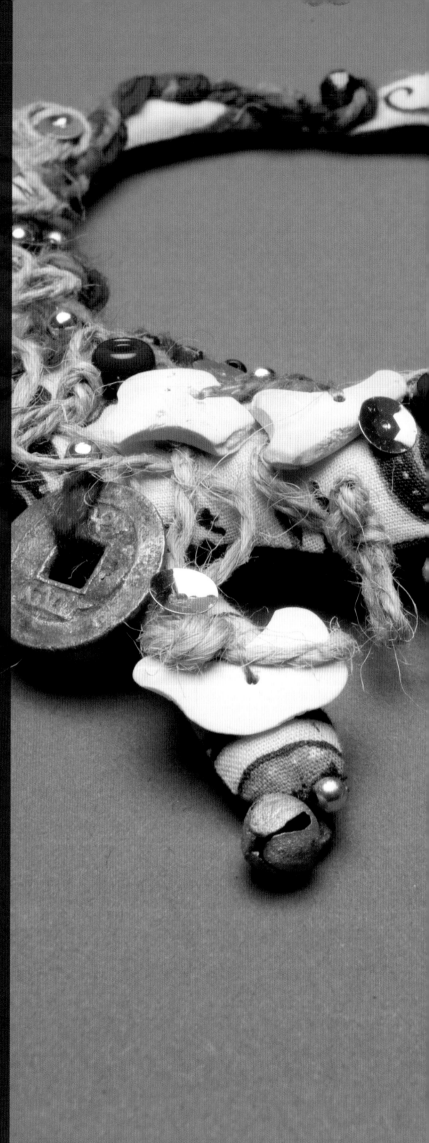

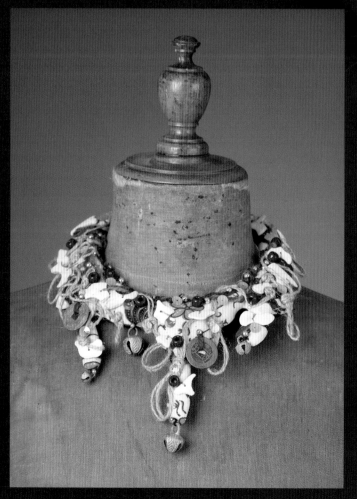

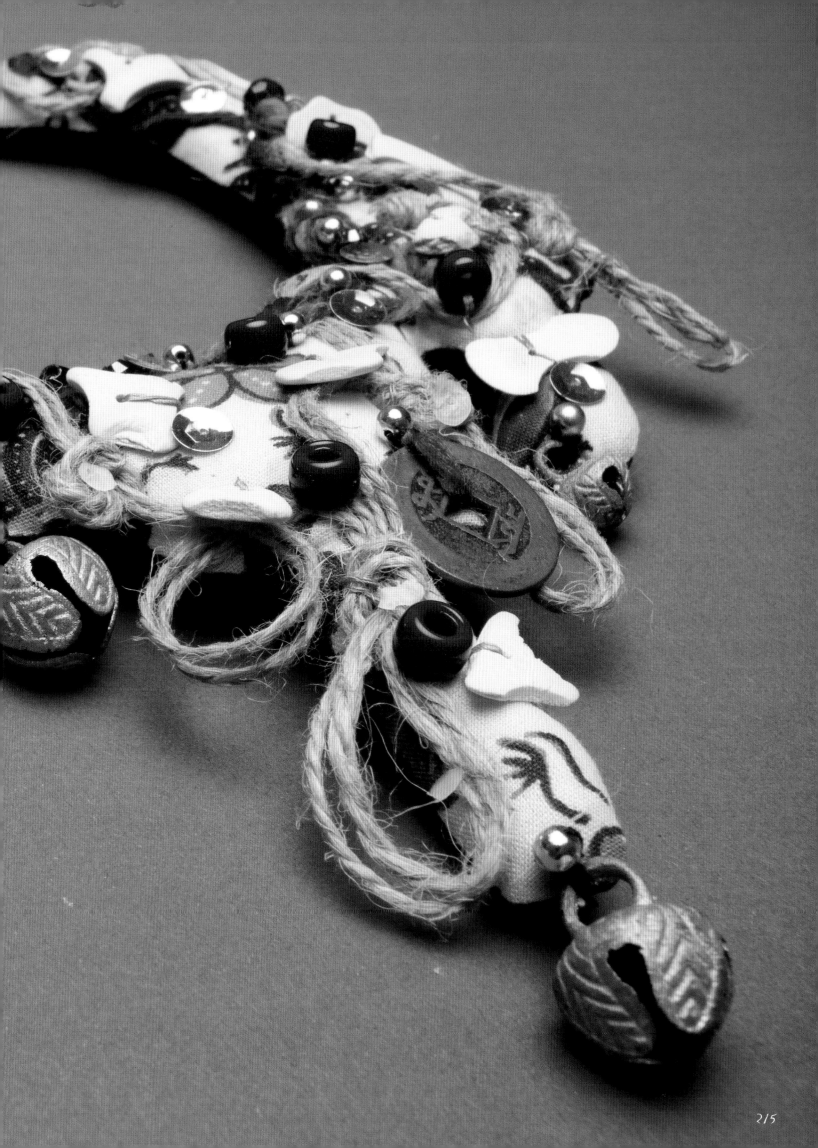

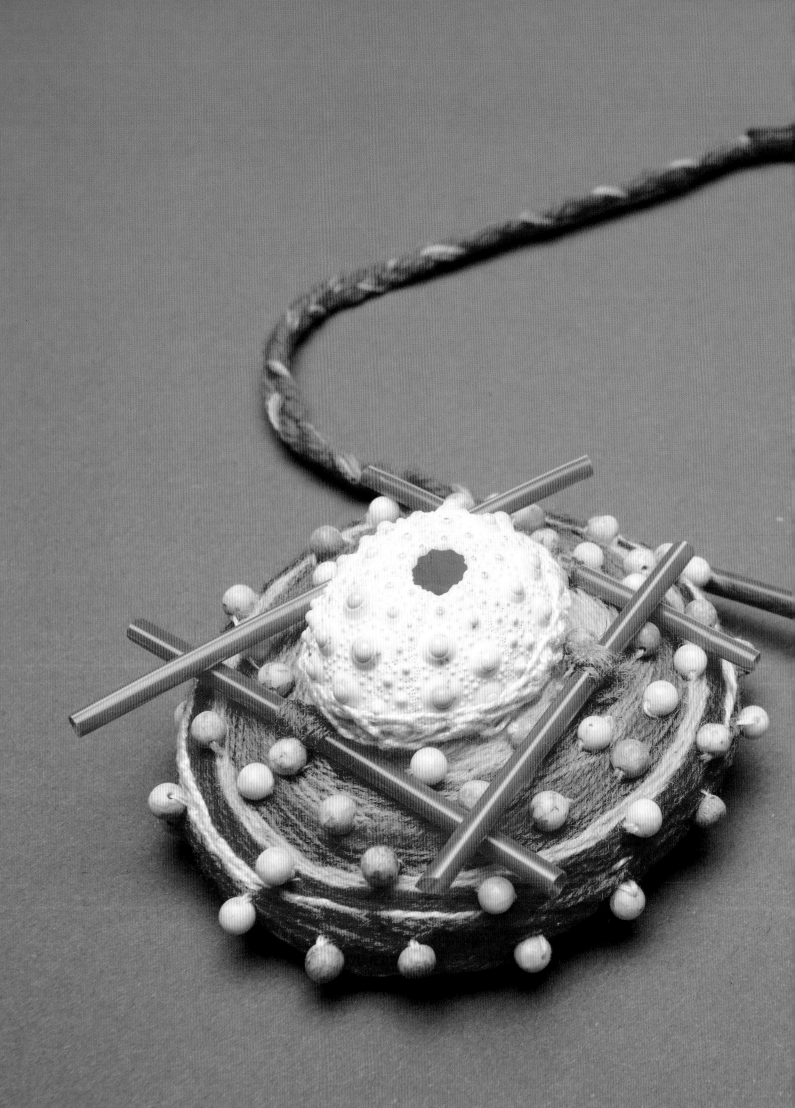

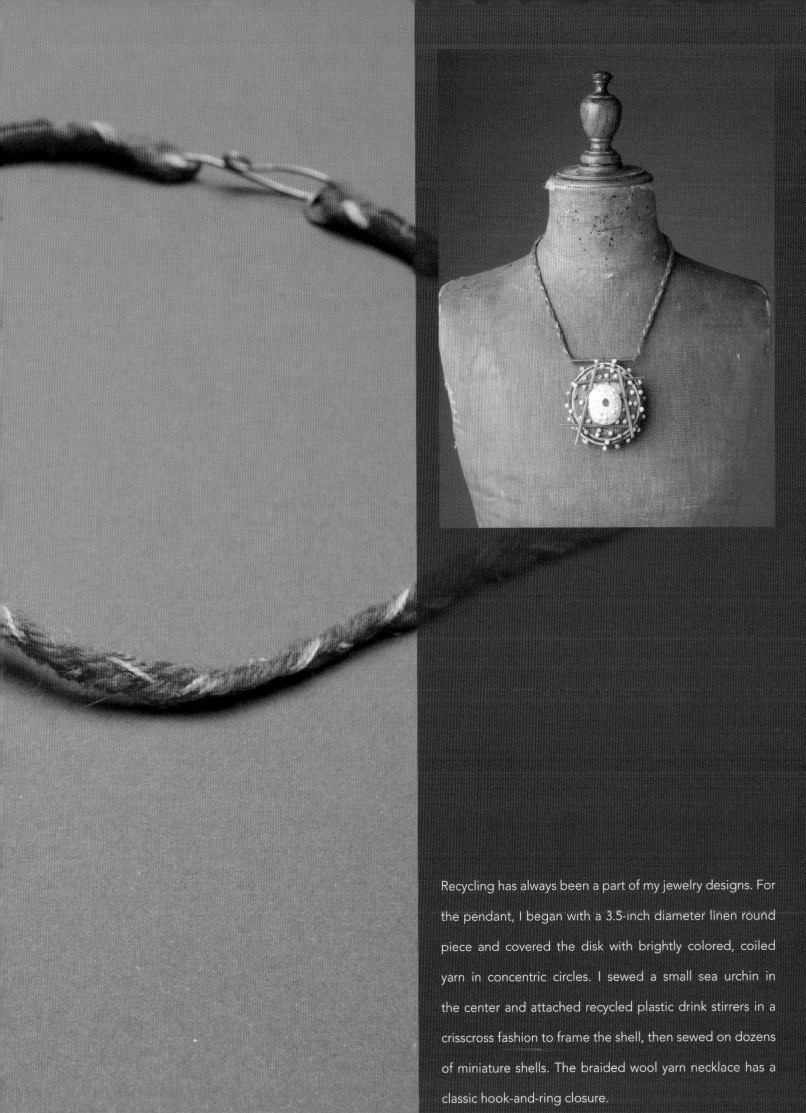

Recycling has always been a part of my jewelry designs. For the pendant, I began with a 3.5-inch diameter linen round piece and covered the disk with brightly colored, coiled yarn in concentric circles. I sewed a small sea urchin in the center and attached recycled plastic drink stirrers in a crisscross fashion to frame the shell, then sewed on dozens of miniature shells. The braided wool yarn necklace has a classic hook-and-ring closure.

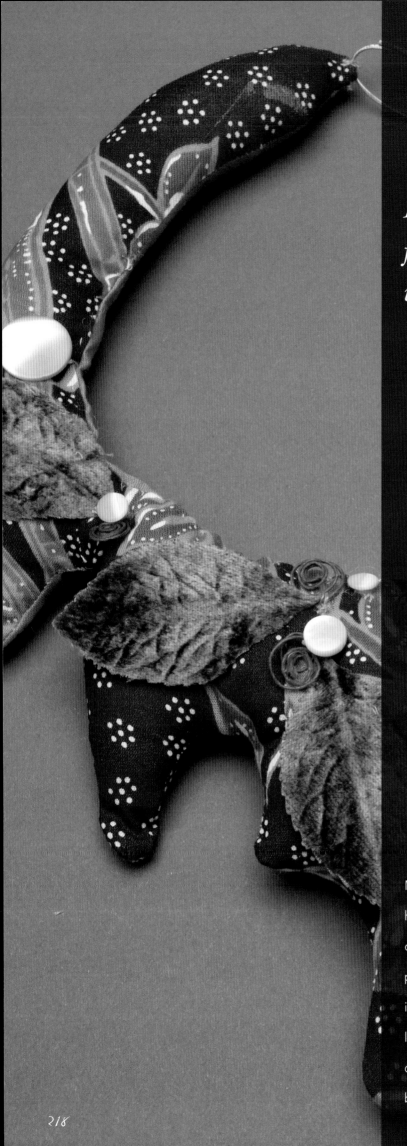

My freeform, sculptural fiber art designs possess a unique dimensional quality.

My design concepts are inspired by materials I have on hand. Following my original freeform neckpiece pattern design, I created a stuffed, collar-style necklace of purple printed cotton fabric plumped with fiberfill. Embellishments include white pearlized buttons and vintage velvet green leaves. The hook-and-ring closure is all that is required to clasp my featherweight neckpiece. Matching fabric-covered button earrings finish the ensemble.

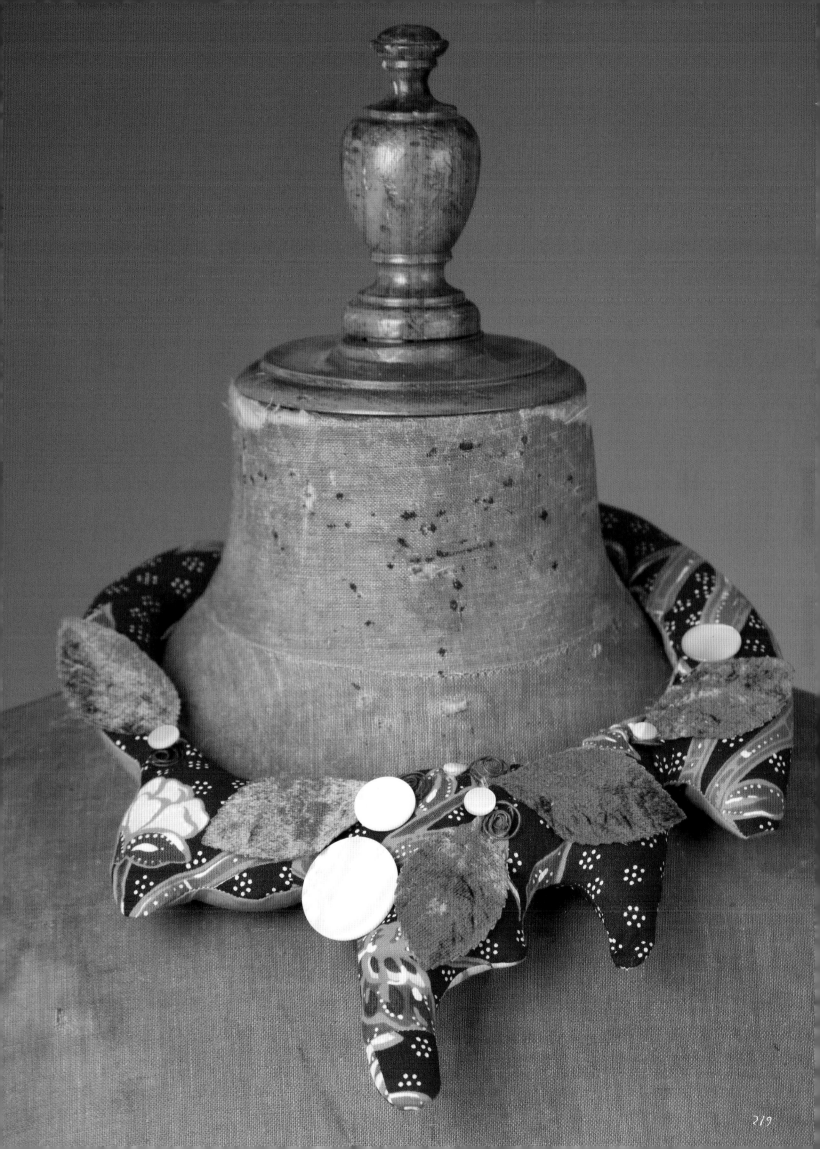

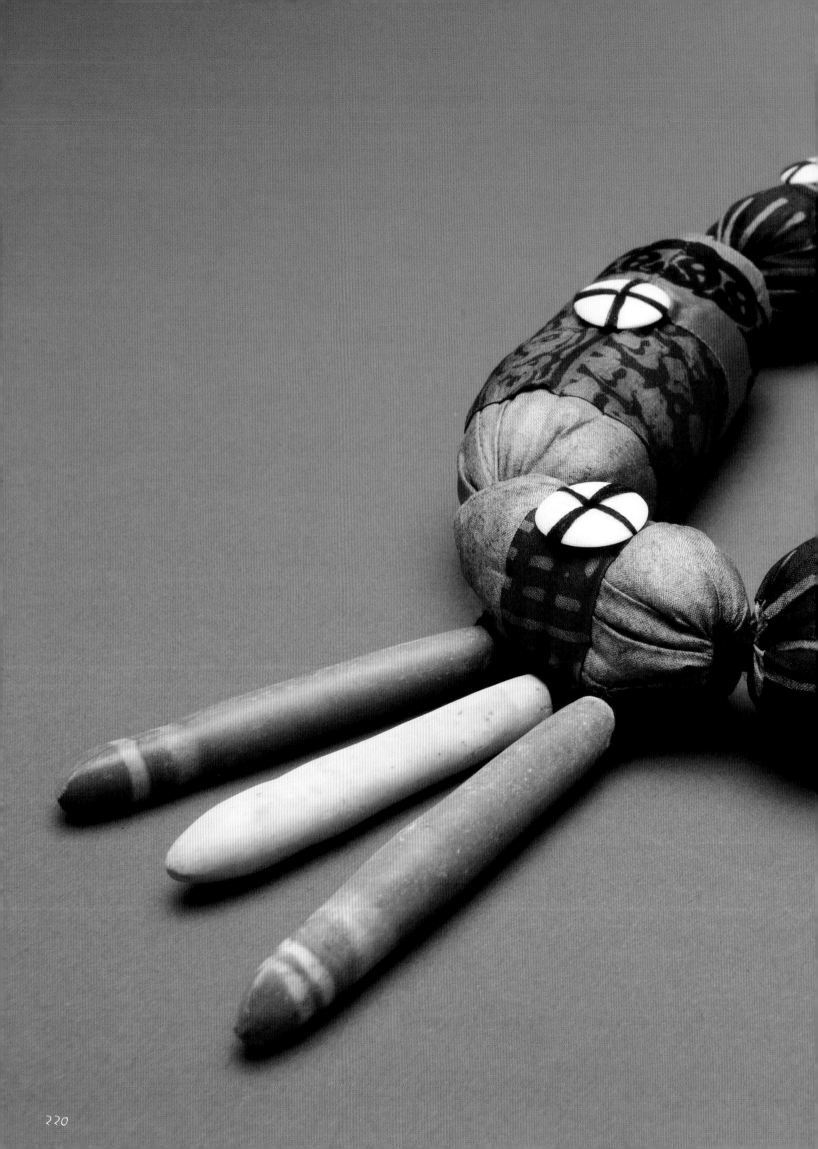

Printed Indian silk tubes are two inches in diameter and stuffed with cotton-polyester fiberfill to create a 32-inch sculptural neckpiece. Black cotton thread is wound tightly to wrap between each segment; I also used the same thread for contrasting stitches to hold white mother-of-pearl shell buttons and three dangling cylindrical seashells. A handmade brass hook-and-eye closure secures the exotic design.

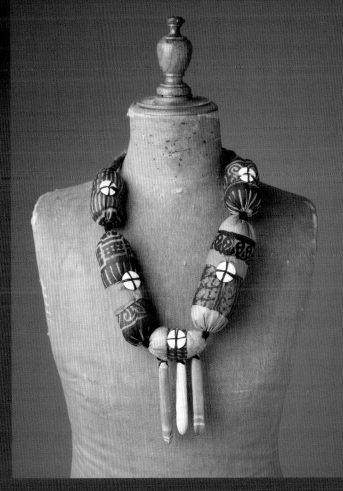

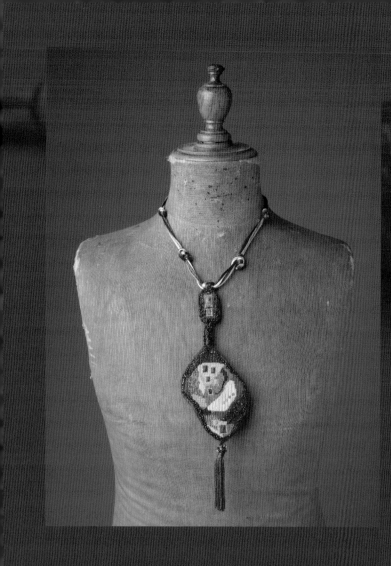

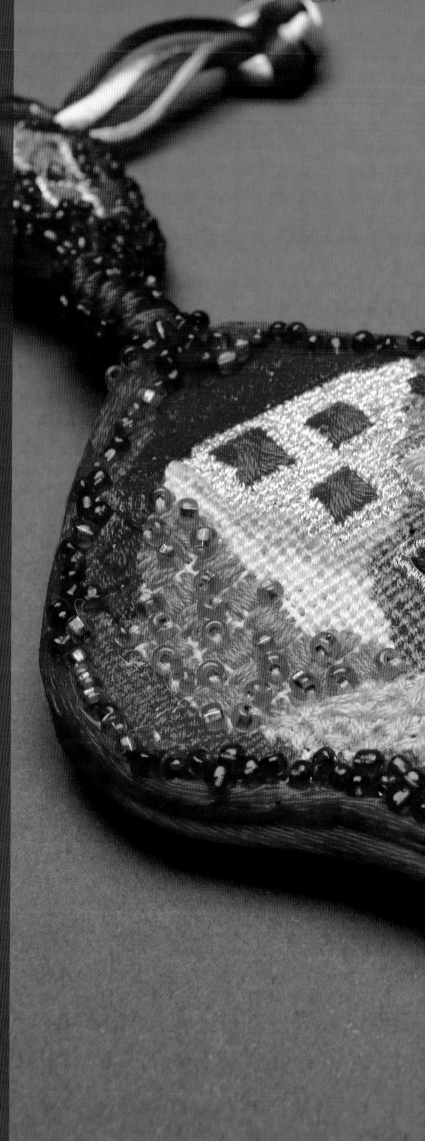

Needlework designs are intricate and time-intensive to make. I created this double pendant from cotton embroidery threads in shades of red, purple and orange. To form the necklace, four strands of rattail are twisted and knotted for interest. Tiny seed beads outline each pendant and a tassel flourish finishes the 20-inch-long piece. All of my closures are handmade and this necklace has a brass hook-and-ring fastener.

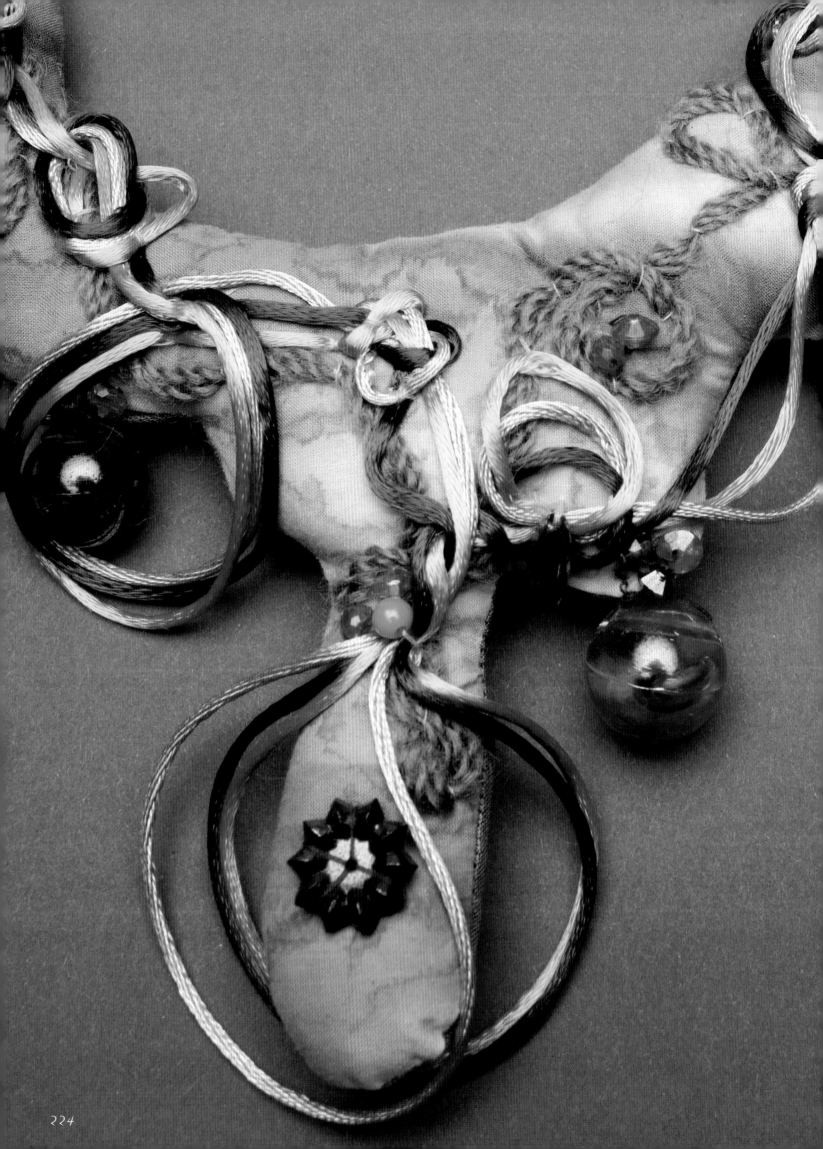

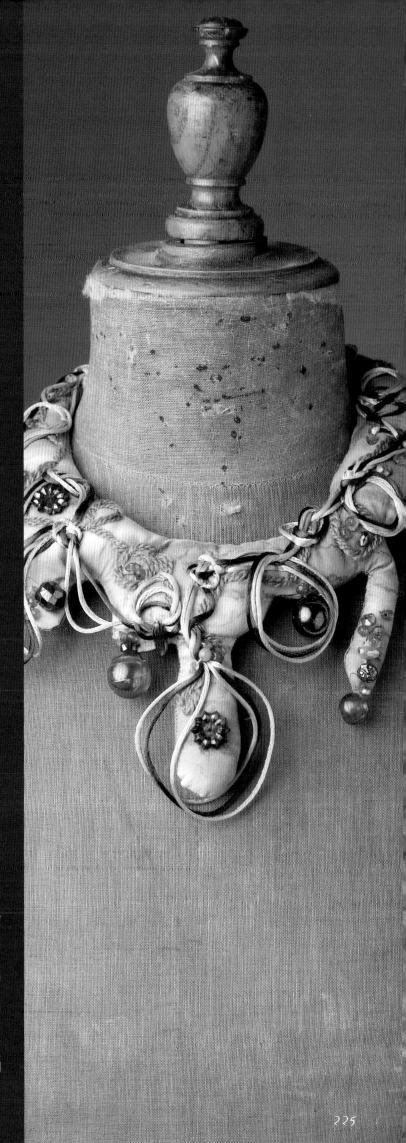

Beautiful fiber art accessories are meant to enhance an outfit with their one-of-a-kind appeal.

Pastel cotton batik in faded shades of blue, pink and purple make a softly feminine backdrop for rattail cording that I loosely looped and stitched to outline the neckpiece. Linen and cotton threads are also sewn on top of the sculptural collar-style creation. Trims include various iridescent, colored and shaped bluish beads. A simple fabric loop and bead fastener secures the necklace.

Since ancient times, dramatic handmade neck pieces have adorned both women and men in many cultures.

I used an ancient needle lace technique with cotton and wool threads to create this vibrant multicolored, textural neckpiece on my homemade pin loom. Decorative beads and a Chinese carved stone fish whistle are sewn on as embellishments to form the pendant drop. This 18.5-inch necklace slips over the head and no clasp is needed.

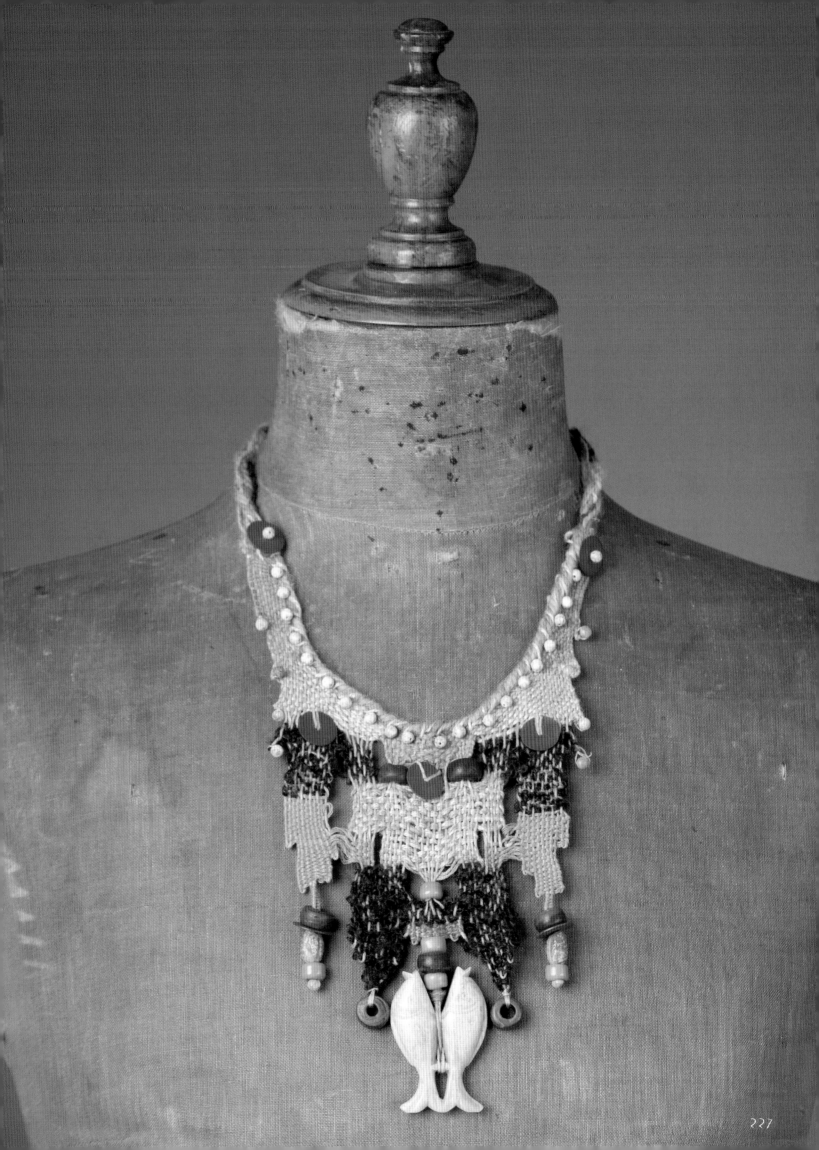

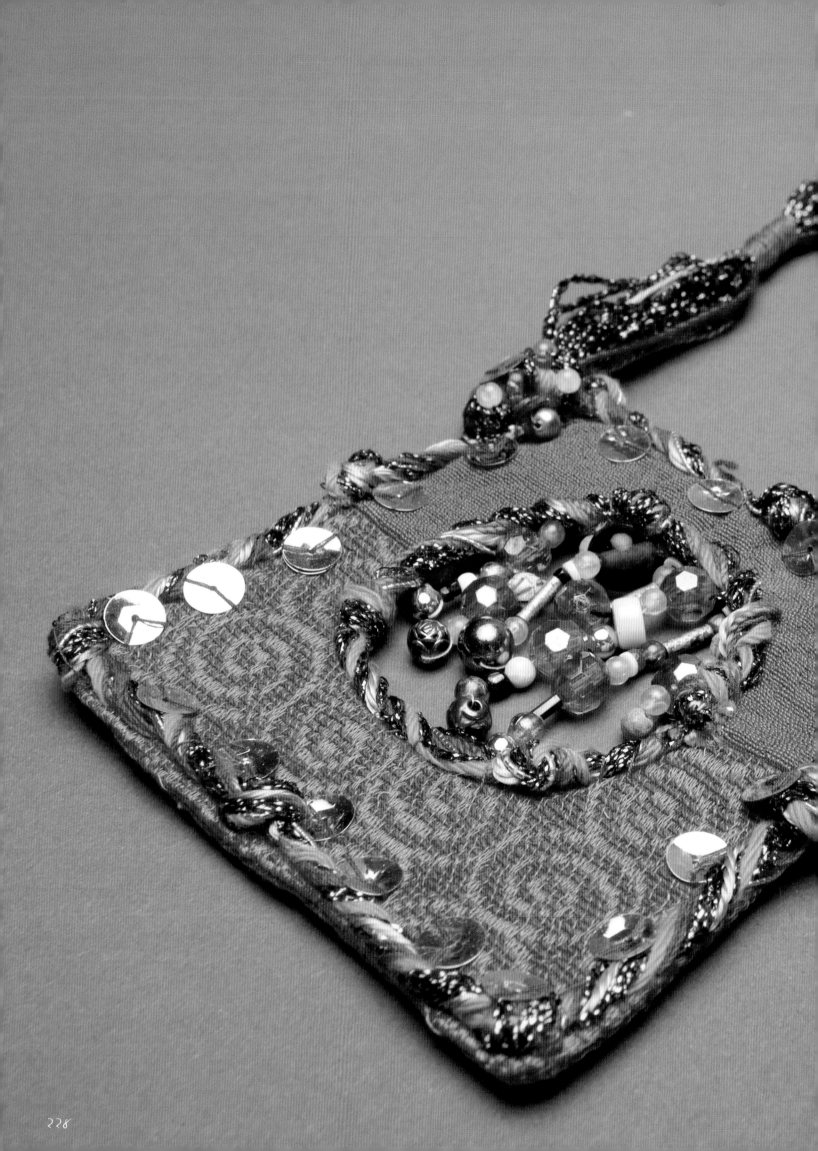

Red and orange cotton damask fabric was doubled to give body to the square pendant shape. I trimmed the middle openwork circle design with gold sequin-and-bead dangles, and then interlaced matching seed-beaded strands together with a "chain" made of various orange-colored threads. A brass fastener with hook-and-ring closure secures this architectural neckpiece.

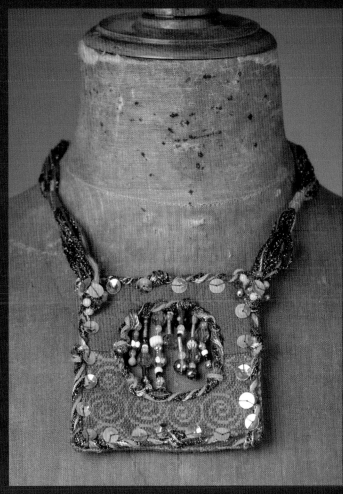

The age-old sewing arts of embroidery and beadwork add a luxurious quality to my original designs.

Inspired by a delicate fragment of Scalamandré silk, I created an oversized collar-style design in a gently scalloped shape with an adjustable single-bead gold cord neck band that also outlines the entire necklace. I embroidered fine wool, gold metallic and silk threads over the pastel fabric to enhance the texture. Old glass beads gracefully dangle from the unusual piece, which was on exhibition in New York City art galleries. This necklace is an over-the-head design.

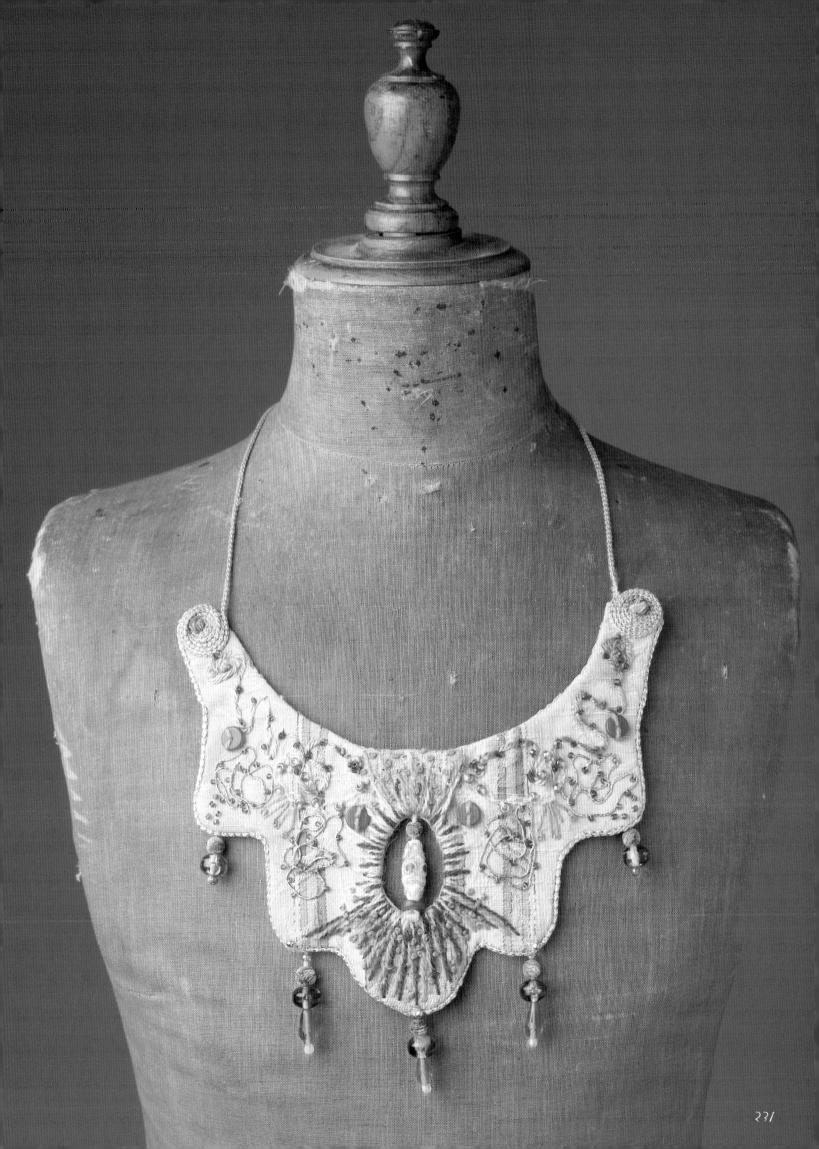

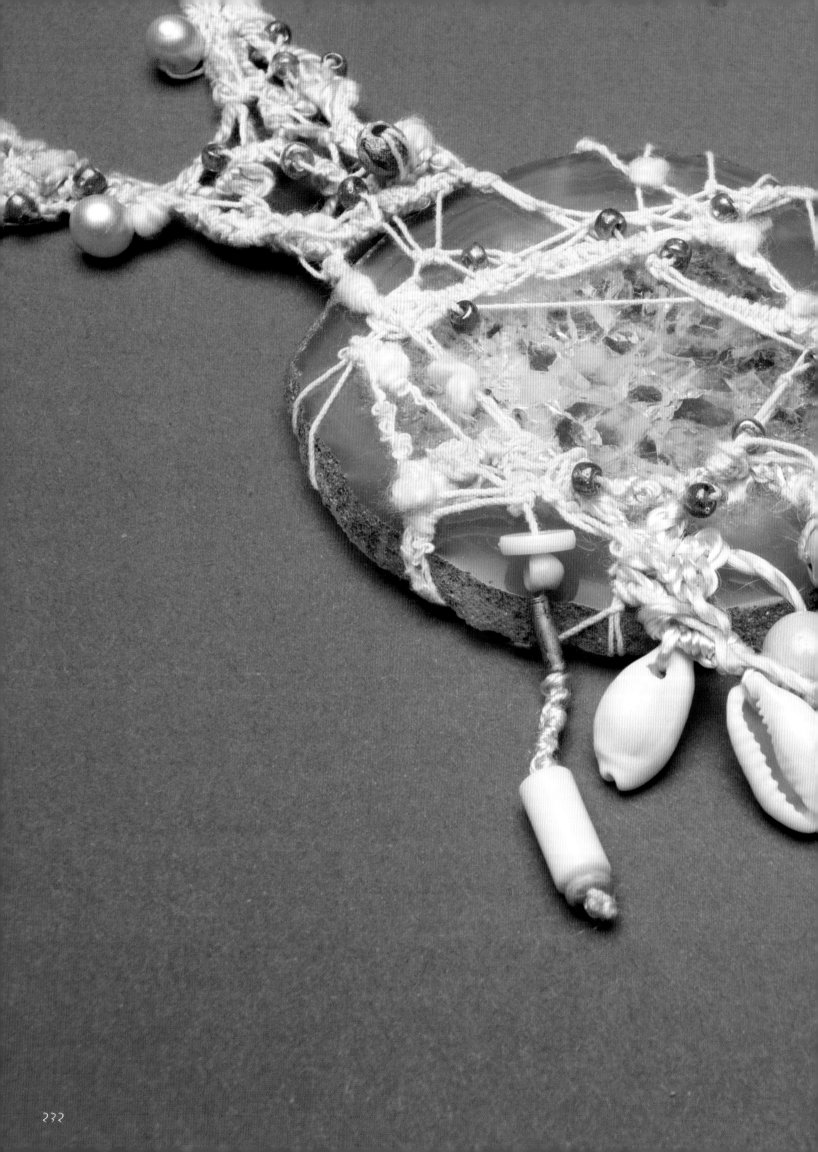

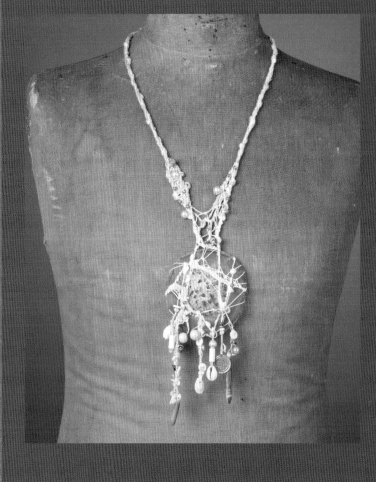

An agate geode slice with its crystalline formation is enhanced and held by a web-like needle lace technique. This ancient needlework method is done using undyed cotton threads. My necklace took many hours of labor once I invented the design, but I really loved the natural agate and wanted to enhance the stone. I sewed beads, small seashells and faux pearls randomly to the piece for added embellishment. A handmade brass hook-and-ring fastener secures the rather heavy pendant.

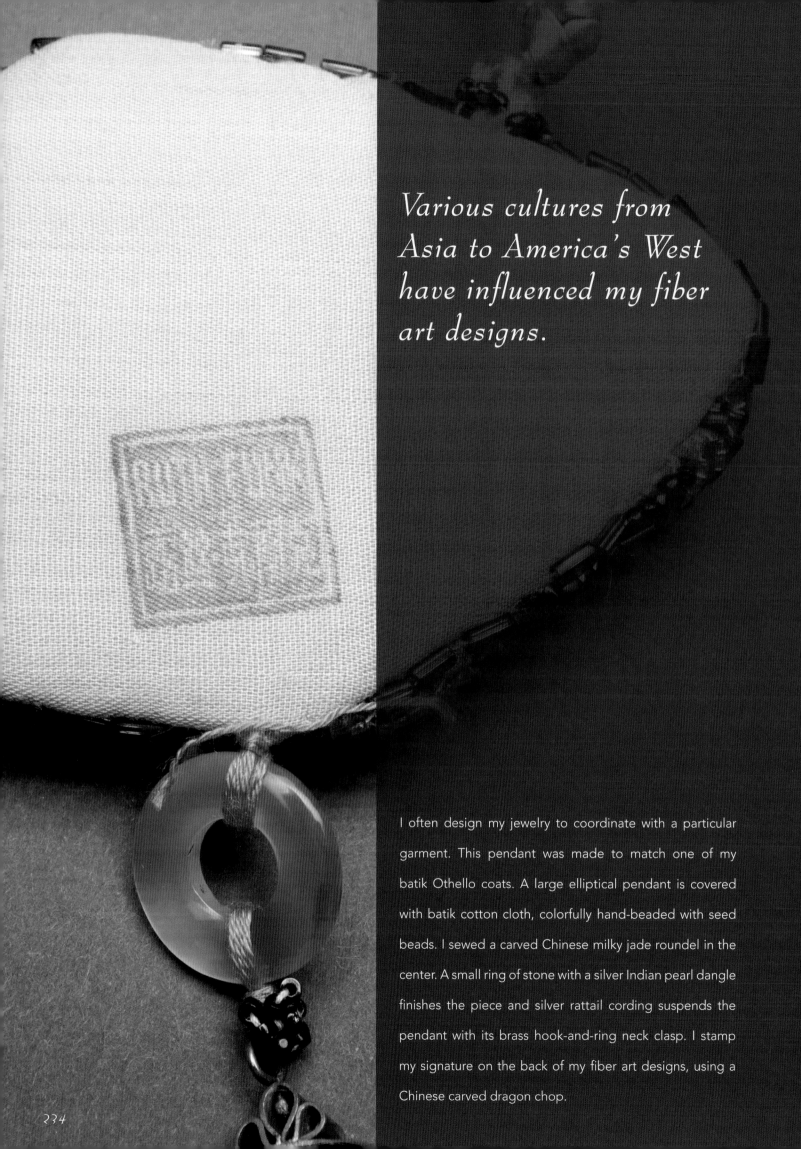

Various cultures from Asia to America's West have influenced my fiber art designs.

I often design my jewelry to coordinate with a particular garment. This pendant was made to match one of my batik Othello coats. A large elliptical pendant is covered with batik cotton cloth, colorfully hand-beaded with seed beads. I sewed a carved Chinese milky jade roundel in the center. A small ring of stone with a silver Indian pearl dangle finishes the piece and silver rattail cording suspends the pendant with its brass hook-and-ring neck clasp. I stamp my signature on the back of my fiber art designs, using a Chinese carved dragon chop.

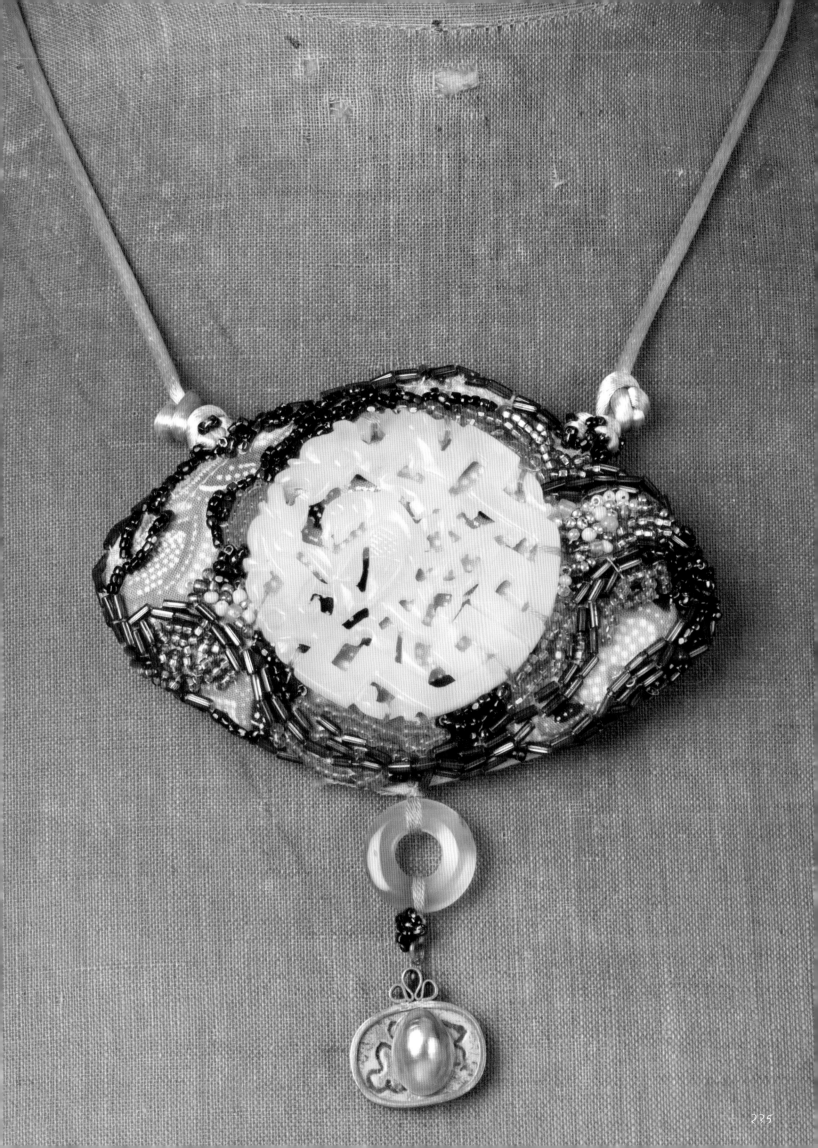

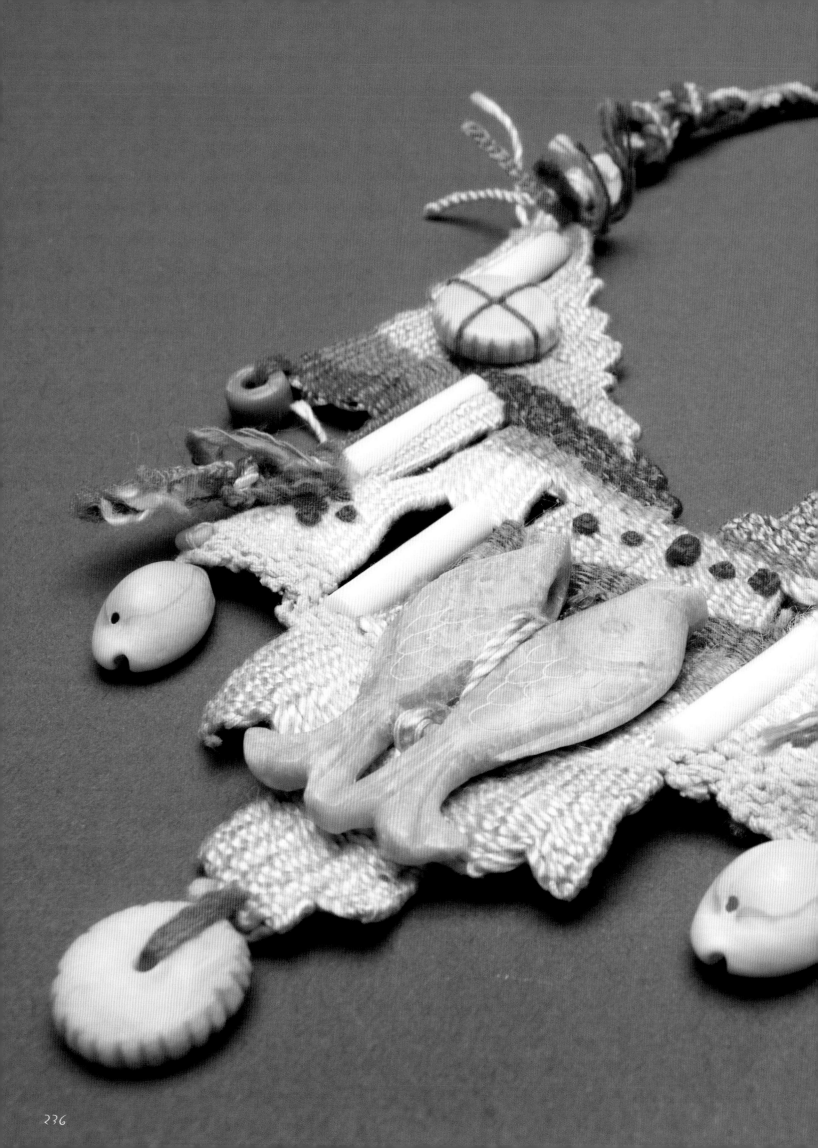

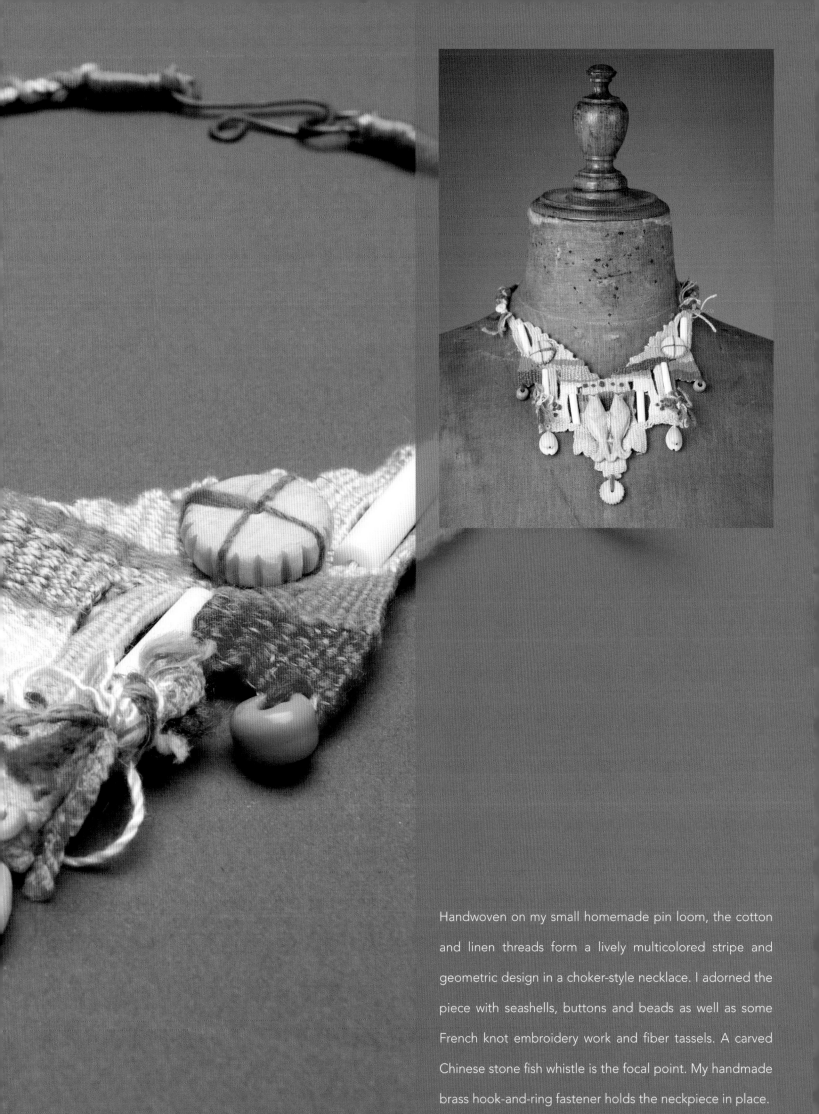

Handwoven on my small homemade pin loom, the cotton and linen threads form a lively multicolored stripe and geometric design in a choker-style necklace. I adorned the piece with seashells, buttons and beads as well as some French knot embroidery work and fiber tassels. A carved Chinese stone fish whistle is the focal point. My handmade brass hook-and-ring fastener holds the neckpiece in place.

*I am drawn to the
African culture's
primitive nature, which
often inspires my work.*

Once exhibited in an artist's cooperative gallery, my
interesting collar-style neckpiece displays a bit of ancient
tribal inspiration featuring a stuffed cotton fabric base
adorned with silver beads and loosely looped red rattail.
Natural spotted guinea fowl feathers sewn on by hand
add a primitive and festive touch. A classic loop and bead
closure clasps the necklace.

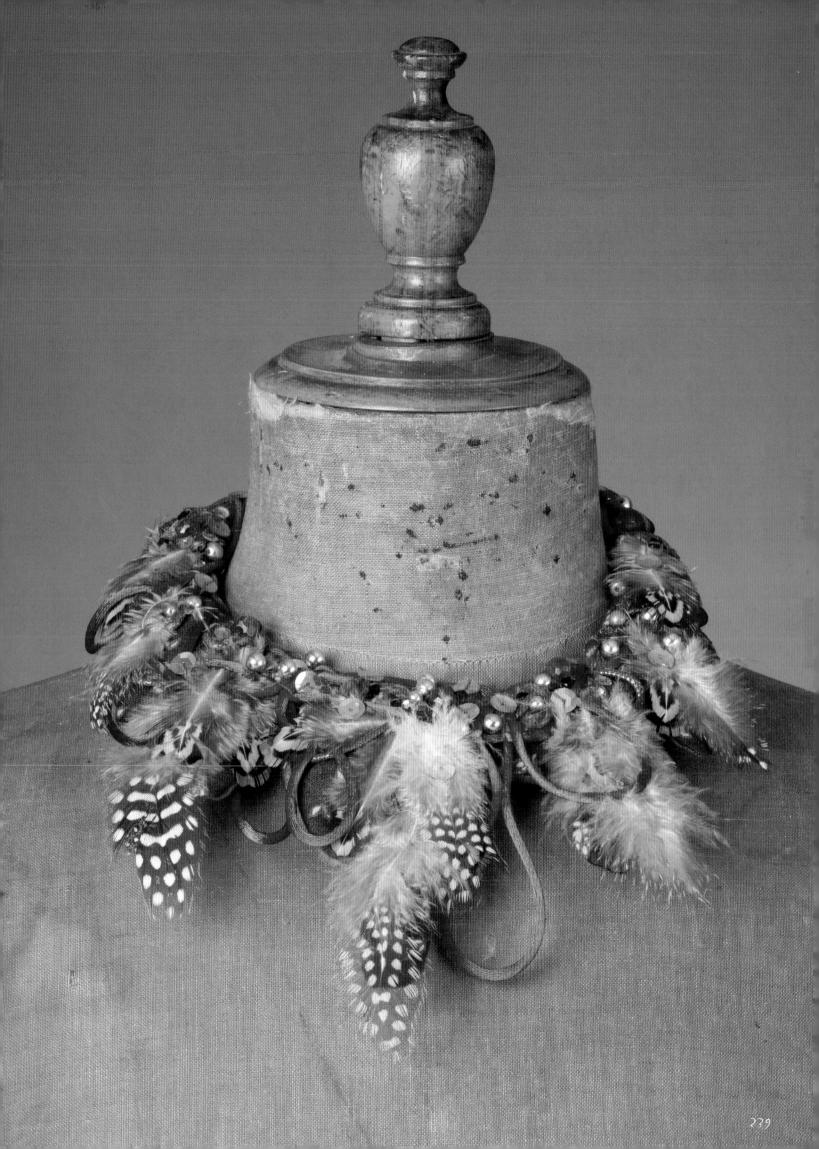

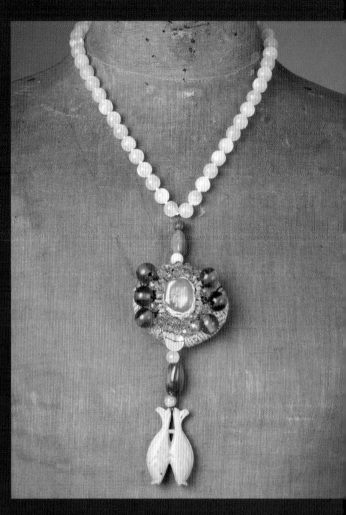

A strand of frosted glass round beads leads to a highly embellished pendant consisting of an oval-shaped fabric base with purple beads, threads and a faux jade center stone. Natural coral beads and a carved Chinese stone fish whistle—that I bought at an art museum gift shop in upstate New York—adorns the elegant 16-inch necklace with elongated pendant. A brass hook and ring closure secures the piece.

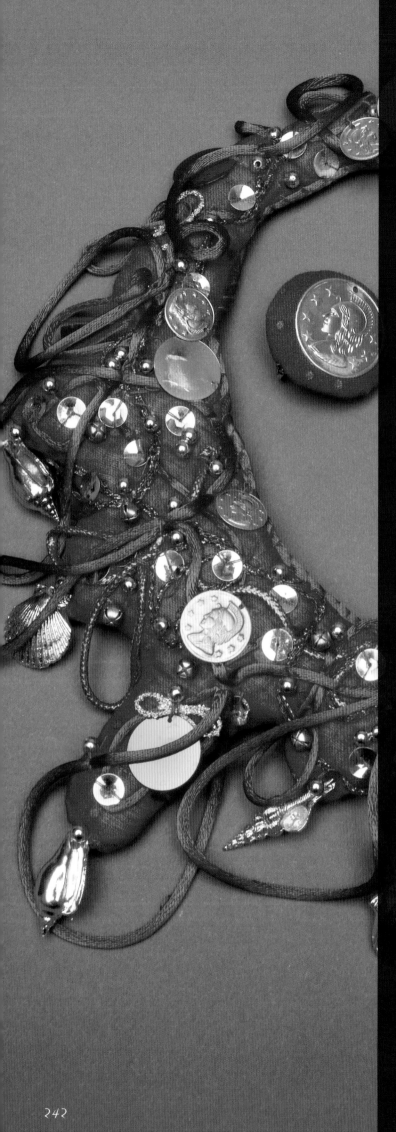

My collection of buttons, fabric swatches, coins, and even Chinese whistles, have become unlikely embellishments.

To design this dramatic collar-style neckpiece using my original pattern, I first formed the base from red cotton batik and stuffed the fabric with fiberfill for a sculptural effect. Then, I embellished the piece with red rattail cording, shiny copper Chinese coins, tiny gold beads and seashell charms. Wool yarn and beads are also sewn randomly on the piece. A coordinating gold chain loop with bead closure completes the necklace. Fabric covered button earrings have coin accents.

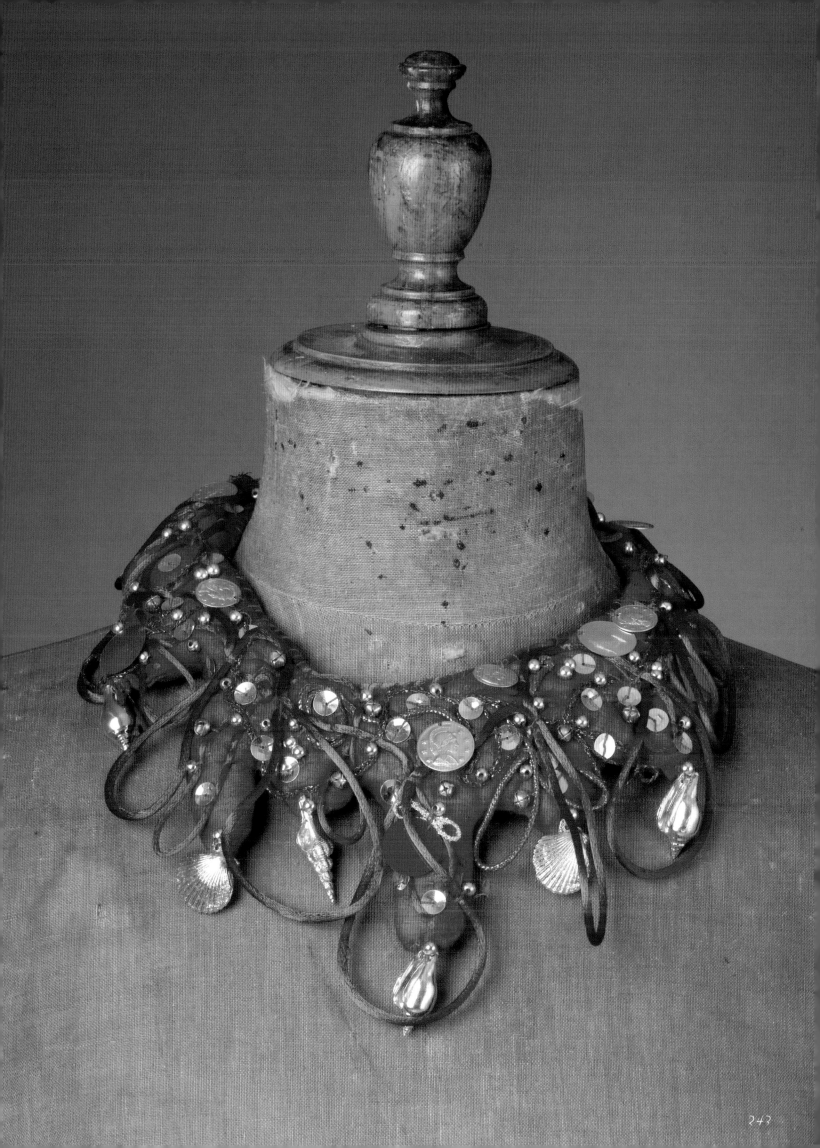

Increasingly rare African amber trade beads with thei
warm golden glow are wired together by softened-stee
stovepipe wire unintended for jewelry making, but often
used in sculpture. My unorthodox approach to this piece
made the jewelry more rustic and complements its antique
stones with the wound, wire medallion effect. Amber beads
were used as a means of monetary exchange at one time. A
silver clasp holds the necklace at the neck.

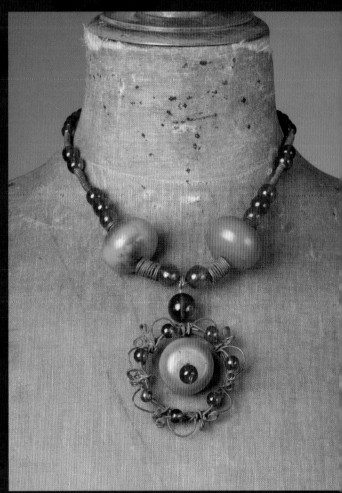

*The contrast of
antique elements with
modern embellishment
makes interesting and
timeless pieces.*

I formed cotton damask cloth with a triangle pattern of gray and pink on rosy pink to create a triangular shaped pendant. I added a dangle of beads to the top point and pewter crescent shapes from Africa to the bottom of the triangle. Rattail cording in blue and orange cotton combine with embroidery threads to hang around the neck. A hook-and-ring clasp secures the piece.

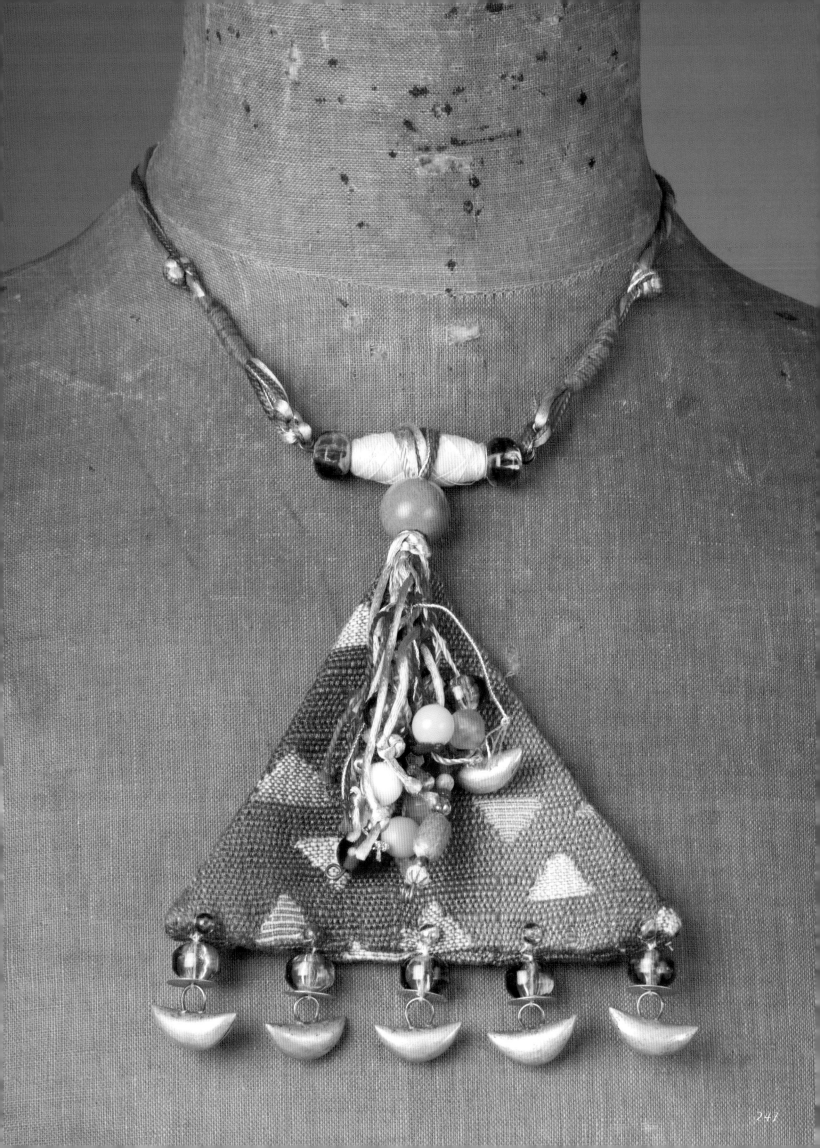

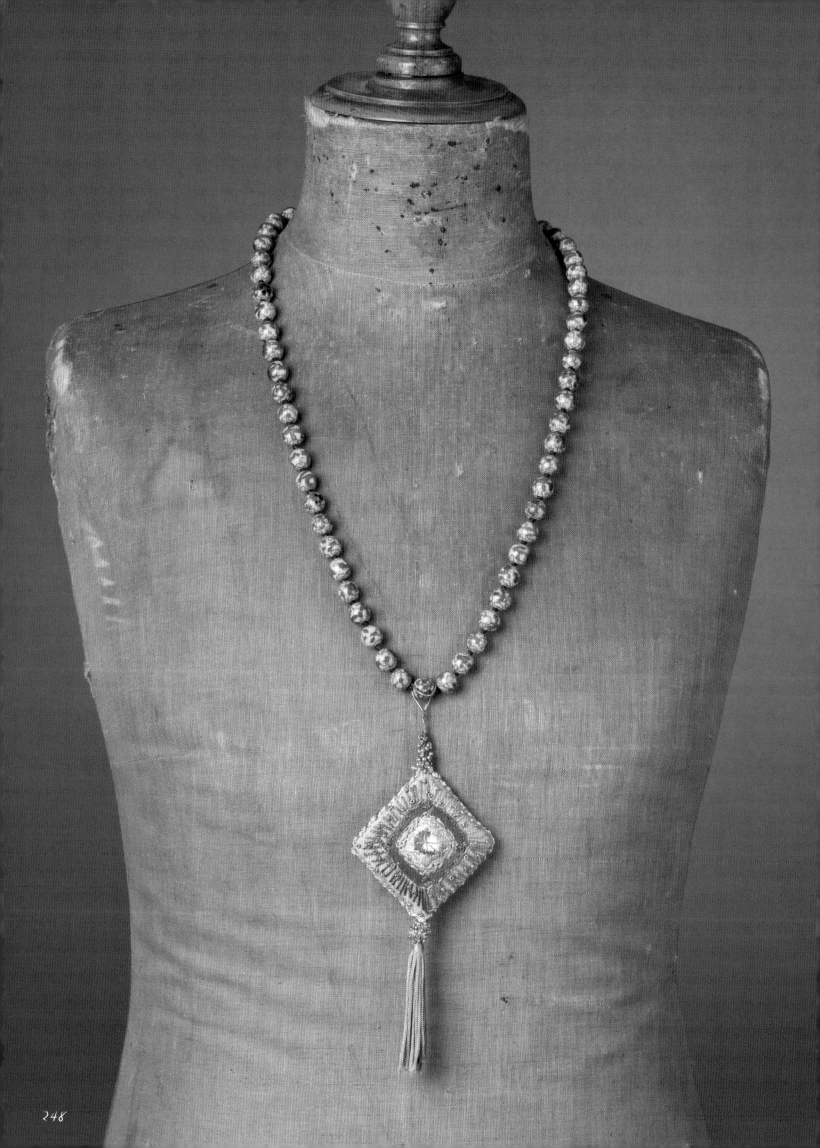

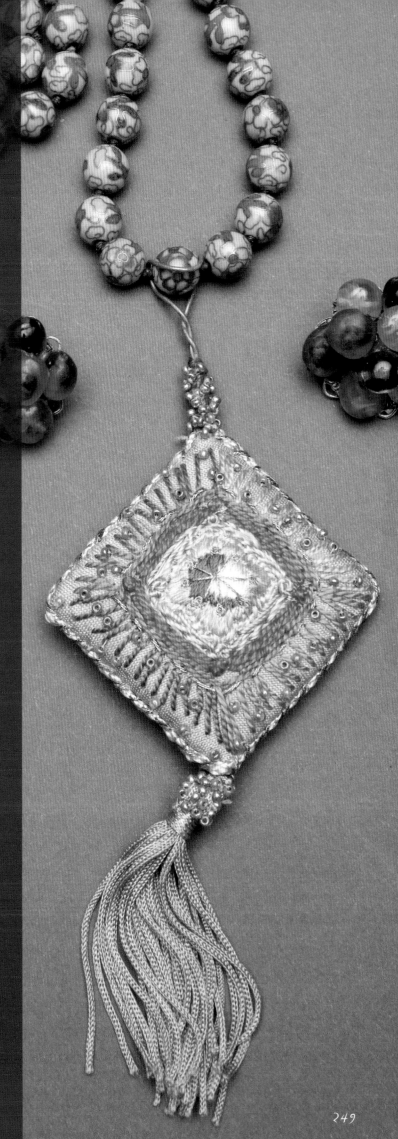

Like miniature works of art, my pendants possess color, texture, shape and fine craftsmanship.

When I visited China in 1986, I brought back a beautiful collection of blue, tan and green cloisonné enamel beads about half an inch in diameter, which became my inspiration for this neckpiece pendant. I also embroidered the green, blue and red diamond-shaped piece with silk and cotton threads and sewed on decorative seed beads as accents. This pendant is 25 inches long and has been on exhibit in several galleries. Blue bead earrings complete the look.

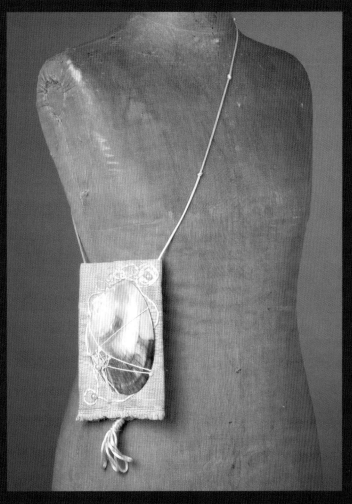

I loved the highly iridescent surface of a seashell, which inspired my purse design. This evening bag was based on an ancient Japanese concept of a purse-within-a-pocket construction, customarily worn on a garment's belt. Its outer pocket is made of cotton damask with one fringed edge and the central seashell is sewn onto the fabric. I added needle lace technique and faux pearl accents. The interior purse is made of striped orange cotton damask. I decorated it with embroidery floss, tiny beads, a slice of seashell and French knots. Its shoulder strap is made of silky rattail cording and a matching tassel trims the inner purse.

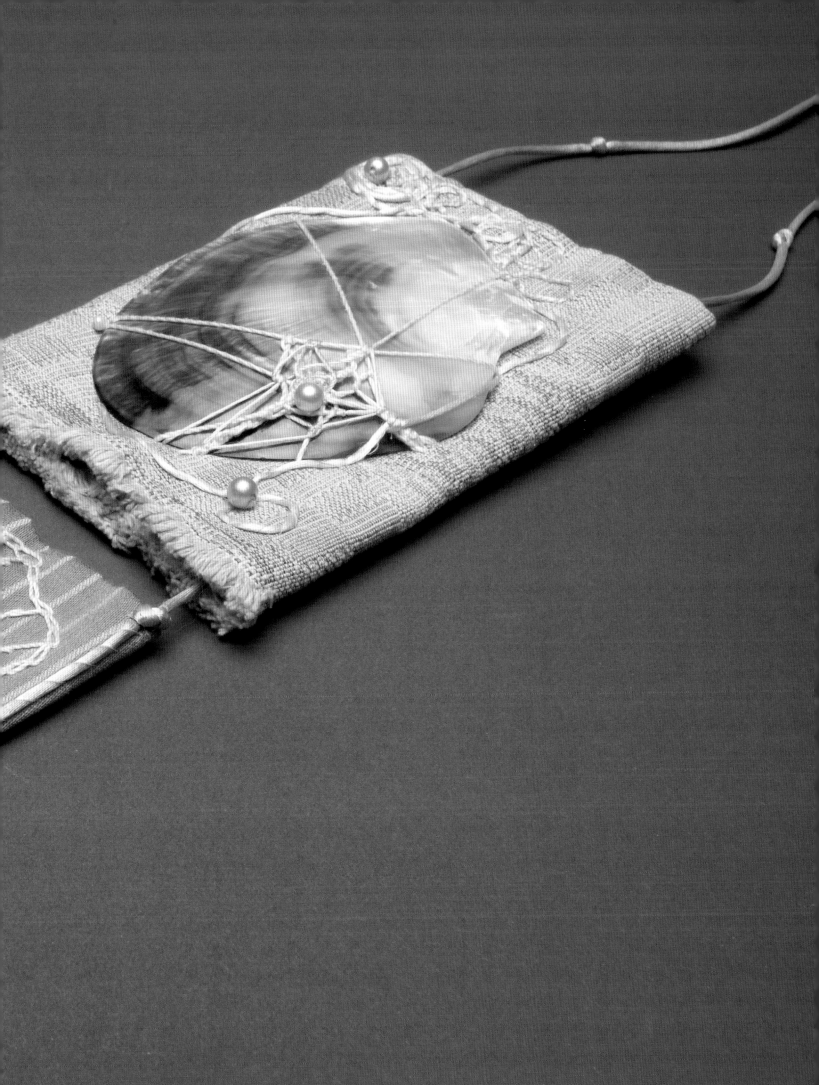

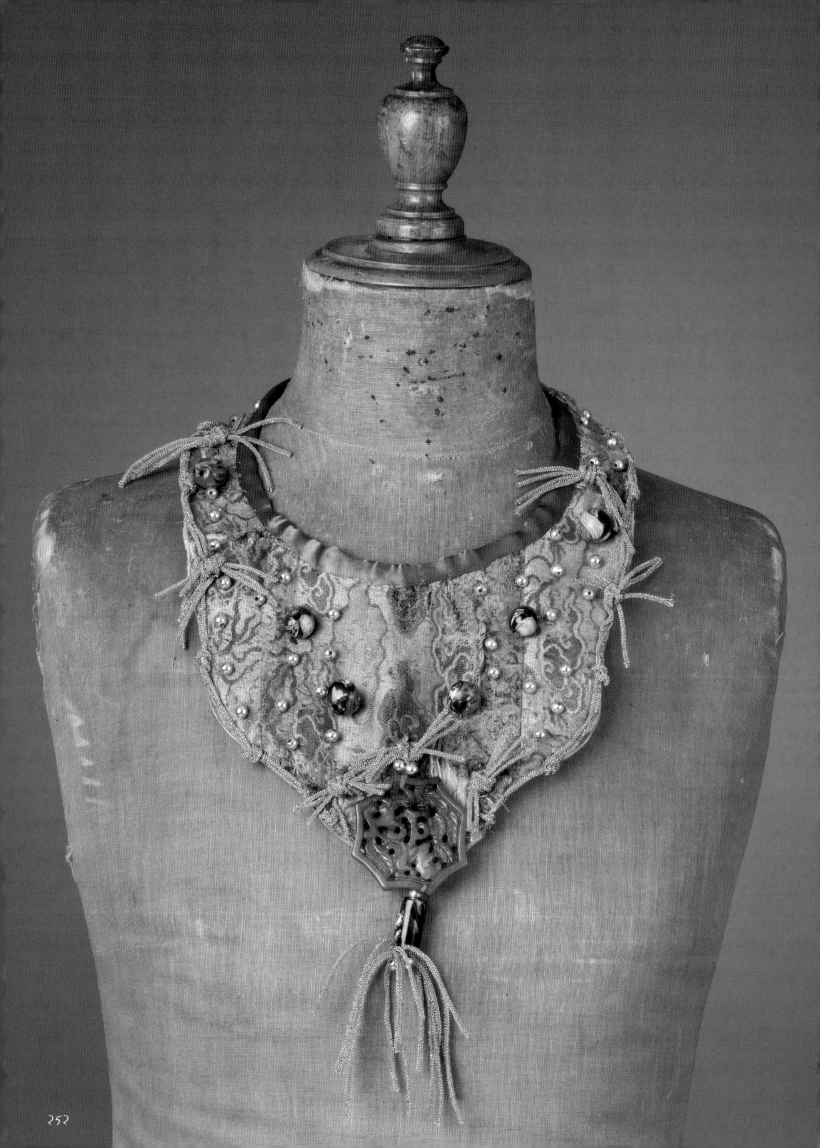

I may find a carved stone or slice of geode for inspiration, then the jewelry design evolves from nature's gift.

I never made my jewelry with the intention of selling it, but I have worn many pieces to events and galas. This flat, collar-style neckpiece features an interesting blue, gold and brown printed damask base trimmed with gold cording. Glass Italian beads and small silver beads embellish the piece. I sewed an octagon-shaped Chinese flat stone in deep brown to the bottom of the necklace as the centerpiece. The closure is a simple hook and ring.

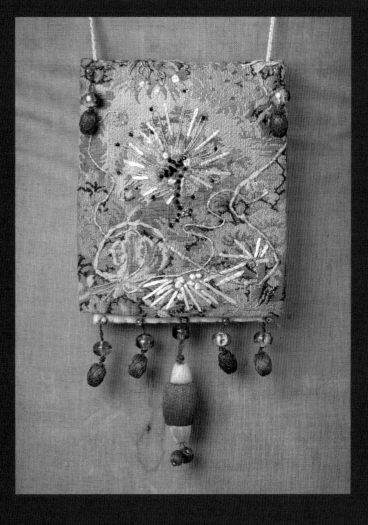

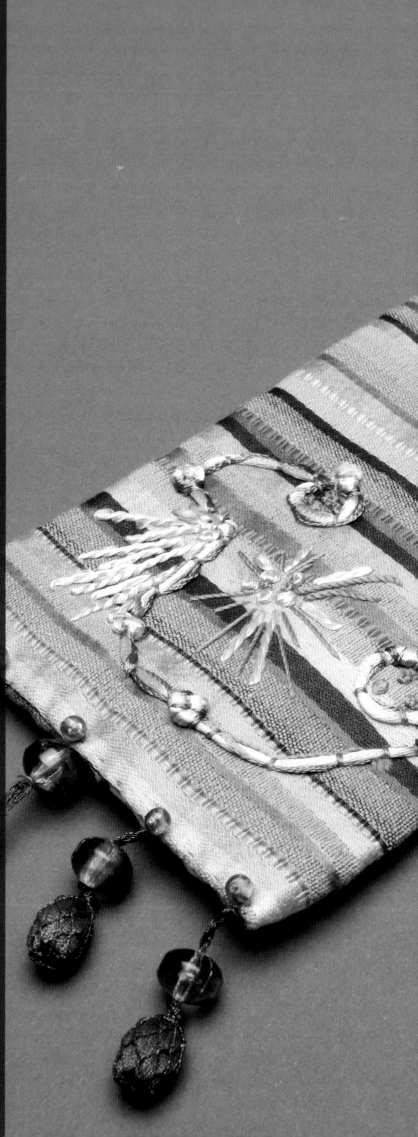

Asian inspired, the main pocket-purse is made from a vintage floral cotton damask remnant. I embellished the outer pocket with metal threads and embroidery floss in a starburst effect. I used vintage multicolored striped rayon to construct the inner purse. Embellishments include unusual antique beads along the bottom edge and colorful embroidery stitches. The purse hangs from gold metallic cording, which can be used as a shoulder strap or worn attached to a belt in the Japanese tradition.

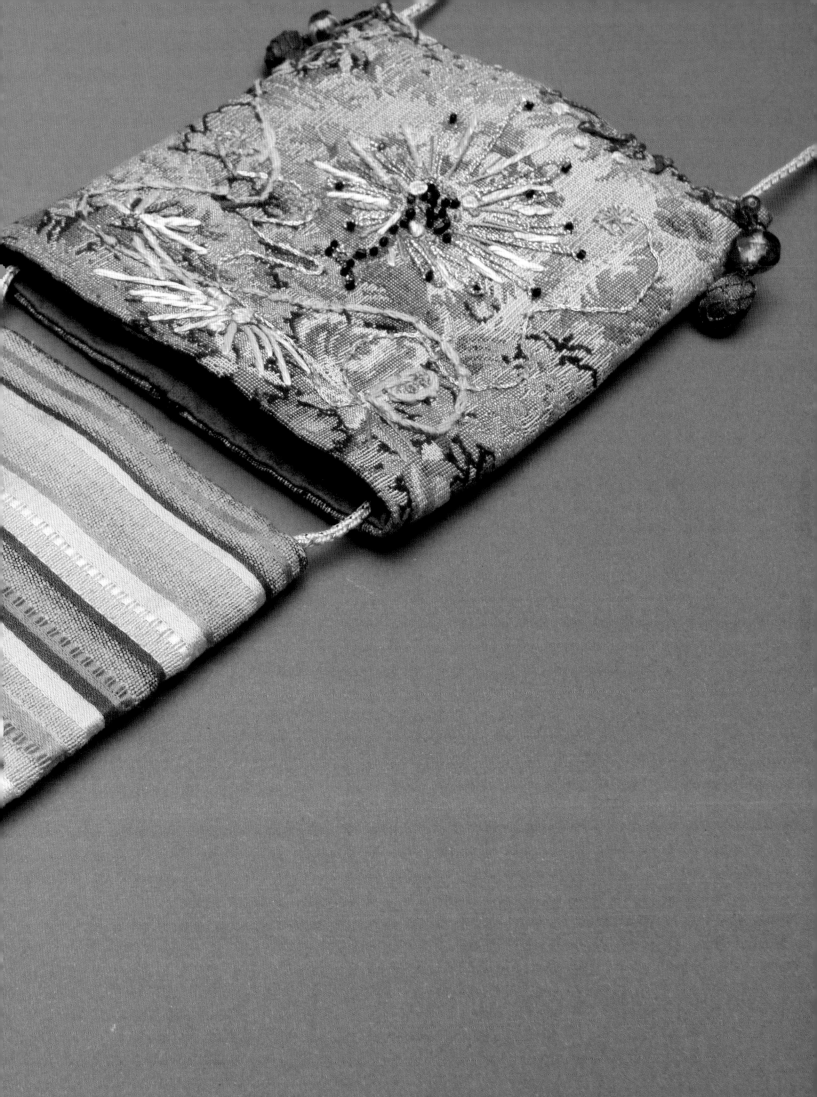

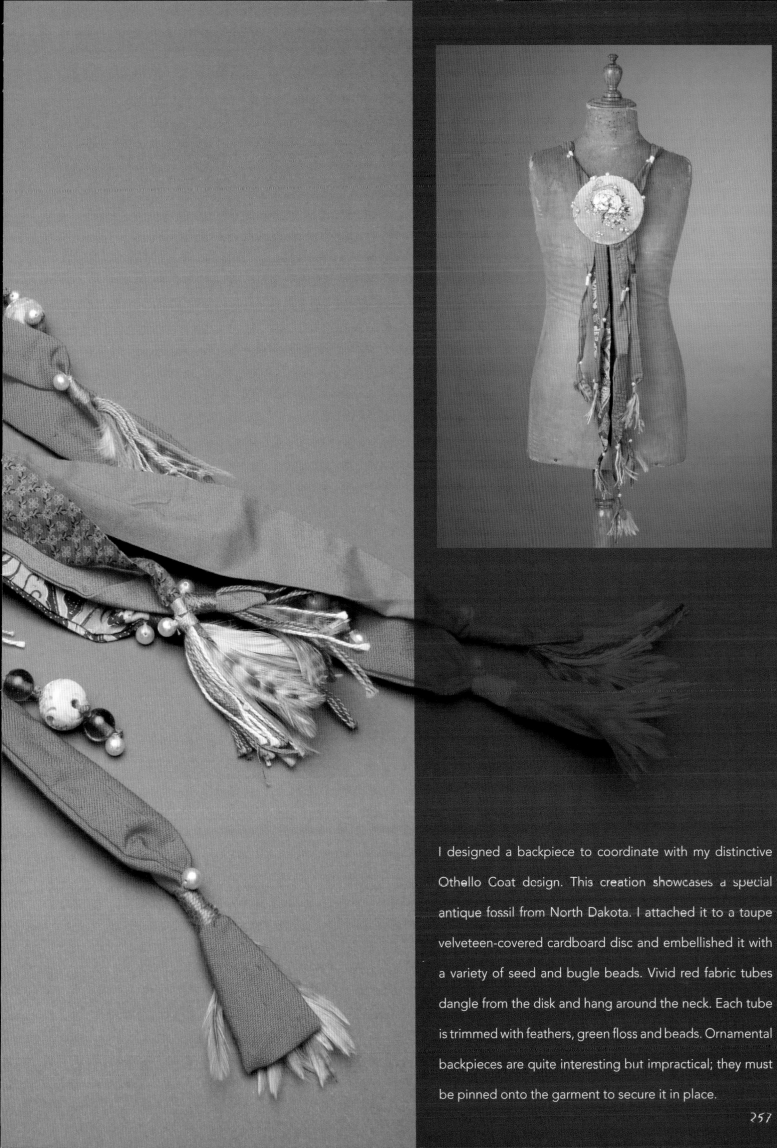

I designed a backpiece to coordinate with my distinctive Othello Coat design. This creation showcases a special antique fossil from North Dakota. I attached it to a taupe velveteen-covered cardboard disc and embellished it with a variety of seed and bugle beads. Vivid red fabric tubes dangle from the disk and hang around the neck. Each tube is trimmed with feathers, green floss and beads. Ornamental backpieces are quite interesting but impractical; they must be pinned onto the garment to secure it in place.

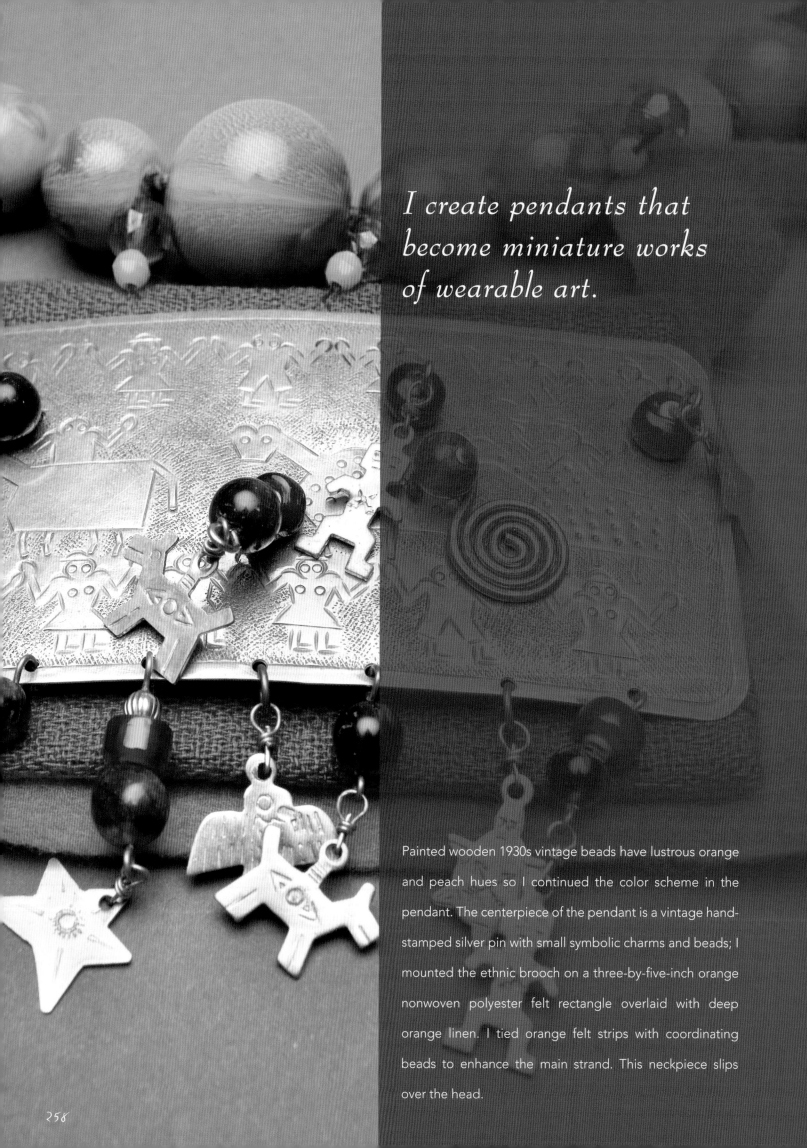

I create pendants that become miniature works of wearable art.

Painted wooden 1930s vintage beads have lustrous orange and peach hues so I continued the color scheme in the pendant. The centerpiece of the pendant is a vintage hand-stamped silver pin with small symbolic charms and beads; I mounted the ethnic brooch on a three-by-five-inch orange nonwoven polyester felt rectangle overlaid with deep orange linen. I tied orange felt strips with coordinating beads to enhance the main strand. This neckpiece slips over the head.

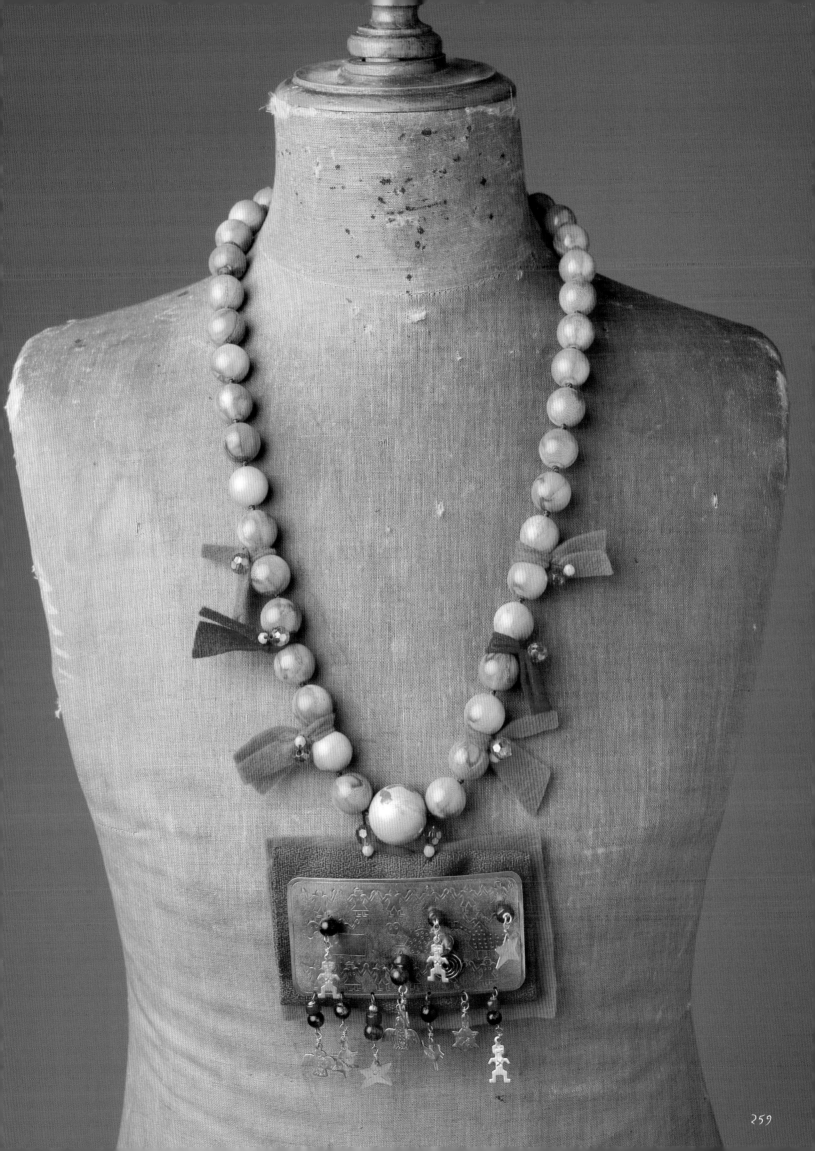

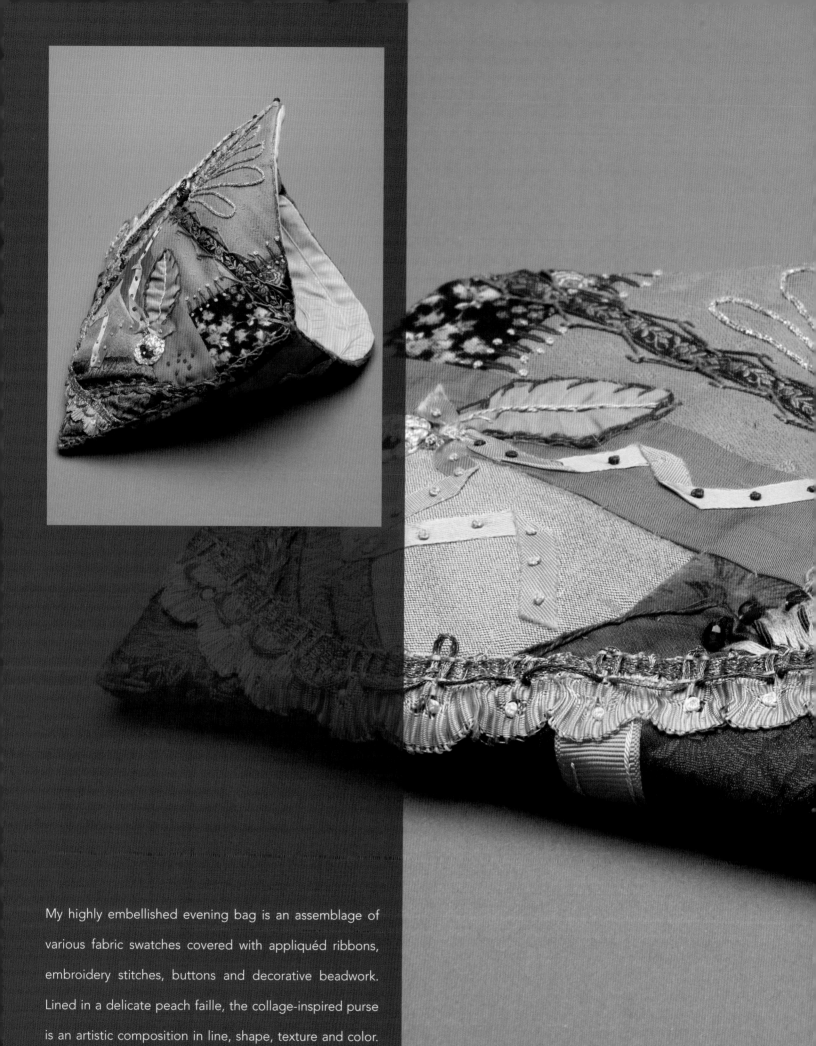

My highly embellished evening bag is an assemblage of
various fabric swatches covered with appliquéd ribbons,
embroidery stitches, buttons and decorative beadwork.
Lined in a delicate peach faille, the collage-inspired purse
is an artistic composition in line, shape, texture and color.
My classic clutch purse construction features a commercial
closure that snaps shut to secure its contents.

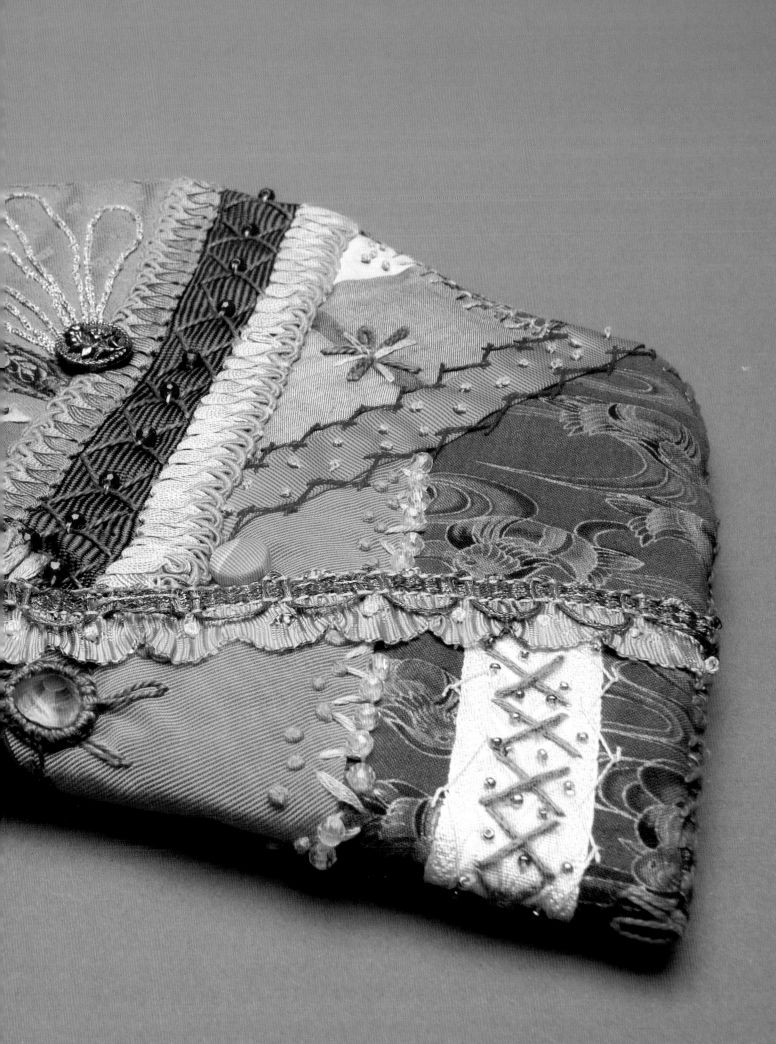

GLOSSARY

Definitions as applied to textiles and fiber art.

Reference

Acrylic Quick-drying, lightweight synthetic textile fiber made by polymerization of acrylonitrile. A fine, soft and luxurious fabric with the bulk and hand of wool.

Alizarin Orange or red natural crystalline compound also made synthetically and used to make red dyes and pigments.

Appliqué Cutout cloth decoration or shape hand-sewn to a larger piece of material.

Art-to-Wear Creative movement originating in the 1960s that refers to individually designed pieces of handmade clothing or jewelry created as fine or expressive art. Wearable and often sold or exhibited in galleries.

Asante Also known as Kente cloth made in Guana. Woven in narrow warp strips of rayon or silk, this textile begins and ends with five design blocks. The name for each Kente pattern is derived from the warp striping, though the designs in the weft are also significant.

Asasia Kente cloth made in Guana. The Ashanti aristocracy dressed in prestigious gold artifacts and silk textiles; most elaborate cloths, called asasia, were reserved for the king.

Aubusson Decorative tapestry or pileless, densely patterned carpet woven in Aubusson, France, or those similar to the ones made there.

Bargello Needlepoint stitch that produces zigzag lines. The technique is named after the Bargello, a museum in Florence, Italy, which exhibits chairs upholstered in fabric worked in this stitch.

Batik A printed fabric created using the "resist-dye" technique, an Indonesian method of hand-printing textiles by coating the areas not to be dyed with hot wax.

Beadwork Hand-sewn ornamentation using beads.

Berber Thick, heavy covering for a floor, usually made of woven wool or synthetic fibers.

Bernina A sewing machine made in Switzerland known as a preferred professional brand with high-quality performance.

Binding The finished seam or hem of a garment created by stitching on an edging, band or trim. A separate band of body fabric sewn on and turned down so the attaching seam is not visible.

Block Printed The technique by which hand-carved wooden blocks covered with dye are repeatedly pressed along a length of cloth to create patterns.

Bouclé Fabric of uneven yarn that has a knobby woven effect.

Braid A woven narrow band made by interworking a group of warp strands together diagonally across the width of the fabric usually used for trim and decoration.

Brocade A class of richly decorative, shuttle-woven fabrics that have the look of being embossed. Often made in colored silks and with gold and silver threads.

Burlap Coarse, woven fabric usually made from jute fibers and vegetable fibers.

Calico Printed cotton fabric with a small, overall pattern that is often floral.

Cambric Also known as chambray. Lightweight cotton cloth used as fabric for lace and needlework. Cambric, also known as batiste, was first used in Cambria, France.

Cashmere Wool fiber obtained from the cashmere goat. Fine in texture, strong, light, and soft, and when made into garments, warmer than the equivalent weight in sheep's wool.

Cellulose Obtained from wood pulp and cotton, mainly used to produce cardboard and paper and derivative products such as rayon fabric.

Challis Usually printed with pattern, the soft, lightweight fabric is made of wool, cotton or rayon.

Chintz Modern chintz is lightweight, calico cotton cloth printed with bright overall floral patterns on a light background.

Cochineal The name of both crimson or carmine dye and the cochineal insect from which the dye is derived. After synthetic pigments and dyes such as alizarin were invented in the late 19th century, natural-dye production diminished.

Collage A work of visual art, made from an assemblage of different forms and shapes glued to a surface of paper, canvas or fabric, thus creating a new whole.

Combing A method of preparing fiber for spinning by use of combs. The combs used have long metal teeth; one comb holds the fiber while the other is moved through, slowly transferring the fiber to the moving comb. This preparation is commonly used to spin a worsted yarn.

Cording An edge finishing sometimes called piping; cording is wrapped in fabric and sewn, then attached as trim.

Corduroy A textile composed of twisted fibers that, when woven, lie parallel to one another to form the cloth's distinct pattern called a "cord." Modern corduroy is composed of tufted cords, sometimes with a channel between the tufts. A ridged form of velvet.

Cotton Derived from a shrub native to tropical and subtropical regions around the world. The fiber is spun into yarn or thread and woven to make a soft, breathable textile, which is the most widely used natural-fiber cloth.

Couching In embroidery, couching and laid work are techniques in which yarn or other materials are laid across the surface of the ground fabric and fastened in place with small stitches of the same or a different yarn. When couching threads contrast with laid threads, patterns may be worked in the couching stitches.

Couture The art of designing and making fashionable women's clothing, often one-of-a-kind creations. The term comes from the French word *cousture* meaning "sewing."

Crêpe A type of woven or knitted fabric with a wrinkled surface. Thin crêpe is called crêpe de Chine, which means Chinese crêpe.

Cretonne A heavy, unglazed cotton, linen or rayon fabric, colorfully printed and used for draperies and slipcovers.

Crewel A decorative form of surface embroidery using wool and a variety of different embroidery stitches to follow a design outline applied to the fabric. The technique is at least a thousand years old.

Crochet A process of creating fabric from yarn or thread using a crochet hook. Similar to knitting, crocheting consists of pulling loops of yarn through other loops.

Cut Velvet The most common type of velvet is a plain weave with a deep-cut pile. Characterized by a soft quality, it comes in rich colors and is typically used in formal wear. Cut velvet has a pattern cut out from around uncut loops of pile.

Cutwork Openwork embroidery in which the ground fabric is cut away from the design.

Damask An ornamental fabric of silk, wool, linen, cotton or synthetic fibers with a pattern formed by weaving. Made with one warp and one weft in which warp-satin and weft sateen weaves interchange.

Dhurrie A flat-woven cotton rug made in India.

Discharge Sewing machine presser-foot mechanism that releases the fabric after a seam is stitched.

Double-Needle Technique Machine-stitching technique that uses the double needle to create two rows of stitching on the garment right side and forms a zigzag stitch on the garment wrong side.

Embellishments Anything that adds design interest to a piece; they can be sewn or glued to the garment or fiber art design.

Embroidery The art of decorating fabric with designs stitched in strands of thread, floss or yarn using a needle. Beads and sequins are often a part of the design.

Eyelet A small hole edged with embroidered stitches as part of a fabric design.

Faille A somewhat shiny, closely woven silk, rayon or cotton fabric characterized by slight ribs in the weft.

Felt Versatile nonwoven textile usually made from tightly pressed acrylic or wool fibers. It does not fray or unravel and is often used for handicrafts.

Fiber Art Fine art style that uses textiles such as fabric, yarn, natural and synthetic fibers to create art, jewelry and clothing. It focuses on tactile materials and the handcrafted nature as part of its significance.

Fimo® Clay Invented by Eberhard-Faber, the polymer modeling clay can be molded into any shape or design, and after baking, can be drilled, sliced, cut, sanded or painted. The product is most commonly used to create beads and embellishments.

Fine-Gauge Netting A semi-sheer, net-type fabric, also called illusion. Often used for skirts and veils in clothing, decorative elements in crafts and collages. It may also be called net or tulle.

Flax One of the oldest fiber crops in the world. The use of flax for the production of linen goes back 5,000 years. Flax fiber is soft, lustrous and flexible. It is stronger than cotton fiber but less elastic

Floss Embroidery floss is thread composed of six loosely twisted strands available in cotton, silk and rayon. Strands can be separated to create varied thicknesses as desired.

Fly Shuttle The flying shuttle was developed by John Kay in 1733. Its invention was one of the key developments in weaving that helped fuel the Industrial Revolution. When weaving on a loom, the shuttle carries the weft yarn across the loom through the shed formed by the raised warp threads to form the fabric.

Fragment Small piece or remnant, usually of a fragile or antique fabric.

Fringe An ornamental border consisting of the ends of the warp, projecting beyond the woven fabric. It is usually made separately and sewed on, consisting of projecting ends, twisted or plaited together or as loose threads of wool, silk or linen.

Frog Closure Chinese-style sewing notion used like a button to close a garment. The splaying knotwork closures are often highly ornamental and made of rich braid, rayon or metallic cord.

Gauze Lightweight, open-weave fabric of cotton or silk made by either a loose plain weave or leno weave technique.

Georgette Traditionally a strong sheer silk with a matte crinkle surface. Durable, yet drapes gracefully. The crêpe-like texture feels slightly rough and dull, but gives the fabric a bouncy, flowing look.

Gimp A narrow flat braid or rounded cord of fabric used for trim.

Grosgrain Ribbon A closely woven silk or rayon fabric with narrow horizontal ribs; a ribbon made of this fabric.

Haik A large piece of cotton, silk or wool cloth worn as an outer garment in Morocco.

Handwoven Material woven on a hand-operated loom. The uneven quality of the material is highly prized for certain types of garments.

Herringbone A pattern consisting of rows of short, slanted parallel lines with the direction of the slant alternating row by row and used in embroidery and weaving. A twilled fabric woven in this pattern.

Ikat A style of weaving that uses a tie-dye process on either the warp or weft before the threads are woven to create a pattern or design. A double Ikat is when both the warp and the weft are tie-dyed. Designs appear similar to blurred water reflections.

Indigo Indigo-dyed textiles are valued for their deep blue color made of dyestuff extracted from plants by boiling. Indigo dying was used from 2500 B.C. until synthetic aniline dyes became available.

Jacquard Fabric of intricate variegated weave or pattern such as brocade, damask and matelasse.

Kashmir Also known as cashmere. Textiles of wool or silk handwoven on looms in Kashmir, India, and made into luxurious shawls.

Kelim/Kilim Flatwoven tribal rugs constructed in a tapestry weave.

Kente Handwoven on a horizontal treadle loom, Kente is a brightly patterned, ceremonial cloth of the Ashanti.

Khadi A coarse homespun, handwoven cotton cloth made in India. The raw materials may include cotton, silk or wool, which are spun into threads on a spinning wheel.

Kimono Traditional Japanese T-shaped, straight-line robes that fall to the ankle, with banded collars and wide, full-length sleeves. The garment is secured by a wide belt called an Obi.

Knitting A method by which thread or yarn may be turned into cloth. Hand knitting consists of loops called stitches pulled through each other with a special needle.

Kuba Cloth Authentic African Kuba cloth is a decorative fabric woven from natural raffia palm leaves, often geometric or abstract in design.

Kuba Velvet Fragile raffia fibers are woven, embroidered, appliquéd and tufted into beautiful cloth. The tufted technique forms a velvety texture.

Lace A lightweight openwork thread pattern, made by machine or by hand. Lace-making includes bobbin, needle lace and tatting techniques.

Lamé Brocaded fabric woven with metallic threads, often of gold or silver with a distinctive sheen.

Lawn A plain weave textile, originally linen but now chiefly cotton. Lawn is designed using fine, high-count yarns, which results in a silky feel.

Linen A lightweight, natural fabric woven with fibers from the flax plant.

Loom Machine or device used for weaving thread or yarn into textiles.

Maasai A common African textile woven and beaded by the Maasai people.

Mandarin Collar Narrow, upright collar divided in front, adapted from the Asian style.

Matelasse The type of weave of jacquard fabric. A triple-woven fabric and the weaving process creates quilt-like indentations.

Moire A silk fabric having a watermark, wavy surface pattern, obtained by passing it through engraving rollers, producing crushed "watermark" patterns that reflect light differently. Used most often on ribbed fabrics made with cotton, acetate, rayon, silk and some manufactured fabrics. Also, an artifact made by weaving, felting, knitting or crocheting natural or synthetic fibers.

Molas A colorful fabric panel of Central American origin, sewn with a reverse-appliqué technique and used for decorative purposes or clothing.

Metallic Thread Shiny thread made of metal fiber, usually in gold and silver used in embroidery and sewing.

Mohair The long silky hair of the Angora goat. Fabric made with yarn from this hair.

Mordant A substance used to set the dyes for permanent color on textiles.

Mud Cloth An African textile-making method. Narrow strips of hand-spun, handwoven cotton are stitched together into a whole cloth, then painted with patterns and symbols using river mud.

Muslin White cotton fabrics of plain weave. Muslins were first made at Mosul, now a city of Iraq. Widely made in India, they were first imported to England in the late 17th century.

Needle Lace Needle lace is the pinnacle of lace-making arts. The most flexible and time-consuming, it consists of using a needle to stitch up hundreds of little stitches to form the lace itself.

Needlepoint Traditional needlepoint is embroidery done on canvas using wool to execute the classic tent stitch.

Obi The traditional sash that ties around a Japanese kimono jacket.

Opus Anglicanum Also known as English work. Exquisite needlework of medieval England done for ecclesiastical or secular use on clothing, hangings or other textiles, primarily by nuns and then by laywomen in workshops.

Organic Materials Any embellishments from nature such as semiprecious stones, dried mushrooms, leaves, wood or seashells used to adorn a garment or fiber art piece. Certain dyes and cloth-making techniques use plant-derived colors or even mud.

Organza A sheer, stiff fabric of silk or synthetic material usually used for trim or evening dresses.

Osnaburg A type of coarse, heavy cloth woven of linen or cotton.

Othello Coat An elegant ankle-length, cocoon-style coat pattern reminiscent of royal robes and 1920s-era evening coats. Only three yards of fabric and two machine-sewn straight seams are needed to construct the coat. This obscure pattern is Ruth's most free-flowing garment style.

Paisley Fabric typically made of soft wool, woven or printed with colorful, curved designs and patterns.

Palampore A hand-painted and mordant-dyed bed cover made in India during the 18th century using the kalmari technique, whereby an artist draws designs on cotton or linen fabric with a kalam pen containing mordant, then dips the textile into dye.

Papiér-Mâche A craft using layers of paper dipped in a mixture of glue and water, adhered onto an object creating a sculptural form. The piece becomes hard when the paste dries and can be painted.

Passementerie The art of making elaborate trimmings or edgings of applied braid, gold or silver cord, embroidery, colored silk or beads for clothing.

Patchwork Pieces of cloth of various colors and shapes are sewn together to form one larger cloth. A method often used in quilt-making, handmade garments and purses.

Petit Point Also known as tent or needlepoint stitch. A small, diagonal embroidery stitch crosses over the intersection of one horizontal and one vertical thread on needlepoint canvas forming a slanted stitch.

Pin Loom The small, hand-held loom with metal straight pins in which the weft thread is carried through the shed by a long eye-pointed needle instead of by a shuttle. Also called a needle loom.

Piping Soft cotton cord forms the filling for piping. Cord piping is commonly used for edge treatments to give visual interest or definition. While bindings enclose or edge a garment, piping is inserted between seams.

Plain Weave The most basic of the three fundamental types of textile weaves. The warp and weft are aligned so that they form a simple criss-cross pattern. Each weft thread crosses the warp threads by going over one, then under the next, and so on. Also called the tabby weave.

Polished Cotton Either a satin weave or plain weave cotton that is finished chemically to appear shiny.

Polyester A manufactured, woven fiber introduced in the early 1950s, second only to cotton in worldwide use. Characterized by high strength, excellent resiliency, high abrasion resistance and wrinkle resistance. Low absorbency allows the fiber to dry quickly; the synthetic fabric is derived from fiber filaments of polymer resins.

Pongee A soft, thin cloth woven from Chinese or Indian raw silk. Originally woven on hand looms in the home, the unbleached textile is light or medium weight, and tan or ecru in color. Originally from Chinese "penchi" which means woven at home.

Prints Designs printed on textiles including screen- and block-printing, flatbed, rotary press and digital printing technology. Traditional floral designs, motifs, dimensional effects and repeat patterns are transferred to fabric.

Puffs Three-dimensional puffs are made of fabric circles, gathered and sewn in the center to form dimensional rosettes used for decorative embellishment on Ruth's garments. Also called poufs.

Quilting A method of sewing or tying two layers of cloth with a layer of insulating batting in between. The pieces are hand-stitched through layers of fabric and filling, so as to create a design.

Raffia An African palm tree having large leaves that yield a useful fiber similar to a strong, pliable straw. The leaf fibers of this plant are used for tribal clothing and trims, mats, baskets and other products.

Ramie A tall perennial herb of tropical Asia, cultivated for the fiber from its woody stems. The flax-like fiber from the stem of this plant is used in making fabrics and cordage.

Rattail A smooth, shiny cording product used for necklaces, knotting, bridal wear, fashion accents and craft projects.

Resist-Dye Technique Found in most cultures, resist-dye practices are based on the principles of folding, tying or covering areas of fabric, which prevents dye from coming into contact with certain parts of the cloth. This process is used to create beautifully abstract and patterned textiles. Batik and Shibori are two well-known resist-dye techniques.

Rickrack A flat narrow braid woven in zigzag form, used as a trimming for clothing or curtains.

Roving Natural fiber yarns that have been drawn out and slightly twisted in preparation for spinning.

Sampler A piece of folk art embroidery produced as a demonstration of skill in needlework. It often includes the alphabet, figures, motifs and decorative borders.

Sari A garment worn by southern Asian women that consists of several yards of lightweight cloth draped so that one end forms a skirt, and the other a head or shoulder covering.

Satin Smooth fabric, as of silk or rayon, woven with a glossy face and a dull back. A basic weave construction with the interlacing of the threads so arranged that the face of the cloth is covered with warp yarn or filling yarn and no twill line is distinguishable.

Screen Printing A screen is made of porous, finely woven mesh stretched over a frame. Areas are blocked off with a non permeable material to form a stencil, so the open spaces allow the ink to appear. The screen is placed atop fabric, and ink is placed on top of the screen and pressed through to create the design.

Sheers The term sheer refers to semi-transparent cloth. It is usually a very thin knit and is used to make curtains, tights and stockings.

Shibori Technique Method of resist-dyeing that includes stitching, clamping and binding techniques.

Shisha Tiny round or diamond-shaped mirrors are sewn on with a framework of stitches. A centuries-old folk embroidery of Russia and Central Asia, shisha is believed to originate from India. Shisha work is part of the great embroidery tradition and is used as textile embellishment.

Silk The strongest natural fiber. Silk fabric is produced from yarn spun from silk waste. This fine, lustrous fiber is used to make thread and fabric. It is one of the oldest textile fibers known to man. Different variations include: jacquard, brocade, charmeuse, crêpe, chiffon, China silk, dupioni, faille, matelasse, pongee and georgette.

Spindle Wheel A rod or pin, tapered at one end and usually weighted at the other, on which fibers are spun by hand into thread and then wound. A similar rod or pin used for spinning on a spinning wheel; a bobbin or spool on which thread is wound on an automated spinning machine.

Spinning Wheel An apparatus for making yarn or thread, consisting of a foot-driven or hand-driven wheel and a single spindle.

Square-Cut Jacket A universal clothing style based on the authentic kimono, mandarin-style and historic straight-line fashion of Japan, China, Africa and Turkey. Ruth's simple T-shaped, Square-Cut Jackets require only three yards of fabric and two simple straight seams.

Straight-Line Long Coat A simple coat based on a classic straight-cut pattern, with an open front that buttons or has closures from the neckline to waist or hips, with sleeves that attach to the bodice at the top.

Stitching Machine zigzag, straight, chain stitch and hand-finishing sewing techniques. A repeated movement of a threaded needle in sewing fabric pieces or

embellishments. A single loop of yarn around an implement such as a knitting needle; the link, loop, or knot made in this way. A mode of arranging the threads in sewing, embroidery, knitting or crocheting.

Taffeta A crisp, smooth, plain-woven fabric with a slight sheen, made of various fibers, such as silk, rayon or nylon, and used especially for women's garments.

Tambour A small wooden embroidery frame consisting of two concentric hoops between which fabric is stretched.

Tapestry A heavy cloth woven with rich, often varicolored designs or scenes, usually hung on walls for decoration and sometimes used to cover furniture.

Tartan Cross-checkered repeating pattern of bands, stripes or lines of various colors and of definite width and sequence, woven into woolen cloth, sometimes with silk added. Such patterns have existed for centuries in many cultures but have come to be regarded as Scottish.

Tassels A bunch of loose threads or cords bound at one end and hanging free at the other, used as an ornament on curtains or clothing.

Tatting Handmade lace fashioned by looping and knotting a single strand of heavy-duty thread on a small hand shuttle.

Tension The act or process of stretching something tight, especially a device that controls the tautness of thread on a sewing machine or loom.

Textiles A cloth, especially one manufactured by weaving or knitting; a fabric. Fiber or yarn for weaving or knitting into cloth.

Threadwork Hand embroidery and needlepoint methods such as cross-stitching, beadwork and creating French knots using needle and thread.

Tie-Dye A resist-dye technique. To dye fabric after tying parts of the cloth so that they will not absorb dye, giving the fabric a streaked or mottled look.

Toile A usually light-colored fabric of linen or cotton printed in the French tradition with a scenic pattern or design often used for curtains and upholstery.

Trapunto A quilting method in which the design is outlined with two or more rows of running stitches and then padded from the underside to achieve a raised effect. This embroidery style originated in Italy.

Tubes Fabric "straws" or cylindrical tubes of cloth sewn by machine and used for dangling adornment on Ruth's garments. When stuffed with cotton fiberfill, they can also become three-dimensional necklaces.

Tulle Fine mesh made of cotton, silk or manufactured fiber.

Tunic A loose-fitting garment similar to a vest, sleeved or sleeveless, extending to the knees and worn by men and women, especially in ancient Greece and Rome.

*Preserving ancestral fiber arts
is my mission; I express this
through my work.*

Turkamon Tassels Long handmade tassels with beadwork usually used for festive decoration on animal saddles. Persian camels were adorned with colorful, wool tassels, designed to flick the flies away.

Turkish Coat Pattern An authentic folkwear garment style that is a favorite with quilters and clothing artists. This ankle-length, straight-line coat originated in Central Asia, where it was made in brilliant silks and floral cottons.

Twill A fabric with diagonal parallel ribs or the weave used to produce such a fabric. One of the three basic textile weaves distinguished by diagonal lines. In the simplest twill, the weft crosses over two warp yarns, then under one, the sequence being repeated in each succeeding row, but stepped over, one warp either to the left or right.

Upholstery Stuffed, padded and spring-cushioned furniture, such as chairs and sofas, or the decorative materials and fabrics that cover them. Italian Renaissance chairs were cushioned with leather, velvet, or embroidery; the French made ornate chairs covered with tapestries and embroideries; England developed upholstery in Elizabethan and Jacobean reigns.

Velvet Soft woven cloth such as silk, cotton, rayon or synthetic fibers having a short, dense pile and a plain, smooth underside. This fabric is often used in luxurious clothing and upholstery characterized by a soft, downy surface formed by clipped yarns.

Vest Classic waist- or hip-length, sleeveless garment, often having buttons down the front, worn by men or women and usually layered over a shirt or blouse.

Voile Light, plain-weave, sheer fabric of cotton, rayon, silk or wool used especially for making dresses and curtains.

Warp In weaving, the warp is the set of lengthwise yarns through which the weft is woven. Each individual warp thread in a fabric is called a warp end.

Weaving The textile-making act and art of forming cloth in a loom by the union or intertexture of threads usually of cotton, wool or flax. Plain or tabby weave is the most basic of the three fundamental types of textile-making techniques. In plain weave the warp and weft are aligned so that they form a simple criss-cross pattern. Each weft thread crosses the warp threads by going over one, then under the next, and so on. The next weft thread goes under the warp threads that its neighbor went over and vice-versa.

Weft The horizontal threads interlaced through the warp in a woven fabric. Also the yarn of spun fiber used for the weft or woof. The yarn is drawn under and over parallel warp yarns to create a fabric. The weft is threaded through the warp using a shuttle. Hand looms were the original weaver's tool, with the shuttle being threaded through alternately raised warps by hand.

Whitework An emboidery technique in which the stitching matches the same color as the foundation fabric, usually of white linen.

Whorl A small flywheel that regulates the speed of a spinning wheel.

Wool The dense, soft, often curly hair forming the coat of sheep and certain other animals, such as the goat and alpaca, consisting of cylindrical fibers of keratin. The hair is spun into textile fibers to create woolen fabric known for its warmth and durability.

Worsted Yarn and cloth made from wool, its name derived from the village of Worstead in Norfolk, England. The cloth has a hard, smooth texture and exhibits the twill weave.

Yarns A continuous strand of twisted threads of natural or synthetic material, such as wool or nylon, used in weaving, knitting or for making tassels.

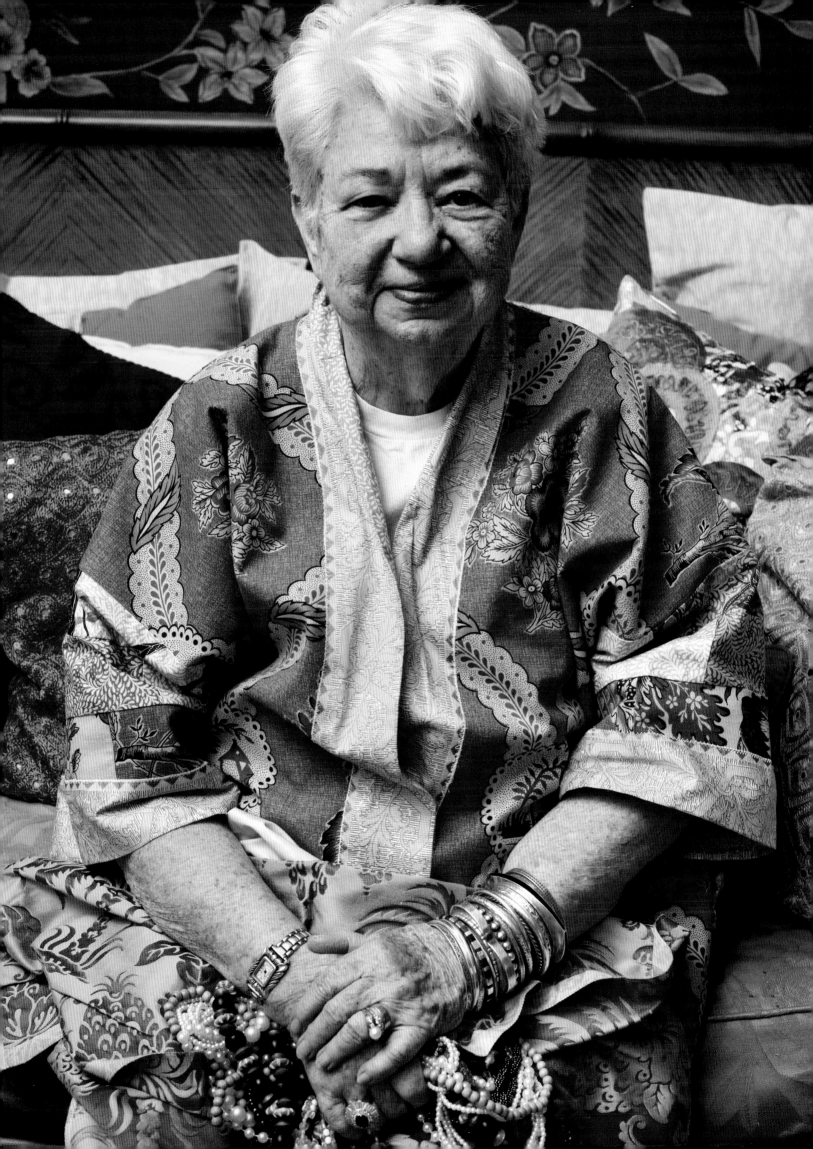

RUTH FUNK
Center for Textile Arts

My lifelong passion for textiles and fiber arts has grown from a personal journey into an ever-expanding sphere of influence—with research, education and preservation at its core. Along my creative path over the last 20 years, I have worked toward realizing my vision to leave a legacy for future generations, a tribute to multicultural textiles.

After attending a textile art fundraising event in 2003 benefitting the College of Psychology and Liberal Arts at the Florida Institute of Technology, I began to imagine creating a textile arts program in collaboration with the institute. My ongoing relationship as a trustee with the university made it clear

Breaking ground from left, Mary Beth Kenkel, dean of the College of Psychology and Liberal Arts; Shellie Williams, executive director of the Brevard Cultural Alliance; Ruth Funk; Anthony J. Catanese, Florida Tech President; Dwayne McCay, Florida Tech provost.
Photograph by Kathy Hagood

that Florida Tech would soon became the ideal venue for my philanthropic dream to unfold: interweaving humanities and the arts with science and technology. I agree with university president Anthony J. Catanese's philosophy on educating the whole brain; my vision for a new textile arts center fully embraces the faculty's commitment to providing high-tech education with a human touch.

I have always wanted a place to preserve rare textiles, exhibit world textiles, teach textile arts and expose people to the value of cultures and cloth. Our technological society today focuses on lightning-speed global communications, computers and engineering, but throughout the dawning of the ages man has creatively expressed life and times through the arts, especially clothing and textiles. I felt it would be wonderful to have an academic environment showcasing some of the finest textiles and exemplary cloth-making techniques from around the world. Florida Tech's student population comes from myriad cultures—those who attend the school represent more than 15 countries spanning several continents—and the 50-year-old institution gladly welcomed the idea for an international textile arts center. Open minds receive great gifts.

Principal benefactor Ruth Funk with Florida Tech President Anthony James Catanese. With a keen eye for textiles, Ruth held a vision for the future, uniting technology with her passion for textile arts at one of the nation's most innovative universities: Brevard County's Florida Institute of Technology. Photograph by Dave Potter

I am proud to say that the Ruth Funk Center for Textile Arts is the first textile art center in Florida. The modern center—adjacent to the Evans Library and across from the picturesque 30-acre Botanical Garden—features exhibition space, museum-quality storage, work space and a mezzanine library containing many books that I have thoughtfully collected over the years. Students also learn by seeing textile shows and exclusive rotating gallery exhibits, while enjoying a forum designed to expand perceptions of the visual arts and encourage dialogue about traditions, cultural identity and aesthetics. In addition, I have donated more than a hundred pieces of my private textile collection and wearable art garments that are now housed in the center for the benefit of university students and visitors alike.

My vision to support the research,
education and preservation of textiles
has come to fruition.

I am thrilled to have helped shape this project and sincerely hope it heightens awareness and appreciation for textiles, not only through my garments that pay tribute to cloths of many cultures, but also through the handcrafted work of other artisans both past and present. Highlighting the center's permanent collection are traditional handmade textiles, embroidery, garments and related accessories from Africa, Japan, India and Central Asia; European and North American embroidery, fine lace and samplers from the 17th through the 20th centuries, as well as contemporary wearable art and fiber arts. Textiles are stored in a climate-controlled, dust-free environment, with acid-free cases to preserve the delicate fibers of contemporary pieces and rarities. We are dedicated to furthering the understanding of cultural and creative achievements in the textile and fiber arts; the center preserves, maintains, displays and interprets an international collection of textiles through public exhibitions and educational programs.

As an artist, art historian, teacher, collector and philanthropist, I have eagerly supported textile arts exhibits, symposia and curriculum on campus since 2004. The Ruth Funk Lecturer program continues to attract guest speakers from some of the most prestigious art museums throughout the United States. It is rewarding to know that my contributions have come to fruition in the heart of the Florida Tech campus. The two-story center has 3,000 square feet of exhibition space, 2,500 square feet of collections storage and work areas, a 700-square-foot mezzanine library and a generous lobby with grand stairway for hosting special functions. The contemporary state-of-the-art textile center building was designed by Holeman Suman Architects of Melbourne, Florida. Emphasizing cultural enrichment within a technical university offers significant benefits to the whole student body and the larger community; I am so gratified to have been an integral part of this shared endeavor.

Most of all, I hope that the center brings increased awareness of fiber arts and the study of age-old crafts, traditional costumes and textiles of diverse cultures. It is my pleasure to invite you to visit the Ruth Funk Center for Textile Arts at the Florida Institute of Technology, the only museum of its kind in Florida.

Share in my passion.

Ruth E. Funk

Founder and Principal Donor, Ruth Funk Center for Textile Arts

Jack Lenor Larsen and Ruth Funk at Florida Institute of Technology's fundraising gala with university president Anthony J. Catanese and his wife, Sara. Photograph by Dave Potter

Florida Institute of Technology
High Tech with a Human Touch™

Ruth's $1.25 million gift to Florida Tech was the financial foundation underlying the beautiful Ruth Funk Center for Textile Arts, which was designed by Holeman Suman Architects and opened to the public in 2009. Visit http://textiles.fit.edu for more information. Please contact the center at 321.674.6129 for details.

EDITOR'S NOTE
The Artist's Studio

Dedicated to her true passion, Ruth is not only a teacher, world traveler, artist, collector, designer, preservationist and textile enthusiast, but a visionary philanthropist. In a visit to her Melbourne home I experienced the artist on all levels, enjoyed her hospitable nature and gained a deeper understanding of her life's work.

When I arrived at Ruth's Florida home, I entered the Spanish-tiled patio with its tropical plants and wind chimes gently blowing in the balmy sea breeze. The serenity moved me, but more than this, the vibrant ceramic pots and colors said, "there's creativity here." She greeted me at the door with her sparkling brown eyes and silver hair, a greeting of warmth with directness and an endearing smile, perfectly lined in her classic red lipstick. Not far behind was Jezebel, Ruth's Himalayan feline.

I stepped into Ruth's world. She surrounds herself with beautiful things like most artists. The proverbial collector and world traveler, Ruth has explored Europe to Asia and Russia to Africa. She has covered countless miles on many continents over the years; adventure is in her blood. Ruth's unusual artifacts exhibit a Bohemian eclecticism. An impeccable taste in furnishings and exquisite interior designer touch shows her artistic talent and affinity for diverse global influences.

Gallery walls are covered with thoughtfully collected pieces from artists known and unknown. Her own vibrant abstract oil painting circa 1950s hangs in the sitting room, inspired by a workshop she had with Hans Hofmann. A charming collection of antique French Quimper faience teapots and plates line the hallway hutch. The sun shines through numerous colored glass pieces and rare objets d'art, which are around every corner throughout her home. Her precious antique porcelain doll collection with an architecturally correct, handmade Victorian dollhouse is lovingly displayed in her private bedroom. The living room's centerpiece is a Chinese daybed lavishly plumped with brightly hued decorative pillows, some made by Ruth and some acquired. A red, hand-painted 17th-century Tibetan lotus flower chest rests in the living room and an English

antique grandfather clock sings melodic tones on the hour. Global is an understatement. Everything in Ruth's possession has a fascinating story, much like the world textiles she collects.

A humble and principled person, Ruth considers her working studio a serious place. This is where she creates her exclusive handmade garments and fiber art jewelry. A 19th-century mannequin stands guard at the door, clothed in an antique Chinese coat with strands of beads and polished stones hanging around its neck for adornment. Shelves of fabric remnants, printed yardage, pieces of silk and handwoven antique fragments are stacked in colorful array. Her Bernina sewing machine, spools of thread and a bulletin board of ideas define the simple space where she concepts, sews and creates from one little chair. A work table and ironing board are ready for laying out new garments, cutting patterns and working with her beloved textiles. Closets brimming with Ruth's original designer garments beckon to be examined closely for their meticulous hand-sewn details, inventive mosaic-like assemblages, unorthodox use of embellishments and superior craftsmanship. Her body of work is clearly a reverent gesture to the past and the heritage of cloth-making.

Then there's the vintage 1907 Chickering baby grand piano near the window, much like the one she played as a child. Ruth plays classical Bach and Chopin whenever the spirit moves her. A private woman, she feeds her soul with music, good literature and fine art. She has stacks of newspapers, clippings, museum catalogs and her mainstay, *The New Yorker*. Staying current on politics, foreign affairs and American culture, she is an avid reader with a keen sense of humor and zest for knowledge.

Her friends, family and grandchildren are in close proximity and she has an active social life with several art-related causes at the forefront. To hear Ruth talk about the Brevard Art Museum and Vero Beach Museum of Art, two Florida art institutions she has enthusiastically supported over the years, she beams with pride. The former art historian, interior design teacher and university educator has been devoted to a newfound mission during her twilight years. Her latest love is the Florida Institute of Technology where the Ruth Funk Center for Textile Arts lives and breathes with her complete collection. Ruth is a giver and a dreamweaver, possessing a philanthropic heart through and through.

We should all be so lucky to hear her pearls of wisdom when she shares her love of traditional textiles and techniques. But it is her unique handmade garments that speak volumes about how much she treasures different world cultures and the people who have perfected the art of weaving threads into cloth. Much like the classic Brothers Grimm fairy tale where Rumpelstiltskin's daughter has a gift for spinning straw into gold, Ruth has created dazzling multicultural garments with her own form of alchemy.

The common thread in my work is love—I am fulfilled immeasurably through my creativity.

PHOTOGRAPHER

Dominic Agostini

Born and raised on the island of Trinidad, Dominic Agostini followed his passion for the art of photography by earning his bachelor's degree from Columbia College Chicago. He began his professional career working with commercial photographers, gaining valuable experience in the studio and on location shooting national ad campaigns. Dominic employs artful lighting techniques and has mastered digital technology, yet he has an affinity for medium format and other traditional photography tools and methods.

A resident of Satellite Beach, Florida, Dominic is a special assignment photographer for local and national magazines—he loves meeting interesting people with each new opportunity that allows him to further explore his talents. Dominic employed a flattering lighting approach in photographing Ruth Funk's collection, allowing the viewer to enjoy each creation as a whole and marvel at the unique, colorful handwoven textiles, meticulous hand-sewn details and fine embellishments. Dominic's photographic images bring the artist's body of work to life and one can almost feel the exquisite materials Ruth has gathered from around the globe.

www.dominicphoto.com

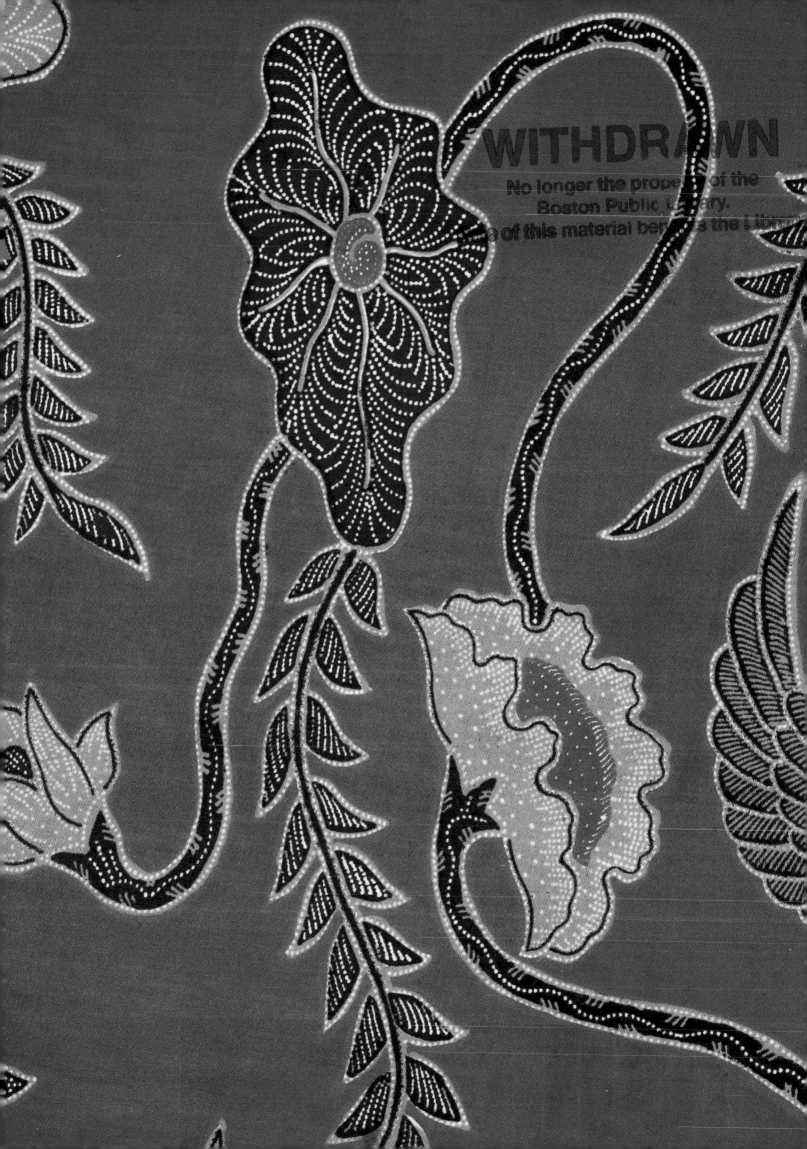